A NATIONAL SOUL
Canadian Mural Painting, 1860s–1930s

A NATIONAL SOUL

Canadian Mural Painting
1860s–1930s

MARYLIN J. McKAY

McGill-Queen's University Press
Montreal & Kingston • London • Ithaca

© McGill-Queen's University Press 2002
ISBN 0-7735-2290-5

Legal deposit second quarter 2002
Bibliothèque nationale du Québec

Printed in Canada on acid-free paper

This book has been published with the help of a grant from the Humanities and Social Sciences Federation of Canada, using funds provided by the Social Sciences and Humanities Research Council of Canada.

McGill-Queen's University Press acknowledges the financial support of the Government of Canada through the Book Publishing Industry Development Program (BPIDP) for its publishing activities. We also acknowledge the support of the Canada Council for the Arts for our publishing program.

Typeset in 11.5/14 Granjon by Donna Bates.
Designed by Miriam Bloom, Expression Communications Inc.

National Library of Canada Cataloguing in Publication Data

McKay, Marylin Jean, 1944-
A national soul : Canadian mural painting, 1860s–1930s

Includes bibliographical references and index.
ISBN 0-7735-2290-5

1. Mural painting and decoration, Canadian. I. Title.

ND2641.M33 2001 751.7'3'097109041 C2001-902771-0

CONTENTS

Illustrations / vii

Acknowledgments / xiii

INTRODUCTION
 Mural Painting in Canada, 1860s to 1930s:
 A New Paradigm for Kitsch / 3

CHAPTER ONE
 The European-Based Mural Movement:
 History and Ideology / 15

CHAPTER TWO
 Civic Mural Paintings:
 "Glorifying the Memories of a Nation" / 24

CHAPTER THREE
 Commercial Mural Paintings:
 "The Glorification of Man's Handiwork" / 60

CHAPTER FOUR
 Protestant Church Mural Paintings:
 "Bringing Back the Soul of the Town" / 78

CHAPTER FIVE
 Catholic Church Mural Paintings:
 "Reflections of Our Community's Soul" / 94

CHAPTER SIX
Mural Paintings in Private Sites:
"Wealth Transfigured into Crowns of Glory" / 109

CHAPTER SEVEN
The "Disappearing" Native in English Canadian
Mural Paintings:
"But He Is Gone and I Am Here" / 134

CHAPTER EIGHT
Progress, Patriarchy, and Public Library Murals:
"Whilst a Sweet-Faced Woman Finds the Books" / 157

CHAPTER NINE
Opalescent Glass Murals in Toronto Kindergartens:
"A High Import Latent Even in *Pat-a-Cake*" / 173

CHAPTER TEN
Canadian Mural Painting, 1940s and 1950s:
The European-Based Mural Movement Lingers On / 193

APPENDIX
Canadian Murals Discussed in *A National Soul* / 207

NOTES / 225

BIBLIOGRAPHY / 261

INDEX / 293

ILLUSTRATIONS

COLOUR PLATES

1 John Leman, *Before the White Man Came,* 1933, foyer, Saskatchewan Legislative Building, Regina (*in situ*). Photo: Saskatchewan Archives Board, R-A II, III(3) / xvii

2 Henri Beau, *The Arrival of Champlain at Quebec,* 1903, Legislative Council Chamber, Palais législatif, Quebec City (now in the Musée de Québec). Photo: Musée de Québec, 34.04, 1983. Photographer Patrick Altman / xviii

3 John Beatty, detail, *Spring,* 1908–10, Rosedale Public School (in hallway of new building). Photo: Tom Moore and the Archives of the Toronto District School Board / xix

4 Emmanuel Briffa, mural painting, 1930, auditorium, Capitol Theatre, Halifax (some in the Provincial Archives of Nova Scotia; others in Historic Properties, Halifax). Photo: Provincial Archives of Nova Scotia / xx

5 Arthur Crisp, *Freight and Travel by Canoe,* 1930, Canadian Bank of Commerce (*in situ*). Photo: Laszlo Cser and the Bank of Commerce / xxi

6 Herbert Stansfield, *Ascension,* 1923, St Anne's Anglican Church, Toronto (*in situ*). Photo: Tom Moore / xxii

7 Frederick Challener, detail, *Enchanted Woodland,* 1924, main floor hall, "Parkwood," home of Samuel McLaughlin, Oshawa, Ontario (*in situ*). Photo: Sunset Studios, Oshawa, Ontario / xxiii

8 Charles Comfort, *Captain Vancouver,* 1939, foyer, Hotel Vancouver, Vancouver (now in the Confederation Centre Art Gallery, Charlottetown). Photo: Confederation Centre Art Gallery / xxiv

FIGURES

1 Augustus Tack, mural paintings, 1920, Legislative Chamber, Manitoba Legislative Building, Winnipeg (*in situ*). Photo: Provincial Archives of Manitoba, N16031 / 30

2 George Southwell, *Enterprise,* 1935, rotunda, Provincial Parliament Buildings, Victoria, British Columbia (*in situ*). Photo: Provincial Archives of British Columbia, B-06675 / 32

3 George Southwell, *Justice,* 1935, rotunda, Provincial Parliament Buildings, Victoria, British Columbia (*in situ*). Photo: Provincial Archives of British Columbia, B-06668 / 33

4 George Southwell, *Agriculture,* 1950s, rotunda, Provincial Parliament Buildings, Victoria, British Columbia (*in situ*). Photo: Provincial Archives of British Columbia, B-06672 / 34

5 Donald Hill, *Time Pointing Out the Opportunities to Acquire Education and Its Rewards,* 1924, Strathearn School, Montreal (destroyed). Photo: Metropolitan Toronto Reference Library / 35

6 Napoléon Bourassa, *Apotheosis of Christopher Columbus,* 1904–12, planned for the National Assembly Chamber, Palais législatif, Quebec City (never installed, now in the Musée de Québec). Photo: Musée de Québec, 65.174, 1992. Photographer Patrick Altman / 36

7 Charles Huot, *The Debate on Languages*, 1910–13, National Assembly Chamber, Palais législatif, Quebec City (*in situ*). Photo: Quebec Provincial Archives, E6, S7, P87443 / 38

8 Gustav Hahn, mural paintings, 1892, Legislative Chamber, Ontario Legislative Buildings (*in situ* but mostly covered with a false ceiling, small areas uncovered). Photo: Paul Tranquada, Building Management and Conservation Branch, Legislative Assembly of Ontario / 40

9 Mary Hiester Reid, *Autumn,* 1913, Town Hall, Weston, Ontario (present location unknown). Photo: Edward P. Taylor Research Library and Archives, Art Gallery of Ontario, LN456, no. 1 / 44

10 Arthur Crisp, mural paintings, 1920, Reading Room, Parliament Buildings, Ottawa (*in situ*). Photo: National Archives of Canada, Ottawa, PA179314 / 44

11 Arthur Lismer, mural paintings, 1927–32, auditorium, Humberside Collegiate Institute, Toronto (relocated to a new auditorium). Photo: Tom Moore / 46

12 George Reid, mural paintings, 1920–30, auditorium, Jarvis Collegiate Institute, Toronto (*in* situ). Photo: Metropolitan Toronto Reference Library / 47

13 George Reid, mural paintings, 1935–38, Palaeontology Galleries, Royal Ontario Musuem (some destroyed, some in storage, Royal Ontario Museum). Photo: Royal Ontario Museum / 48

14 Arthur Lismer and Harold Rosenberg, detail of mural paintings, 1916–18, Halifax or Bedford restaurant (present location unknown). Photo: National Archives of Canada, C144374 / 67

15 Guido Nincheri, mural paintings, 1920, auditorium, Belmont Theatre, Montreal (destroyed). Photo: National Archives of Canada, PA119706 / 68

16 Peter Almini, mural paintings, 1877–78, dining room, Windsor Hotel, Montreal (destroyed). Photo: McCord Museum / 69

17 Hal Ross Perrigard, *Mount Sir Donald Glacier, B.C.,* 1924, Ladies' Waiting Room, Windsor Station, Montreal (destroyed). Photo: Canadian Pacific Archives, 16427 / 70

18 Frederick Challener, mural painting, 1901, saloon of the ss *Kingston* (destroyed). Photo: National Gallery of Canada / 71

19 Frederick Challener, *The Triumph of Drama,* 1897, Russell Theatre, Ottawa (*in situ*). Photo: National Gallery of Canada, 7003 / 72

20 Arthur Crisp, *The Empress of Britain: The Last Word in Ocean Travel*, 1930, Canadian Bank of Commerce (*in situ*). Photo: Laszlo Cser and the Bank of Commerce / 75

21 Adam Sheriff Scott, *The "Pioneer" at Fort Garry*, 1927, Hudson's Bay Company department store, Winnipeg (*in situ*). Photo: Hudson's Bay Company Archives, 1987/363-W316/20 / 76

22 Gustav Hahn, mural paintings, 1890, St Paul's Methodist Church, Toronto (destroyed). Photo: United Church Archives, 90.115P/1296 / 80

23 Robert Harris, *Peace I Leave unto You, My Peace I Give unto You,* 1898, All Souls' Chapel, St Peter's Anglican Cathedral, Charlottetown (*in situ*). Photo: Provincial Archives of Prince Edward Island, 2841-39 / 81

24 J.E.H. MacDonald et al., mural paintings, 1923, St Anne's Anglican Church, Toronto (*in situ*). Photo: Tom Moore / 82

25 Will Ogilvie, mural painting, 1936, Hart House Chapel, University of Toronto, Toronto. Photo: National Archives of Canada, PA186330 / 93

26 Napoléon Bourassa, mural paintings, c. 1880, Notre-Dame-de-Lourdes, Montreal (*in situ*). Photo: McCord Museum / 100

27 Ozias Leduc, *St. Luke,* 1896–99, Saint-Hilaire, Quebec (*in situ*). Photo: Montreal Museum of Fine Arts and © Estate of Ozias Leduc/SODRAC, Montreal, 2000. Photographer Christine Guest / 104

28 Unknown artist, detail, mural paintings, c. 1900, double-parlour, "Old Manse Library" House, Newcastle, New Brunswick (*in situ*). Photo: Susan Butler / 116

29 Guido Nincheri, mural paintings, 1918, grand salon of Château Dufresne, Montreal (*in situ*). Photo: McCord Museum, MP-1978.211.16 / 117

30 H. Schasstein, detail, mural painting, 1878, main hall, Castle Kilbride, Baden, Ontario (*in situ*). Photo: Gary Beach / 119

31 Mary Hiester Reid, *Castles in Spain*, 1896, Reid home, Wychwood Park, Toronto (now in the Art Gallery of Ontario). Photo: Edward P. Taylor Research Library and Archives, Art Gallery of Ontario, 70/18/120

32 F. McGillivray Knowles, detail, *History of Music*, 1911, "Ardwold," Toronto home of Sir John Eaton (now in the Art Gallery of Ontario). Photo: Edward P. Taylor Research Library and Archives, Art Gallery of Ontario, 56/33.2 / 121

33 William Brymner, mural paintings, 1899, dining room, Charles Porteous summer house, Île d'Orléans, Quebec (*in situ*). Photo: National Gallery of Canada / 123

34 George Reid, mural paintings, 1899–1901, library of "Long Garth," Toronto home of Byron Edmund Walker (now in the Art Gallery of Ontario). Photo: Edward P. Taylor Research Library and Archives, Art Gallery of Ontario, LN30-9 / 124

35 Arthur Lismer, *The Picnic*, 1916, summer home of Dr James MacCallum, Georgian Bay, Ontario (now in the National Gallery of Canada). Photo: National Gallery of Canada, 320542. Photographer John Evans Ltd, Ottawa / 126

36 J.E.H. MacDonald, *Inhabitants of Go-Home Bay*, 1916, summer home of Dr James MacCallum, Georgian Bay, Ontario (now in the National Gallery of Canada). Photo: National Gallery of Canada, 320543. Photographer John Evans Ltd, Ottawa / 127

37 Artist unknown, mural paintings, 1912, Bidwell A. Holgate House, Edmonton, Alberta (*in situ*). Photo: Ken Orr / 128

38 George Reid, *Staking a Pioneer Farm,* 1899, foyer, Toronto Municipal Buildings, Toronto (*in situ*). Photo: Tom Moore / 136

39 Frederick Challener, *Upper Fort Garry*, c. 1905, dining room, Royal Alexandra Hotel, Winnipeg (in storage, Manitoba Provincial Archives). Photo: Manitoba Provincial Archives, N13940 / 137

40 James MacDonald, *A Friendly Meeting, Early Canada*, 1923, produced for the Royal Canadian Academy's mural competition of 1923 (now in storage at the Metropolitan Toronto Reference Library). Photo: Metropolitan Toronto Reference Library, T32755 / 138

41 John Chester, drawing for *Champlain Teaches Natives the Charleston*, 1920s, installed as a mural in the Arts and Letters Club, Toronto. Photo: Metropolitan Toronto Reference Library / 140

42 John Beatty, detail, *Governor and Mrs. Simcoe Paddled Up the Credit River,* 1908, Mississauga Golf Club, Mississauga, Ontario (*in situ*). Photo: Tom Moore / 140

43 John Beatty, detail, *Governor and Mrs. Simcoe Paddled Up the Credit River,* 1908, Mississauga Golf Club, Mississauga, Ontario (*in situ*). Photo: Tom Moore / 141

44 Charles Jefferys, detail, mural paintings, 1931, Reading Room, Château Laurier Hotel, Ottawa (in storage, National Archives of Canada). Photo: National Archives of Canada, C6090 / 145

45 Charles Jefferys, detail, mural paintings, 1931, Reading Room, Château Laurier Hotel, Ottawa (in storage, National Archives of Canada). Photo: Metropolitan Toronto Reference Library / 145

46 Charles Jefferys and Frederick Challener, *French Explorers at Malbaie, 1660,* 1928, dining room, Manoir Richelieu Hotel, Quebec (*in situ*). Photo: Metropolitan Toronto Reference Library / 146

47 Charles Jefferys and Frederick Challener, *Clan Fraser Lands at Murray Bay, 1760,* 1928, dining room, Manoir Richelieu Hotel, Quebec (*in situ*). Photo: National Archives of Canada, C5946 / 147

48 Frederick Challener, *Fort Rouillé*, 1928, Loblaws Office, Toronto (in storage, City of Toronto Archives). Photo: Metropolitan Toronto Reference Library / 148

49 Frederick Haines, detail, *The Settlement of Canada*, 1929, Dominion Government Building, Canadian National Exhibition, Toronto (now in the National Trade Centre, Canadian National Exhibition, Toronto). Photo: Diane Falvey / 149

50 Frederick Haines, detail, *The Settlement of Canada*, 1929, Dominion Government Building, Canadian National Exhibition, Toronto (now in the National Trade Centre, Canadian National Exhibition, Toronto). Photo: Diane Falvey / 149

51 James Blomfield, mural paintings, 1903, ballroom of the Lieutenant-Governor's House, Victoria, British Columba (destroyed). Photo: Provincial Archives of British Columbia, C-07768 / 154

52 Blood Indian pictographs, 1929, lobby, Prince of Wales Hotel, Waterton Lake Provincial Park, Alberta (destroyed). Photo: Metropolitan Toronto Reference Library / 155

53 George Reid, *The Community*, 1924–26, main reading room, Earlscourt Public Library, Toronto (destroyed). Photo: Metropolitan Toronto Reference Library / 159

54 George Reid, *The Story Hour*, 1924–26, main reading room, Earlscourt Public Library, Toronto (destroyed). Photo: Metropolitan Toronto Reference Library / 160

55 Unknown artist, Clinton Street Public School, kindergarten, Toronto, c. 1930, with glass murals of c. 1914 (three panels installed in new building, two panels, location unknown). Photo: Archives of the Toronto District School Board / 174

56 Unknown artist, *Mary, Mary Quite Contrary*, c. 1916, Niagara Street Public School, Toronto (*in situ*). Photo: Helena Wilson and the Archives of the Toronto District School Board / 175

57 Rosedale Public School kindergarten, Toronto, 1908–10. Photo: *The School* 1 (September 1912): 323 / 181

58 Unknown artist, *The Little Gardener*, illustration of 1840s for Friedrich Froebel's *Mother-Play Songs*, reproduced in Blow and Eliot, *The Mottoes and Commentaries of Friedrich Froebel's Mother Play*, 228 / 184

59 Unknown artist, *The Hiding Children,* illustration of 1840s for Friedrich Froebel's *Mother-Play Songs*, reproduced in Blow and Eliot, *The Mottoes and Commentaries of Friedrich Froebel's Mother Play,* 254 / 185

60 William van Horne, Dutch nursery frieze, 1910, "Covenhoven," Minister's Island, New Brunswick (*in situ*). Photo: Jeff Gauley / 190–1

61 Jock Macdonald, *Nootka Village*, 1939, main dining room, Vancouver Hotel, Vancouver (destroyed). Photo: National Archives of Canada, PA198 561 / 198

62 Charles Comfort, *Legacy,* 1967, National Library, Ottawa (*in situ*). Photo: National Archives of Canada, C17579 / 200

ACKNOWLEDGMENTS

Many individuals and institutions helped me to research and write this book. Financial aid, which enabled me to see the Canadian murals and their European and American models, came from two main sources: William McKay, who also shared looking at many of the murals with me; and the Social Sciences and Humanities Research Council of Canada, through its Aid to Small Universities Program (disbursed by the Nova Scotia College of Art and Design).

Many archivists, curators, and librarians helped in a variety of essential ways. I would like to thank those at the National Archives in Ottawa; all the provincial archives; the Metropolitan Toronto Reference Library; the Vancouver Public Library; the McCord Museum in Montreal; the National Gallery Library in Ottawa; the Hudson's Bay Company Archives in Winnipeg; and the Edward P. Taylor Research Library and Archives at the Art Gallery of Ontario. Special thanks go to Jill ten Cate (CIBC Archives); Gail Gregory (Records, Archives, and Museum, Toronto District School Board); Elaine Mantua (*Edmonton Journal*); Robert McCausland of McCausland Limited; and Shirley Wigmore (Special Collections Library, Ontario Institute for Studies in Education).

There were many people who, sharing my enthusiasm for Canadian murals, generously gave me photographs or took photographs when I could not: Susan Butler of Newcastle, New Brunswick; Jeff Gauley of St Andrews, New Brunswick; Ken Orr of Edmonton; and Paul Tranquada in the Legislative Assembly of Ontario. As the work came to an end, Megan Deveaux kindly scanned the photographs and taught me how to make better use of my computer.

I would also like to thank the people who helped me to finalize the text for the book: the three anonymous readers who worked on behalf of the publisher and the Humanities and Social Sciences Federation of Canada; Aurèle Parisien of McGill-Queen's University Press, for helping me to shape my research material into a useful scholarly study; and Rosemary Shipton, whose fine editing transformed the manuscript into a readable format.

COLOUR PLATES

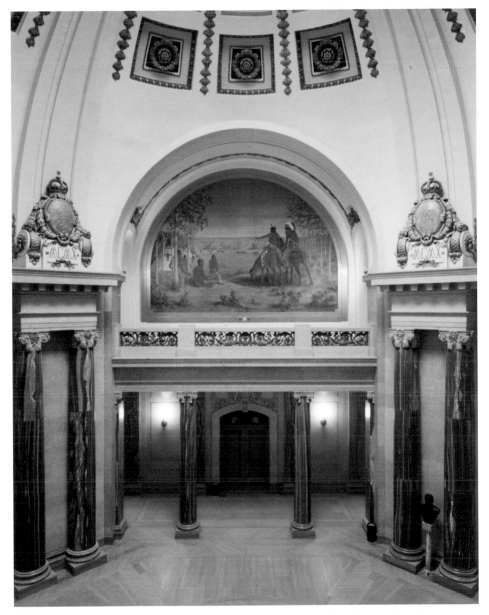

PLATE I John Leman, *Before the White Man Came,* 1933, Saskatchewan Legislative
Building, Regina

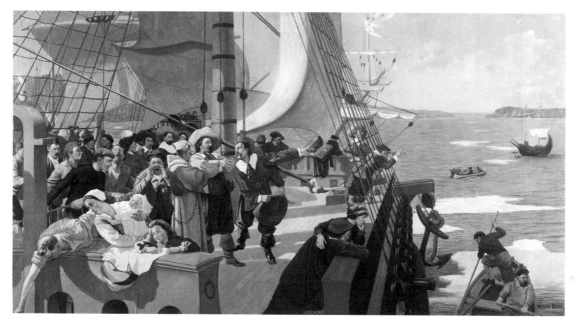

PLATE 2 Henri Beau, *The Arrival of Champlain at Quebec,* 1903, Legislative Council Chamber, Palais législatif, Quebec City

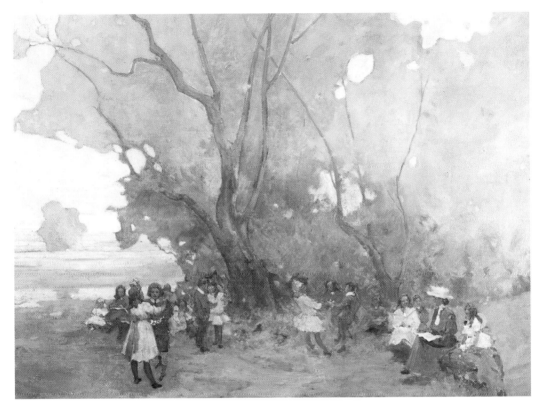

PLATE 3 John Beatty, *Spring*, 1908–10, Rosedale Public School kindergarten, Toronto

PLATE 4 Emmanuel Briffa, mural painting, 1930, Capitol Theatre, Halifax

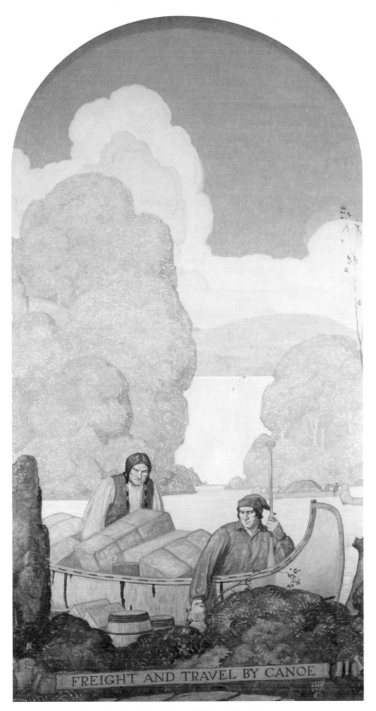

PLATE 5 Arthur Crisp, *Freight and Travel by Canoe*, 1930,
Canadian Bank of Commerce, Toronto

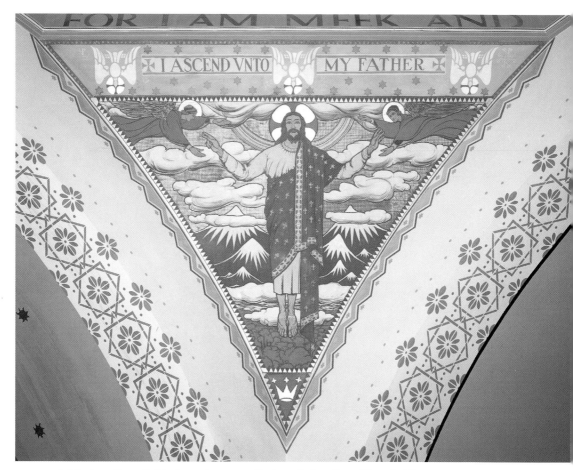

PLATE 6 Herbert Stansfield, *Ascension*, 1923, St Anne's Anglican Church, Toronto

PLATE 7 Frederick Challener, detail, *Enchanted Woodland*, 1924, home of Samuel McLaughlin, Oshawa, Ontario

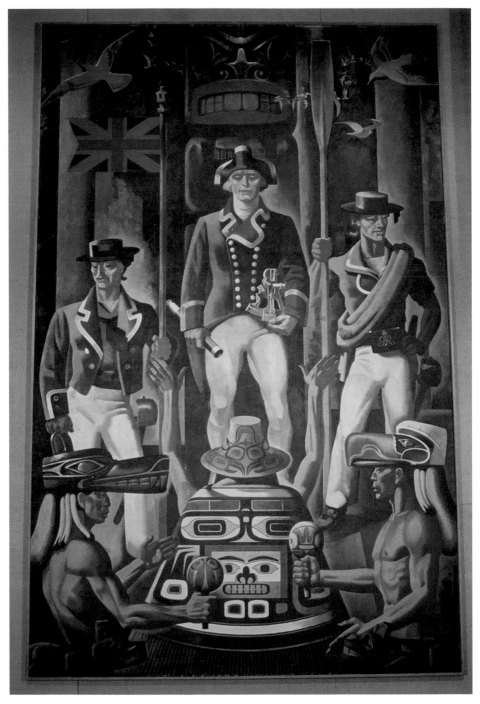

PLATE 8 Charles Comfort, *Captain Vancouver,* 1939, foyer, Hotel Vancouver, Vancouver

A NATIONAL SOUL

WE IN CANADA are too ready to think that we have neither history nor artists, and we are wrong in both cases. Still, so long as we neglect to surround our youth with the inspiration of such history as we have and to extend native encouragement to native artists, we will do much to perpetuate a partial justification of this pessimistic view ... Cannot Canada take breath long enough in its splendid effort to fill to the full the matchless opportunity of the present to provide that the heirs of all this prosperity shall be worthy of their heritage? Will we be satisfied to endow the next generation with a bank account and nothing more? Or would it not be better to leave it some-what fewer dollars and a far higher scale of culture? We can buy pictures as well as the next; and we can take that pride in our native art which will induce us to spend a little money on its encouragement. We have faith in ourselves in other things. Let us have faith in the national soul.

– Albert Carman in *The Canadian Magazine,* 1906.

INTRODUCTION

Mural Painting in Canada, 1860s to 1930s:
A New Paradigm for Kitsch

From the 1860s to the 1930s, professional artists painted murals for civic, commercial, religious, and private buildings across Canada. Some of these murals represented local landscapes, historical events, and contemporary activities; others illustrated Western literature, mythology, and Christian dogma. All were painted in realistic conservative styles. The subject matter of any one of these mural paintings, as might be expected, was linked to the function of the site it decorated. In the early 1880s Napoléon Bourassa decorated Notre-Dame-de-Lourdes in Montreal, a church dedicated to the Virgin Mary, with scenes of her Immaculate Conception (fig. 26). In 1896 Mary Hiester Reid painted a medieval scene, *Castles in Spain,* for her own "castle" / residence in Toronto's Wychwood Park (fig. 31). In 1897 Frederick Challener painted a Greco-Roman Apollo and the muses – the god of music and female inspirations of drama – for the proscenium arch of the Russell Theatre in Ottawa (fig. 19). In 1898 Robert Harris painted *Peace I Leave with You, My Peace I Give unto You* for All Souls' Chapel at St Peter's Anglican Cathedral in Charlottetown (fig. 23). It represents Harris's deceased mother, who attended St Peter's, engaged in conversation with Christ.

In 1912 an unknown artist painted scenes of early settlement in western Canada for a sitting room in the house in which Edmonton architect Bidwell Holgate had just "settled" (fig. 37). In 1913 Charles Huot installed *The Debate on Languages* on a wall of the National Assembly Chamber of the Quebec Palais législatif (fig. 7). It depicts the dramatic moment at which the government of Lower Canada voted to make both French and English the legal languages of the colony. In 1927 Adam Sheriff Scott painted *"The Pioneer" at Fort Garry* on a wall above the elevator on the main floor of the Hudson's Bay

Company department store in Winnipeg (fig. 21). It represents men of European ancestry and Native Canadian men engaged in trade at the company's Fort Garry in the early nineteenth century. This fort, which became the nucleus of the city of Winnipeg was the Hudson Bay Company's first "department store" in Winnipeg. In 1929 Frederick Haines painted eight panels, entitled the *Settlement of Canada,* for the Dominion Government Building at Toronto's annual agricultural fair, the Canadian National Exhibition. In one panel, men with oxen are plowing the land while a woman and children stand at the edge of the field amid pumpkins and apples (fig. 50).

These works of art and others like them were not the first mural paintings to appear in Canada. Nor were they the last. They were, however, different from those produced both before the 1860s and after the 1930s. In the earlier period, the number of mural paintings produced in Canada was low. The muralists were untrained or itinerant artists, and their subject matter was not distinguishably Canadian. In the 1940s, mural painting in Canada waned, a result of the popularity of new stark styles of interior decoration and a preoccupation with the war effort. After the Second World War, some Canadian muralists turned to strongly expressionist modernist styles, while others switched to abstraction. Many of these muralists also painted subject matter with an international appeal. It is reasonable to say, then, that murals painted in Canada from the 1860s to the 1930s form a unified body of work.

The subject matter of these mural paintings, despite its apparent diversity, supports this supposition: it glorified the salient features of Canada as a modern nation-state. Many scholars have concluded that no single set of features suitably describes all modern nation-states. Nevertheless, it is reasonable to argue that, since modern nation-states first appeared in the 1830s, most of them have consisted of a group of people living within defined geographical borders and functioning within both a capitalistic economic system and a political system that recognizes the people as sovereign. Members of any one of these groups have also consciously and enthusiastically shared particular aspects of culture, such as language and history, that distinguish their modern nation-state from others.

Concomitantly, members of any one modern nation-state within Western culture have understood that they share important aspects of culture with all other nation-states within Western culture. These aspects of culture have changed over time. During the years in which the murals described above were painted, however, all Western nation-states recognized Christianity as the most important religion, legally supported patriarchy, and revered ancient Greece and Rome, medieval Europe, and Renaissance Italy as dis-

tinct and important bases of their culture. During the same time period, most of them also happily believed that the modern nation-state was the culmination of a materially and culturally progressive history that belonged exclusively to Western culture. Consequently, they regarded Western culture as superior to other cultures.[1]

It is reasonable to summarize the salient features of the modern Western nation-state from the 1860s to the 1930s as popular sovereignty, Christianity, patriarchy, the material progress of capitalism, and distinct cultural identity (often expressed through racial and cultural imperialism). During this time the hegemonic, or dominant, populations of modern-nation states – white, middle-class, enfranchised, Christian men – were determined to strengthen these features. Otherwise, as they frequently stated, their nations would not continue to "flourish." Methods of doing so, which may be described as expressions of nationalistic sentiment, ranged from war against other modern nation-states and aggressive imperial colonization of non-Western cultures to verbal, written, and artistic glorification of the distinguishing features of the modern nation-state.

In the 1860s, artists and social critics in both French and English Canada began to promote mural painting as a means of glorifying the dominant features of Canada as a modern nation-state. They continued to do so until well into the twentieth century. Not surprisingly, this promotion was conducted differently in French Canada and English Canada. After the British Conquest of 1760, the hegemonic population of French Canada, composed of white, middle-class, enfranchised Catholic men, and faced with the threat of assimilation by the English-speaking, Protestant Dominion of Canada, was eager to see mural painting focus on the distinct cultural aspects of what they called the "nation" of French Canada. As the ardent nationalist Napoléon Bourassa stated in 1883, muralists who chose French Canadian history as their subject matter would be paying respect to a particularly French Canadian national glory.[2] In 1918 Olivier Maurault, a member of the Catholic order of the Saint-Sulpicians, also argued that mural painting should articulate French Canadian nationalism.[3]

From the 1860s to the 1930s many English Canadians also promoted mural painting that would glorify Canada – including French Canada – as a modern nation-state. As Toronto social critic Albert Carman explained in 1906, mural painting would provide a much needed "national soul."[4] In the late 1930s Vancouver muralist George Southwell declared that mural painting would give Canadians "pride in their citizenship."[5] However, the English Canadian focus differed from that of French Canada in its emphasis on

material progress. Although English Canadian muralists were eager to achieve Christianity, patriarchy, and a distinct cultural identity, they often treated these features of the modern nation-state as forms of support for material progress. At the same time they ignored popular sovereignty, presumably because, by the mid to late nineteenth century, Canada, as a member of the British Empire, had achieved this sovereignty peacefully and it appeared to be solidly in place.

Since both English Canada and French Canada participated, in different ways, in the widespread production of mural painting between the 1860s and the 1930s, it is reasonable to assume that some of the murals would have appeared in surveys of Canadian painting. During the first half of the twentieth century they did. In 1925, for example, Newton MacTavish dedicated several pages of his history of Canadian art to English Canadian mural painting.[6] In 1943 William Colgate devoted several pages of his *Canadian Art* to both French and English Canadian mural paintings, commenting that "Canadian [mural] painters have to their credit many successful and important [mural] works."[7]

Remarkably, however, these murals received only brief mention and no illustrations in the largest historical surveys of Canadian painting published between the 1960s and the 1980s: J. Russell Harper's *Painting in Canada,* published in two editions in 1966 and 1977 and in French in 1966; Dennis Reid's *Concise History of Canadian Painting,* published in two editions in 1973 and 1988; and Charles Hill's *Canadian Painting in the Thirties,* published in 1975. Although Hill discussed mural painting, he restricted himself to the few murals of the 1930s that made use of modernist painting styles and ignored the conservatively painted ones. It is not surprising, then, that in the late 1980s one Canadian art critic argued that little mural painting had been done in Canada before the 1930s.[8]

Harper, Reid, and Hill may have overlooked the mural paintings because, by the time they were writing, many of the buildings that had originally housed the murals had been razed or remodelled. In the process, some of the murals were destroyed, while others were put in storage from which they have never returned. However, photographic documentation was available for most of the murals and a significant number were still in place (*in situ*). At least in the case of Harper, there is evidence of conscious rejection. In 1963, as Harper was doing research for his text, he wrote to Mary Wrinch Reid – the second wife and widow of Toronto muralist George Reid – to ask for information about her husband's easel paintings. In this letter Harper stated: "I should also like to put in a mural – this will have to remain until

I can see how much actual space there will be."[9] In the end Harper did not include mural painting. Therefore, explanations other than the mural paintings' lack of visibility in the 1960s are required to account for their absence from these texts. There are three reasonable suggestions.

First, Harper, Reid, and Hill composed their texts just before and just after the centennial celebrations of Canada's Confederation in 1967; indeed, Harper was specifically commissioned to write his book by the Canada Council and the University of Toronto Press as a joint project for the Centennial. All three authors were fuelled by the intense levels of nationalistic sentiment that surrounded this event. Furthermore, Hill's text was written as a National Gallery exhibition catalogue at a time when part of the gallery's mandate was to promote national art. Consequently, these scholars wanted to illustrate their books with art that glorified the salient features of Canada as a modern nation-state. Logically, then, they could have included the mural paintings that had been produced from the 1860s to the 1930s as a means of evoking nationalistic sentiment.

However, Harper, Reid, and Hill were also eager to demonstrate that, during these years, which coincided with the "modern" period, Canadians were producing paintings that "fit" the modernist paradigm. This model, set out succinctly in Clement Greenberg's now famous article of 1939, "Avant-Garde and Kitsch," dominated Western art history from the 1940s to the 1970s. It argued that the commerce and politics of modern life had led to the widescale production of debased forms of modern cultural artifacts designed to satisfy the "masses." To counteract the negative effects of this art and to maintain high levels of "taste," Greenberg advised artists to work in abstraction. He also praised any art that appeared, in retrospect, to have been part of a progression towards abstraction. This type of art would be a personal expression of the artist/genius and would also invite a personal response from the viewer. Greenberg and other art critics and historians referred to this art as "avant-garde" or "formalist modernism." For many of them it was the only "good art."

As Harper, Reid, and Hill wrote their surveys of Canadian painting they must have recognized that the Canadian mural paintings of the 1860s to the 1930s were not avant-garde. Indeed, these murals offered conservatively rendered and easily readable images of historical and contemporary local events or illustrations of well-known Western mythology, literature, and Christian dogma. They supported the idea, in place since the Renaissance – and opposed by Greenberg – that a painting should be "a window on the world" that sought a group response from viewers. Greenberg called this type of art "kitsch," the opposite of avant-garde. It was art produced for the masses "out

of the decadence of capitalism." Harper, Reid, and Hill were not eager to highlight these murals in their texts.

At the same time, the subject matter of most of the murals was local, so it did not represent the monolithic pan-Canadian nationalism that Harper, Reid, Hill, and many other Canadians craved from the 1960s to the 1980s. For example, Charles Huot's *Debate on Languages* of 1913 for the National Assembly of the Quebec Palais législatif (fig. 7) was designed to evoke nationalistic sentiment in French Canadians, while Adam Sheriff Scott's *"Pioneer" at Fort Garry* of 1927 for the Hudson's Bay Company department store in Winnipeg was intended to inspire feelings of loyalty to a local commercial enterprise (fig. 21).

As Harper, Reid, and Hill rejected the murals on the basis of both style and content, they turned to easel-style landscapes of remote areas of Canada which they regarded as modernist in style and capable of evoking nationalistic sentiment in all Canadians. These landscapes, most of which represented northern Ontario, were painted from the 1910s to the late 1930s by eight Toronto-resident artists (Frederick Carmichael, Franz Johnston, Lawren Harris, Alexander Jackson, Arthur Lismer, J.E.H. MacDonald, Tom Thomson, and Frederick Varley). All but Thomson – who died in 1917 – formed the Group of Seven in 1920. Although it is not difficult to explain why Harper, Reid, and Hill concluded that the work of Thomson and the Group of Seven could evoke nationalistic sentiment in all Canadians, a re-examination of the events leading up to their assessment makes it clear that these landscapes could not possibly have evoked such a response. Furthermore, this re-examination not only suggests that their conclusion is one of many narrow Ontario / Toronto-centric visions of Canadian art history but also "makes room" for the mural paintings as significant artistic expressions of nationalistic sentiment within the histories of Canadian painting.

First, it is important to understand that, since at least the third quarter of the nineteenth century, inhabitants of Ontario, but especially those in Toronto, have assumed that residents of other parts of Canada share their views. As Richard Preston stated in a study on national identity in Canada, "Ontarians blithely tend to identify Ontario with Canada, and vice versa, to the manifest annoyance of people in other provinces."[10] In the twenty-five years after 1850, Toronto (along with nearby areas of southern Ontario and English Montreal) became the prime source of manufactured goods for other parts of Canada, as well as the prime recipient and processor of natural resources and agricultural products from those areas. From this time on, as all types of contemporary publications confirm, social critics in Toronto became obsessed with material progress. In addition, they believed that material progress in

other parts of Canada should be groomed to fit with Toronto's. As Toronto lawyer George Denison argued in 1909, "It [is] apparent that until there [shall] grow not only a feeling of unity, but also a national pride and devotion to Canada as a Dominion, no real progress [can] be made towards building up a strong and powerful nation."[11]

Based largely on this point of view, the highly successful Canadian Club – with its first branches in southern Ontario cities – was founded in 1893. It aimed to "foster a patriotic Canadian sentiment" and to "weld people of diverse political views into one homogeneous organization so that they should know ... their country ... and serve her as best they could."[12] As one of its guests speakers at the Toronto branch (to which several Toronto muralists belonged) stated in 1905: "All true Canadians should have one sole aim in view and should unite in combing our energies to ... the right development of Canada."[13]

In response, many artists and art critics in Toronto suggested as early as the 1880s that landscape art could provide solid support for "the right development of Canada," because it would necessarily glorify Canada's rich, land-based, natural resources. In 1894 Toronto artist William Sherwood wrote an article entitled "A National Spirit in Art" for the Toronto-based *Canadian Magazine;* he urged Canadian artists to focus on landscape, since it could represent what was distinct about Canada. Twenty years later, Toronto social critic Gregory Clark reiterated Sherwood's point of view as he declared: "Landscape is all that is national yet."[14]

As early as 1886, Toronto artists organized a sketch club, which eventually became known as the Toronto Art Students' League, for the production of "distinctly Canadian art." By the time the league folded in 1904, Toronto area landscapes dominated the members' work. Apparently members never considered describing this work as "distinctly Toronto art," even though it looked nothing like landscapes in other parts of Canada.[15] In 1899 other Toronto artists formed the Mahlstick Club for the same purpose that the league had been formed. In 1907 other Toronto artists formed the Canadian Art Club, "to produce something that shall be Canadian in spirit, something strong and vital and big, like our northwest land."[16] By the time the club ended in 1915, some critics in Toronto and English Montreal believed that it had not attained its goal. The landscapes produced by members, critics argued, were conservative in style, devoted to tamed pastoral and sylvan landscapes, "too European," and not "distinctly Canadian."

In response, Toronto critics and art patrons turned to the landscapes of northern Ontario that Thomson and future members of the Group of Seven

had recently begun to paint. These critics and patrons admired a number of features in this work. First, since very few artists had painted northern Ontario before this time, critics and patrons reasonably regarded the work of Thomson and the group as unique and as evidence of a distinct Canadian culture. They also found the bold brushstrokes and strident colours of modernist art that Thomson and the group used particularly suitable for the depiction of the strong rugged features of Ontario's North. Furthermore, since Thomson and his colleagues claimed – falsely – that they had invented these stylistic techniques, early twentieth-century Toronto critics and art patrons who were not familiar with modernist painting concluded that the styles of these northern landscapes were also unique. In addition, since these painters rendered northern Ontario – erroneously – as uninhabited , the critics and patrons welcomed their landscapes as prophets of material progress for eager Toronto entrepreneurs.[17] Indeed, they saw these wilderness landscapes as evocative of rich but untapped natural resources that were waiting for Canadians, especially those in Toronto, to extract. Finally, and obviously ironically, early twentieth-century Toronto critics and patrons admired the work of Thomson and his colleagues because it responded to the increasingly vociferous demands of Torontonians for respite from the squalor and disease of modern urban life.[18]

At the same time, Toronto critics and patrons argued – following the lead of Thomson and members of the Group of Seven themselves – that this art, despite the fact that most of it represented northern Ontario, could evoke nationalistic sentiment in *all* Canadians. The critics continued to make this claim throughout the 1920s and 1930s, as did the artists, in lectures given mostly in Toronto and in articles written mostly for scholarly and popular journals published in the city. In 1926 Fred Housser, a Toronto friend of members of the Group of Seven, wrote a book in praise of their work for a Toronto publisher (Ryerson Press). It was entitled *A Canadian Art Movement,* even though it is likely that, at this time, most Canadians had never heard of the group. "An Ontario Art Movement" would have been a more realistic title; "A Toronto Art Movement" more realistic still.

During the same time period Eric Brown, the director of the National Gallery in Ottawa, purchased landscapes painted by Thomson and members of the Group of Seven for the gallery. He also arranged for international exhibitions of their work. Brown's "taste" for these landscapes was formed, at least initially, by the prominent Toronto banker Sir Edmund Walker, who favoured works by Thomson and the group and, as a board member for the National Gallery, oversaw the hiring of Brown.[19] For all these reasons, by the

late 1930s the work of Thomson and the Group of Seven had become, at least in the view of some influential people, part of the "nation's" art, and not just that of a province or a city.

In the post–Second World War period, residents of Ontario, but particularly in Toronto, continued to admire the northern landscapes of Thomson and the Group of Seven. However, the supply of these paintings was becoming limited. Thomson had died in 1919 and MacDonald in 1932, while some of the six remaining members of the original group were no longer painting rugged northern wilderness landscapes. Others were no longer painting landscape at all. Therefore, the prices for the work of these artists rose, especially for the northern Ontario landscapes.

Within this context, individuals and galleries outside Ontario began to purchase landscapes by Thomson and members of the Group of Seven. Often they chose paintings of local landscapes done by the few members of the group who occasionally worked outside Ontario. It is unreasonable to assume, however, that these purchases indicated that people across Canada saw the work of Thomson and the group in general as capable of representing a pan-Canadian nationalism. Rather, the art that was fashionable in Toronto, the largest English Canadian city with the largest art scene, determined to some extent what art was fashionable for the wealthy in any part of Canada. It also determined to some extent the purchases made by art galleries across Canada, which were often staffed by Toronto-trained curators.

As Harper, Reid, and Hill were composing their surveys of Canadian painting during the 1960s, 1970s, and 1980s, they must have considered this post-1945 pan-Canadian interest in Thomson and the Group of Seven. They also took into account earlier histories which claimed that the work of Thomson and the group was original, modernist, and capable of evoking nationalistic sentiment in all Canadians. At the same time, they would not have encountered artists or art critics in any other part of Canada who were bold enough to assume that the art of their own region could speak for all Canadians. Consequently, with their view of Toronto as the centre of Canada firmly intact, Harper, Reid, and Hill were able to justify their choice of the landscapes of Thomson and the group as true modernist representatives of a pan-Canadian nationalism.

However, Harper, Reid, and Hill seem not to have taken into account the complexity of this pan-Canadian interest in Thomson and the Group of Seven. They appear to have ignored the fact that the pre-1945 histories of Thomson and the group had been composed almost entirely by the members themselves or their friends. They discounted the point that there was no

evidence that Canadians, outside Ontario, accepted the Toronto equation between nationalistic Canadian painting and the work of Thomson and the group before the 1940s, while there was some evidence they did not. For example, in 1932, when the National Gallery of Canada was vigorously promoting the work of Thomson and the Group of Seven as a national vision, 118 artists from across Canada sent the director a letter in which they protested this type of support.[20]

It is, therefore, unreasonable to regard the work of Thomson and the Group of Seven as an "art for a nation," the title under which the National Gallery exhibited the group's work as late as 1995. Rather, it ought to be seen as a regional expression of nationally held values. As such, it posits the presence of other regional artistic expressions of nationally held general values, such as the murals painted from the 1860s to the 1930s. It is also no longer reasonable to ignore the mural paintings because they fit Greenberg's definition of kitsch, not modernism. In fact, as a way of judging the "importance" of art, Greenberg's modernist paradigm has not been accepted for some time. Since at least the early 1980s, many scholars have concluded that art should be studied on the basis not of its putative intrinsic aesthetic value but of the ways in which it was invested with meaning by its social context. Therefore, as these scholars have argued, the conservative art of the modern period – which includes the mural paintings – is just as worthy of study as the avant-garde. These scholars have also concluded that Greenberg's obsession with objective qualities and the progress towards abstraction has obstructed research in art, such as the Canadian mural paintings, that can be labelled "modern," but not "modernist."

At the same time, it is important to understand that these mural paintings merit consideration on another basis. Indeed, they were part of an extensive mural painting movement that began in the modern nation-states of Great Britain and Northern Europe in the 1830s and quickly spread throughout Western culture. I will call this movement, which so far has no generally accepted name, the "European-based Mural Movement," or Mural Movement for short, to distinguish it from later Western mural movements. The Mural Movement functioned outside Canada just as it did within. Its advocates claimed that nationalistic sentiment was a prerequisite to a "flourishing" modern nation-state. They argued that mural paintings that clearly glorified the defining features of the modern nation-state could evoke nationalistic sentiment. Consequently, thousands of mural paintings of this type were produced until sometime in the early decades of the twentieth century (the date varied from country to country), when their styles and agen-

das become irrelevant or unacceptable. In the 1980s scholars began to give serious consideration to the work of the Mural Movement outside Canada. The Canadian work deserves the same attention.[21]

I begin this study of the Canadian work in chapter 1 with a history of the Mural Movement. Then, in the next five chapters, I look at the Canadian mural paintings according to the types of buildings they decorated – civic, commercial, Protestant, Catholic, and private (homes and clubs). In each one I consider the general functions of each type of mural painting. I also provide French, English, and American examples of the type of mural painting discussed, since Canadian muralists often used murals from these three countries as models. At the same time, I use these foreign murals to provide a view of the international dimensions of the Mural Movement, without attempting the impossible task of considering it in its entirety.

Chapters 7 to 9 discuss the complexity of the conditions surrounding representation within the murals. Chapter 7 considers racial imperialism as a distinct aspect of Canadian identity by looking at a large number of mural paintings in English and French Canada that glorified the dominance of French and English Canadian cultures in relation to Native Canadian cultures. It also mentions a smaller number of mural paintings in English Canada that glorified the hegemony of English Canadian culture in relation to French Canadian culture. Chapter 8 considers mural paintings in libraries which illustrated both the symbiotic relation between cultural progress and material progress in modern nation-states and the roles to which patriarchy in modern nation-states confined women within material and cultural progress. In other words, this chapter deals with public cultural institutions which, while set up as instruments of enlightenment, also acted as instruments of social control. Chapter 9 looks at what is likely the largest project of the Mural Movement in Canada – the installation of opalescent glass mural paintings in at least thirty-four public kindergarten classrooms throughout Toronto. It argues that the subject matter of these murals was selected to teach young children the modes of behaviour that would support the interests of the dominant population of the modern nation-state.

Chapter 10 concludes this study of the Mural Movement in Canada with a discussion of a smaller body of Canadian mural paintings, produced from the late 1930s to the late 1950s, that continued to employ the subject matter of the Mural Movement while adopting the stark modernist styles that Mexican and American muralists had been using from the mid-1920s. Some Canadian scholars have suggested that, based on style, these later Canadian mural paintings belong to the Mexican-American Mural Movement. On the

basis of subject matter, however, I argue that these Canadian murals ought to be regarded as a later and waning stage of the Mural Movement.

The emphasis throughout this book is on mural paintings installed in Toronto buildings. Chapters 4, 8, and 9 focus on Toronto murals, while chapter 2 provides an extensive discussion of Toronto-based publications on mural painting. This emphasis is not unreasonable. Apart from Catholic Church muralists in Quebec, Toronto mural painters were more active than mural painters in other parts of Canada. More civic, commercial, and private mural paintings were installed in Toronto than in any other Canadian city, while many Toronto mural advocates, unlike mural advocates in other parts of Canada, frequently discussed civic mural painting in public lectures, scholarly journals, and magazines of general interest. As early as 1895, they also formed professional associations for the promotion of mural painting. Given Toronto's relatively large, wealthy, and culturally homogenous population, as well as its early establishment of art institutions, this level of activity is not surprising.

This book does not pretend to be a compilation of all mural paintings produced in Canada during the years of the Mural Movement. Many of the murals were destroyed without being published or recorded in archives, and, in any case, it is reasonable to work with representative types. Readers should be able to add murals to this study with which they are familiar. For convenience, I have provided an appendix that lists all the murals mentioned in this text.

The European-Based Mural Movement:
History and Ideology

On a superficial level, mural painting distinguishes itself from easel painting by its permanent attachment to the wall of an architectural structure and, often, by its relatively larger size. Of more significance is the fact that its subject matter is related to the function of the architecture to which it is attached. Mural painting intensifies the viewers' experience as they "read" a particular architectural site. All art reflects and constructs the social values of the culture in which it is produced, and mural painting clearly has the capacity to do so in an emphatic manner.

This special feature of mural painting has been well understood since human beings began to produce art. Prehistoric people in many parts of the world applied painted images first to the walls of caves and then to the plastered walls of architectural structures in which rituals connected to the images took place. People in historic cultures continued this practice. Until the 1830s within Western culture, those who commissioned mural paintings were either religious leaders or aristocrats. Religious leaders commissioned murals for public and private architecture – for churches and monastery refectories, for example. Aristocrats commissioned murals for public architecture designed to support their claims to rule, such as town halls and courts, and for private architecture such as castles, palaces, and luxurious town homes, in which they lived and received visitors. Then, in the 1830s, a new source of patronage developed for a new type of mural painting which would remain strongly intact until the 1900s in some Western countries and the 1930s in others. This European-based Mural Movement, or Mural Movement for short, accounted for the production of thousands of mural paintings.

Patronage for the work of the Mural Movement came from educated,

upper- and middle-class, enfranchised, Christian men who, as a result of the Industrial Revolution and political activism, formed the hegemonic populations of modern nation-states. These men were eager to protect their achievements, but they understood that the values of the modern period were not as unified or coherent as values of earlier periods had been. They were afraid that other individuals might not support their values. In response, social critics within their ranks promoted, among other things, the production of art that would glorify the distinctive features of the modern nation-state: Christianity, patriarchy, popular sovereignty, cultural identity, and the material progress of capitalism. This type of art, these critics believed, would encourage all viewers to support these values. The status of the dominant members of the population would be protected and the benefits of the modern nation-state would continue to be conferred on all citizens. Art that supported these features would act as a type of social reform. As Charles Eliot Norton, professor of art history at Harvard University, stated in 1888: "The highest achievements in the arts [are] not so much the products of solitary individual artists as the expressions of a nation's faith, loftiness of spirit, and the embodiment of its ideals."[1] English art critic Lys Baldry agreed, when he stated in 1907 that art was "a factor in national progress and well-being."[2]

Many of these social critics also believed that mural painting was the best type of art to enshrine the significant features of the modern nation-state. As they reminded their readers, architecture was the "most important art." Mural painting, therefore, would take on the importance of architecture and intensify the viewer's experience of that form of art. In turn, this experience would inspire viewers to alter their values and behaviour in favour of those supported by the murals. A personification of Justice, for example, painted in a dramatic fashion on the wall of a courthouse, might encourage viewers to respect the law. A history of the printed word on the wall of a public library might induce patrons to respect the library's book collection and to educate themselves by reading. Murals devoted to biblical subject matter on the wall of a church might prompt worshippers to support Christian codes of behaviour. Images of ancient Greco-Roman deities on the walls of luxurious private homes might influence visitors to support the owner in political endeavours, since clearly the host was financially successful and cultured. As social critics remarked, mural paintings could perform these types of functions much better than easel paintings because murals could be made as large as the walls they decorated. They had a greater visual impact. Moreover, mural painting's regular use of colour and frequent use of sequential panels worked well with narrative representation. And, as cultural the-

orist Edward Said has argued, narrative permitted modern nation-states to explain all activities carried out in their formation.[3]

In a clear sense, then, social critics from the 1830s to the 1930s who espoused the values of the nation-state, promoted mural painting for the same reason that religious and aristocratic elites had commissioned them. If only *their* values could prevail, *their* power and *their* prosperity could be assured. Indeed, these later mural advocates understood, although they did not articulate it in the same way that cultural theorists such as Antonio Gramsci and Stanley Fish eventually would, that the most effective type of consent or support is formed not by legal or physical coercion, but by structures of understanding that are displayed as generally held values.[4]

As ideological support for nationalistic mural painting mounted after the 1830s, the necessary technological support was also being developed. Since the late medieval period, artists in Northern Europe and England – where the Mural Movement began – had seldom worked with monumental mural painting. Fresco, whether *buon* (pigments mixed with water and applied to wet plaster) or *secco* (pigments and a binding medium applied to dry plaster), flaked in cold, damp climates, as many medieval mural paintings in England and Northern Europe had demonstrated. Oil paint, invented in the fifteen century, darkened when placed on plaster. The technique of *marouflage* (oil or tempera paint on canvas glued to the wall), in use from at least the sixteenth century, overcame the problems of fresco and oil painted directly on plaster, but, with only hand looms available, large seamless canvases could not be produced.

In the early nineteenth century, mural technology began to change after the invention of the mechanical loom and the development of superior adhesives. Marouflage could now be used for large wall and ceiling surfaces, and it allowed artists to prepare their murals in the comfort of their own studios. Consequently, marouflage became the favoured working mode. At the same time, muralists, especially in cold northern climates, invented new techniques, such as waterglass (watercolours on dry plaster sprayed with silica), spirit fresco (pigments, oil, wax, and a binder on dry plaster), and opalescent glass (a type of glass rendered opaque by layers of pigment that could be manipulated to form images).

With technological and ideological support in place, muralists were ready to glorify the modern nation-state. Since they believed, along with the social critics, that the subject matter of art constructed meaning, they endorsed sombre, didactic images based on time-honoured classical, medieval, and Renaissance themes. However, around 1890, muralists rejected this approach in favour of images of recent local history or ordinary, contemporary activities.

In other words, the subject matter of the Mural Movement responded in a belated fashion to Parisian art critic Charles Baudelaire's now famous call of the 1860s for "a painting of modern life." Classical references were used much less frequently and were often placed in separate panels.

This later work did not reject the values espoused in the earlier work. Indeed, it continued to support them and to work towards social reform, though in a different way. While in the earlier period a muralist might have chosen to glorify material progress and popular sovereignty with classical personifications of industry and democracy, a later muralist might represent the same themes with images of contemporary citizens in their best clothes at a holiday picnic. Material progress provided the clothes; democratic labour laws provided the holiday.

The advocates of mural paintings did not believe that subject matter alone brought about social reform. Style, too, played a role. Many artists and art critics wrote guidelines for mural painters which encouraged muralists to support the integrity of architecture by eschewing illusionistic spatial devices such as *chiaroscuro* and modelling.[5] Instead, muralists should take a two-dimensional approach. At the same time, the guidelines directed artists to employ conservative figure styles so that viewers could easily read the subject matter. They also suggested that muralists who were working with the marouflage technique should use encaustic paint (oil or tempera mixed with wax) to reduce light reflections and enable viewers to see the images more clearly.

Many of these guidelines also argued that murals should offer viewers a sense of morality through their "beauty." This point of view was based on a Christianized version of Plato's equation of beauty and morality. According to this theory, everything, including beauty, had been created by God. Since God was also the source of morality, the beauty of the natural world was moral too. Consequently, art that imitated the beauty of nature or the natural world as closely as possible (despite the recommended two-dimensional approach) could act as a moral force, just as subject matter could. Artists could capture "beauty" or "morality" better than anyone else because they were more sensitive to beauty than were other people. This belief originated with the establishment of aesthetics in the mid-eighteenth century in the writings of Immanuel Kant and other German Idealist philosophers. By linking this idea with the Platonic theory of beauty and morality, mural advocates could reasonably insist that artists, but especially muralists, could and should act as prophets or guides of moral behaviour.

These recommendations for the style of mural painting produced a distinct mural aesthetic that remained in place until well into the twentieth cen-

tury. The muralist who became most admired for his adherence to this principle is France's Pierre-Cécile Puvis de Chavannes. Puvis de Chavannes first worked with this aesthetic in the 1860s, and, by the 1890s, many muralists and art critics in all Western countries looked to it as an ideal. The English art critic Philip Hamerton argued: "The painting should [allow the viewer to] feel the wall to be a wall still, upon which certain events have been commemorated. Amongst French mural painters, no one has understood this so well as Puvis de Chavannes."[6] American muralist John La Farge stated that the "clarity" of Puvis de Chavannes's work enabled the subject matter to contribute to the "moral character" of the viewer.[7]

During the time that the Mural Movement was active, a variety of modernist painting styles were developed and replaced one another quite quickly. Muralists, however, were reluctant to adopt these styles because they did not want viewers to make individual responses, in the way they did to modernist painting styles. Rather, since the muralists intended their work to act as a type of social reform, they sought a group response. At the same time, muralists were part of their local artistic communities, and many of them were anxious to embrace contemporary art practices. To accommodate both positions, muralists either employed less extreme versions of modernist styles or began to work with a modernist style about a decade after it first appeared in easel painting. For example, muralists adopted impressionism in the late 1880s or 1890s, and pointillism only after the turn of the century.

Although mural advocates in all Western countries promoted both the subject matter and the style of mural painting as factors in social reform, mural advocates in any one country defined social reform in ways that were particular to their own country. They realized that these statements might seem to be self-serving, applied to commercial, private, and religious mural paintings, so restricted them largely to civic murals. However, all the work of the Mural Movement was designed to promote social reform.

In France the successful revolutionary Republicans of the late eighteenth century envisioned civic mural paintings that would persuade Royalists and Bonapartists to acknowledge the legitimacy of republican government and to accept its political platform. They continued to do so – without any concrete results – as various royalist and imperial regimes were constituted and reconstituted throughout the first seventy years of the nineteenth century. In the mid-nineteenth century, for example, Michel Chevalier argued that, if a republican form of government were restored, it would commission large-scale historical mural paintings in civic sites that would act as "a vast means of moralizing an entire nation."[8] When the Third Republic was established

in 1871, it did just that. It launched a massive campaign to install mural paintings in civic sites throughout the country to act as "moral agents." As Jules Ferry, the minister of fine arts in the last quarter of the nineteenth century, argued, historical mural decoration was needed as a tool for "the floating masses."[9]

In England, mural painting advocates were particularly interested in seeing civic mural paintings act as determinants of moral behaviour for the working classes. They took as their model the moral behaviour of the middle or upper class. In 1835, for example, members of a select committee of the English government that had been formed to consider decoration for the new Houses of Parliament in London stated that mural painting was "capable of eminently subserving the progress of morality ... amongst the manufacturing population."[10] However, mural advocates in general, and members of this committee in particular, did not believe that this process should erase class distinctions. As member Charles Cockerell argued, in fine art, the "knowledge of the artisans, whose bread is earned in laborious work, must always be very limited, compared to those who have ... been brought up in the finest schools."[11] Important contemporary English social critics like Thomas Carlyle supported this point of view by claiming that artists, as more sensitive human beings, should act as moral leaders for the less receptive working classes.

John Ruskin, a mural advocate and one of the most influential social critics of the second half of the nineteenth century in English-speaking countries, strongly supported this point of view. It was the duty of "the offices of the upper classes," he stated, " ... to keep order among their inferiors."[12] In 1876 Ruskin, Octavia Hill, and other social activists formed the Kyrle Society to bring "natural and artistic beauty," including that of mural painting, into club rooms and other small-scale civic buildings associated with the working classes. These people, they said, led "the saddest lives," surrounded by "ugliness, monotony, and coarseness."[13]

In the United States, in contrast, civic mural painting was, at least ideally, charged with helping to create a single class of citizens. In 1904, for example, art critic Irene Sargent wrote: "Murals would bring together the sweat of the laborer and the revenues of the millionaires." They would "never be the toy of a favored class, but [would be] on the contrary, dependent for existence on popular support."[14] American muralist William Low similarly argued that, unlike easel paintings, mural paintings would not be "hidden away in the cabinets of the rich." They would be "an everyday affair" for the American people and would make them "one and all so sturdily individual."[15]

Given such important functions for civic mural painting, as well as the large role that Christianity played in modern nation-states, it is not surprising that civic mural painting was also given a Christian gloss. In France, Léonce Bénédite stated at the end of the nineteenth century: "We confer on [mural painting] sacred, commemorative and educational roles ... We attach the idea of a moral mission to the decoration of our public walls."[16] In England, in 1912, Archbishop of Canterbury Randall Davidson gave a public lecture in which he promoted civic mural decoration because it would provide spiritually uplifting subject matter.[17] In the late nineteenth century in the United States a muralist was considered to be "a high-priest of the emotions ... endowed with a missionary spirit."[18]

At the same time, many mural painting advocates in England and the United States, where there was no recognized distinct national school of painting, argued that mural paintings in civic and other types of sites would provide such a school, just as mural paintings, they believed, had done for earlier Western cultures, especially Renaissance Italy. In turn, a national school would evoke nationalistic sentiment. Without such sentiment, or so mural advocates claimed, material progress, which most English and Americans regarded as desirable, could not easily take place.

In her 1846 text on early Renaissance mural painting, Mrs Merrifield stated that, if English artists were to imitate this earlier work, they could produce a national school.[19] American muralist Frederic Crowninshield favoured civic and other types of mural painting for the same reason. As he stated in a lecture in 1888, a time when many Americans were obsessed with achieving cultural production that might rank with that of the Italian Renaissance, "Why should not our present prodigious building activity – far surpassing that of Italian Renaissance republics – fortify itself with a sister art, and raise a race of mural painters who might prove the peers of the men of 1500?"[20] The 1916 brochure of the National Society of Mural Painters (founded in New York City in 1895) stated: "[Through mural art] a country becomes a nation."[21] French mural advocates, especially after France's loss in 1871 to Germany in the Franco-Prussian War, promoted the decorative arts, including mural painting, for similar reasons. They wanted to exhibit what they believed to be distinct and superior aspects of their culture.[22]

Mural advocates in France, England, and the United States were also concerned with the supposed ability of mural paintings in all types of sites to stimulate various kinds of wealth. As the report of England's select committee of 1835 stated: "If high art flourished, subordinate [commercial design] branches would receive nourishment and strength."[23] In 1889

Scottish social critic and civic mural advocate Patrick Geddes agreed: "[The fine arts], hitherto ignored, or even rebutted by the economist as matters of unproductive luxury ... henceforth occupy their rightful place as the highest processes of industry."[24] Americans had similar economic hopes for mural art, but also saw mural paintings as a means of attracting wealthy tourists, just as older European mural paintings did. In this regard, the prolific American muralist Edwin Blashfield claimed: "The prosperity of [the hotel keepers of] Perugia has come straight off the palette of Perugino."[25] In 1916 the American National Society of Mural Painters made financial profit one of its official goals.[26]

It is also clear that mural advocates in France, England, and the United States recognized a commonality among mural paintings in civic, commercial, religious, and private sites. Indeed, as Blashfield declared in 1898, mural painting was designed to enhance both "the pleasures of private life" and "the dignity of public life."[27] Moreover, most texts composed by mural painting advocates, such as Lys Baldry in England and Pauline King in the United States, were illustrated with mural painting from all four types of sites, as though mural paintings of all kinds were equally respectable components of a contemporary phenomenon.[28]

Still, mural advocates did not clearly articulate this connection. To understand it better, it is useful to look at it through Jürgen Habermas's theoretical framework of public and private spheres in Western culture. Although, as Jeff Weintraub has explained, no single or dichotomous model of the public/private distinction can capture the institutional and cultural complexity of modern societies, Habermas's model is useful for understanding the relation between the public and private work of the Mural Movement.[29]

Habermas has argued that, as educated and authoritarian professionals developed a liberal market economy in the late sixteenth century, they created Western culture's first modern public sphere. This public sphere was relatively small and separate from the state. So, in a sense, it was still private. In the late eighteenth century, however, this public sphere began to grow rapidly. By the end of the nineteenth century it had become the economic framework of modern life. All citizens inevitably functioned within it, as the family surrendered the power it had once possessed as the main source of personal identity to the authority of the public sphere. As a result, the strong boundaries between the private and public spheres (at least in an economic sense) dissolved.[30] The Mural Movement reflected and supported this dissolution as its work in both public and private spaces enthusiastically supported the salient features of the modern nation-state.

The Mural Movement came to Canada in the 1860s, though Canadian muralists were already familiar with some of its work in England, France, and the United States. Some of them had travelled, and others had seen illustrations. Many had read the rhetoric of mural advocates in these three countries. Canadian muralists generally adopted the subject matter and styles of the murals and the arguments of the mural advocates in England, France, and the United States. Yet, because the work of the Mural Movement was based on nationalistic sentiment, and a key component of nationalism is distinct identity, murals in each country, and often within regions of a country, had unique features. The Canadian murals are no exception.

Civic Mural Paintings:
"Glorifying the Memories of a Nation"

As modern Western nation-states developed from the early nineteenth century, their dominant populations – composed of enfranchised, middle-class, Christian men – worked to safeguard their own values and to offer them to others, primarily by, charging the state with the responsibility for particular services. Some of these services, such as justice and taxation, had traditionally belonged to government. However, with the unprecedented increase in population that took place after the early nineteenth century, the modern nation-state required larger buildings to house these services. Other services, such as health and education, were new and required specific architectural forms. Consequently, from the early nineteenth century on, new buildings such as city halls, legislatures, courthouses, customs houses, hospitals, schools, and libraries appeared throughout Western culture.

These new civic buildings required "signs" that clarified their functions, accounted for the state's control of these functions, and encouraged positive reactions to this control. From the 1830s until the 1920s or 1930s (the date varied from country to country), the use of earlier architectural styles for the new civic buildings regularly provided one type of sign. The use of a medieval church style for a new legislative building, for example, could suggest to viewers that they should revere the activities that took place within this site as they would the activities that took place within a church.[1] During the same time period, thousands of mural paintings that glorified the modern nation-state also acted as signs for civic buildings. These features reflected the values of the state's hegemonic populations – Christianity, patriarchy, popular sovereignty, distinct cultural identity, and the material progress of capitalism. Civic murals regularly glorified all but Christianity,

though occasionally they included it too. Before examining Canada's civic mural paintings, it is useful to look briefly at those that were done in France, England, and the United States, since Canadian muralists were familiar with this work and often used it as models.

Many civic mural paintings in these other countries glorified the material progress of capitalism as a major feature of the modern nation-state. Before 1890, they regularly employed classical (or, more correctly, classicizing) images to this end. Between 1878 and 1886, for example, Lord Leighton painted two mural panels for London's South Kensington Museum (now the Victoria and Albert Museum): *Industrial Arts as Applied to War* and *Industrial Arts as Applied to Peace* (both *in situ*).[2] In each panel a classical personification of the industrial arts presides lovingly over manufactured items. The many Canadian muralists who trained or travelled in England and later painted civic murals in Canada – such as John Beatty, Arthur Lismer, George Reid, and Mary Hiester Reid – certainly saw and admired Leighton's work.

In 1905 Francis D. Millet installed an elaborate painted mural program dedicated to a history of shipping in Western and non-Western cultures from 1000 BC to AD 1900 for the Call Room of the Custom House in Baltimore, Maryland (*in situ*). Like Leighton's work, it was designed to glorify material progress. Furthermore, because it surveys shipping over a long period of time within Western and non-Western cultures, culminating in the present day in Western culture, it provided audiences with what recent cultural analysts have described as a "metahistory" – a fictive theoretical base by which the phenomenon of progress within Western culture may be retroactively substantiated.[3] Canadian muralists who travelled to Boston, including Elizabeth Annie Birnie, Frederick Challener, and George Reid, may well have seen Millet's work. If not, they could easily have read about it in professional journals available in Canada.[4]

Many civic mural paintings in France, England, and the United States glorified popular sovereignty. In 1883, Léon Glaize installed *The Triumph of the Republic* and *Revolutionary Heroes in Front of the Tribunal of Posterity* in the Salle des Fêtes of the *Mairie* of the Twentieth Arrondissement in Paris (*in situ*).[5] Here Glaize represented Republican soldiers, who had fought for the establishment of popular sovereignty in France, in front of an enthroned classical personification of posterity. This type of image flattered viewers by suggesting that they (or at least their ancestors) had consciously and intelligently taken steps to create a modern nation-state. Later civic mural paintings employed contemporary images to make similar statements. Maurice Chabas, for example, employed an impressionistic style to paint a mural representing

a family holiday picnic for the Mairie of the Fourteenth Arrondissement in Paris 1888 (*in situ*). In a civic site, this mural subtly referred to the laws passed by French Republican governments which made such holidays available. The many Canadian muralists who worked for extended periods in Paris before returning to Canada to paint civic murals, such as Henri Beau, Napoléon Bourassa, Charles Huot, and George Reid, undoubtedly saw Chabas's and Glaize's murals as well as some of the hundreds of others like them in French mairies and other French civic sites.[6]

Other civic work of the Mural Movement in France, England, and the United States glorified distinct features of each country's cultural production and, by implication, its superiority to that of other modern nation-states and non-Western societies. Between 1848 and 1854, for example, Edward Armitage, John Herbert, John Tenniel, George Watts, Charles Cope, and John Horsley provided the Upper Waiting Hall of London's Parliament Buildings with illustrations from Chaucer, Spenser, Shakespeare, Milton, Dryden, Pope, Scott, and Byron (*in situ* and recently restored).[7] In 1915 artist Vesper Lincoln George extolled the distinct nature of American culture in a mural he installed in the Edward Lee McClain High School in Greenfield Ohio (*in situ*). In the centre an enthroned classical personification of America sits in front of a large pot (America's melting pot of races). From the left, immigrants of various ethnic origin move towards America. They depart on the right, having turned into fair-haired Anglo-Saxons. On the painting are two inscriptions: "And God Hath Made of One Blood all Nations of Men to Dwell on the Face of the Earth" and "Equality, Liberty, Opportunity, Prosperity."[8] It is unlikely that Canadian muralists travelled to Ohio to see this mural, but those who visited Boston could well have seen it, since its three panels were on display at the Boston Art Club in 1918, 1919, and 1920 before it was installed in Ohio.[9] Interestingly, two Canadian mural paintings done a few years later for Montreal high schools employed the same composition: Donald Hill's *Time Pointing Out the Opportunities to Acquire Education and Its Rewards* of 1924 for Strathearn High School (fig. 7), and Leslie Smith's *Education Extends an Open Hand to All Classes* of 1924 for King Edward VII High School (present location unknown, probably destroyed).

The civic work of the Mural Movement in France, England, and the United States also regularly glorified patriarchy. In some cases it did so indirectly – by representing activities from which women were regularly excluded, such as lawmaking and revolutionary battles. In other cases it did so directly, as when Gustave Boulanger decorated the *Salle des mariages* of the Mairie of the Thirteenth Arrondissement in Paris in 1877 (*in situ*). In the central panel

(which brides and grooms face), Boulanger placed a husband and wife enthroned on a raised dais, dressed in classical costume and flanked by personifications of appropriate virtues. In another panel, *Vir esto* (literally "Be a man"), one man is armed for war while another leans on a gear wheel and designs a machine with a compass on a piece of paper. In *Uxor esto* (literally "Be a wife"), one woman nurses a child while another holds the torch of fidelity.[10]

Because civic murals were installed in sites that commanded authority and were, at one time or another, visited by almost all citizens, they were generally regarded as more important than commercial, Christian, or private mural paintings. But this point of view alone did not lead to commissions. Other prerequisites had to be in place. First, there had to be a critical mass of population. A significant segment of this population had to be well educated enough to believe that civic art could construct and support the dominant features of the modern state. This population also had to be wealthy enough to fund both the mural painting and the reasonably elaborate civic architecture that would house it. The presence of professional art schools provided further support for the production of civic and other murals. In short, the Mural Movement oversaw the production of civic murals in urban centres and in prosperous rural areas that had well-established material and cultural bases.

The production of Canadian civic mural paintings followed this same pattern. Given Canada's large territory, however, its relatively small population from the 1860s to the 1930s composed largely of uneducated immigrants, and its relatively weak economies in some areas, it is not surprising that certain regions of Canada supported more civic mural painting than others. Moreover, compared with other Western countries, the number of civic mural paintings done in Canada was small.

A weak economy undoubtedly accounts for the fact that professional artists provided no monumental civic mural painting for Canada's Maritime provinces. Prosperity first appeared in the Maritimes in the early nineteenth century as England ordered wooden sailing ships for both the Napoleonic Wars in Europe and the War of 1812 against the Americans. Over the next few decades agricultural land was developed in New Brunswick, Prince Edward Island, and the Annapolis Valley of Nova Scotia. Populations grew, urban centres developed, and universities were established. Correspondingly, small mural paintings began to be commissioned, often from itinerant or nonresident artists, for businesses and homes and, occasionally, for civic sites such as courthouses. An example that is still *in situ* is a British coat of arms installed in Lunenberg County's courthouse in 1810 (now the parish hall of St John's Anglican Church).[11] However, given the Maritime's status as a British colony

at this time, and a general level of contentment with this status, these murals simply focused on Canada's legal relationship with Great Britain.

This limited civic mural practice in the Maritimes might well have grown and become part of the Mural Movement after Confederation in 1867 and the establishment of the Victoria School of Art and Design in Halifax in 1888. However, the three Maritime provinces experienced an economic depression just after 1870 as foreign construction of iron steamships put an end to wooden shipbuilding. At the same time, none of these provinces had other natural resources to provide an alternative economic base. Some industry came to the Maritimes in the mid to late nineteenth century, but the National Policy tariffs of 1879 discouraged trade with the nearby United States, while the cost of shipping manufactured goods to other places in Canada led to the closure of many industries. The resulting unemployment led to a significant emigration of population, and the cities in these provinces had relatively small populations during the active period of the Mural Movement. At the same time, most manufactured goods were imported to the Maritimes (by 1919, four-fifth's of Canadian manufacturing took place in Ontario and Quebec).[12] Naturally, profits returned to out-of-province businesses rather than being used for the support of local artistic activity. For all these reasons, few, if any, civic mural paintings were commissioned in the Maritimes. Provincial archives do not record any such commissions.

Civic mural production was also weak in Alberta and Saskatchewan. These two provinces did not join Confederation until 1905. Their populations remained small until the last few years of the nineteenth century, despite the Dominion Lands Act of 1872, which offered land to homesteaders, and the arrival of the railway in 1883. In 1896 hard, fast-maturing spring wheat was developed. From this time, immigration increased rapidly, though a significant proportion of the new settlers were from Eastern Europe and were uneducated, dedicated to a rural lifestyle, and unconcerned with a type of public art developed in Western countries to evoke nationalistic sentiment. Furthermore, art schools were not established in these two provinces during the active period of the Mural Movement.

Given the relatively late date for the earliest civic mural paintings in Alberta and Saskatchewan, the first ones depicted contemporary scenes and local landscapes rather than Greco-Roman, medieval, or Renaissance allegories. Shortly after 1918, for example, an unknown patron commissioned Vancouver artist John Girvan to come to Edmonton to paint a mural of First World War battle scenes in Memorial Hall (present location unknown).[13] In 1933 John Leman, an employee of the Department of Public Works in

Saskatchewan, painted *Before the White Man Came* for the south alcove of the rotunda of the Saskatchewan Legislative Building in Regina (plate 1). It depicts Native men and women in a village on one of Saskatchewan's Qu'Appelle Lakes (see chapter 7).[14] In the same year, the federal government commissioned Augustus Kenderdine to design a mural for the reception room of a building at the World's Grain Exhibition and Conference in Regina.[15] It depicts agricultural land in the Qu'Appelle Lakes region (and is now in storage at the Saskatchewan Archives Board).

Manitoba's situation was similar to that of Alberta and Saskatchewan. As late as 1870, Winnipeg was a village of wooden structures with a population of 241 that was entirely dependent on the fur trade. Manitoba's population began to grow, like Alberta's and Saskatchewan's, after the passing of the Dominion Lands Act, the arrival of the transcontinental railway, the development of the hardier strain of wheat, and the influence of immigrants. However, since 35 per cent of these immigrants were from Eastern Europe, the population as a whole did not provide strong support for civic mural painting.

Nevertheless, from the 1890s, Winnipeg's population and wealth grew rapidly in comparison with those of cities in Saskatchewan and Alberta. It became a railway hub for western Canada and the mid-western United States, exporting agricultural production and importing manufactured goods. Still, art schools were not established until much later. Winnipeg's boom period ended relatively quickly, as railway shipping rates rose, wheat prices began to fall in 1913, and the Panama Canal opened in 1914, eliminating Winnipeg's role as a major player in North American transportation services.

During the boom, however, an elaborate program of civic mural painting was planned for Manitoba's provincial Legislative Building. Not surprisingly, the artists were foreign, a fact lamented by at least two Toronto artists.[16] In 1913 the Manitoba government commissioned the English firm of Simon and Boddington to build a new legislative building.[17] From the beginning, Frank Simon envisioned mural paintings for the Legislative Chamber. He believed, as did all adherents of the Mural Movement, that sculpture and painting should be closely allied with architecture and that mural painting acted as a type of social reform for a general population. "Men and women cannot be happy or good in surroundings that are commonplace, ugly and uninspiring," he stated, and the Platonic "beauty" of mural painting as well as its subject matter have "moral, economic and intellectual" value.[18]

Simon, for unknown reasons, hired the American Augustus Tack, who was not experienced in mural painting, to decorate the Legislative Chamber.

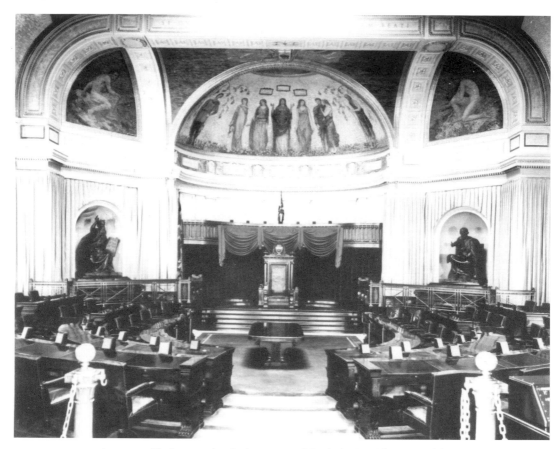

FIG. I Augustus Tack, mural paintings, 1920, Manitoba Legislative Building, Winnipeg

Between 1918 and 1920 Tack used an impressionistic style to cover the upper levels of most of the walls with old-fashioned classical personifications of virtues associated with the law, such as Justice, Prudence, Faith, and Mercy (fig. 1). Simon also hired the famed English muralist Frank Brangwyn to paint *The Allegory of Canada's War Record* over the doors to the chamber. In this panel of 1921, also in an impressionistic style, Brangwyn adopted realistic contemporary subject matter. Canadian soldiers dig a trench, play musical instruments, and eat soup from a pot. Near a roadside shrine with Madonna and child, French peasants till the soil. In the background, a large gun and a destroyed church can be seen.

The history of civic mural painting in British Columbia is similar to that of the Prairie provinces. A stable population grew only from the 1880s, as the railway arrived and a diversified economy, based on agriculture, timber,

mining, and shipping, developed.[19] Within this context, two monumental civic mural programs were completed in the first half of the twentieth century. In 1903 local artist James Blomfield installed a lavish mural program in the ballroom of Government House in Victoria, British Columbia (fig. 51). The work was composed of colossal figures of Indian warriors on the spaces between the ceiling arches, connected by an interlace design of pine cones, pine needles, dogwood, and other local flora. Painted with the totems (protective spiritual images) of various Northwest Coast Native tribes, these figures appear as "Canadianized" classical personifications (see chapter 7).[20]

In 1935 local artist George Southwell was commissioned to paint murals in the rotunda of the Parliament Buildings in Victoria. Southwell believed that civic mural painting was particularly important: "[To evoke] pride of citizenship," he said, " ... it is necessary to cultivate through pictorial representation a true knowledge of our notable events as ocular demonstration leaves positive impressions on the mind."[21] For the walls, Southwell provided images of local historical activities that also acted as examples of virtues he argued were necessary for the establishment of a civilized society: *Courage* (the meeting of Captains Vancouver and Quadra at Nootka Sound); *Enterprise* (James Douglas and his followers lay the foundation of a Pacific port for the Hudson's Bay Company; fig. 2); *Labour* (James Douglas supervises construction of Fort Victoria / Langley for new colonists); and *Justice* (Chief Justice Sir Matthew Baillie Begbie and Secretary Powley persuade Indians not to go to war or to hold court during the Caribou gold rush; fig. 3). The pendentives of the rotunda's dome – which Southwell did not begin until 1952 because of health problems – depict the four primary industries of British Columbia: logging, mining, fishing, and agriculture (*Agriculture;* fig. 4).[22] Some social critics in the first half of the twentieth century in British Columbia wanted to see more civic work like Blomfield's and Southwell's, but few commissions were granted. In response, local artist and cultural critic Charles Scott was able to state, with regret, in 1932: "Many of our public buildings, including our schools, are notoriously devoid of decoration or pictorial imagery."[23]

Given Quebec's early date of settlement, relatively large population, stable economy, respect for monumental architecture, and establishment of art institutions, it is reasonable to expect that this province would have produced a large number of civic mural paintings. Certainly both French and English Canadians in Quebec advocated murals of this type. In 1868 Napoléon Bourassa recommended historical mural paintings for civic sites because they would "glorify the memories of a nation."[24] He also urged public funding for civic mural painting, stating that "the action of the community is always

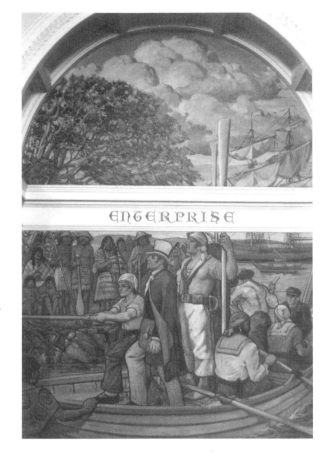

FIG. 2 George Southwell,
Enterprise, 1935,
Provincial Parliament
Buildings, Victoria,
British Columbia

preferable to that of the individual."[25] In 1892 Ludger Larose similarly argued that art with historic subject matter would encourage French Canadians "to love their country."[26] In 1920 Montreal architect Ramsay Traquair pleaded: "Oh that the walls of some public building were available! Painting might here in Canada take its proper place as an art of Public Life, for we seem to have the painters."[27]

Nevertheless, for a number of reasons, few civic mural paintings were produced in Quebec. First, Catholicism was a key component of French Canadian nationalism, and the large number of mural paintings done for Catholic churches largely fulfilled the role of the civic mural painting, at least for French Canadian Catholics (see chapter 5). Second, it would have been difficult to install civic mural paintings – which normally represent historical subject matter – with images that would have satisfied both French and English Canadians in Quebec, since each group had its own view of Quebec history. The mural paintings in the Chalet of Montreal's Mount Royal Park

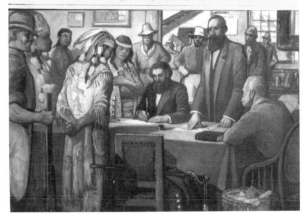

FIG. 3 George Southwell, *Justice,* 1935, Provincial Parliament Buildings, Victoria, British Columbia

in the early 1930s (*in situ*) may well have pleased both groups, but for different reasons. An examination of their subject matter provides some insight into this delicate and typically Canadian problem.

In 1931 Montreal's municipal government commissioned thirteen artists to paint murals for Mont Royal's Chalet as a "make-work" project in response to the Great Depression. Some of the artists were French Canadian; others were English Canadian.[28] The panels represent French Canadian history from 1534 to 1760 – from the first arrival of the French to the English Conquest. The absence of post-Conquest events permits a proud reading for French Canadian history. Yet the program can also suggest that there was no French Canadian history between the Conquest of 1760 and 1931, only English Canadian history. Therefore, these murals can be read as references to the British Conquest.

Other civic mural paintings in Quebec appear to have been done for sites frequented mostly by the English or for those visited mostly by the French,

FIG. 4 George Southwell, *Agriculture,* 1950s, Provincial
Parliament Buildings, Victoria, British Columbia

and the subject matter corresponds to the taste of the viewer. In this way, sponsors avoided the problem of whose history to depict. For example, when the Royal Canadian Academy held a mural contest in 1924, four of the six winning submissions were done by English Montreal artists for civic sites in Quebec used predominantly by English Canadians. Robert Pilot painted *The First Traders of New France* for the English-speaking Montreal High School (now in the offices of the Protestant School Board of Greater Montreal). Donald Hill painted *Time Pointing Out the Opportunities to Acquire Education and Its Rewards* for Montreal's English-speaking Strathearn School (fig. 5). Leslie Smith painted *Education Extends an Open Hand to All Classes* for Montreal's English-speaking King Edward VII School (present location unknown, probably destroyed). And Charles Simpson painted *St. Columba Bringing the Elements of Celtic Art into Scotland,* a particularly English subject, for the Art Gallery of Montreal, a site frequented mostly by English Montrealers (now in Trinity College School, Port Hope, Ontario).[29]

Mural paintings were also installed in the Palais législatif in Quebec

FIG. 5 Donald Hill, *Time Pointing Out the Opportunities to Acquire Education and Its Rewards,* 1924, Strathearn School, Montreal

City, a civic site frequented predominantly by French Canadians. Most of the panels depict French Canadian history before the British Conquest of 1760. They were designed to evoke loyalty to French Canada and to maintain French Canada as a distinct nation. The architectural commission for the Palais législatif had been given to local architect Eugène Taché in 1876. He based his design on the sixteenth-century wing of the Louvre. Since the French were active in Canada at the time the French palace was built, it is reasonable to assume that Taché's choice of style was intended to remind French Canadians of their European roots and to raise French Canadian nationalistic sentiment.[30]

While Taché was planning the architecture of the Quebec Palais législatif, he envisioned decorating its interior with lavish mural paintings based on those he had seen recently in the new Hôtel de Ville in Paris. When construction of the legislative building was almost complete, Premier Ross agreed with this plan: "The interior offers a vast opportunity for wall decoration," he said, "to which many of the various episodes in our national history lend themselves in all their magnificence."[31] Three years before Ross made this statement, Napoléon Bourassa provided the provincial government with a plan for a mural program for Taché's legislature. For the National Assembly Chamber, Bourassa would have installed a painting that he began in 1859 in Paris, the *Apotheosis of Christopher Columbus* (fig. 6). Here, against classical arches and clouds, Columbus meets with famous scientists, writers, artists, musicians, philosophers, political leaders, and explorers of Western culture

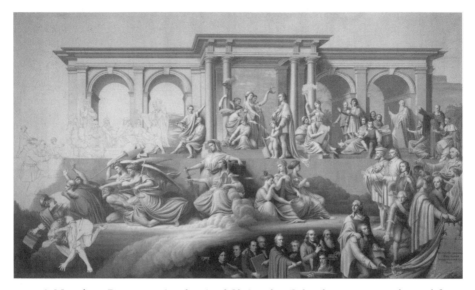

FIG. 6 Napoléon Bourassa, *Apotheosis of Christopher Columbus,* 1904–12, planned for the Palais législatif, Quebec City

from across time as well as with personifications of Justice, Truth, and other virtues. French Canadian heroes such as General Montcalm and Louis-Joseph Papineau were included, but so too were famous English Canadians, including General Wolfe and Sir John A. Macdonald, presumably because this site represented both the English and French populations of Quebec. Bourassa's composition was clearly influenced by Paul Delaroche's *Hemicycle* of 1841, painted for the École des Beaux-arts in Paris (*in situ*). Delaroche's mural, which Bourassa had seen, depicts a meeting of famous artists from all time periods of Western culture.

Bourassa planned to do other mural paintings for the National Assembly Chamber which would have been entirely devoted to pre–British Conquest French Canadian themes: the visit of Jacques Cartier to the village of Hochelaga, the defence of Fort Verchères, Dollard's heroic battle at Long Sault, the sinking of the *Auguste,* and the death of Montgomery at Près-de-ville. He also planned to decorate the ceilings of this space and the Legislative Council Chamber with painted personifications and attributes of the law, justice, science, the arts, industry, commerce, and agriculture. In the end, however, arguing a lack of funds, the provincial government did not hire Bourassa to install any of this work. [32]

At the turn of the century the Quebec government commissioned Henri Beau to paint *The Arrival of Champlain at Québec* – another pre-Conquest

theme that was particularly important to French Canadians – for the Legislative Council Chamber of the Palais législatif (plate 2). When Beau installed this mural in 1903 he surrounded it with an elaborate frame, so it appeared as an easel painting, although it was glued to the wall in the marouflage technique. In both style and composition, he followed Puvis de Chavanne's *Marseilles, Porte of the Orient* of 1869, a depiction of contemporary prosperity in the southern French city commissioned by the Musée de Marseilles (*in situ*). Its companion piece, *Massilia, Greek Colony,* represents historical prosperity in the city of Marseilles. Beau intended to do a companion piece for *The Arrival of Champlain* based on *Massilia,* to be entitled *Work and Peace Make Canada Prosperous.*[33] But the commission was not forthcoming, likely because Beau's first panel had been criticized for its historical inaccuracies.[34]

In 1909 Beau proposed to decorate the National Assembly Chamber, but he was again refused, probably for the same reason. A year later, Quebec artist Charles Huot was chosen to decorate this space. Almost twenty-five years earlier both Bourassa and Taché had suggested Huot as an assistant for the mural decoration they hoped would be installed in the Palais législatif. Since that time, Huot had studied in Paris and had seen many of the mural paintings commissioned by France's Third Republic for civic sites. He had also completed a program of mural paintings for the church of Saint-Saveur in Quebec City.[35] Moreover, Huot was a friend of Thomas Chapais, a member of the Legislative Assembly who favoured mural painting for the site and Huot as the muralist.[36] In 1913 Huot hung *The Debate on Languages* (sometimes entitled *January 21, 1793, the First Sitting of the Legislative Assembly of Lower Canada,* another important event in the history of French Canada) in the National Assembly Chamber (fig. 7).[37]

Between 1914 and 1920 Huot decorated the ceiling of the National Assembly Chamber with *Je me souviens (I Remember).* This mural has a large central panel painted as an illusionistic view of the sky through the ceiling, as well as five irregularly shaped corner panels. A personification of the soul of Quebec sits on the clouds in the central panel. She is surrounded, as in Bourassa's planned mural, by famous people from Western culture, including French and English Canadians. Many European muralists had produced this type of composition in the seventeenth and eighteenth centuries for ceiling paintings in baroque-style churches and palaces. Nineteenth-century European artists, such as France's Albert Besnard and George Clairin, had also revived the practice for theatre decoration. Huot had likely seen some of these examples and he may have borrowed the idea for a civic site because he recognized the dramatic potential in government, or, given the

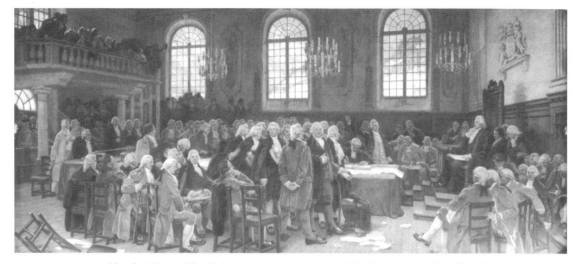

FIG. 7 Charles Huot, *The Debate on Languages*, 1913, National Assembly Chamber, Palais législatif, Quebec City

close association between religious and secular life in French Canada, because he intended to draw a comparison between the Quebec site of government and Catholic church interiors. The title of Huot's ceiling painting, *Je me souviens,* which eventually became an official motto for Quebec, directs the viewer to remember French Canadian history. Taché, who appears in the painting, had coined the phrase in 1883 with this particular meaning.[38] Between 1926 and 1930 Huot also produced *Sovereign Council* as a replacement for Beau's *The Arrival of Champlain at Quebec*. Presumably Beau's work was dismissed on the basis of earlier criticisms as well as Huot's established position.

More civic mural paintings were produced in Ontario than in other parts of Canada. Given the relatively large and wealthy population, composed for the most part of people of Anglo-Saxon ancestry, as well as the early establishment of educational institutions, including an art college, this level of activity is not surprising. Still, because most of Ontario's population had a working-class background and saw civic art as frivolous, the number of civic mural paintings was not large, compared with those completed in other Western countries such as France, England, and the United States.

Some of the earliest civic murals in Ontario were the same as those produced in the Maritimes. They consisted simply of single panels of coats of arms painted in *grisaille* (various tones of grey or greenish-grey used to represent sculpture in a *trompe l'oeil,* or illusionistic, fashion). They may have functioned as a bridge between the eighteenth and early nineteenth centuries'

strong taste for sculpture – which included a rejection of elaborate mural painting – and the revival of mural painting (the European-based Mural Movement) that began in the 1830s. For example, Josef Moser, an itinerant painter of German origin, painted a coat of arms in grisaille flanked by illusionistic marble pilasters in the 1860s for one of the walls of the courtroom in Victoria Hall, the town hall in Cobourg (*in situ*). He also painted trompe l'oeil architectural decoration, including pilasters and imitation marbling, for the upstairs concert hall in the same building (*in situ* in a restored form).[39] John Walthew painted another trompe l'oeil coat of arms for the town hall in Aylmer, Ontario, in 1873–74 (*in situ,* but no longer visible).[40] These murals are small, designed to highlight the British presence in Canada by means of the lion and unicorn symbols within the coats of arms. They did not fully participate in the Mural Movement, which promoted monumental mural painting based on jubilant nationalistic sentiment.

Civic mural paintings that more clearly align with the Mural Movement appeared in Ontario in the 1860s. Until about 1900 they employed strong classical features, just as civic mural paintings in other Western countries did until the decade earlier. For example, in 1861 Mr A. Todd covered the ceiling of the reading room of the Toronto branch of the Mechanics' Institute with a Greco-Roman mythological scene (destroyed, exact subject matter unknown). The institute, which received private and public funding to provide instructional programs for adults who had not received a formal education, had branches in most English-speaking countries.[41]

In 1892 the Ontario government hired German immigrant Gustav Hahn to paint murals for the Legislative Chamber of the new Ontario Legislative Building (now the Ontario Legislative Buildings) in Toronto (fig. 8). Hahn painted the north and south walls with classical female personifications of Moderation, Justice, Power, and Wisdom entwined in a massive Celtic vine scroll, which highlighted the Anglo-Saxon ancestry to which most of Ontario's contemporary population belonged. He also painted images of gold and brown maple leaves on a sage-green background in the spaces between the wooden ceiling beams, making a clear but restrained reference to the prosperity provided by local Ontario woodlands. [42]

In 1895, partly in reaction to the huge success of American mural paintings at the World's Columbian Exposition held in Chicago in 1893, a number of Toronto artists formed the Society of Mural Decorators. In its first year of operation the society planned mural paintings for the Council Chamber of Toronto's new Municipal Buildings (now the Old City Hall). They were

FIG. 8 Gustav Hahn, mural paintings, 1892, Ontario Legislative Buildings, Toronto

rejected because of a lack of funds. Sketches for the panels demonstrate that, on one wall, George Reid, Wyly Grier, and William Cruickshank would have painted *Industry, Integrity,* and *Intelligence.* On another, Cruickshank and Frederick Challener would have painted *Peace, Government,* and *Prosperity.*[43] The first panel would have represented men forging metal, weighing and selling grain, constructing a building, and unloading ships on the Toronto waterfront; the second would have had men herding sheep and settling a land dispute, and women spinning wool. In the entrance to the chamber, Reid and Gustav Hahn would have painted classical personifications of Science and Art.

In 1899 Reid donated two historical mural panels for the entry hall of the Toronto Municipal Buildings in the hope of encouraging commissions for other parts of the building: *The Arrival of the Pioneers* and *Staking a Pioneer Farm* (fig. 38). In the spandrels of the arches that separate the two panels, Reid (or Hahn) painted classical personifications of virtues relevant to city government, such as Justice. Much to Reid's disappointment, this work did not promote the hoped-for commissions for other parts of the building.[44]

A year before this installation, Reid and other Toronto mural advocates had formed the Toronto Guild of Civic Art. It was patterned after similar associations in the United States that had been organized in connection

with the widespread City Beautiful Movement.[45] James Mavor, a professor at the University of Toronto and one of the founding members of the guild, articulated its goals: "[The guild was organized] to promote and encourage the production of works of art intended for the embellishment of the city or for its public buildings." The encouragement of civic art, he noted, was an appropriate function of the modern municipality. Mavor also explained that mural painting was the most appropriate form of decoration for public architecture, since this type of art expressed "public magnificence."[46]

By the late 1890s Mavor and other Toronto civic mural advocates, like those in foreign countries, were beginning to recommend the replacement of this classical type of subject matter with local, contemporary, everyday images. As Mavor stated in 1899: "[Mural painting] should have some interest by way of association to the average person who is likely to see it ... A laboured attempt to illustrate a recondite allusion or to express in paint that which is probably not susceptible on any terms of being so expressed, is apt to miss its point so far as concerns the average observer, while the story which is so simply told on canvas as to be intelligible to a child may also be the most interesting to the cultivated intelligence."[47]

At the same time, many cultural critics in Toronto were arguing that the Canadian landscape was unique yet familiar to Canadians. It was also the main source of material progress. From at least the 1880s, therefore, artists who were producing easel paintings chose landscape as the local, contemporary, everyday subject matter that could best raise nationalistic sentiment. As Toronto artist and cultural critic William Sherwood stated in 1894: "In a most material way is the landscape painter furthering patriotic sentiments."[48]

Toronto civic muralists agreed. In 1898 Reid explained, as part of a promotion of civic mural painting, "[Mural Art] must come through a genuine love for ... the air, the soil, the climate of our country."[49] Challener stated in 1904 to an audience of Ontario architects: "[Canada] has much to celebrate [in mural art], the settlement of the country [and] the exploration of its rivers and lakes."[50] Arthur Lismer supported this view when he stated in 1926 that "landscape provides the background for industrial expansion [and] contains the hoarded treasures for the sustenance of countless generations."[51]

Consequently, in the early twentieth century Ontario muralists began to put more focus on landscape. In this way their work differed from contemporary muralists in foreign countries and in other parts of Canada who continued to focus on the human figure (for example, George Southwell's murals in the Provincial Parliament Buildings, Victoria, British Columbia,

figs. 2 to 4; and Donald Hill's mural for Strathearn High School, Montreal, fig. 5). Concomitantly, these Ontario muralists employed aspects of historical descriptions of Greco-Roman Arcadia to suggest that Ontario was a modern version of this mythical and wondrous landscape.

According to Greco-Roman poets such as Theocritus and Virgil, Arcadia was composed of pastoral and sylvan landscape (rather than wilderness), in which people could enjoy agricultural abundance and cooling woodland streams in an eternal summer season. As such, ancient Arcadia was a welcome contrast to life in the large cities that had developed in Hellenistic and Roman cultures. During the medieval period, as Europeans fortified their cities against barbarian invasions, the open countryside took on a distinctly negative connotation. By the time of the European Renaissance, this point of view was much less prominent, as travel became less dangerous and the countryside provided a welcome contrast to rapidly growing cities. Within this context, sixteenth-century European explorers described North America as Arcadia, in contrast to Europe.

In the late eighteenth century, United Empire Loyalists – people who fled the United States during and after the American Revolution as an act of loyalty to England – began to refer to Ontario as Arcadia because they believed that God had rewarded their loyalty with Ontario's ideal agricultural land. Ontario novelist and poet William Kirby's poem of 1859, "U.E.A. Tale of Upper Canada," articulates this position. It begins with a quotation from Virgil and goes on to praise the Loyalists for the wisdom of their decision to immigrate to "Arcadia," with its "azure skies that breathe immortal air" and "gentle streams that wind themselves away / Through flowery meads and fields of golden corn."[52] This vision of Ontario continued throughout the century. For example, in his poem of 1886, "Tecumseh," Charles Mair similarly described Upper Canada as a garden that was there for the Loyalists to take.[53]

In the late nineteenth and early twentieth centuries, as the negative features of urbanization intensified in the Western world, general references to Arcadia as a temporary escape from modern urban life – albeit without rejecting modern urban life's desirable elements – permeated many forms of high and popular culture in all Western countries, including Canada. Within this context, supported by the United Empire Loyalists' descriptions of Ontario as Arcadia, writers in the late nineteenth and early twentieth centuries intensified the comparison between Ontario and Arcadia. For example, Ottawa-based poet Archibald Lampman wrote "Favourites of Pan," in which he told his readers they could recapture Arcadia by listening to the

sounds that frogs made in the Ontario woods, since frogs learned these sounds originally from Pan, the flute-playing satyr of Arcadia.[54] Ontario writers who described Canada in this way did not, however, desire a return to the Arcadia of antiquity. Rather, they believed that Canada was a new Arcadia and that their poetry was evoking nationalist sentiment. As Ottawa-based poet Duncan Campbell Scott said of Lampman: "The nature [Lampman] saw was the Canadian Scene and it may well be said of him as was said long ago of [ancient odes to Arcadia] ... His Muse is the Muse of his native land."[55] By 1914 the Ontario population was so familiar with the idea of Ontario as an Arcadia that Ontario humorist Stephen Leacock was able to satirize the comparison in his enormously popular *Arcadian Adventures with the Idle Rich.*

From the late nineteenth century, many Toronto mural painters made plans to decorate local civic sites with representations of historical events set in lush pastoral and sylvan, or Arcadian, landscape settings. In this way they could evoke Greco-Roman Arcadia without having to employ old-fashioned classical personifications. Some of these mural paintings were installed; some were not. On several occasions between 1897 and 1907 the Toronto Guild of Civic Art offered, unsuccessfully, to paint historical murals for the walls around the grand stairway of the Ontario Parliament Buildings. Those of 1907 would have had prominent landscape settings.[56] In 1904 the guild proposed mural paintings for the main rotunda of the federal Parliament Buildings in Ottawa. William Brymner, Franklin Brownell, and Edmund Dyonnet, as well as Challener, Grier, Hahn, and Reid, would have painted *Canada Receiving the Homage of Her Children.* In the centre they suggested a classical enthroned personification receiving a procession of nine female personifications of her provincial "daughters." All the figures would be set in a prominent landscape background of forests, agricultural land, mountains, and lakes. This project, too, was turned down for lack of funds.[57]

In 1906 Frederick Haines painted a mural for the public school in Meadowvale, Ontario (*Indians on the Credit River,* now in the offices of the Credit Valley Conservation Authority).[58] It represents Native men in a canoe. The sun is shining as they paddle down a river surrounded by otherwise uninhabited lush green woodlands. Between 1908 and 1914 Elizabeth Birnie installed mural paintings in the Collingwood Public Library (destroyed) and Penetang Public Library (now in storage in Discovery Harbour in Penetang).[59] Those in Penetang employ the flat light colours of Puvis de Chavannes to represent local historical events set against monumental views of the nearby lake. In 1910 John Beatty installed three large

FIG. 9 Mary Hiester Reid, *Autumn*, 1913, Town Hall, Weston, Ontario

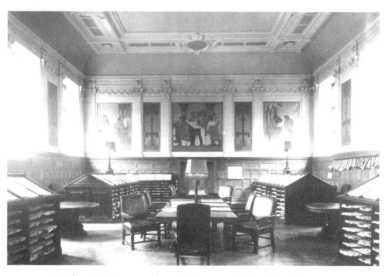

FIG. 10 Arthur Crisp, mural paintings, 1920, Reading Room, Parliament Buildings, Ottawa

mural panels in the kindergarten room of Rosedale Public School in Toronto (fig. 57 and plate 3). They depict relatively small figures of children at a school picnic in a spring woodland, of a farm family haying in summer, and of children and grandparents in a fall field of pumpkins and drying corn, all within dominant landscape settings. Three years later the Toronto Board of Education began to install opalescent glass murals in kindergarten classrooms. Between this time and 1919, at least thirty-four Toronto kindergartens were decorated in this way. (see chapter 9). In 1913 Mary Hiester Reid painted *Autumn,* a landscape of the local Humber Valley, for the Town Hall in Weston, Ontario (fig. 9).[60] In 1920 New York-based Canadian muralist Arthur Crisp painted seventeen mural panels for the reading room of the Parliament Buildings in Ottawa (fig. 10). They are devoted to a history of the printed word, but also provide images of Canada's natural resources as a means of demonstrating the dependence of cultural progress on material progress.[61]

To promote more civic mural commissions, the Royal Canadian Academy held competitions in 1923 and 1924. One of the 1923 winners was Toronto artist J.E.H. MacDonald's *Friendly Meeting, Early Canada* (fig. 40). Although dominated by human figures, it represents the transfer of land from Native people to people of European ancestry, who, in the background, are preparing the land for agriculture (see chapter 7).[62] One of the 1924 winners, George Reid, painted one large panel of uninhabited woodland and five other panels devoted to educational activities set in prominent woodland settings. In 1926 he installed these panels in Toronto's Earlscourt Public Library (figs. 53 and 54; see chapter 8).[63]

In 1929 Frederick Haines and several of his Ontario College of Art students painted *The Settlement of Canada* for the Dominion Government Building at Toronto's Canadian National Exhibition. It consists of eight panels devoted to land conquest, exploration, and subsequent agricultural settlement (figs. 49 and 50). Its subject matter was most appropriate for its site, since the Canadian National Exhibition was organized to celebrate material progress and the support that imperialist activities gave to material progress.[64]

Between 1927 and 1932 the Literary Society of Toronto's Humberside Collegiate commissioned Arthur Lismer to paint five mural panels for the high school's auditorium (fig. 11).[65] The central panel is composed of classical personifications of Truth, Wisdom, Courage, Beauty, Innocence, and Devotion. The other panels, reading from left to right, represent the various populations of Canada – Native, French, and English – from the sixteenth

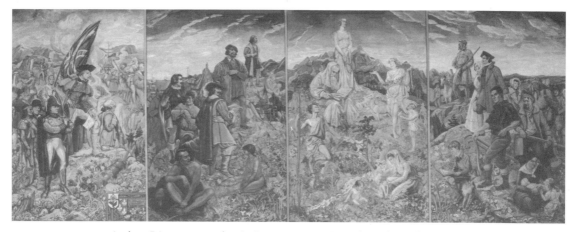

FIG. 11 Arthur Lismer, mural paintings, 1927–32, Humberside Collegiate Institute, Toronto

century to the twentieth. All the figures are placed in lush landscape with distinctly Canadian flora and fauna.

George Reid installed a monumental historical mural program in the auditorium of Toronto's Jarvis Collegiate between 1928 and 1930. Students raised the funds as a memorial to Jarvis students and teachers who had died in the First World War (fig. 12). The panel that sits above the balcony on the south wall is composed of European explorers engaged in preparations for travel. The two panels beside the stage on the north wall, *Patriotism* and *Sacrifice,* depict students paying homage to enthroned personifications of these two virtues. The long single panel that sits under the balcony on the south wall, and the five panels that occupy the west wall, chronicle Canadian history "from sea to sea," beginning with John Cabot's arrival on the east coast and ending with Alexander Mackenzie's on the west. A common ground line links the five west-wall panels and gives a prominent place to landscape.[66]

In 1932 the Royal Ontario Museum in Toronto commissioned Charles Jefferys to paint four murals (of two or three panels each) on the theme of human life, from the Palaeolithic period to the Bronze Age, for its Palaeontology Galleries.[67] Jefferys completed the first one, of three panels, on the Mousterian period in 1933, and the fourth, of three panels, on the Bronze Age in 1935 (one panel in the C.W. Jefferys Secondary School, Downsview, Ontario; several in storage in the museum; location of the others unknown, probably destroyed). All include dominant landscapes, some of which were intended to represent the regions of western Canada in which dinosaur

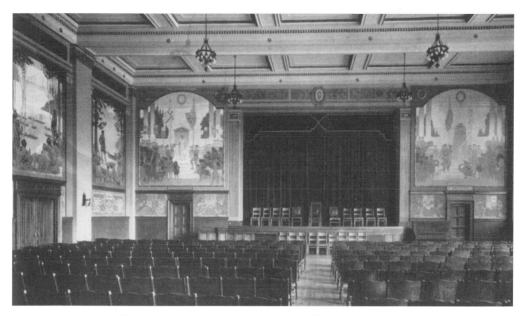

FIG. 12 George Reid, mural paintings, 1929–30, Jarvis Collegiate Institute, Toronto

remains had been found. The other two murals, which were to have been composed of two panels each and to have illustrated the Cave Period and the Downland Dwellers, were not completed, likely because Jefferys was ill.

In 1935 the Royal Ontario Museum commissioned thirty-four painted panels (based on funding from the Leonard Estate) on the same subject from George Reid. Installed between 1935 and 1938, they illustrate the history of the world up to the time that Jefferys's murals began (fig. 13).[68] Jefferys's and Reid's museum mural paintings reflect not only an awareness of similar murals installed earlier in foreign museums but also the widespread contemporary interest in museum displays that demonstrated Darwinian evolution – and Western culture as the successful culmination of that evolution.[69]

Civic mural advocates in Toronto frequently wrote and lectured on the importance of civic art. Their rhetoric clearly imitated that of French, English, and American civic mural advocates published in journals that were available in Canada. For example, those in Toronto argued, just as foreign muralists had, that painting should be "intertwined [with architecture] in inseparable bonds. Each may live apart from each other and be beautiful in itself, but the perfect life can only be consummated in conjunction with each other."[70] They also contrasted civic mural painting with civic easel painting, concluding that civic mural paintings were "unselfish." As Margaret

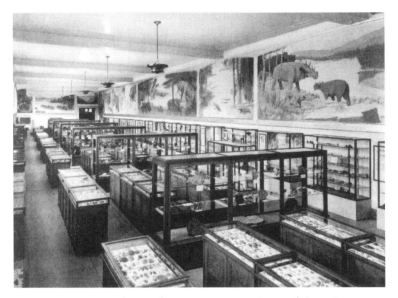

FIG. 13 George Reid, mural paintings, 1935–38, Royal Ontario
Museum, Toronto

Fairbairn argued, easel paintings were simply "isolated thoughts" that could
never carry out the important functions of mural painting.[71]

Furthermore, Toronto mural advocates agreed with foreign mural advo-
cates, who stated that civic mural paintings were the most important of the
four mural types. They recognized, as did foreign mural advocates, a rela-
tion between the civic mural and the other mural types – commercial,
Christian, and private – although they did not clearly articulate the ability
of these three types to evoke nationalistic sentiment. For example, in his lec-
ture of 1904 to Ontario architects, Frederick Challener praised civic mural
paintings in ancient cities such as Athens on the grounds that the city's his-
tory was "made living on the walls so that the humblest and least educated
citizen knew its principal and worthiest events."[72] He explained that
Canadian artists, including himself, had recently begun to do the same kind
of work, and gave examples of mural paintings executed exclusively for com-
mercial and domestic sites.

In 1925 J.E.H. MacDonald took the same approach as he compared the
Christian mural paintings he had just completed for St Anne's Anglican Church
in Toronto (fig. 24 and plate 6) with civic mural paintings in Manchester's
Town Hall (*in situ*).[73] The Manchester murals done by Ford Madox Brown in
the late nineteenth century depict the social, scientific, and industrial history of
local textile manufacturing from the Roman period to the nineteenth century.[74]

Therefore, MacDonald's and Challener's comparisons may initially appear to be inappropriate. However, these comparisons effectively acknowledged what Jürgen Habermas would later explain as the merger of the public and the private economic spheres in late-nineteenth-century Western culture (see chapter 1). Indeed, civic and commercial mural painting overtly glorified material progress, while religious and private murals employed the profits from material progress to provide sanctuaries from the negative features of material progress, without openly condemning these features. They, too, supported material progress. Challener's and MacDonald's comparisons were entirely appropriate.

Toronto civic mural painting advocates also believed, as did those in foreign countries, that civic mural paintings with historical subject matter could best evoke nationalistic sentiment. In his 1904 lecture Challener claimed that public mural paintings would "make history known to everyone."[75] In his 1926 address to the Canadian Club of Toronto, Arthur Lismer echoed this sentiment: "A great work to be undertaken by some society in the future would be to place in every great school in the province noble and dignified mural decorations representing great episodes in the Canadian story ... The more we can tell in song, work and picture of our historical background the more enriched our national consciousness will be."[76]

According to Toronto mural painting advocates, civic mural paintings might also, as English and American mural advocates hoped, provide a national school of art. One Toronto art critic stated in 1899: "[If civic murals] commemorative of important stages in the country's development" were produced, "a national school of art would appear."[77] Nevertheless, Torontonians did not share the obsessive American need to "surpass" the Italian Renaissance. One Toronto art critic even stated in 1897 with remarkable confidence, given Toronto's limited art scene at the time, that "Michelangelo himself might get a few points [from the Ontario Society of Artists] could he return for a little while, as to the best materials and means of mounting his wonderful frescoes; he evidently did not know it all."[78] In 1930 another Toronto critic stated that theatre patrons could comfortably view Frederick Challener's *Meeting of Venus and Adonis* in Toronto's Royal Alexandra Theatre "without the feeling in your neck we are told one has after a morning in the Sistine chapel with Michael Angelo."[79]

With such serious tasks to perform, Toronto's Mural Movement advocates adopted the German Idealist / Platonic equation between both beauty and good and artist and prophet (see chapter 1). Consequently, they gave civic mural paintings a Christian gloss, just as foreign muralists did. In 1898 James Mavor claimed that mural painting would "ultimately form the visible

substance of the immortality of the artists."[80] In 1899 Jean Grant, an art critic for *Toronto Saturday Night,* explained that nothing could be compared to civic mural paintings "except the pulpit."[81] She also wrote: "[Murals paintings] transform our ... civic buildings ... from mere piles of brick and stones ... into sanctuaries in which the spirit is refreshed."[82] In 1921 a contributor to the Toronto architectural journal, *Construction,* stated that "he who would approach [mural painting] must be furnished with some radiance of the divine fire."[83]

Writing for *The Canadian Theosophist* in 1925, just two years before he began to paint his murals at Toronto's Humberside Collegiate (fig. 11), Lismer argued on the same basis: "Art unfolds the purpose of humanity [and] the art of a nation is the expression of the nation's presence on the path that leads towards things of the spirit."[84] In his 1926 address to the Canadian Club, Lismer similarly declared: "When the art impulses of a nation are stirred then something vital moves into a responsive rhythm and we recognize a spiritual force that rises far above the trivialities or differences of schools and methods, foreign customs and stale fashions."[85] At the same time, mural painting advocates in Toronto ironically recognized a direct economic value in mural painting, just as English and American mural advocates did. In his 1904 lecture Challener explained: "Most assuredly there is money in mural painting ... if only the municipality spends a little money along those lines."[86]

To enable civic mural paintings (as well as other types of mural paintings) to perform all these functions as easily as possible, Toronto and foreign mural advocates alike recommended the use of Puvis de Chavannes's two-dimensional mural style. In 1898 Mavor stated: "The masters in mural painting, for instance, Puvis de Chavannes ... consider that the characteristics of mural painting should be the presence of broad, flat colour masses."[87] In 1901 Margaret Fairbairn declared that mural painting had found "its highest expression in the works of Puvis de Chavannes."[88] In 1906 John Beatty wrote: "The painter must, to a great extent, forget all that subtle modeling which has been acquired by years of study and aim at broader, simpler plains. A mural decoration should lie flat and become a part of the ceiling or wall that it is intended to adorn."[89] And, as late as 1931, the architects of the Canadian Bank of Commerce in Toronto insisted that Arthur Crisp rework his almost completed mural paintings for the Foreign Exchange Office (fig. 20 and plate 5) so they would look more like the work of Puvis de Chavannes.[90]

Artists and social critics in Toronto frequently lamented the lack of opportunity to do civic mural painting. In his 1904 lecture, for example, Challener ruefully stated that the Toronto Municipal Buildings were "but a whitened

sepulchre."[91] At the same time, these mural advocates exaggerated the quantity of civic mural paintings and downplayed the problems of civic commissions in England, France, and the United States – the countries whose murals were best known to Toronto mural painting advocates. Since contradictory information frequently appeared in publications that were available in Canada, it is reasonable to assume that the Toronto advocates constructed these views as a means of shaming Canadian governments into commissioning more civic work. An examination of these constructions is, therefore, a useful way to look at the discourse of the civic work of the Mural Movement in Toronto and other parts of Canada, where civic mural painting advocates seem to have shared the views of the Toronto artists but rarely published them.

When the Third Republic was formed in France in 1871, it immediately called for the large-scale production of civic mural paintings and other forms of art that would glorify the salient features of the modern nation-state and provide a unified vision of French society. From at least the last decade of the nineteenth century, Toronto civic mural painting advocates clearly understood this process and openly praised it.[92] However, these same people simultaneously praised the mural paintings of earlier and repressive aristocratic regimes – those of Napoleon I, Louis XVIII, Charles X, Louis-Philippe, and Napoleon III – as if all these mural paintings were part of a single phenomenon. In this way the Toronto advocates falsely enlarged the civic work of the Mural Movement in France and shamed the contributions of Canadian governments.[93]

Furthermore, Toronto civic mural painting advocates did not acknowledge the heated and well-publicized French debates that began in the 1880s over the change in subject matter of civic murals – from somber, didactic, and classical historical images to representations of contemporary people engaged in mundane activities.[94] As the French commission that was overseeing the mural decoration of the Hôtel de Ville in Paris in the late 1880s declared, "all [civic] works of art must now become the direct expression of nature, free from allegory and myth."[95] In response, fervent Republican Albert Besnard, for example, painted eight panels for the vestibule of the Sorbonne's École de Pharmacie (*in situ*) between 1882 and 1888. In one panel, *The Chemistry Lesson,* students take lecture notes in modern university classrooms. In another, *Illness,* a young girl lies in a modern bed with modern medicine on the bedside table. In 1893 Pierre Vauthier painted prosperous French families of the 1890s taking part in a local public holiday celebration for the *Salle des Fêtes* of the Mairie at Bagnolet (*in situ*).[96] Some French critics were pleased with these types of changes. Others, however, urged the government to give commissions to muralists who would employ

the subject matter of the earlier and more conservative type of mural that they regarded as more appropriate for civic art.[97] In the case of Besnard, for example, the daily press argued that his work emphasized reality over deeper thematic implications.[98]

It is simply not possible that Toronto civic mural painting advocates were unaware of this debate. Even if some of them did not read the French publications, they did read American and English journals that regularly discussed these issues. Furthermore, Toronto civic mural painting advocates were just as concerned as the French – perhaps more so, given Canada's relatively homogeneous middle-class population – with the lack of relevance of classical images to modern life.[99] Toronto civic mural painters made the same shift in subject matter from the somber, didactic, and classical to the local and everyday about twenty years after the French did.

Civic mural painting advocates in Toronto also ignored the intense debates that arose in France about appropriate styles for civic mural art. As French mural painters turned to everyday subject matter, they simultaneously moved from either academic styles or the *juste milieu* to modernist styles. Jules Chéret employed an impressionistic style for his painted homage to comedy, dance, music, and pantomime of 1903 for one of the Salles des Fêtes in Paris's Hôtel de Ville (*in situ*).[100] In 1906 Henri Martin adopted a type of pointillism for his murals in the Salle des pas perdus in the Capitole at Toulouse. In 1937 Maurice Denis painted murals on a musical theme for the state-owned Théâtre du Palais de Chaillot in Paris (*in situ*) in a modernist, flattened geometric style.[101]

These transformations enraged some French critics. One complained that the murals in the Hôtel de Ville in Paris turned the building into "a tower of Babylon." Others believed that their various painterly styles clashed or were too eclectic and too orientated to the common tastes of the public.[102] Some French critics specifically rejected impressionist styles, which they saw as overly concerned with the sensual or material rather than focused on the ideal or the conceptual. Some even found the work of Puvis de Chavannes unacceptable. Alphonse de Calonne, for example, described Puvis de Chavannes's style as obstructive to the communication of clear ideas, and his figures in one mural as "feeble, limp and scattered."[103]

Again, it is impossible to believe that Toronto civic mural painting advocates were unaware of these critiques, and of similar critiques of French mural paintings made by English and American writers. One English critic for the *Saturday Review* described the use of pointillism in French civic mural paintings as "wrong-headed."[104] American art critic Marianna van

Rensselaer found Puvis de Chavannes's colours too pallid.[105] Other American critics described some of the French civic work as "eccentric," "bizarre," "insipid," and "higgledy-piggledy," produced by artists who were "wretched bed-fellows" emitting a "cacophony of sounds."[106] Given these many negative views, it is difficult to assume that the monolithic Toronto view of French civic mural painting as entirely trouble free simply represented a coincidental agreement of art critics. Rather, it is more reasonable to conclude that it represented an attempt to persuade Canadian governments that civic mural painting patronage could be an entirely positive experience.

Toronto civic mural painting advocates published similarly fictitious accounts of the civic work of the Mural Movement in England. First, they asserted that the three largest civic mural painting programs in England – those in the Houses of Parliament, the South Kensington Museum, and the Manchester Town Hall – had been publicly funded. They claimed that there were many more publicly funded civic mural paintings in England. George Reid, for example, stated that these three programs were "but examples of many which in our own time have been designed for important [English civic] architectural settings."[107]

These claims were not true. The mural painting programs in the Houses of Parliament, the South Kensington Museum, and the Manchester Town Hall received significant amounts of private funding. Moreover, the mural painting in the Houses of Parliament were never completed. There was even a forty-year hiatus between the first and the last installations in this site that English art critics publicly decried. Ford Madox Brown was also bitterly disappointed at being given only one room to decorate at Manchester's Town Hall rather than the five that had originally been considered.[108] There were not enough funds for the other four. Yet Toronto critics described this commission as if Brown had intended to decorate only the one room.[109]

Furthermore, many civic mural paintings throughout England were privately funded, as the Canadians must have known. Alderman Sir Stuart Knill's gift of mural paintings to London's Guildhall in 1890 is a good example in a large urban centre (destroyed).[110] Lady Denman's 1923 gift of mural paintings to the Victory Hall in Balcombe, Sussex, provides an instance in a village setting (*in situ,* recently restored). At times English artists donated mural paintings to civic sites as a means of encouraging civic commissions, though they were usually as unsuccessful as George Reid had been in 1899 in Toronto. Joseph Southall's murals of the late 1890s for Birmingham's Town Hall are an example of this phenomenon (destroyed).[111] Sigismund Goetze's murals of the early twentieth century for the Foreign and

Commonwealth Office in London (*in situ*) are another.[112] Faculty and students at English art schools – for example, the Birmingham School of Art – also regularly provided civic sites such as schools, hospitals, and libraries with mural painting at little or no charge.[113] Yet Toronto civic mural painting advocates did not mention this practice, even though it was openly discussed in English literature that was available in Canada.

Toronto civic mural painting advocates also ignored the fact that many English art critics lamented the small number of civic mural painting commissions in their country. In 1880 an art critic for the *Magazine of Art* stated: "Municipalities abroad are often exercised in their minds as to the beautifying and decorating the interior and exterior of buildings contained in their several towns. How refreshing it would be if some of ours did so."[114] Over twenty-five years later, little had changed: English muralist Lys Baldry declared that "scores of public buildings in London and the provinces are allowed to remain in a condition of dingy bareness."[115]

At the same time, Toronto critics failed to acknowledge that more mural paintings were produced in England for commercial and domestic sites than for civic sites, even though an identical situation existed in Canada. Commercial funding also provided some of the largest painted mural programs in England, such as that done for London's Royal Exchange from 1895 to 1933 (see chapter 3). Arthur Lismer, in his praise of English mural paintings, referred briefly to this work, without giving it a name.[116] Clearly he was not eager to bring it or any other privately funded work to the attention of his audience.

As Toronto critics praised the three English civic mural painting programs, they also ignored the many technical problems that plagued the muralists at these sites (and at others). For the Houses of Parliament, muralists had begun in the 1840s with fresco because they believed it was durable and did not have the light reflection problems of oil paint.[117] However, these mural paintings began to deteriorate almost immediately. Oil was tried and appeared too glossy – even when mixed with wax and used in the marouflage technique. Then the newly developed waterglass technique was used, but it, too, had problems. Lord Leighton next used the new medium of spirit fresco for *Industrial Arts as Applied to War* and *Industrial Arts as Applied to Peace,* which he installed in the 1880s in the South Kensington Museum.[118] By the end of the century this work had greatly deteriorated, but Canadians who saw and praised it did not mention this fact.

Brown, too, encountered technical difficulties at Manchester. After doing six panels in the waterglass technique, he changed to spirit fresco for the seventh and did five more in marouflage. At this time William Minto, biogra-

pher of English muralist William Bell Scott, stated that "wall-painting in this climate has been a curse to all who have tried it."[119] No hint of these negative views appeared in Canadian discussions of English mural painting.

The English murals also spurred public debates about appropriate subject matter for civic mural paintings, another point that Toronto civic mural advocates did not acknowledge. These debates began as early as the mid-nineteenth century, when John Leech claimed in *Punch* that, since the mural paintings at the Houses of Parliament were supposed to elevate the morals of the working classes, "their great fault is that their subjects are not of the present day." [120] In the late nineteenth century Ford Madox Brown took part in this debate by rejecting classical allegory for his Manchester Town Hall murals, arguing that such representations were suitable only for "highly cultured" people.[121] In 1925 English art critic Herbert Furst similarly argued that the subject matter of the newly installed mural paintings in the Houses of Parliament is "remote and hardly in contact with the present at any point."[122] Other English critics also noted that many of the mural paintings in the Houses of Parliament were located in areas to which the public did not have access. Yet Canadian art critic Louis Lovekin, writing for *Saturday Night* in 1925, simply described the mural paintings in the Houses of Parliament as "a syllabus of national history" and as "successive events in the nation's progress."[123].

Civic mural style was another issue of contention in England. For example, when Goetze finished his classical mural paintings for the Foreign and Commonwealth Office in London just after the First World War, they were denounced as old-fashioned.[124] In 1930 the House of Lords denounced Frank Brangwyn's *British Empire Panels* for the Royal Gallery (which Lord Iveagh, rather than the public purse, funded) as too modern.[125] Brangwyn had chosen impressionism as a style, and the wealth and beauty of the Commonwealth for which the soldiers had died as subject matter. By the time he had completed five of sixteen planned panels, members of the House of Lords complained that their brightly coloured tropical vegetation and their modernist style were inappropriate for a war memorial and an awkward contrast to the Gothic revival style of the Houses of Parliament. In 1933 Lismer pointed to this rejection as a great loss and a lesson for Canadians not to follow.[126] However, by referring only to this particular commission, he gave credence to the view that the many other mural paintings in the Houses of Parliament were produced without problems.

Toronto mural painting advocates took the same idealistic approach to American civic mural paintings. First, they did not acknowledge the many American pleas for public funding for civic mural painting. For example, in

1902 William Low stated that American muralists had so little work, they were obliged to illustrate or teach in order to survive.[127] In 1904 Charles Shean, president of the National Society of Mural Painters, explained: "Our People, as a whole, are still absorbed in other matters, and a general appreciation of mural art remains to be developed, and an effective popular support remains to be secured."[128]

Toronto mural painting advocates also ignored the frequently expressed American support for private funding for such work. Indeed, many Americans believed that governments should not bear the entire responsibility. In 1894 American art critic Frank Fowler stated: "The general prevalence of large fortunes has given us the right to expect that a portion of this treasure will be expended by its owners after the manner of enlightened possessors of wealth in Europe, *viz.,* by calling on those whose taste and study have prepared them to beautify and embellish ... all those places where humanity meet to carry on the functions of a civilized society."[129]

In 1904 Shean expressed the same point of view when he wrote: "If mural art is to be a living force, [it] will receive efficient aid and guidance from the many active and public-spirited patriotic societies scattered throughout the Union."[130] Artist and art critic William Harris supported this opinion, claiming that "the blame [for a lack of civic mural decoration] cannot be fixed upon the politician, because the politician is but a creature of the popular votes and represents his constituents."[131] In response to this sentiment, private American citizens funded hundreds, if not thousands, of civic mural paintings. Municipal art societies also regularly funded mural paintings after obtaining various private donations. Undoubtedly the Canadians did not mention these examples, or the views that supported them, because they wanted to fault Canadian governments for the lack of civic mural paintings in Canada.

Toronto mural painting advocates also falsely reorganized the history of civic mural painting in the United States. In the 1890s, as Toronto mural advocates began to promote civic mural painting, they claimed that it had begun in this same decade in the United States, with murals at the Chicago World's Fair, the Boston Public Library, and the Library of Congress in Washington. They ignored American art historians of the turn of the century who clearly stated that civic mural painting began to be produced in the United States in the 1870s, with William Hunt's murals in the Assembly Chamber of the State Capitol building at Albany, New York (*in situ,* but in poor condition, and no longer visible above a false ceiling).[132]

The Toronto mural painting advocates probably ignored Hunt's work because of compositional and technical problems they did not want to high-

light. At least one American critic did not believe that Hunt's murals worked well with the space they decorated.[133] More important, Hunt had painted his images directly on the stone surface, rather than using the marouflage technique, because he believed that mural art should be "part of the architecture." Shortly after installation, the paint began to separate from the wall.

Between the time that Hunt's Albany mural was installed and the early 1890s, few American civic mural paintings were commissioned. In response, many American mural painting advocates published and lectured on the need for civic mural paintings. In 1889 one critic wrote: "A close survey of what has been done in American cities in the direction of municipal art readily reveals how little has been accomplished."[134] In 1904 another stated: "Throughout the land, public buildings stand bare and unadorned, their nakedness crying out for covering."[135] Yet in 1898 Toronto's George Reid argued that the American muralists had an ideal situation.[136]

Toronto mural painting advocates lavished most of their praise for American civic mural paintings on two specific programs: those done from the early 1890s to 1919 for the Boston Public Library, and those done in the mid-1890s for the Library of Congress in Washington. Much of what they had to say, however, contradicts facts. For example, although the Toronto critics claimed that the Boston murals were publicly funded, they were not: some of them were underwritten by elaborate private subscriptions. Moreover, the three largest commissions for the Boston Public Library were given to France's Puvis de Chavannes and to two American artists resident in England, Edwin Abbey and John Sargent, because there were almost no experienced muralists in the United States. Some Americans were not pleased with this arrangement; yet, even though Toronto artists had complained about the same practice in their own country, they never referred to these American critiques.

Subject matter was also a problem at the Boston Public Library. Puvis de Chavannes's decision to focus on classical personifications of knowledge caused some critics to view the work as outdated and lacking in specifically American content (*in situ*). John Sargent's history of religion for the hall leading to Special Collections (*in situ*) evoked displeasure and even vandalism among those who were unhappy to see a civic space used to extol any religion, including Christianity. Some Jewish Americans also regarded Sargent's Jewish panel as critical of Judaism. At one point a Senate bill was passed to have *Synagogue* removed, although it was later repealed.[137]

The style of the Boston mural paintings evoked further criticism, which the Toronto mural advocates also ignored. Some critics admonished Abbey

and Sargent for disregarding the many contemporary mural manuals that advised the elimination of detail for the sake of a clear reading. There was so much detail in their Boston Library mural paintings that, after the work was completed, explanatory guide sheets and books had to be produced for visitors.[138] Other American critics argued that Puvis de Chavannes's mural paintings did not work well in the space they occupied – in the four walls that surround the library's grand stairway – because he worked from models, without ever having seen the space. One Canadian critic from English Montreal mentioned this feature of these murals, but Toronto critics did not.[139]

Despite all these problems with the Boston murals, George Reid referred to them simply as "an example of the influence [of great European mural art] which has reached the new country."[140] For Toronto art critic Jean Grant, Sargent's Boston murals were "a delight" and "must make a pleasing display." Her use of the word "must" suggests that she had not seen work, but was eager to promote *any* civic mural.[141]

In 1895 American artists resident in the United States began to install a monumental program of over one hundred painted panels in the Library of Congress in Washington. Its theme is the evolution of knowledge, and the United States as the final inheritor of, and best contributor to, wisdom through the ages. The mural paintings are dominated by classical personifications, but of specifically American phenomena such as westward territorial expansion. They are painted in brilliant reds, yellows, and greens, in imitation of the colours of ancient Roman wall paintings. Unlike the mural paintings at the Boston Public Library, those at the Library of Congress were described by many Americans as easily readable and as blatantly and jubilantly nationalistic.

Still, the Library of Congress murals received some severe criticism, all of which Toronto mural painting advocates ignored in their monolithic positive view of the work.[142] While the Library of Congress murals were being installed, one American critic complained that "the true danger lies rather in the choice of artists ... who are not decorators by nature." This critic also offered a warning against what he perceived as "a gilt-gingerbread effect," "overloading," "the preference of anything to nothing," and "the aim at quantity rather than quality."[143]

Other Americans were critical of the classical subject matter of the Library of Congress mural paintings.[144] In 1901 Charles Shean wrote, in reference to the Library of Congress murals: "[Artists] must learn to make the walls of our public buildings splendid with pictured records of American

exploit and achievement, of American industry and commerce, of American life and cultures. On all sides there is a growing desire for monuments reflecting the commanding power and greatness of this Republic."[145] Concomitantly, other critics were praising mural paintings that focused on ordinary people and everyday activities. Selwyn Brinton stated that John White Alexander's mural paintings of 1905 for the Carnegie Institute in Pittsburgh (despite their inclusion of a medieval knight) were "mainly and intentionally realistic" because "the crowds of working men and women who fill the panels of the great stairway show the type of working people of America who throng her busy factories and streets."[146]

At the same time, many American mural painters continued to employ a classical mode for civic mural painting until well into the twentieth century because they believed that this mode provided the type of decorum that civic mural painting merited. This point of view was vigorously defended in many publications that were available in Canada. Nevertheless, Toronto mural painting advocates ignored this debate, even though Canadian murals underwent the same changes in subject matter at approximately the same time. Clearly the Toronto critics did not want to suggest to civic authorities in Canada that American civic mural paintings, any more than civic mural paintings in England and France, could be problematic.

CHAPTER THREE

Commercial Mural Paintings:
"The Glorification of Man's Handiwork"

The material progress of capitalism – which has been a dominant feature of modern nation-states from their inception in the early nineteenth century – created a need for new types of buildings in which services and products could be promoted and sold on a broad scale. These new commercial buildings, like the new civic buildings, required "signs" that clarified their functions and encouraged a positive reaction. Until the 1920s or 1930s (the date varied from country to country), the use of earlier architectural styles for new civic and commercial buildings provided one type of sign. For example, a Roman temple plan – or at least its façade – might be employed for a bank. In this way the activities that took place inside the new building appropriated the serious and respectable quality of the earlier building type. Because many people in the nineteenth century regarded these large-scale commercial enterprises as somewhat vulgar, architects and businessmen thought this type of appropriation was necessary.

Mural paintings in new commercial buildings also acted as a sign of respectable and well-established commercial success. The representation of a modern ocean liner on the wall of a bank, for example, could suggest that the bank had made successful investments in shipping. The representation of historic trading activities on the wall of a department store situated on or near the site on which the historic trading took place could provide the store with an honourable lineage and remove or alleviate any association with crassness. Commercial mural paintings could, by these means, encourage the viewer to spend or to invest.

Encouraging people to engage in a particular activity was not a new phenomenon. Before the modern period, however, entrepreneurs and investment

dealers had focused on small groups of people with whom they could com-
municate on a personal basis. Most ordinary people purchased what they
needed and not much else. In the modern nation-state, in contrast, the all-per-
vasive system of capitalism required, as Jean Baudrillard has argued, "the real-
ization of capital" – the conversion of the entire population into consumers of
enormous numbers of products and services by persuading them that they
needed these items even if they did not.[1]

This conversion required efficient forms of communication or marketing.
In response, reasonably inexpensive methods to reproduce images and text
were developed. At the same time, the modern nation-state's acceptance of
responsibility for public education led to a dramatic increase in literacy
rates. Marketers could, therefore, juxtapose images of products and services
with promotional text and reproduce the ensemble in newspapers, maga-
zines, posters, and billboards. As Roland Barthes has argued, this combina-
tion quickly became a powerful means of persuading viewers to become
consumers.[2] Some commercial mural paintings used this same ensemble.
However, because many mural paintings were located at some distance
from the viewer, the use of text was not always practical. In any case, mural
paintings had more subtle techniques at their disposal.

Mural paintings were usually larger than advertisements in newspapers,
journals, or posters and were visually more imposing. Although they were
not always larger than advertisements on billboards, all this advertising
came in multiple copies. A mural painting, in contrast, was a unique work
of art designed and installed by a professional artist who, in the modern
period, was regarded as insightful and respectable. In other words, mural
painting, though a decorative art, was also a fine art. As such, in the nine-
teenth and early twentieth centuries at least, mural painting belonged to high
culture. Other forms of advertising did not. At a time when the populations
of modern nation-states were faced with a confusing array of products and
services whose quantity, quality, and usefulness were not readily understood,
businessmen were anxious that their output should inspire confidence
among potential customers. Works of fine art that provided these products
and services with explanations and respectable histories, and were attached
to an impressive piece of architecture, fulfilled that role.

There were two basic types of commercial mural paintings. The first,
which I will call the business commercial mural painting, was commis-
sioned for banks, stores, stock exchanges, and head offices of companies.
Many of these murals, especially those produced before 1900, depicted site-
related activities in much older and venerable cultures such as ancient Rome,

Gothic Europe, or Renaissance Italy. They glorified distinct identity, in addition to material progress, as a salient feature of the modern nation-state. They also affirmed the respectability of the business by linking it to an esteemed time period in Western culture. Other business commercial mural paintings provided a visual history of a product or service from ancient times to the modern period in both Western and non-Western cultures. This type of mural painting suggested not only that the product or service of the modern period was superior but that the one within Western culture was superior to anything that might be found in non-Western culture.

Canadian mural painting advocates were familiar with some business commercial mural paintings in France, England, and the United States. It is impossible to know precisely which ones, since, in their efforts to promote civic mural paintings as the most important type of mural painting, the Canadians rarely mentioned foreign business commercial mural paintings. Nevertheless, a brief description of a few examples will provide some idea of what the Canadians had likely seen either on site or in reproduction and, therefore, what they may have used as models.

In 1875 Henry Lévy and Diogène Maillart painted *Industry and Commerce Converge to Prepare Beauty* on the ceiling of the reading room of the Galeries du Bon-Marché, a Paris department store (mural destroyed). The room was designed as a meeting place for customers and as a space in which husbands could wait while their wives shopped. In the mural painting, Mercury, the Roman god of commerce, delivered gold jewellry to Venus, the Roman goddess of beauty. Another figure offered Venus purple cloth, which had been associated with the aristocracy since at least Roman times. Vulcan, representing industry, fashioned a metal vase with a hammer. Presumably Industry and Commerce represented the waiting husbands, and Beauty the shopping wives.[3] It is likely that some of the many Canadian muralists who spent long periods of time in Paris made use of this room.[4]

In 1920 Ezra Winter and Barry Faulkner provided a monumental mural program for the offices of the Cunard shipping company in New York (*in situ*). It represents a history of Western shipping, with a focus on the boats in which Leif Ericsson, Christopher Columbus, and Sir Francis Drake travelled to North America. These boats are arranged within a painted architectural structure derived from the mural painting of ancient Rome, another Western culture noted for its commercial sea traffic. Some Canadian muralists may well have seen this mural. Arthur Crisp, a Canadian muralist based in New York, likely considered the Cunard murals before he painted his history of shipping for the Bank of Commerce in Toronto in 1930 (fig. 20 and

plate 5). Toronto muralist George Reid may also have considered it before he painted his history of travel from Europe to the New World as part of his mural program for Toronto's Jarvis Collegiate (fig. 12). Canadians who did not see this mural could have looked at detailed descriptions and photographs of it and of other boat murals in publications available in Canada.[5]

Around 1900, the subject matter of business commercial mural paintings shifted, as did that of mural paintings in other types of buildings, from site-related activities set in much earlier and revered time periods of Western culture to site-related activities set in the recent past or even the contemporary period. This subject matter was selected to draw a closer relationship among the viewer, the site, and the product or service offered by the site. In other words, marketing techniques were being refined. A good example of this type of mural painting was done for London's Royal Exchange between 1890 and 1933. Toronto muralists J.E.H. MacDonald and Arthur Lismer, and some of the many other Canadian muralists who spent long periods of time in London, almost certainly saw it.[6]

The Royal Exchange program consists of thirty-two painted panels set in niches in a central roofed courtyard of a building modelled after the ancient Roman Pantheon (all panels *in situ,* but difficult to see as a result of new construction).[7] Both the site and the decoration aligned the Exchange with the famed artistic and commercial culture of the ancient Romans. The program provides a history of trade and commerce in the London area, moving from early scenes such as Lord Leighton's *Phoenicians Trading with the Early Britons on the Coast of Cornwall* of 1895 to Lucy Kemp-Welch's *Women's Work in the Great War, 1914–1918.* Various businesses and professional associations paid for the panels, and there was some attempt to link subject matter to donor. The Sun Fire Insurance Company, for example, paid for Stanhope Forbes's panel of 1899, *Great Fire of London, 1666.*

The second type of commercial mural painting, which I will call the social commercial mural painting, was installed in public buildings in which social activities took place on a lavish scale, such as theatres, hotels, restaurants, spas, and casinos. It generally functioned in the same way as the business commercial mural painting, but had some features all its own. Before the nineteenth century, buildings designed to accommodate such social activities were either private or the property of the aristocracy. The new public sites flattered the viewers – the middle classes – by acclaiming them as the aristocracy of modern life (which, in fact, they were).

The subject matter of the social commercial mural painting provided even more support for this acclamation. Like the mural paintings in business

sites, some of the murals in social sites represented activities set in the venerable time periods of ancient Rome, medieval Europe, and Renaissance Italy. They equated the viewers with the aristocratic, heroic, and even divine figures within the murals who were also watching theatrical performances, dining, or dancing. Other commercial mural paintings in social sites, represented recent historical or contemporary site-related activities. In mural painting format, these activities were aggrandized in both a literal and a figurative sense, and viewers were encouraged to eat, drink, or spend more. The social commercial mural painting, like the business commercial mural painting, acted as a marketing tool to turn the viewer into a consumer. They promoted material progress, one of the features of the modern nation-state that the Mural Movement functioned to support.

At the same time the social commercial mural painting provided a temporary sanctuary from the negative features of the material progress of modern life, such as urban overcrowding, disease, poverty, crime, and technology's disfigurement of the landscape. As American mural advocate Charles Caffin stated in 1913, mural paintings were necessary because "everywhere, indeed, material progress is scarred with the blight of Ugliness."[8] The mural paintings provided a reprieve from "ugliness." This reprieve encouraged viewers to spend without condemning the sources of the negative features of material progress, since the same sources also provided the positive features of modern life. So, in this way, too, commercial mural paintings supported material progress.

From the 1870s many French buildings, which some Canadian muralists must have visited, employed particularly elaborate mural paintings of the social commercial type. For example, at the turn of the century more than twenty-five artists covered the walls and ceilings of the buffet of the Gare de Lyon in Paris with paintings framed with garish, baroque-style, gilded stucco frames. The paintings are copies of tourist posters that represented places on the Paris-Lyon-Marseilles train route, as well as travellers engaged in seemingly joyful activities in these places. The travellers are joined by mythological Roman figures such as Flora, Mercury, and female personifications of prosperity.[9] This rich presentation is complemented by heavy purple wall hangings, lace curtains, bronze lamps, and Second Empire style furniture (all *in situ*).

Clearly, this type of decoration was designed to encourage spending and to promote material progress. At the same time, as Nancy Troy has explained, the elaborate nature of French interior decoration of this period also glorified distinct cultural identity, another feature of the modern nation-

state. In the face of their 1871 defeat by the Germans in the Franco-Prussian War, she argues, the French were anxious to exhibit what they believed to be distinct and superior aspects of their culture.[10] Since the decorative arts had always been a particularly important part of their culture, they reinforced efforts in this field.

Thousands of social commercial mural paintings that focused on the abundance of the classical world – and thus on the right of the middle classes to pursue and to enjoy this abundance – were installed throughout France and other Western countries from the mid-nineteenth to the early twentieth century. They were not all as elaborate as those in the Gare de Lyon. In 1902 a number of muralists decorated the walls of the restaurant in the Royal Academy in London. In one panel, *Spring Drawing Away Winter,* by Frederick Appleyard, Flora is in the centre. At her side is a personified male wind who blows away a personification of winter. This panel and its companions reassured viewers that not just looking at art in a gallery, but also eating in an art gallery, provided a link to culture.

In 1930 Frank Brangwyn painted a mural with similar subject matter, the gifts of Mother Earth, for the dining room of the passenger ship *Empress of Britain* (destroyed). It confirmed for the viewers, who had earned the money to sail on this ship – whose very title provided a link to aristocracy – that they had the right to enjoy the lavish food that the dining room served and the mural paintings depicted. The many Canadian muralists who travelled to England by ship likely saw Appleyard's and Brangwyn's work. If not, they saw similar murals.

This classical type of social commercial mural was particularly popular at the turn of the century in New York, America's largest and most commercial city. It was also a city with which some Canadian muralists and mural advocates, especially those in Montreal and Toronto, were familiar. In 1898, for example, Edward Crowninshield painted the Italian Campagna and the Alban Mountains around Rome for the café of New York's Hotel Manhattan (destroyed).[11] In 1907 Everett Shinn painted eighteen panels devoted to classical dramatic themes for Belasco's Stuyvesant Theater (*in situ*).[12] In 1911 Thomas Dewing painted the ceiling of the ballroom of the Hotel Imperial with personifications of *Night, Day* and *Dawn,* in a style that was compared to Tiepolo's paintings for European palaces (now in the National Museum of American Art, Washington, DC).[13]

These murals clearly glorified both the material progress of capitalism and distinct cultural identity. In a more covert fashion they also glorified patriarchy, another characteristic of the modern nation-state from its inception in

the 1830s until well into the twentieth century. Two painted panels that were installed in the Women's Building at the World's Columbian Exposition of 1893 in Chicago – which was attended by many Canadians, including Toronto muralist George Reid – provide a good example. At one end of the building Mary MacMonnies painted *Women of Arcadia,* in which women in the imaginary Greco-Roman world of Arcadia hauled water and tended to children and a returning hunter (present location unknown, probably destroyed). At the other end of the building Mary Cassatt painted *Modern Women,* in which nineteenth-century American women picked apples in an orchard.[14]

Given the location of this mural painting, a fair ground, and the fact that fairs of the modern period were designed primarily to document material progress as expressions of national pride, it is reasonable to argue that the artists and the patrons of these panels intended them to demonstrate women's roles in material progress. At the same time, as Keith Walden has argued, women played an important role at fairs, often outnumbering the men in attendance. They were also more mobile at fairs than they were in many other public sites, free to see and to be seen. Women as well as men criticized this aspect of fairs. Cassatt's and MacMonnies's mural paintings were no doubt intended to support women's traditional place within the modern nation-state.[15] The activities within the two murals support this interpretation. Cassatt's panel depicted women picking apples and so conjures up comparisons with Eve, who, by eating an apple, brought labour, mortality, and evil into the world. Furthermore, Cassatt's work aligned woman with nature and reiterated the age-old exclusion of women from culture. MacMonnies's work provided the "honourable" history for the reaffirmation of patriarchy in Cassatt's.[16]

From the 1860s to the 1930s, hundreds of business and social commercial mural paintings were produced in Canada within the tenets of the Mural Movement. Until around 1900, commercial mural paintings in Canada, like civic mural paintings, imitated French, English, and American mural paintings. They therefore frequently employed classical themes. After this time, some Canadian commercial murals represented local history, just as contemporary foreign commercial murals did. Other Canadian commercial murals represented landscape, and, not unreasonably, since land was the source of Canada's major commercial exports, fish, grain, timber, minerals, and hydroelectric power.

Compared with the commercial mural painting done by professional muralists in other parts of Canada, very little was done in the Maritimes.

FIG. 14 Arthur Lismer and Harold Rosenberg, mural paintings, 1916–18, restaurant in Bedford or Halifax

These provinces did not have the economic and cultural base to support monumental professional mural painting (see chapter 2). Still, many small-scale commercial mural paintings were done by untrained artists. Charles Mackenzie, for example, painted the proscenium arch of the Opera House in Pictou, Nova Scotia, in 1915 with floral motifs and a coat of arms (in storage in original building in 1986).[17]

Other commercial mural paintings in the Maritimes were done by professional artists who were commissioned to come to the region for specific work. Quebec muralist Ozias Leduc decorated the Halifax Banking Company in Antigonish between 1902 and 1903 (subject matter unknown, probably destroyed) while he was there primarily to complete a monumental program of mural painting for the town's St Ninian's Catholic Church (in situ).[18] Between 1916 and 1919 Harold Rosenberg, who taught at the Victoria School of Art and Design in Halifax (now the Nova Scotia College of Art and Design), and Arthur Lismer, who during this time served as principal of the school, painted landscape murals for a local restaurant or restaurants (detail, fig. 14).[19]

In 1930, Emmanuel Briffa, a Malta-born Montreal artist, provided a monumental mural program composed of eight large panels for the Capitol Theatre in Halifax. They were copies of Canadian historical paintings: Charles Jefferys's *Founding of Halifax* (plate 4) and *Order of Good Cheer,* William Eagar's *Halifax Tandem Club,* John Theophilus's *Shannon and Chesapeake,* R. Paton's *Siege of Louisburg,* and, by unknown artists, *Wolfe Landing at Louisburg, Royalists Arriving at Shelburne,* and *The Landing of the Loyalists.*[20] This approach to the decoration of the Capitol was chosen by a

FIG. 15 Guido Nincheri, mural paintings, 1920, Belmont Theatre, Montreal

committee composed of employees of Famous Players Theatres and local Halifax businessmen.

In terms of their size, Briffa's murals are unusual for the Maritimes. They are also unusual in terms of theatrical decoration since they represent local historical events set in prominent landscape settings. Other theatres occasionally commissioned landscape mural paintings; for example, unknown artists painted landscape murals for Vancouver's Columbia Theatre in the 1920s (destroyed) and for Toronto's Hollywood Theatre in 1930.[21] Overall, however, few theatre mural paintings used local landscapes, while fewer still employed local history. Indeed, until well into the twentieth century, theatre mural paintings depicted subject matter that conjured up imaginary worlds. Classical images were popular, but others, such as ancient Egypt were also found. The mural paintings done for the Belmont Theatre in Montreal in 1920 by Italian immigrant muralist Guido Nincheri are a good example of this fanciful approach to mural decoration (fig. 15) as are the mural paintings in the Grand Theatre in London, Ontario, of 1901 (*in situ*). Those installed in the Royal Victoria Theatre in Victoria, British Columbia, in 1913 (destroyed), the Empire Theatre in Edmonton in 1920 (destroyed), and the Capital Theatre of 1929 in Saskatoon (destroyed) demonstrate the ubiquity of this type of mural decoration.[22]

Monumental commercial murals painted by professional artists were as scarce in French Quebec as they were in the Maritimes, but for a different

reason. The Catholic Church regularly cautioned French Canadians about material progress, and public entertainment, and their dangerous links to secularization and English Canada. Both, it preached, could easily destroy French Canadian culture. In English Quebec, in contrast, many commercial mural paintings were commissioned. The earliest ones, like the earliest civic mural paintings, were painted by foreign or itinerant artists. For example, in 1877–78 Peter H. Almini, an Italian immigrant from Chicago, painted the ceilings and walls of several of the public rooms in the Windsor Hotel in Montreal with *trompe l'oeil* architectural decoration, naturalistic flowers and cupids, and geometric designs. The designs resemble samples in Owen Jones's *Grammar of Ornament,* published just a few years earlier in England, and demonstrate the eagerness of the muralist or the patron to work with the latest fashion. In the dining room / ballroom of the Windsor Hotel, Almini also painted a series of landscapes along the coving of the ceiling. It is no coincidence, given their relatively early date within Canada's participation in the Mural Movement, that they represent European sites (fig. 16).[23]

Commercial mural paintings done after 1900 in English Quebec demonstrate the change from classical or fanciful images based on foreign models

FIG. 16 Peter Almini, mural paintings, 1877–78, dining room, Windsor Hotel, Montreal

FIG. 17 Hal Ross Perrigard, *Mount Sir Donald Glacier, B.C.,* 1924, Ladies' Waiting Room, Windsor Station, Montreal

to contemporary and local images with an emphasis on landscape. For example, Hal Perrigard painted *Mount Sir Donald, Glacier, B.C.* of 1924 for the ladies' waiting room of Montreal's Windsor Street Railway Station (fig. 17).[24] It depicts a man dressed in nineteenth-century clothing on a horse travelling through the Rocky Mountain region of Canada. Viewers were encouraged to imitate this man's exciting activity by, first of all, purchasing a train ticket to western Canada.

Mural paintings done for passenger boats that operated between Ontario and Quebec demonstrate the same shift of subject matter. In 1901 Frederick Challener painted classical sea nymphs in a lunette for the saloon of the ss *Kingston,* a passenger boat that belonged to the Richelieu & Ontario Navigation Company (fig. 18).[25] In 1926 Cory Kilvert painted a "landscape map" mural (destroyed) for the main staircase of the saloon of the ss *Northern,* a passenger boat that belonged to the Clarke Steamship Company. It provided a bird's-eye view of Hochelaga (Montreal), with "all the important discoveries and events in that part of the New World from the time of Eric the Red to the Siege of Louisburg" – that is, from the tenth to the eigh-

teenth century. By going no further than the British Conquest, Kilvert, as civic muralists in Quebec, avoided the question of whose history to represent. The map also placed local flora, fauna, and Native people on the surface, in imitation of the earliest European maps of North America.[26]

In 1928 Charles Jefferys, assisted by Frederick Challener, painted two large panels, *French Explorers at Malbaie, 1660,* and *Clan Fraser Lands at Murray Bay, 1760* (figs. 46 and 47) for the archway of the dining room at Manoir Richelieu at Murray Bay (Malbaie) in Quebec, a resort that catered to Americans and English Canadians. The figures in the mural carry out land settlement in prominent landscape settings.[27] They also demonstrate the change from Native territory to French territory and from French to British (see chapter 7). Adam Sherriff Scott's work of 1930 for the Grill Room and the gallery of the dining room in Lucerne-in-Quebec (now the Château Montebello), also a resort with a largely English Canadian and American clientele, provides the same basic history (*in situ* with some rearrangements).[28]

Many commercial sites in Ontario were decorated with mural painting from the 1860s to the 1930s. Toronto, which was a large manufacturing and finance centre as well as a city with a relatively active social life, received the

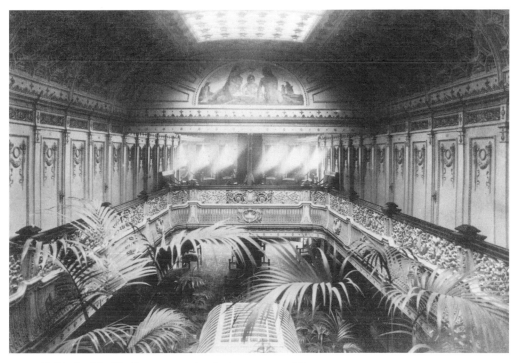

FIG. 18 Frederick Challener, mural painting, 1901, ss *Kingston*

FIG. 19 Frederick Challener, *The Triumph of Drama*, 1897, Russell Theatre, Ottawa

most. Before 1900 these mural paintings were usually classical in tone. For example, in 1897 Frederick Challener installed *The Triumph of Drama* in the Russell Theatre (or Russell Opera House) in Ottawa (fig. 19, detail). The three panels depict personifications of painting, music, dramatic literature, poetry, electrical science, fame, love, and hate, all seated on clouds and paying homage to drama. In 1907 Challener painted the proscenium arch of Toronto's Royal Alexandra Theatre with a meeting of Venus and Adonis and various attendants (*in situ*).[29]

After this time, Toronto muralists with commercial commissions rejected the classical in favour of local and contemporary history and landscape. In 1928, for example, Challener installed *The French at Fort Rouillé* in the Toronto offices of Loblaws, a major grocery store chain (fig. 48). This mural represents trade between eighteenth-century Natives and French Canadians. It links the nobility of the fort, which the fort's age alone conferred, with the contemporary trading company of Loblaws. The owners of Loblaws would have appreciated this connection, as they were anxious to eliminate any elements of crassness associated with their business (see chapter 7).

Murals that extolled material progress were ubiquitous in Canada – and throughout Western culture – from the 1860s to the 1930s. They appeared not only in paint but in many other media too. In 1929 James MacDonald and his son Thoreau were hired to decorate the Concourse Building in Toronto, a site that was rented by various businesses.[30] Their work glorifies the material progress provided by both Canadian manufacturing and Canadian agriculture. On the exterior over the main doorway, MacDonald placed a stone mosaic mural that represents symbols of the four elements (air, earth, fire, and water), Canadian fauna, and emblems of various industries

associated with the four elements: a steam shovel, a plough, a wheat sheaf, an airplane, and electric power. In the lobby are stone inlays that represent Canadian deer against a reddish-grey ground, an arrangement that evokes the idea of Arcadia. The deer are accompanied by engraved quotations from three Canadian poems, two of which refer specifically to Canada as a lush Arcadia. On the upper levels of the exterior walls are Canadian Native thunderbirds. At this time many English Canadians appropriated images from Native culture that appeared particularly powerful, despite the fact that they devalued most other aspects of Native culture. It is reasonable to assume, therefore, that MacDonald was invoking the power of the thunderbird to support the businesses in the Concourse Building.

In 1929 Frederick Haines and several of his Ontario College of Art students painted *The Settlement of Canada* in eight panels for the Dominion Government Building at Toronto's Canadian National Exhibition (figs. 49 and 50). It represents the conquest, exploration, and agricultural settlement of land in Canada. Since this mural was commissioned for a federal government building, it is officially a civic work of art, not a commercial one. However, the Canadian National Exhibition was, like all fairs and exhibitions of the modern period, organized for businessmen and farmers to advertise their products and to extol material progress. Both the federal and the provincial governments established their presence at the exhibition to demonstrate the support they had given, and were still giving, to private forms of material progress. Haines's mural was designed to refer specifically to the support that Canada's federal government had given to Canadian farmers.

At the same time, Haines's mural glorified patriarchy as a dominant feature of the modern nation-state. In one panel (fig. 50) a man and his son plough a field. The man's wife stands with her daughter and baby outside the arena of male activity – that at first glance appears to be the only subject of the panel – on ground that is covered in a distinctly unnatural arrangement of apples and pumpkins. The wife is connected to both nurture and nature. The apples also connect her to Eve, who, according to Christian tradition, ate an apple in defiance of God's command and so brought pain and death into the world. In other words, the female figures are set on the sidelines of material progress, and for good reason.

Between 1930 and 1931 Charles Jefferys, assisted by Frederick Haines and Herbert S. Palmer, painted four panels for the writing room of the Château Laurier, the Canadian Pacific Railway hotel in Ottawa (figs. 44 and 45, two other panels destroyed).[31] They depict Native religious ceremonies carried

out in connection with the Ottawa River and the English military's construction of the Rideau Canal. They suggest that Western technology is superior to that of the Native people.

In 1930 the Toronto architectural firm of Pearson and Darling hired Arthur Crisp to paint eighteen mural panels on the history of transportation for the Foreign Exchange Office of the Bank of Commerce in Toronto.[32] They provide the same glorification of material progress and cultural imperialism as Jefferys's Château Laurier mural paintings. Crisp's program begins with early forms of transport, such as *Man and Beast Transport, Primitive Skin Rafts,* and *Freight and Travel by Canoe* (plate 5). The final panel represents a contemporary English ship and is entitled *The Empress of Britain: The Last Word in Ocean Travel* (fig. 20).[33] These mural paintings glorified the superiority not only of modern transportation but also of Western transportation.

Commercial mural paintings in the Prairie provinces followed the same pattern as those in other parts of Canada. They began with classical themes and moved to images of local Canadian history and landscape. Without an established art school, muralists at first had to be imported from Toronto and English Montreal. For example, in 1906 Montreal artist Henri Beau painted a mural of a vineyard for the café of the Royal Alexandra Hotel in Winnipeg (destroyed).[34] It likely provided a Dionysiac/Bacchic scene. Sometime between 1906 and 1910 Toronto artist Frederick Challener provided eight mural panels for the dining room of the same hotel. As subject matter, he chose various events from the history of Manitoba's Native people. The four extant panels are *Buffalo Hunt, Upper Fort Garry* (fig. 39), *The Government of the Indian Tribes,* and *Indian Camp.* In these four panels small figures of Native people are set within monumental landscapes.[35]

Another large-scale commercial mural was installed in Winnipeg in 1927 by Toronto-based artist Adam Sherriff Scott. It was composed of two panels: *Building of Fort Charles* (in storage in Manitoba Provincial Archives) and *The "Pioneer" at Fort Garry in 1861* (fig. 21). These panels were placed over the elevators on the first floor of the Portage Avenue branch of the Hudson's Bay Company's store in Winnipeg. The panels represent early trading posts in Winnipeg, of which the modern Hudson's Bay store was clearly a descendant.

Commercial mural paintings in British Columbia have the same basic history. For example, in 1905 the Royal Bank of Canada commissioned James Blomfield to paint murals for its local head office at Hastings and Granville streets in Vancouver. One panel, *Vancouver Triumphs,* represented a classical, enthroned, female personification of the city of Vancouver, flanked by stand-

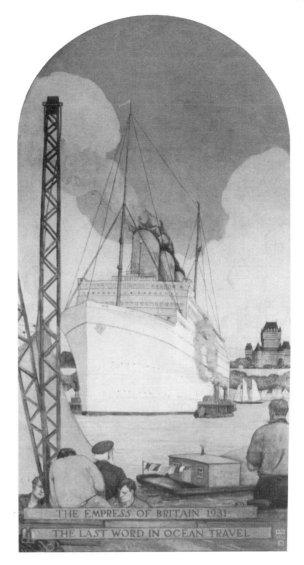

FIG. 20 Arthur Crisp, *The Empress of Britain: The Last Word in Ocean Travel*, 1930, Canadian Bank of Commerce, Toronto

ing figures representing industry and agriculture. The second panel, *Acadia,* represented a classical personification of the Maritime provinces, where the Royal Bank was founded (present location of both panels is unknown, probably destroyed).[36]

After 1900, commercial mural paintings in British Columbia moved from the classical type of image in Blomfield's work to local history and landscape. Between 1902 and 1905 an unidentified artist painted elaborate local landscape mural paintings for the reading room of the Empress Hotel in Victoria, British Columbia (destroyed).[37] In 1916 Vancouver artist Adelaide

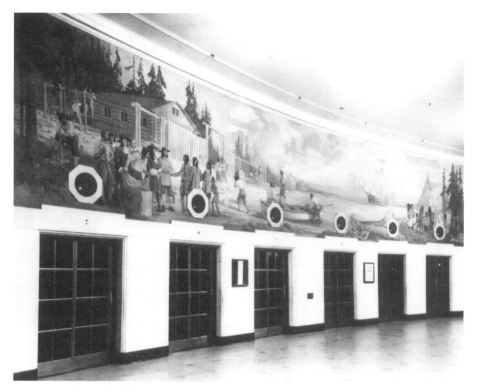

FIG. 21 Adam Sheriff Scott, *The "Pioneer" at Fort Garry*, 1927, Hudson's Bay Company department store, Winnipeg

Langford provided sixteen panels of local landscapes for the Canadian Pacific Railway's passenger terminal (now Waterfront Station, *in situ*).[38] In 1925 the *Vancouver Province* newspaper hired local artist John Girvan to paint seven panels of local history in the lobby of its main building (two panels lost, five panels in the Vancouver Show Mart building). The five remaining panels depict panoramas of the harbour in which activities related to early settlement and commercial activity take place.[39] In 1927 John Innes (assisted by George Southwell) painted ten panels for the Vancouver department store of David Spencer (some panels destroyed, some panels in storage in the Art Gallery of the University of British Columbia).[40] They represent logging, mining, fishing, and agriculture. One panel includes an image of Simon Fraser on the Fraser River.

A commercial mural that English artist Frank Brangwyn painted for a Canadian company in England makes a similar statement. In 1909 Canada's Grand Trunk Railway commissioned Brangwyn to paint *The Introduction of European Civilisaton into the Country of the Red Indian* for its office in

Trafalgar Square in London (mural now in the Canadian Government Conference Centre, Ottawa). As in many mural paintings that Canadian artists did for commercial (and other) sites, Native Canadians meet first the prospectors and then the surveyors of the railway. They stand in awe of Western technology, then disappear. A contemporary critic referred to the subject matter of Brangwyn's mural as "the glorification in the victory of man's handiwork," a description that could well be applied to all the commercial work of the Mural Movement in Canada and elsewhere.[41]

Protestant Church Mural Paintings: "Bringing Back the Soul of the Town"

In the first half of the nineteenth century Christians began to revive medieval and Renaissance styles of church architecture and interior decoration – including lavish mural painting – as a means of recreating the intensely spiritual environments they believed had belonged to these earlier churches. These environments, Christians argued, would counteract the attacks that various aspects of modern life were making on Christian authority. Scientific discoveries were refuting the claims of the Bible. The technology of material progress was providing people with physical comforts that led them to rely less on the spiritual comforts of religion. The squalor and disease of modern urban life was discouraging the poor from attending church. At the same time many other religions, especially those of Asian origin, were becoming increasingly accessible and popular as more people travelled. As the literacy rate rose, those who could not travel could still read about these religions in a variety of inexpensive publications that appeared in all Western countries. Finally, non-institutionalized spiritual practices, even such simple ones as ouiji boards, were encouraging people to develop personal spiritual practices.

The reintroduction of lavish mural painting to counteract these attacks within the Catholic Church is not surprising, given that Catholics had employed this type of decoration from the early Christian period to the early eighteenth century (with a hiatus of approximately a century during which starker neo-classical styles of interior decoration were dominant). Protestants denominations, in contrast, had eschewed lavish church decoration since their establishment in the sixteenth century. However, because many Protestants believed that contemporary criticism of Christian authority might cause irreparable damage, they too turned to lavish forms of interior decoration, including mural painting, in the 1840s.

Protestant mural paintings glorified Christianity as a salient feature of Western culture's modern nation-states. These mural paintings also supported material progress, another characteristic of the nation-state, though in a convoluted way. They provided a psychological haven from the negative aspects of material progress, without hindering the development of any of its positive features, just as mural paintings in commercial sites designed for social activities did (see chapter 3). At the same time, mural paintings in Protestant churches gave wealthy parishioners, whose fortunes had been made as a result of the material progress of the modern age, the opportunity to fund such decoration. These parishioners were able to contribute to the spiritual lives of others while assuaging their own souls, which, many of them feared, had been tainted by material progress.

Church mural paintings first appeared in Protestant churches in the 1840s in association with the Anglo-Catholic movement in England. William Dyce's frescoes for All Saints' Church, Margaret Street, London, done between 1853 and 1859 (*in situ*) were undoubtedly seen by the many Canadian artists who travelled to England in the late nineteenth and early twentieth centuries. Support for this type of decoration quickly spread to other Protestant denominations and to other countries. The mural paintings begun in 1852 for Bowdoin College Chapel in Brunswick, Maine (*in situ*), provide an early American example.[1] A better-known American example, and one many Canadian muralists saw, is John La Farge's mural program of the late 1870s for Boston's Holy Trinity (Episcopalian) Church (*in situ*).

From the 1860s on, many Protestant churches in Canada were decorated with mural painting. Some of these murals employed only stencilled patterning of non-figural or simple figural motifs. Possibly they were commissioned by congregations that were still not completely comfortable with Catholic figural representations. In 1867 the firm of Gundry & Langley painted the ceiling of Holy Trinity Anglican Church in Toronto blue, with gold stars (destroyed), just as muralists had done for the Bowdoin, Maine, Chapel in the 1850s (and as muralists had done in the Early Christian period).[2] Presumably the combination was intended to represent heaven. In the 1870s a Mr Page decorated St John's Anglican Church in Lunenberg, Nova Scotia. He also painted the ceiling blue, with gold stars, and the walls a lighter blue with gold lilies, a flower symbolic of the Virgin Mary. Behind the altar and flanking the stained-glass windows he painted scrolls with biblical texts. At approximately the same time an unknown artist provided a non-figural stencilled frieze on the four walls of the Baptist Church in Falmouth, Nova Scotia (*in situ*), even though most Baptist churches did not participate in this revival of mural painting.[3] In 1914 W.E.N. Hunter constructed the First Methodist Church in Hamilton,

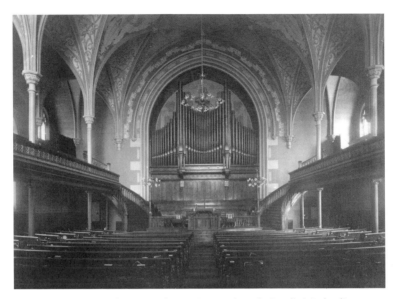

FIG. 22 Gustav Hahn, mural paintings, 1890, St Paul's Methodist
Church, Toronto

Ontario, and arranged to have it lavishly decorated with gold stencilled floral
motifs against a sage-green background (destroyed).[4]

During the same period many Canadian muralists provided figural mural
paintings for Protestant churches. In the early 1870s an unknown artist dec-
orated Toronto's Metropolitan Methodist Church with angels against stylized
foliage.[5] In 1890 Gustav Hahn provided similar decoration for St Paul's
Methodist Church, Avenue Road, in Toronto (fig. 22). In the late 1890s
George Reid painted trumpeting angels for All Souls' Church in Onteora,
New York, where he spent many summers.[6] In 1898 the well-known
Maritime portrait painter, Robert Harris, provided figural mural paintings for
All Souls' Chapel at St Peter's Anglican Cathedral in Charlottetown, Prince
Edward Island. Some of these paintings illustrate Christian narratives; oth-
ers act as memorials to Harris family members (detail, fig. 23).[7]

Protestant churches continued to be decorated with figural mural paint-
ings as late as the 1930s. For example, in 1934 Edward Hughes, Orville
Fisher, and Paul Goranson painted six large figural panels of Christian nar-
rative for the First United Church in Vancouver (destroyed).[8] In 1936 the
Browne family of church decorators painted murals for the neo-Gothic St
Jude's Anglican Church in Brantford, Ontario.[9] These murals include elab-
orate biblical narratives as well as decorative motifs of intertwining vine
scroll that refer to the Christian Eucharist (*in situ*). Vine scroll, adopted from

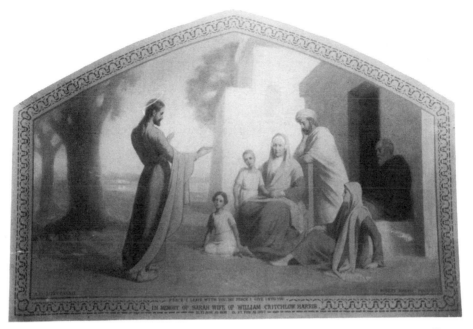

FIG. 23 Robert Harris, *Peace I Leave unto You, My Peace I Give unto You,* 1898, All Souls' Chapel, St Peter's Anglican Cathedral, Charlottetown

medieval art, became an important feature of art produced within the tenets of Western culture's Arts and Crafts Movement. This movement, which began in the mid-nineteenth century, promoted handcrafted art – including mural painting – in opposition to the perceived poor quality of machine-made art. Like contemporary church mural painting, it was a response to the negative features of modern life, without condemning the positive features.[10]

In general terms, there is little more to say about Protestant church mural decoration in Canada during the 1860s to 1930s. However, each Protestant mural commission has a history that almost certainly includes some congregational resistance. A detailed investigation of one commission should provide a clear idea not only of its own complexities but of others of its type. To demonstrate these complexities, this chapter will focus on the mural program at St Anne's Anglican Church in Toronto.

In 1923 the Reverend Lawrence Skey hired J.E.H. MacDonald to lead a team of artists to decorate the parish's new Byzantine-style structure, St Anne's. He directed the artists to represent the divinity of Christ.[11] In response, they covered the curved vault of the apse with an elaborate gold vine scroll on a blue ground (fig. 24). As at St Jude's, the vine scroll symbolizes the Eucharist, but it also draws the mural painting into the Arts and Crafts Movement with which

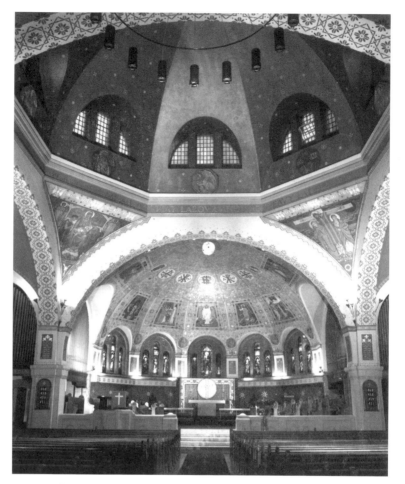

FIG. 24 J.E.H. MacDonald et al., mural paintings, 1923, St Anne's Anglican Church, Toronto

MacDonald associated himself. In a more particular sense it is reminiscent of the apse vault of the early Christian/Byzantine Church of San Vitale in Ravenna.[12]

Within the vine scroll, the St Anne artists placed seven medallions with symbols that appear frequently in Early Christian/Byzantine art. Below the medallions they provided seven icon-like panels with narrative scenes that commonly formed the core of Byzantine church decoration.[13] The central panel represents the Transfiguration, which suggests it is based on two Byzantine mosaics of the same subject that are similarly located in apses at Sant'Apollinare Nuovo in Ravenna and at St Catherine's Church on Mount Sinai.[14]

On the pendentives of the dome, set apart as they are in traditional Byzantine decoration, the artists represented the most important events in

Christ's life – the Nativity, the Crucifixion, the Resurrection, and the Ascension (plate 6). These scenes have borders of floral patterns that may also be linked to patterns associated with the Arts and Crafts Movement. The dome, now gold with white stencilled stars, was originally painted red and decorated with Christian motifs. At its base, four painted medallions with heads of the Old Testament prophets – Moses, Isaiah, Jeremiah, and Daniel – alternate with sculpted heads of the Four Evangelists. The use of medallion busts for biblical figures was commonplace in Byzantine church decoration, as were portraits of the Evangelists in front of the apse and typological arrangements of Old and New Testament figures.

By the time this interior decoration was completed, in December 1923, no other Protestant church in Canada had been so lavishly embellished with figural images. Yet, in the 1920s, Toronto was a typical provincial city and the parish of St Anne's was working class. As MacDonald stated, it was composed "mostly of Orangemen" with "a restricted idea of colour or display."[15] At the time of its installation, many journalists and newspaper art critics commented, sometimes negatively, on the unique nature of the interior decoration. Augustus Bridle, art critic for the *Toronto Star,* stated that St Anne's had "the most unconventional Anglican interior."[16] Roy Greenaway, art critic for the *Toronto Star Weekly,* referred to the complex as "Lawrence Skey's Byzantine [*sic*] Defiance."[17]

Most subsequent discussions of St Anne's mural paintings have followed the approach of Bridle and Greenaway: the critics have focused on the paintings and have expressed surprise at the use of Byzantine models. At the same time, critics have tried to account for the appearance of this lavish work in such a conservative context. None has been able to do so. In 1980 John Bentley Mays, art critic for the *Globe and Mail,* could say no more than that the mural paintings were "fabulously beautiful."[18]

This inability to account for the unique nature of St Anne's interior decoration is not surprising, given that critics have always focused on the mural paintings to the exclusion of the setting as a whole. Undoubtedly they took this approach because three of the muralists – Frank Carmichael, J.E.H. MacDonald, and Frederick Varley – were well known as landscape artists of the Group of Seven. However, this approach does not make sense, since the mural paintings were simply the final stage of a neo-Byzantine ecclesiastical ensemble that began with the choice of a Byzantine architectural style. It is, therefore, the unique choice of the Byzantine architecture for an Anglican church in early twentieth-century Toronto that first requires an explanation.

In 1907 the Reverend Lawrence Skey and other members of the building committee of St Anne's elected to replace their overcrowded Gothic Revival

building with a neo-Byzantine structure.[19] The design, by local architect William Ford Howland, included a centralized plan in the shape of a Greek cross, a plain brick exterior, a central dome 60 feet high resting on pendentives, and a raised chancel set in a semi-domed apse in the west arm of the cross. This first church in Canada to adopt the distinct features of Byzantine architecture was erected in Toronto in 1908.[20] It was immediately regarded as unusual. A fearful Anglican bishop even suggested that the Byzantine style might cause passersby to mistake it for a synagogue or a mosque.[21]

Details of the design competition that the St Anne's building committee held, and that might account more clearly for the choice of the Byzantine style, are not extant. Nor are there any records of the negotiations between the architect and the building committee. In 1988 Catherine Mastin made the first scholarly investigation into the choice of St Anne's Byzantine style, albeit as part of a larger study that focused on determining the iconographical models for the mural paintings. She concluded that the Byzantine style was the personal choice of Lawrence Skey. The minister strongly supported union with other Protestant churches as a means of strengthening Christian belief in an increasingly secular world. Since the Byzantine style was developed between the fourth and sixth centuries, before the church had divided into sects, Mastin concluded that Skey chose Byzantine architecture as a symbol of union. Skey would have been particularly sensitive to this symbolism, she said, because he had travelled to Constantinople shortly before St Anne's design was selected.

Mastin also stated that Skey could not have selected the Byzantine style through a desire to imitate other recently constructed neo-Byzantine churches, for there were too few to have attracted his attention. Similarly, he could not have been influenced by contemporary publications on Byzantine architecture because strong interest in this field appeared only after 1907. Finally, Mastin doubted that Howland could have suggested a Byzantine design, for, at the time of the commission, his professional experience was limited.

Church records clearly indicate, however, that Skey never went to Constantinople.[22] Nor was Skey unique in his support for union with the Eastern Orthodox Church. Christians everywhere, including Anglicans, had voiced similar pleas throughout the nineteenth and early twentieth centuries, usually as a means of providing a united front against modernity's scepticism of Christian teachings.[23] Furthermore, as a former prize-winning theological student at Wycliffe College in Toronto, Skey would have known that, well before the establishment of a distinct Byzantine architecture, the

Christian Church had broken up into many sects. He would not have seen a Byzantine design as a clear symbol of unity.[24] Finally, with regard to Mastin's conclusion, it is unreasonable to argue that, by the time Howland submitted his design for St Anne's, there was no professional or lay interest in Byzantium. In fact, the design of St Anne's was part of a modest, but widespread, revival of Byzantine church architecture that began in Europe in the 1820s. Unfortunately for scholars interested in this revival, and St Anne's place within it, no comprehensive history has been written.[25] The main facts can, however, be summarized.

Until the 1820s, Europeans regarded Byzantine architecture as static and unworthy of study. Then developments in historiography invited scholars to provide a more objective understanding of the medieval period in general. Furthermore, the Romantic search for a modern architectural style led to an examination of the transitional and flexible aspects of Byzantine architecture that were inherent in its synthesis of the Greek, the Eastern, and the Christian.[26] Concomitantly, the cessation of the Greek War of Independence and increased colonialism and trade offered more opportunities for Europeans to travel to the Middle East, while, for those who stayed at home, orientalism provided exotically compelling views of Byzantium.

As a result, from the 1820s until the time of the construction of St Anne's, German and French scholars not only published many accounts of Byzantine architecture but opened institutes and inaugurated journals devoted to Byzantine studies.[27] In the 1850s, by which time Byzantine architecture appeared in a much more positive light, French architects had begun to build churches with Byzantine features.[28] Given the English Canadian and Protestant affiliation of St Anne's, however, this commission ought to be examined more closely within the revival of Byzantine church architecture in England and the United States. The English phase, which began in the 1840s, focused on the supposed intense spirituality of Byzantine art and architecture, in contrast to the French focus on structure. In 1847, for example, the Scottish art historian and connoisseur Lord Lindsay published *Sketches in the History of Christian Art,* in which he argued that Byzantine art and architecture provided a purer and more direct expression of Christianity.[29]

Most important in terms of popularizing Byzantine art and architecture for the English-speaking public was the publication of John Ruskin's *Stones of Venice* between 1851 and 1853. In these volumes, Ruskin provided impassioned descriptions of the beauty, harmony, and inherent morality of the hand-crafted work of the Byzantines. As he stated, "Foolish modern critics have seen nothing in the Eleusinian divinity of Byzantine tradition."[30] Over

the next half-century and well into the twentieth, Ruskin's views were supported and published by many art critics, including those associated with the Arts and Crafts Movement. These publications were, of course, available in Canada, where they were widely read and highly regarded.[31]

Throughout the second half of the nineteenth century, many scholarly articles on Byzantine church architecture were published in England. By the end of the century, lavishly illustrated books had appeared, such as Lethaby and Swainson's well-known *Church of Sancta Sophia, Constantinople* of 1894. At the same time, English architects laid out the practical features of Byzantine church plans in texts designed for fellow architects.[32] The building of neo-Byzantine churches followed. For example, in 1877 John Oldrid Scott designed the Anglican Church of St Sophia, Moscow Road, London (now the Orthodox Cathedral of London) with a Greek cross plan, a red brick exterior, and interior banding of brick and stone.[33] In 1895 Arts and Crafts architect John Bentley began the construction of London's neo-Byzantine and Catholic Westminster Cathedral. Its monumental size, distinct domes, banded brickwork, and prominent central London location brought the Byzantine revival to the attention of the English-speaking world.[34] It also encouraged imitation. For example, Beresford Pite's Anglican Christ Church, Brixton Road, Oval, was erected between 1897 and 1903.[35]

As Westminster Cathedral was being constructed in London, the Byzantine revival appeared in the United States. Heins and La Farge's St Matthew's Catholic Cathedral was under construction in Washington, DC from 1893 until 1913.[36] Howells and Stokes's St Paul's non-denominational memorial chapel was built on the campus of Columbia University in New York between 1904 and 1907.[37] A related body of American literature appeared in this period too.

Canadians, however, did not write books, produce journals, or open institutes devoted to Byzantine studies. Moreover, Canadian architects did not employ Byzantine models with any seriousness before the construction of St Anne's. Indeed, in terms of Canadian Byzantine architecture before St Anne's, it is possible to point only to the Chandler family mausoleum of 1900 in Toronto's Mount Pleasant cemetery.[38] This mausoleum was probably inspired by Louis Sullivan's Byzantine-style mausoleum designed for the Wainwright family in Chicago several years earlier, but without Sullivan's rich decorative detail the Toronto structure appears as a dull domed cube.[39] It is not surprising, then, that J.E.H. MacDonald came to the conclusion, as a result of his observation of the low borrowing rate of Byzantine texts at the University of Toronto – where he sought models for St Anne's mural paintings – that "people don't bother very much about the Byzantine Empire."[40]

He was not correct in his assumption, but he would have been if he had said "Canadians" instead of "people."

Nevertheless, English and American books and popular journals that illustrated and discussed Byzantium architecture in a positive light were widely available in Canada. For example, in 1906, in an article on Venice in *Canadian Magazine,* a journal of general interest, Elsie Waters stated in clear Ruskinian tones: "Not here do we find the dim religious light, the solemn shadows of Gothic cathedrals, but in the Byzantine architecture, in the wondrous blending of colour, in the flow of gold and gems, St. Mark's stands alone."[41] In 1909 *Construction,* a Canadian journal for architects and engineers, published a lengthy illustrated discussion of Westminster Cathedral. The author stated, obviously with an assumption of his audience's understanding of Byzantine architecture, "Few will doubt the peculiar fitness of the selection of this style, for Byzantine Art was the first distinctly Christian Art."[42]

As a result of such articles, the prominent Toronto banker and art patron Byron Walker (later Sir Edmund Walker) assumed as early as 1898 that his audience would understand what he meant when he used the term Byzantine as he supported the installation of mural paintings in the recently constructed Toronto Municipal Buildings. "If murals were added [to the Toronto Municipal Buildings]," he stated, "in some far-off century the students of the present Byzantine revival may find our interiors as interesting as [those in Ravenna]."[43] Moreover, Toronto's *Globe* was able to quote Walker's statement with the assumption that its readers would understand the reference.

Furthermore, Canadian architects usually studied in France, England, or the United States and, on their return to Canada, made extensive use of foreign architectural publications, where, in the late nineteenth century, there was considerable discussion of Byzantine architecture. St Anne's architect, William Ford Howland, was a member of the Toronto Architectural Sketch Club, founded in 1889 "to broaden horizons" of local architects and affiliated with the Architectural League of America.[44] He was also a resident of New York City for two years before 1907. He must, therefore, have been familiar with the recent literature on the Byzantine revival and with the American monuments designed in Byzantine styles. It is reasonable to conclude that Howland introduced the Byzantine plan to the St Anne's building committee, based on his professional knowledge of the Byzantine revival.

Still, Howland's familiarity with and recommendation of a Byzantine design does not account for its reception by the St Anne's building committee.

Such a plan must still have seemed somewhat eccentric to provincial work-ing-class Orangemen. However, these men must have been as concerned as any Christians about the increasingly secularized nature of modern culture. To a large extent this concern accounts for their willingness to accept a Byzantine design.

Christians who feared the effects of secularization expressed their concern in ways that were individual to their nationality. In England, many impor-tant social critics, including Thomas Carlyle, John Ruskin, and Matthew Arnold, frequently stated that, without church-enforced values, members of the working classes would not support the values of the middle and upper classes. In the United States, alarm was frequently declared over each indi-vidual's loss of "intense experience."[45] Protestant Canadians issued bleak, highly descriptive forecasts of a society stripped of the public good once insti-tutionalized moral standards collapsed. Toronto social critics play a large role in these forecasts. As Arnold Haultain lamented in late-nineteenth-century Toronto: "Materialism does not explain everything. The nineteenth century seems to have brought us to the edge of a precipice, and to have left us there gazing wistfully into outer space."[46] Contemporary Toronto social critic Goldwin Smith was obsessed with the disintegration of institutionalized moral authority. As he wrote about Darwin's *Descent of Man:* "It is difficult to see what can restrain the selfishness of the ordinary man, and induce him, in the absence of actual coercion, to sacrifice his personal desire to the pub-lic good."[47]

Protestant Christians proposed a number of solutions to the secularization of modern life. Church union, which offered strength in numbers, was one of them. Medieval architecture and interior decoration was another. First the Gothic phase of the medieval period was adopted, then the Romanesque. The Byzantine was selected next by a small but significant number of con-gregations because of its link to an earlier and "truer" period of Christianity. Cardinal Vaughan had chosen to build Westminster Cathedral in part for this very reason.[48] It was undoubtedly within this context that a Byzantine design found favour with St Anne's Orangemen. Indeed, in 1912, just five years after the completion of the building, one of the church's publications stated: "In the construction ... we chose the Byzantine, the most primitive form of church architecture."[49]

Still, what encouraged the conservative building committee of St Anne's to adopt a design that would be unique in Canada? In so doing, committee members relinquished the strong association between the Anglican Church and the Gothic style that had existed since the 1830s.[50] They rejected the style

in which St Anne's had originally been built, including an addition constructed in 1889. Years later the Reverend Skey reminisced: "We [were] severely criticized for following the Byzantine or Greek instead of the popular Gothic style of architecture."[51] There must have been other reasons to support this choice.

One motivation may have been the keen sense of competition that existed in Toronto at the turn of the century between Anglican and evangelical churches. In 1850 most of Toronto's church-going population had been Anglican. Fifty years later the evangelical population had surpassed the Anglican.[52] Consequently, new churches had to be built and architectural styles had to be chosen. In Great Britain and in the United States, evangelical churches throughout the nineteenth century were built in either a neoclassical or vernacular style.[53] Clearly these choices were made in part to avoid the strong association between the Gothic and the Anglican Church. However, from mid-century on in Toronto, the exteriors and some interior details of evangelical churches were commonly designed in the Gothic style. Presumably this choice was made as a means of adopting the higher status that the Anglican Church possessed. At the same time, the evangelical churches rejected the typical Gothic interior floor plan – a basilica with a centre aisle leading to the chancel or sanctuary. Rather, they employed a variety of preaching halls or auditory churches that facilitated the delivery of sermons to large crowds, brought the parishioners closer to the preacher, and demystified the sacrament.[54]

This issue of ecclesiastical style in turn-of-the-century Toronto is further complicated by the fact that Anglicans had been pursuing the same evangelical goals of visibility and audibility within the basilican plan since the last third of the nineteenth century.[55] Obviously the centralized plan of a Byzantine design solved this problem. As St Anne's church officials declared, the Byzantine was appealing because it would provide a church "in which all could see and hear."[56] Moreover, the selection of Byzantine over Gothic permitted St Anne's parish to accomplish what the evangelicals had done in this regard without imitating them. In a sense, then, St Anne's new structure devalued the evangelical use of the Gothic. Finally, an additional attraction of the Byzantine style to St Anne's parish must have been its low construction costs and relatively short construction time. A Gothic structure required a great deal of sculptural ornament, much of which had to be completed at the same time as the structure. Byzantine, in contrast, had little exterior ornament, and what it did have could be done after the construction was finished. It was less expensive overall, and the expense could be spread over a

longer time period. Certainly Cardinal Vaughan in London found this feature of Bentley's Byzantine design most appealing.[57]

Elaborate mural decoration was part of a Byzantine architectural ensemble. Therefore, St Anne's mural paintings were simply the final stage of an attempt to provide a more spiritual Christian setting by means of a neo-Byzantine ecclesiastical design. Nevertheless, St Anne's Byzantine-style paintings are particularly lavish and colourful. What motivated working-class Orangemen in provincial Toronto to commission them? First, many other Protestant churches, including several local Methodist churches, had received elaborate mural decoration well before the paintings were installed at St Anne's. So, Protestant church mural painting was simply in style. Nevertheless, the mural paintings in other Protestant churches were subdued in terms of colour and non-figural in composition, while those at St Anne's may be described as flamboyant figural narratives. Indeed, MacDonald was well known, and at times condemned, for his wildly colourful, expressionistic renderings of Ontario's northern wilderness. In 1916 Toronto art critic Hector Charlesworth had argued that MacDonald's use of colour was offensive and crude. For Charlesworth, MacDonald seemed to have thrown "his paint pots in the face of the public," to the point where he should entitle his paintings "Hungarian Goulash" and "Drunkard's Stomach."[58] By 1924 MacDonald's landscapes had also received favourable criticism, but even Augustus Bridle, who was enthusiastic about MacDonald's work, claimed that he made "the rainbow look like the wrong side out."[59] Why, then, was MacDonald selected as the chief decorator?

It is likely that members of the St Anne's building committee would have been impressed with MacDonald's faculty position at the Ontario College of Art and by his successful private commercial design practice. MacDonald had also gained some experience in mural decoration when, in 1916, he and other artists had painted the main room of the summer home of Dr J.M. MacCallum in Georgian Bay (fig. 36).[60] Then, just months before the St Anne's commission, MacDonald had won a prize in the Royal Canadian Academy's mural competition (fig. 40).[61] He had also publicly praised George Reid's Toronto City Hall mural paintings (fig. 38) and lamented the lack of civic mural painting in Canada.[62] Undoubtedly, then, MacDonald was given the commission at least in part because he was, in the words of Lawrence Skey, "one of the foremost members of the profession."[63]

At the same time, the decision to hire MacDonald may have had something to do with his familiarity with neo-Byzantine architecture, as unlikely as that may seem. Skey stated that MacDonald was the artist whose "ability would be most likely to produce a color scheme, which would be reverent,

harmonious, and in keeping with the traditions of the [Byzantine] architecture of the church."[64] Moreover, Skey recounted that he and MacDonald had met at Toronto's Arts and Letters Club on a number of occasions, even before the war, to discuss "the mysteries of Byzantine architecture."[65]

One might well wonder what MacDonald knew of Byzantine architecture at this time. It is impossible to know with certainty, but the answer may lie in MacDonald's residence in London, England, between 1903 and 1907, where he worked as a designer for Carlton Cards. During this time MacDonald undoubtedly visited the recently opened neo-Byzantine Cathedral of Westminster, centrally located between Westminster Abbey and Victoria Station, and may have visited John Oldrid Scott's St Sophia.[66] He probably also saw Haywood Sumner's Byzantine-style interior decoration of 1898 in All Saints' Anglican Church in Ennismore Gardens, Knightsbridge. Sumner covered the church's triumphal arch with framed images within a vine scroll, the overall effect of which is remarkably like MacDonald's decoration of St Anne's apse.[67] MacDonald must, therefore, have been as good a source of information on neo-Byzantine church interiors as the Reverend Skey was likely to find in early twentieth-century Toronto. Skey himself had visited England in 1892, before the construction of Westminster Cathedral, and did not go again before MacDonald painted the murals. So, Skey's knowledge of Byzantine style would have been restricted to what he had read.[68]

Finally, MacDonald may well have been chosen to decorate St Anne's in part because of what Paul Duval has described as the artist's strong spiritual nature, albeit one without attachment to a specific sect.[69] As Alison Garwood-Jones has argued, MacDonald was eager to accept the commission because he regarded it as an opportunity to provide art that would reintroduce medieval spirituality into the modern world – as an opportunity to provide art for the public good.[70] Indeed, after MacDonald finished his work at St Anne, he published an article in which he claimed that the mural paintings would provide "religious vitality" and connect "our busy mechanical period with the far-off poetic days when the church was the soul of the town and its beautifying the ideal of the rich, and the devotion of the artist."[71] MacDonald made similarly spiritual expressions in the many poems he wrote and published.[72]

MacDonald's views on the potential for mural decoration to provide art for the public good were also expressed by his seemingly curious comparison of the St Anne's mural paintings with Ford Madox Brown's mural paintings in Manchester's Town Hall and the mural paintings in "an English exchange." Undoubtedly MacDonald was referring to the murals in London's Royal Exchange. The Manchester and London murals were devoted to a history of

trade and commerce, and MacDonald had probably seen both during his years in England.[73] As products of the European-based Mural Movement of the 1830s to the 1930s, the Manchester and Royal Exchange mural paintings functioned to promote material progress through the raising of nationalistic sentiment.

At the time MacDonald painted the St Anne murals he was also intensely involved in producing images of Canada's wilderness landscape as a means of raising nationalistic sentiment and of promoting, among other things, material progress. It is reasonable to assume that MacDonald designed the St Anne's program, at least in part, to perform the same function. Certainly MacDonald employed some of the same devices at St Anne's that he did in his wilderness landscapes. He used the same vibrant colours. He also originally planned to include "Canadian motifs, the trillium and other flowers and leaves, and not necessarily the peacock ... of the Byzantines, but a little zoo of our own, hawks, blue jays, robins, wild ducks, orioles, deer moose, beaver, and squirrels."[74] In the end, such images did not appear. Still, the *Ascension of Christ* (plate 6) does take place in front of a striking image of the Rocky Mountains, while the interior of the dome was originally painted red so it would imitate a Canadian sunset.[75] In 1936 Will Ogilvie included Ontario deer and trillium flowers beside images of the Virgin Mary and Christ in murals he painted for the University of Toronto's Hart House Chapel. Presumably he did so for the same reason that MacDonald employed Canada as a setting for Christian images (fig. 25).

However, even without these individual motifs, the mural paintings at St Anne's supported material progress. Indeed, as imitations of medieval art, they provided an intensely spiritual haven from the negative features of modern life, without actually criticizing it. They also provided parishioner and businessman Samuel Stewart, who donated the costs of St Anne's murals in his will, with an opportunity to assure himself that the material progress on which he had made his money did not direct all aspects of his life.[76] Other mural paintings in local Protestant churches were funded in the same way. For example, the Massey family, whose wealth was based on the manufacturing of agricultural machinery, financed Ogilvie's University of Toronto murals. The Harris family, whose wealth came from the same source, financed the murals at St Jude's Anglican Church in Brantford, Ontario. And Edward Wood, vice-president of Central Canada's Savings and Loan Company, financed Gustav Hahn's murals at St Paul's Methodist Church (fig. 22).

MacDonald acknowledged this complex phenomenon of modernity – in which the public and the private spheres both exalted material progress and

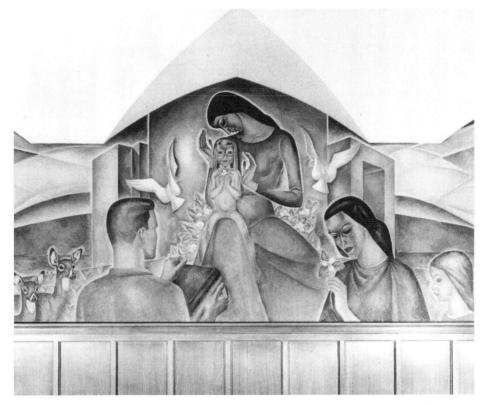

FIG. 25 Will Ogilvie, mural painting, 1936, Hart House Chapel, University of
Toronto, Toronto

shrouded its negative side effects – when he favourably compared his mural
paintings at St Anne's to those in London's Royal Exchange and in
Manchester's Town Hall. He made the same sort of reference when he
wrote: "It is perhaps typical of our time that the [chocolate] factory [that faces
St. Anne's] should overshadow the church."[77] In so doing he was explaining
that his murals might, in turn, "overshadow" the chocolate factory. He was
also firmly locating his work within the Mural Movement of the modern
period, rather than simply within age-old traditions of Christian church
mural decoration.

Catholic Church Mural Paintings:
"Reflections of Our Community's Soul"

In the 1830s, after approximately one hundred years of relatively stark neo-classical styles of ecclesiastical interior decoration, Catholic churches within Western culture began to commission mural paintings on a regular basis. Given the conservative nature of the Catholic Church, it is not surprising that they continued to do so until the 1950s. The new mural paintings were primarily designed, as all earlier Catholic mural paintings, to provide images that would teach doctrine and inspire devotion. These mural paintings also functioned, like those in Protestant churches, to extol Christianity as a prominent feature of the modern nation-state in which the mural paintings were produced (see chapter 4).

At the same time, Catholics, like contemporary Protestants, were eager to employ mural painting to create intensely spiritual environments that they believed would combat the inroads that modern life had begun to make on Christian authority. In this 150-year period they hoped that mural paintings would provide a sanctuary from the negative features of material progress. Most Catholics did not, however, reject the positive features of modern life any more than Protestants did. Thus, albeit in an indirect way, Catholic Church mural paintings supported material progress. It is, therefore, reasonable to state that the thousands of Catholic Church murals produced from the 1830s to the 1950s were part of the European-based Mural Movement and functioned to glorify the modern nation-state.

Unlike Protestant Christians, Catholic Christians would have been immediately comfortable with this return to painted mural decoration, since Catholic churches had been lavishly decorated with mural paintings from the early Christian period to the early eighteenth century. The Catholic Church

in French Canada participated in this revival of mural painting and its parishioners understood the basic process. As a writer for *Le Canadien* stated as early as 1854: "The [church] artists of our day [in France] have tried to bring back to life traditions of artists of earlier times,"[1] and suggested that French Canadians should do the same. They soon did.

French Canadian Catholic Church mural paintings functioned differently from those in other countries and in English Canada. Many of them were concerned with the glorification of distinct identity, another feature of the modern nation-state. In other countries, mural paintings in civic sites normally performed this role, but French Canadians feared they would lose their distinct identity if they were assimilated into the very English Dominion of Canada. Since Catholicism was an important part of French Canada's sense of self, glorification of that distinct identity could logically take place within the French Canadian Catholic Church. First, however, what aspects of French Canadian history made French Canadian Catholic muralists and mural patrons employ church mural painting, rather than civic mural painting, to glorify their identity?

In 1763 the British conquered French Canada. The Treaty of Paris, which transferred the French colony to the British, made it clear that the British intended to transform Quebec into an English-speaking colony. Catholics were denied the right to hold office. English immigration was encouraged, in part to dilute French Canadian culture. Moreover, the colony was denied an elective assembly, one of the features of British government in the Thirteen Colonies to the south. Very quickly, however, Britain realized that it was necessary to offer concessions to French Canada, especially as a means of retaining its loyalty in the face of American dissatisfaction with colonial status. In 1774 Britain passed the Quebec Act. Parts of it recognized the French language, the use of French law in civil cases, and the right of the French Catholic clergy to educate French Canadians and to collect tithes. In return for these concessions, the Catholic Church was to encourage French Canadians to cooperate with the British.

At this point the French Canadian Catholic Church was in a position to strike another bargain, in this case with the French Canadian people. French Canadians would give the church complete control over education, health, social welfare, and social activities. In return, the church would make every effort to resist British efforts to assimilate French Canadian culture. Since the church was the only strong institution in French Canada at this time, it is not surprising that French Canadians willingly entered into this agreement.

Still, the Quebec Act did not provide representative government. In 1791, as a result of pressure not so much from French Canadians but from recently

arrived United Empire Loyalists and English merchants in Montreal, Britain passed the Constitutional Act. It created the colonies of Upper Canada and Lower Canada and granted each a legislative assembly. French Canadians maintained the rights granted by the Quebec Act of 1774. In a sense they also received their own territory, basically the province of Quebec, even though then, as now, the "French Canadian nation" extended beyond these borders. Still, the new governments of Upper and Lower Canada included a British-appointed executive branch to control the actions of the assemblies.

Over the next several decades French Canadians came to resent this executive branch, as did English Canadians in Upper Canada. This resentment produced the short-lived Rebellion of 1837 in Lower Canada led by the ardent French Canadian patriot Louis-Joseph Papineau. In response, the British passed the Act of Union of Upper and Lower Canada in 1841. Lower Canada then included large regions populated for the most part by English Canadians. Consequently, many French Canadians saw the Act of Union as all too capable of annihilating their culture through the process of assimilation. As a result, they turned to recently developed European trends of thought regarding the modern nation-state and began to consider various ways of preserving the distinct elements of their society or "nation," as they began to call it.

In 1867, with the establishment of Confederation and the concomitant creation of the province of Quebec, some of the threats to French Canadian culture that had been formed by the Act of Union of 1841 disappeared. However, Confederation made Quebec an even smaller part of a larger and predominantly English country under a federal government. Over the next few decades, threats to French Canadian culture continued to come from English Canada. The restriction of French as a language of school instruction in Alberta, Saskatchewan, Manitoba, and Ontario in the late nineteenth and early twentieth centuries weakened support for French Canadian culture outside Quebec. Wars waged by Britain in South Africa and Europe in these years led to the conscription of French Canadians who were unwilling to fight what they described as "English wars."

At the same time, threats to French Canadian culture arose from within. Some French Canadians were demanding secularized education. Some French Canadian women were calling for women's rights. Furthermore, opportunities for employment were encouraging many French Canadians to move from rural areas and small towns to Montreal and to large cities in the northeastern United States. In such places, the English population and the secular social life weakened the culture of the French Canadians.

To deal with these new threats, and to save tax dollars, nationalistic

French Canadian governments in Quebec continued, until well after the middle of the twentieth century, to give the Catholic Church full power over education, health, social welfare, social activities, and many aspects of daily life that, in other modern nation-states, were rapidly being secularized. French Canadian clerical nationalists welcomed this arrangement. In 1868 Mgr Ignace Bourget, bishop of Montreal, wrote: "The true patriot is a sincere Catholic. Religion inspires love of country, and the love of country causes love of religion ... Without religion, the national interests are sacrificed; and without the fatherland, religious interests are forgotten and set aside."[2] Many non-clerical French Canadian nationalists also supported this arrangement. In the late nineteenth century, newspaper editor Jules-Paul Tardivel wrote: "The French race in America will never have any influence for good unless it is solidly based in the province of Quebec as a fortress. We must occupy the territory of this province ... We must develop and strengthen ourselves here, under the protection of the Church ... whose magnificent institutions are still our greatest strength."[3] In 1902 French Canadian journalist and educator Henri Bourassa stated: "The clergy is yet and ought to remain our supreme leading class. It forms among us a genuine moral and intellectual aristocracy."[4] In this way, as historian Roberto Perin commented, the Catholic Church was "rehabilitated as a national institution."[5] It retained many of the responsibilities that, at various points in the nineteenth and twentieth centuries, were transferred to the nominally secular control of the modern nation-state.

Yet, as Ramsay Cook argued, while the dominant clerico-nationalist ideology that permeated Quebec before the Second World War was nationalist in a religious and cultural sense, it was not predominantly nationalist in a political sense. As the French Canadian nationalist Étienne Parent stated in 1846: "We should realize that the greatest threat of all is directed not against our political freedom ... but against our nationality. It is, therefore, our nationality that needs the most protection. Our nationality should be our prime concern. Then all the rest will automatically fall into place."[6] In the early twentieth century Henri Bourassa, in his editorials for *Le Devoir* and his many public speeches, combined an ardent cultural nationalism with the promotion of a federation of autonomous provinces and a compact of two distinct – English and French – Canadian cultures.[7] Other passionate contemporary separatists like Jules-Paul Tardivel and abbé Lionel Groulx also envisioned political independence at a date well into the future.

From the mid-nineteenth century, as a means of maintaining a distinct French Canadian culture within Canada, many Catholic clergy adopted two positions that strongly influenced French Canadian mural painting in the

1860 to 1950 period. The first was messianism, the belief that God gives particular groups of people particular missions. If a group of people accepts a divine mission, it will eventually be rewarded; if it does not, it will be punished. One of the earliest and most influential members of the Quebec clergy to preach messianism, while simultaneously supporting Confederation and a place for French Canada within it, was Mgr Louis-François Laflèche. In 1866, just before he became bishop of Trois-Rivières, he wrote: "Every nation in the human race has ... been entrusted with its own special mission." The first mission of the French Canadians, Laflèche explained, was to remain the Catholic "Kingdom of Canada." The second was to expand this kingdom by bringing Catholicism as a form of enlightenment "to those wretched communities that, for centuries, had been floundering in an abyss of ignorance and brooding in the shadow of death in this beautiful, fertile valley." In other words, the French Canadians were to Christianize Native Canadians, an activity in which they had been involved since the seventeenth century.

As a reward for what they had already done in this respect, Laflèche claimed, God had given French Canadians the valley of the St Lawrence as their fatherland. The early explorers were, he believed, the equivalents of Abraham. As God said to Abraham in the Old Testament, so he said to Cartier and Champlain: "Come to the land I shall show you; I shall turn you into a great nation." Laflèche also explained that God would "severely punish ... nations who have not understood their mission, or have refused to fulfil their destiny."[8]

Nationalist clergy members linked messianism to the survival of French Canadian culture. In a sermon given in 1902, Mgr L.-A. Pâquet stated: "Yes, to ... defend all that makes up the precious heritage of Christian traditions, surely this is our vocation. In order to perform this role a people must remain true to itself. French Canada will accomplish God's purposes and respond to its sublime calling only to the extent that it maintains its own way of life, its individual character, and its characteristic spirit."[9] In 1926 abbé Camille Roy argued: "We must react and struggle against novelty [of modern life] or else we must alter the soul of our native land. We are too overrun with foreign influences. It will always be of value to remind French Canadians that remaining faithful to tradition is a sacred duty. That is why it is always a failing and a betrayal of the race to forget traditions."[10] A few years later abbé Groulx, writing in the French Canadian nationalist journal, *L'Action française,* stated: "To be French is to remain French. More than our right, it is our duty and our mission."[11] Elsewhere he said: "What is

demanded of nations is to express original patterns of thought and life, a distinct humanity, and it is thus that a people attains civilization."[12]

From the 1840s, in addition to messianism, French Canadian clergy adopted a position known as ultramontanism – the belief that the papacy in Rome "beyond the Alps" should control many aspects of life outside the Vatican. As Jeffrey von Arx has explained, definitions of ultramontanism varied from one national church to another.[13] In France, for example, the term was frequently applied from the early nineteenth century to conservative Catholics who resented the restrictions that had been made on the secular power of the Catholic Church in France first by the revolutionaries in the late eighteenth century and then by Napoléon's Concordat of 1801. Therefore, they supported the former and longstanding link between the Catholic Church in France and French royalists.

Quebec clergy promoted ultramontanism as a form of support for a distinct nationalistic French Canadian identity. There was irony here, since in France and other parts of Europe ultramontanism was anti-nationalist. As Susan Trofimenkoff states: "[The Quebec clergy] developed a vast ideological justification for their activities, drawing on European sources of ultramontanism and Quebec nationalism to spin a dream of French Canadian unanimity under clerical direction."[14] To this end Bishop Bourget invited pro-ultramontane religious orders to settle in Quebec. He also encouraged the construction of Saint-Jacques-le-Majeur (Maire-Reine-du-Monde) in Montreal, in imitation of St Peter's in Rome, as a symbol of Quebec's loyalty to the Vatican.[15] In 1868 Bourget and Laflèche even sanctioned sending French Canadian military aid to Italy, to assist the pope against Italian nationalist insurgents who wanted to unify the country and confine the pope to spiritual matters.[16]

Just at this time, French Canadians began to promote the production of mural paintings in both civic buildings and Catholic churches as one means of preserving their cultural identity. For example, in 1864 French Canadian muralist Napoléon Bourassa helped to found the *Revue canadienne* as a form of literary support for the cultural aspirations of French Canadians. In the four articles he wrote for this journal between 1864 and 1868, he promoted mural paintings that represented French Canadian history. This type of art, Bourassa believed, would help to preserve the French Canadian "nation."[17] At the same time, Bourassa and other French Canadians believed that mural paintings in Catholic churches, as well as in civic sites, could help to preserve the French Canadian "nation." For example, in 1918 Mgr Olivier Maurault, the artistic director of the Saint-Sulpician library in Montreal and a supporter of the French Canadian church muralist Ozias Leduc, argued in *L'Action française* that

FIG. 26 Napoléon Bourassa, mural paintings, c. 1880,
Notre-Dame-de-Lourdes, Montreal. Photo: Notman Photographic
Archives, McCord Museum, 1544

French Canadian nationalism would be best articulated in church mural paint-
ing.[18] Two years later Arthur Laurendau, writing for the same journal, agreed,
stating that there could be no national art without church mural decoration.[19]

This promotion of mural painting resulted in only a few civic commissions
(see chapter 2), but in a large number of commissions for the Catholic Church.
Although the subject matter of many of these images was devoted to Catholic
dogma, many of them also included representations of local French Canadian
history. In 1900 Charles Huot installed an extensive mural painting program
in Saint-Saveur Church in Quebec City (most panels *in situ*). Painted in early

nineteenth-century versions of Baroque styles that he had seen in Paris, Huot covered the church with Christian scenes such as *Heaven, Hell, The Last Judgement,* and *The Transfiguration.* In some of these panels – *Paradise,* for one – Huot included members of local French Canadian Catholic orders and Native Canadians, who, presumably, had reached Paradise as a result of the messianic efforts of the French Canadian priests and nuns.

Other artists employed style as a means of support for French Canadian nationalism. In the early 1880s Bourassa installed a lavish program of mural paintings devoted to the theme of the Immaculate Conception for Montreal's Church of Notre-Dame-de-Lourdes (fig. 26). Much of what he had to say about these murals simply places them within the tenets of the Mural Movement. He wanted them to be easily readable, to discourage the viewer's thoughts from straying, to be unified with the architecture, and to maintain their decorative character. However, he also stated: "With the help of favourable light, I could bring painting, sculpture and architecture into harmony. That would be a great thing ... If I could bring together a number of pupils as was done with great enterprises in the past ... we could cover Canada with sublimes monuments. Out of this would be born a national school ... formed of immortal sources of beauty."[20] In this statement Bourassa acknowledged that it was not only the Christian subject matter of the murals that would strengthen French Canadian nationalism but also their style.

As Raymond Vézina has explained, Bourassa followed a popular nineteenth-century belief – and a particular expression of this belief provided by the French intellectual Victor Cousin – that equated "beauty" with "good." Since God was the source of "good" or "morality," "beauty" supposedly came from God. Artistic beauty in the form of style was, therefore, moralistic, since it came from God. This idea, with its basis in Plato, has a long history within Western culture including its appearance in the medieval philosophy of St Thomas Aquinas. Interestingly, Aquinas was revived with great enthusiasm by Catholics in the nineteenth century.

Furthermore, as Vézina has also pointed out, Bourassa openly acknowledged that the style of his work at Notre-Dame-de-Lourdes was based on the style of mural paintings produced by French muralist Hippolyte Flandrin for Catholic churches in Paris in the mid-nineteenth century.[21] Flandrin and his contemporaries employed a medieval style: a background of shallow two-dimensional, empty space, often painted gold; flattened unmodelled figures with strong outlines; muted colours; and an emphasis on frontality. Furthermore, these French muralists placed the figures in a hierarchical or hieratic order rather than in a natural arrangement. In other words, the most

important figures were larger and centralized. According to a recent struc-turalist analysis that art historian Michael Driskel has made of this style, many Catholic Church mural painters in France, including Flandrin, employed it as support for the ultramontane position – for the authority of the pope over sec-ular matters in France. Driskel called this style the "ultramontane aesthetic."[22]

According to Driskel, important ultramontane sympathizers in France had recommended this aesthetic for this very purpose. In 1836 Alexis-François Rio published *De la Poésie chrétienne dans sa matière et dans sa formes,* a study of Italian painting from the trecento to the early Renaissance. He established a polarity between a sacred, mystical, Christian style – based on stasis, simplicity, and muted colours – and the chaos of Baroque natural-ism. The former style, Rio believed, had eternal qualities; the latter he asso-ciated with paganism and the negative features of modern life.[23] In his widely read manual of 1845 on mural decoration, French ultramontane Jean-Philippe Schmit also supported the ultramontane aesthetic. Religious murals "ought to inspire thought of calm, union, unity," he said. Pictorial forms should be "separate and distinct from one another," and there should be "firm contours to minimize the effects of transiency."[24] Schmit also called specifically for the hieratic ordering of Byzantine iconic figures rather than historical or narrative scenes. Style would provide a symbolic dimension of ultramontane thinking; respect for religion and for the pope would follow.

Many French Canadian Catholic Church muralists employed the ultra-montane aesthetic for the same reason. In 1896 curé Léon-Alfred Sentenne commissioned five artists – Charles Gill, Joseph Saint-Charles, Henri Beau, Joseph-Charles Franchère, and Ludger Larose – to install twelve mural paintings in the Sacred Heart Chapel at Montreal's Notre-Dame Cathedral (destroyed). Working with the ultramontane aesthetic they had absorbed during recent studies in France, these artists painted ten panels devoted to Catholic dogma. But one panel, *The First Mass in Ville-Marie* by Saint-Charles, represented ordinary French Canadians taking part in a mass. Another, also by Saint-Charles, was entitled *The Oath of Dollard and His Companions.* Adam Dollard des Ormeaux was a French solider who had come to New France in the seventeenth century. He attacked the Iroquois with the aid of other French soldiers and groups of Huron and Algonquin. The Iroquois won the battle and killed the French soldiers. Although the battle was clearly secular, in the nineteenth century French Canadian historians turned it into a religious and nationalistic epic by claiming that the Catholic soldiers were defending the "nation" of New France.[25] In other parts of Canada this type of image as a mural painting would most likely have been installed in civic

architecture, while its ultramontane aesthetic might well have been interpreted as a stylistic device without an ideological base.

Other French Canadian Catholic Church muralists were more blatant in their support of ultramontanism. In the 1930s the clergy at Notre-Dame-de-la-Défense in Montreal commissioned Italian immigrant muralist Guido Nincheri to install mural paintings that included a portrait of the Italian Fascist leader Benito Mussolini. Since Mussolini had just honoured the Lateran Treaty of 1929 that granted the Vatican independence from Italy, this portrait almost certainly represents an open ultramontane position.[26] In a study of the mural paintings Nincheri did for Saint-Léon-de-Westmount in Montreal between 1918 and 1951, Rhona Goodspeed argued for this interpretation. The church is dedicated to a pope, Leo I, and the Westmount murals represent him at the door of Heaven, with St Peter holding the keys to the Kingdom. The murals also provide a history of the Pontificate, including the expulsion of Attila and the barbaric Huns, and explain the basis for the authority of the pope. Goodspeed suggests that the pro-ultramontane clergy at Saint-Léon's gave this commission to Nincheri because of his ability to paint in an Italian Renaissance style and to reflect a culture in which the pope had exercised a great deal of control over secular society. Since Nincheri was eventually "knighted" by the Vatican, it is easy to imagine that he, too, was sympathetic to the ultramontane position.[27]

Many other French Canadian Catholic Church muralists, including one of the most prominent, Ozias Leduc, employed the ultramontane aesthetic. Leduc also made direct references to secular French Canadian culture and to the dominant role that the Catholic Church played in secular French Canadian life. At first these references were subtle. Between 1896 and 1899 he installed murals in the Church of Saint-Hilaire in the village of the same name. He painted fourteen Stations of the Cross and fifteen panels that depicted the life of St-Hilaire, the Four Evangelists, and the Seven Sacraments (*in situ*). For this work he used shallow two-dimensional space, muted colours, strong outlines, and large amounts of space between the figures. Clearly, all these features belong to the work of the Mural Movement in general. Therefore, at first glance at least, it is possible to argue, as with Bourassa's work, that Leduc was simply working within the contemporary Christian tradition to counteract the secularization of the modern world.

However, Leduc also replaced the antique props in his preparatory drawings for St-Hilaire with local Quebec vegetation (see *St Luke*, fig. 27). It seems likely, then, that he was making the same statement that Bourassa had made about the unified nature of French Canadian Catholicism and French

FIG. 27 Ozias Leduc, *St. Luke,* 1896–99, Church of Saint-Hilaire, Saint-Hilaire, Quebec

Canadian secular life. Like Bourassa, Leduc had spent many months in Paris, where he too saw the ultramontane church murals (after being trained in Quebec as a muralist by Italian immigrant muralist Luigi Capello). Furthermore, he spoke as clearly as Bourassa of the important relationship between the Quebec Catholic Church and the preservation of French Canadian culture, composed of the church, the French language, and rural values. For both artists, the church and the culture were basically one. As Leduc stated in 1903: "The observance of the laws of God is not opposed to the veneration which we have for whatever has been handed down to us by our ancestors. After Faith, its language is what a nation holds most dear."[28]

Between 1917 and 1919 Leduc painted murals for the Sacred Heart Chapel/ Baptistery of the Church of Saint-Enfant-Jésus, Mile-End, in Montreal (*in situ*), where the curé, Philippe Perrier, was an ultramontane sympathizer.[29] In one panel, *The Sacred Heart of Jesus,* Leduc employed the ultramontane aesthetic

to paint Christ and angels standing in a row at the front of a shallow landscape and observing the Sacred Heart. To the right, a woman and child watch as one man sows seeds and another ploughs the land. To the left are a quarry, a partly constructed building, the smokestacks of factories, and the dome of Montreal's cathedral. According to art historian Monique Lanthier, these scenes represent the Christian sanctification of secular labour. Even though the Catholic Church in French Canada was vocal in its preference for the rural life, Leduc represented both equally.[30] I would argue, however, that Leduc did give some preference to the rural. There is no indication that the building under construction is in the city, nor does the quarry have a visible urban setting. Moreover, the city is far away, in the background. It is represented by billowing smoke from factories, as an unhealthy or even evil environment, while the dome of the church looms over the factories as if to state that the church might control the negative urban scene or act as a refuge from it. Furthermore, Leduc painted the borders of these panels – a formal device employed by the ultramontane French muralist Hippolyte Flandrin – with maple and apple products and foliage – with rural references.[31] While sanctifying labour in general, these murals promote rural values over urban ones.

In reference to these Mile-End murals, Leduc stated: "We felt that this would be a living church, a reflection of our past and of our community's soul."[32] His words are essentially the same as those of English Canadian art critic Albert Carman, who wrote in 1906 that secular civic murals with secular historical subject matter would provide a much needed "national soul."[33] In other words, Leduc was giving his church murals a role in the support of French Canada as a distinct "nation" that might well have appeared in civic mural painting in Quebec. Leduc may even have intended his maple leaves at Saint-Enfant-Jésus to symbolize the maple leaf as the emblem of Quebec's nationalist Saint-Jean-Baptiste Society. This society was founded in Montreal in 1834 to give French Canadians "a rallying cry," to defend French Canadian "language, rights and institutions."[34] In so doing it developed the birthday of the Catholic saint into a *fête national* – a type of holiday that is both national and religious. One of the society's founders, Jacques Viger, stated in a speech that has been widely published and evoked over close to two centuries: "This tree – the maple – which grows in our valley ... at first young and beaten by the storm, pines away, painfully feeding itself from the earth, but it soon springs up, tall and strong, and faces the tempest and triumphs over the wind which cannot shake it any more"[35]

Leduc acknowledged that this work at Saint-Enfant-Jésus, based on the sensuous line of Art Nouveau, was part of the Symbolist Movement. But he

described his earlier work as "symbols," too, as ideas produced as much by the lines and the colours as by the subject matter.[36] Clearly, Leduc was working with the Platonic / Thomist identification of the "beautiful" and the "good," just as Bourassa had been. Leduc made this position obvious when he said in 1928 that the artist's role was to fashion "a little beauty toward the good." He also said that "the beauty we see is the result of exact proportions, of rules governed by that order which seems to be, must be, the pivot around which the human soul circles."[37] As other scholars have pointed out, by this time Leduc had come under the influence of Maurice Denis, a French church decorator. Denis was a strong advocate of Catholic Church art, including murals, but he realized that if Catholic Church art was to remain vital it had to adopt modernist styles of art.[38]

Leduc's murals at the Church of Notre-Dame-de-la-Présentation in Shawinigan-Sud in Quebec provide an even clearer statement of his approach to Catholic mural decoration. This work was done between 1942 and 1955, after the dates given at the beginning of this book for the active period of the Mural Movement. However, until Quebec's Quiet Revolution, which began around 1960 and ultimately rejected the dominant role of the Catholic Church in French Canadian society, church mural painting in Quebec maintained the mural painting traditions established in the 1870s. Therefore, as Barbara Winters says of these late murals of Leduc's, they represent "a significant and provocative visual doctrine of the Catholic Church ... before the Quiet Revolution."[39]

Leduc's murals at Notre-Dame-de-la-Présentation illustrate narratives from the Old and New Testaments and from apocryphal Christian literature and also represent scenes from French Canadian history – such as Père Jacques Buteux's death at the hands of the Iroquois in 1652. They glorify both Christianity and distinct identity as features of the modern nation-state of French Canada. They include representations of contemporary French Canadian labourers in both rural and urban settings, scenes that would not be out of place in murals in civic or even commercial sites: farmers, butchers, and metal foundry and paper mill workers.[40] They glorify material progress, another characteristic of the modern nation-state. The absence of female workers in all these labour scenes underscores the strong patriarchal position of the Catholic Church in particular, and of modern nation-states in general, since thousands of French Canadian women worked outside of the home in the years these murals were painted.

At the same time, like all French Canadian Catholic Church murals that illustrate a secular activity or event, Leduc's murals at Shawinigan-Sud

draw the secular back into the realm of the sacred. Indeed, with his images of labour, Leduc was again referring to the sanctity that Christianity had given secular labour. With his images of colonization and evangelization, Leduc was illustrating messianism in action. Winters suggests that Leduc's murals in Shawinigan-Sud were also designed to emphasize submission to God's divine plan as the road to salvation. This emphasis was generally considered necessary because Christianity's role in mid-twentieth century Western culture had been seriously threatened by the socioeconomic changes that resulted from industrialization and urbanization. It was considered particularly necessary in Shawinigan-Sud because international trade unions, and their associations with secularization and anglicization, had arrived in the region in the 1940s and 1950s.[41] Arthur Jacob, the Shawinigan curé who asked Leduc to decorate the Shawinigan church, was involved in the organization of local Catholic labour unions. These local unions promoted a traditional, distinct, French, Catholic society, one over which the Catholic Church held power. Interestingly, as Winters points out, Shawinigan industries preferred the Catholic unions because, as one company brochure stated, "the satisfaction of the French Canadian people is a factor of great importance for employers in this region [and is] attributable to the wise and good direction of ... the Catholic priests. For centuries in this region the first principle of the habitants' religion has to be satisfaction with their lot ... Another important factor for labour is the [large] size of the French Canadian family. Since they all must eat ... they all must work ... the wages asked for are extremely low."[42] It is not surprising that local industries made substantial financial contributions towards Leduc's murals at the Shawinigan church.

This fusion of French Canadian religion, history, and contemporary life in Leduc's murals, as in those of other French Canadian nationalistic muralists, clearly demonstrates that these artists saw these elements as mutually supportive and necessary to the survival of the "nation" of French Canada. As Robert de Roquebrune, a French Canadian journalist, nationalist, and friend of Leduc, argued in 1916 in *L'Action française:* "The day when French Canadians possess their own true art is the day that their culture will be saved."[43]

From the last quarter of the nineteenth century and until well into the twentieth, the ultramontane aesthetic regularly appeared in murals in other types of Catholic ecclesiastical buildings in French Canada. In 1920, for example, Nincheri provided hieratic figural murals with gold Byzantine backgrounds for the Mother House of the Sisters of the Holy Name of Jesus in Montreal.[44] Furthermore, this aesthetic appeared in Catholic churches and

other Catholic ecclesiastical buildings in other parts of Canada. Montreal muralist François-Xavier-Édouard Meloche used the ultramontane aesthetic at St Simon and St Jude Roman Catholic Church at Tignish, Prince Edward Island in 1885 (*in situ*).[45] Muralist Count Berthold von Imhoff used the style at St Peter's Catholic Cathedral near Muenster, Saskatchewan, in 1919.[46] Ozias Leduc used it again in the Chapel of Saint Joseph in the Hospital of the Grey Sisters in St Boniface, Manitoba (*in situ*). He likely also used it for the murals he installed in the Assembly Hall of the Catholic St Francis-Xavier University in Antigonish (present location and subject matter unknown, probably destroyed).[47]

Given Leduc as the muralist and the large French Canadian population in St Boniface, the Saint Joseph Chapel murals were most likely designed from a French Canadian sense of ultramontanism. The others may or may not have included support for ultramontanism in a general sense, but not in a French Canadian sense. Or they may simply represent the artists' desire to work with a popular style. In any case, all these Catholic Church murals outside French Canada were products of the Mural Movement simply by virtue of their return to medieval-style church decoration and their provision of a refuge from the industrialization, urbanization, and secularization of the modern nation-state.

Mural Paintings in Private Sites:
"Wealth Transfigured into Crowns of Glory"

Until the early nineteenth century, mural paintings for private residences were commissioned only by aristocrats. Most, if not all, of these mural paintings represented light-hearted activities of Greco-Roman deities. Some aristocrats may have found satisfaction in the link this subject matter forged between themselves and a type of divinity. All of them would have welcomed the relationship this subject matter constructed between them and ancient Greece and Rome as important and powerful bases of Western culture. And all of them would have understood that this subject matter belonged exclusively to them in a sense, since their education, provided by their wealth, permitted them to read it. Residential mural paintings produced before the early nineteenth century acted as signs of the power of the aristocratic patron.

From the early nineteenth century until well into the twentieth century, people who had been enriched by the Industrial Revolution joined aristocrats in the commissioning of residential mural paintings. The male members of this newly wealthy population also commissioned mural paintings for the private clubs they established as "homes away from home" in which to discuss business and to socialize. Until around 1900, many of these mural paintings used the same subject matter as had the murals of the aristocrats. Others represented light-hearted activities set in medieval Europe or Renaissance Italy, time periods that, by the nineteenth century, were as much revered as bases of Western culture as the Greek and the Roman. After 1900, some artists continued to employ the same subject matter for murals in the homes and private clubs of the newly wealthy. Others turned to the representation of recent local historical scenes that had particular relevance

for family or club members. Still others depicted the contemporary social activities and pastimes, such as sailing and holidays at country homes, that family and club members enjoyed.

Some contemporary critics suggested that the newly wealthy chose this subject matter and commissioned mural paintings for their homes and clubs simply to provide light-hearted visual entertainment for family and for visitors. As English mural painting advocate J. Beavington Atkinson stated, "Of private mansions we may safely declare that ... the mural paintings ... enter upon realms of poetry and usurp the realms of imagination."[1] It is more reasonable to suggest, however, that the newly wealthy commissioned mural paintings devoted to Greco-Roman, medieval, and Renaissance themes and to expensive contemporary social activities for the same basic reason that members of the aristocracy had done: they wanted to demonstrate their power. In the case of the newly wealthy, the base of their power lay in features of the modern nation-state: popular sovereignty, the material progress of capitalism, distinct cultural identity, Christianity, and patriarchy. They included mural painting in their homes and clubs as a means of glorifying some of these characteristics – in particular, material progress, cultural identity, and patriarchy. These private murals, then, belong to the European-based Mural Movement that functioned to glorify the modern nation-state.

The private mural paintings of the newly wealthy worked in a variety of ways to glorify material progress. First, no matter what their subject matter, mural paintings in residences and private clubs, juxtaposed with expensive furnishings and other works of art, demonstrated the material progress of the patron. The murals that depicted Greco-Roman, medieval, and Renaissance themes stated in a more covert manner than the representations of social activities that the patron could afford a good education. In addition, mural paintings were not only a type of decorative art but a type of fine art. As fine art, they offered their patrons a sense of cultural importance or prestige and personal cultural progress – supported by material progress – that other types of decorative art could not. Compared with easel painting, the most commonly produced type of fine art, mural painting was larger, more expensive, and permanent. Newly wealthy mural painting patrons could reasonably hope that mural paintings would provide them with a level of status equivalent to the level that "old money" and a lengthy, respectable family lineage had given to aristocrats.

The newly wealthy who made their fortunes in particularly crass areas, such as coal mining or slaughterhouses, also believed that mural painting could provide an artistic refuge from the most negative features of material progress. The construction of refuges from the negative features of modern

life is often described as a type of "antimodernism" (see chapters 4 and 5). Antimodernists promoted, among other things, pre-industrial modes of artistic production as a means of combatting the perceived ugliness of machine-made goods. Often they did so within formal chapters of the wide-spread Arts and Crafts Movement. Since muralists worked by hand and employed teams of painters, just as medieval guild workers had done, members of the Arts and Crafts Movement readily embraced mural painting.[2] Yet most antimodernists had neither the ability nor the desire to rid modern life of the technological developments that were responsible for many of its negative features. Rather, they realized that these developments went hand in hand with the comforts of modern life. As American social critic Arthur Spencer wrote in 1904, in a promotion of both the Arts and Crafts Movement and material progress, "Let not machinery be banished from modern life – that would be absurd."[3] As a type of antimodernism, mural painting in the homes and clubs of the newly wealthy worked in this same way. It provided a refuge that lessened the need to critique material progress. It supported material progress, though in a convoluted manner.

The Greco-Roman, medieval, and Renaissance subject matter of private mural paintings of the newly wealthy also worked to glorify distinct identity as a major characteristic of the modern nation-state. Indeed, it represented the supposed power of Greco-Roman and Renaissance cultures and the superior morality of medieval culture as glorious bases of Western culture. It also permitted newly wealthy mural patrons to display a distinct type of culture that had once belonged exclusively to aristocrats. In this way the newly wealthy could reassure themselves that they were the aristocracy of modern life, which of course they were.

Finally, mural paintings commissioned for the private spaces of the newly wealthy in the nineteenth and early twentieth centuries were designed to glorify and sustain patriarchy. In private residences and clubs, some mural painting supported patriarchy by representing Greco-Roman mythological female figures who were known primarily for their sexual activities, such as Aphrodite / Venus and the nymphs. Others represented the muses, Greco-Roman female figures who inspired men to produce various forms of writing and music, but were not creative themselves. Others employed medieval themes, taken from romance literature of the Middle Ages, that featured passive females and active males. And some represented contemporary women lying in fields, sitting in woodlands, or picnicking. Children are often included, but men are not. Mural paintings in men's private clubs regularly represented images of mythological or historical male warriors, writers, and political leaders. Viewers were led to

associate women with nature, and men with business and the production of culture. In other words, a private mural painting mirrored and strengthened the practices of the household or club for which it was produced.

When Canadian muralists received commissions for mural paintings in private sites, at least before 1900, they tended to imitate mural paintings for these locations in France, England, and the United States. Although they had not likely seen many of these foreign mural paintings *in situ*, many French, English, and American mural painters had published their designs for private mural paintings in journals that were readily available in Canada. It is useful to look at a few foreign private mural painting before looking at Canadian examples.

Many mural paintings in private homes in France, England, and the United States were designed to link the private patron to classical culture. In 1908 Edward Burne-Jones and other artists painted twelve mural panels devoted to the theme of Cupid and Psyche for the dining room of George Howard's house in London (now in the Birmingham City Art Gallery).[4] In this ancient tale, Psyche is punished for disobeying her husband. In the same year Gabriel Thomas commissioned Maurice Denis to paint ten mural panels for the dining room of his chateau at Meudon-Belleville in France (panels now in the Musée départemental du Prieuré in Saint-Germain-en-Laye). They represent female figures at various stages of life – child, fiancée, wife, mother – seated in meadow-like landscapes. They weave flower garlands, converse, and pick fruit. Below each large panel is a small predella panel in *grisaille*.[5] Here classical nudes are situated on blank backgrounds relieved by abbreviated landscape motifs.

Many mural paintings in private homes in France, England, and the United States were designed to link the patron to the supposed intense morality of the medieval period. Cardiff Castle in Wales is probably the most elaborate example. In 1868 its owner, John Patrick Chrichton-Stuart, whose fortune came from his father's investment in dockyards for the export of coal, undertook the restoration of the living quarters of the castle. Chrichton-Stuart's architect, William Burges, decorated the renovated spaces, including the children's nursery, with illustrations of French thirteenth-century history and literature (*in situ*).[6]

From the mid-nineteenth century in England and from the late nineteenth century in the United States, many mural paintings in private homes featured European Renaissance themes. Contemporary cultural critics in both places lamented the fact that their countries had made great strides in military and commercial endeavours over the past few centuries, but had never reached the cultural heights of the Italian Renaissance. In 1908, quite likely in response to this type of criticism, Lynn Jenkins and Gerald Moira installed mural paint-

ings in the library of W.F. Unsworth's English home which illustrated Renaissance English literature, such as Robert Herrick's "Gather Ye Rosebuds While Ye May" (present location of murals unknown).[7] In 1910 American muralist Violet Oakley decorated the foyer of the Charlton Yarnall house in Philadelphia so that his family would appear to be connected to the culture and knowledge of ancient Greece and Rome, Renaissance Italy, and the modern world. In the stained-glass dome (destroyed), Oakley placed an image of a classical personification of wisdom. In the four pendentives, she painted images of historical architecture, such as an Egyptian pyramid and a modern skyscraper. In three lunette panels she painted three stages in the life of a man: *The Child and Tradition, Youth and the Arts,* and *Man and Science.* In the latter panel a man watches a biplane fly over the city of Florence, one of the most important cities in Renaissance Italy. In three octagon panels Oakley painted the Greco-Roman hero Hercules strangling a serpent (a popular ancient Roman theme), and other figures paying homage to the modern scientific advancements of radio, electricity, and aviation (mural paintings now in the Woodmere Art Gallery, Philadelphia).[8]

Some American mural painters employed French Rococo styles to decorate private homes. This use is not surprising given this style's association with the intimate domestic interiors of the eighteenth-century aristocracy. In 1924 muralist Everett Shinn decorated the dressing room of Mrs William Coe on Long Island (present location of murals unknown). Contemporary art critic Giles Edgerton eagerly explained that Shinn had "realized the French spirit so completely ... that he seems to be the Fragonard and Watteau of the 20th century."[9] Some newly wealthy Americans were so anxious to possess European culture of this type that they removed European mural paintings from their original settings and installed them in their own homes.

Mural paintings in private clubs in France, England, and the United States also regularly employed classical, medieval, and Renaissance themes. In 1854, for example, Dante Gabriel Rossetti and his associates painted scenes from Mallory's medieval tale, *Morte d'Arthur,* on the upper walls of the Oxford Union, a private club at Oxford University (*in situ*).[10] In 1903 Herbert Draper painted murals for the Drapers' Hall (no connection between the names), a livery club in London, England. Here he installed *Prospero Summoning the Nymphs and the Deities* on the ceiling of the club's main hall.[11] One English critic noted a relationship between material progress and this mural: "[It] is a sign that England ... is ... alive to the fact that the arts are not merely luxuries, but necessary servants to all the needs of life in a progressive country. When they are neglected, the standard of workmanship is lowered in a thou-

sand ways throughout a whole nation, and the dignity of independent labour declines at a rapid pace much to the injury of national character."[12]

From 1902 to 1904 Siddons Mowbray covered the walls and ceilings of the library of the University Club in New York with mural paintings in the style of Italian Renaissance muralist Pintoricchio (*in situ*). They represent the contents of the library – Old and New Testament narratives; classical allegories of music, rhetoric, and geometry; historical and romance literature; and portraits of famous "sages." One contemporary critic described Mowbray's work as "Old Italy in New York."[13]

Until the end of the nineteenth century, many private homes and some private clubs throughout Canada received similar mural paintings. Occasionally they were based on medieval history, but most often employed classical motifs or narrative themes. The amount of work commissioned in each region or province corresponds to its economic, social, and political situation (see chapter 2).

Private mural paintings were produced as early as the 1840s in the Maritime provinces. For example, between 1846 and 1848 an anonymous and likely untrained painter decorated the parlour of William and Hannah Croscup's house in Karsdale, Nova Scotia, with scenes taken from *The Illustrated London* (paintings now in the National Gallery of Canada, Ottawa).[14] The use of mural painting by middle-class individuals such as the Croscups draws this work into the parameters of the Mural Movement, which did, after all, begin in Great Britain and northern Europe in the 1830s. Still, the subject matter of the Croscup work, as well as its folk-art style, does not permit it to sit firmly within the movement, which functioned to glorify the salient features of the modern nation-state. Rather, it suggests a longing for the comparatively civilized world of England.

By the 1860s, however, mural paintings were being produced within the tenets of the Mural Movement for private sites in the Maritime provinces. For example, a number of homeowners in St John, New Brunswick, commissioned joyously classical mural paintings in the 1860s or 1870s, likely from itinerant Italian-trained artists. Some, such as those at 1 Prince William Street, which were more elaborate than others, were probably commissioned by the Moran family, wealthy St John shipbuilders.

The walls of the vestibule included two scenes of Cupid and Psyche in niches. Painted in *grisaille*, they were intended to resemble three-dimensional sculpture set in three-dimensional niches (for a similar mural painting, see fig. 31). The ceiling of the vestibule is painted in a classical / Renaissance style with feigned carved coffers and rosettes. The ceiling of the front half of the drawing-room, or parlour, has a painted cupid with symbols of the seasons

in each corner. It also has *trompe l'oeil* rope mouldings, leaf scrolls, and flowers painted to look like plasterwork in light grey and white, and four painted medallions, each with a female head. Possibly they too represent the seasons. In the centre of the ceiling is a band of naturalistic flowers in a gilded plaster moulding. On the walls below this ceiling are wide, rectangular, painted *faux* marble panels. In between are narrower rectangular panels containing painted fruit, vegetables, urns, jugs, and wine glasses, all suspended by ribbons (all *in situ,* although mural paintings that once decorated the dining room and the back half of the drawing room have been destroyed).

Two of Moran's Prince William Street neighbours commissioned similar mural paintings for their homes. The walls of the large double drawing room, or parlour, at Number 5 display *trompe l'oeil* architectural motifs. The ceiling has Renaissance-inspired grotesque faces and panels. Some of the panels contain painted blue birds; others have tulips, lilacs, roses, daisies, and zinnias. Other areas of this house, including the walls of the servants' staircase, were given *faux* marble panels. The person who commissioned these mural paintings was probably James Dever, a flour and wine merchant and a federal government senator.

This type of decoration – small depictions of flora and fauna as well as specifically classical motifs – was in vogue for many decades in the Maritimes. In the early 1900s another wealthy St John citizen had his drawing-room ceiling decorated with roses, cupids, and images of the four seasons. At this relatively late date it is not surprising that the artist also included local and contemporary images of Acadia University, a suspension bridge, and Niagara Falls (*in situ*).[15] At approximately the same time, elaborate mural paintings were installed on the ceiling and upper border of the walls of the drawing room of the manse of St James' Presbyterian Church in Newcastle, New Brunswick (later to become the home of Lord Beaverbrook).[16] They include landscapes and natural motifs such as birds and fruit (*in situ,* fig. 28).

Occasionally a medieval theme appeared in mural paintings in private sites in the Maritimes in the nineteenth century. For example, in 1890 George Lyons painted the medieval theme of *Elaine's Death* in the first-floor hallway of the John Wylie Churchill house in Hants County, Nova Scotia. It is a copy of Gustave Doré's engraving used as a frontispiece for the 1867 edition of Tennyson's *Elaine* (*in situ,* building is now the Hantsport Memorial Community Centre).[17] Most private mural paintings in Nova Scotia were, however, less elaborate. The artists, the majority of whom were itinerant or local amateurs – since there was not enough work of this type in the Maritimes to provide an artist with a living – simply covered small areas of

FIG. 28 Unknown artist, mural paintings, c. 1900, "Old Manse Library" House, Newcastle, New Brunswick

walls and ceilings with images of fruit and flowers by means of stencils. The occasional use of a cupid connected this work to the classical world.

Classical mural paintings were also done for many private sites in English Quebec from the 1860s until well into the twentieth century. Given the wealth of English Quebec, they were often more elaborate than those in the Maritimes. Sometime after 1861 a muralist decorated some of the principal rooms of the home of Sir Hugh Allan in Montreal (destroyed). They included *trompe l'oeil* architectural details, cupids, flowers, and garlands.[18] In 1902 Frederick Hutchison employed a Rococo style to paint classical nudes in the reception room of the Montreal house of Charles Hosmer, manager of the CPR's telegraph system (in *situ*).[19] In the early twentieth century an unknown artist painted the walls and ceilings of the breakfast room of Montreal's University Club to resemble a vine-covered bower, thereby relating the site to classical Dionysos / Bacchus (destroyed).[20] In 1918 Guido Nincheri decorated the grand salon of the "chateau" of Oscar and Marius Dufresne in Montreal with scenes that illustrated the classical legend of Orpheus (fig. 29 detail, *in situ,* now the Musée des arts décoratifs).[21] Nincheri also illustrated thirteen classical allegories in the boudoir of the same house.

The situation was quite different in French Quebec. Occasionally a French Canadian artist would paint murals for his own home, but the Catholic Church, which played a large role in secular life in the province, promoted the practice of piety in the home. Logically this support could have led to the installation of elaborate religious mural paintings in the home, but

the church's support for a rural, unostentatious lifestyle, as well as the relative lack of wealth among many French Canadian families, discouraged this lavish type of decoration.

Evidence of what the French Canadian Catholic Church did envision as suitable domestic decoration lies in a commission that abbé Albert Tessier gave to his friend Ozias Leduc, a well known artist and church muralist, in 1941. Tessier asked Leduc to create a relatively small easel painting that could be reproduced and distributed to propagate Catholic ideology in French Canadian households. In response, Leduc painted *Mater Amabilis (Beloved Mother)*. In this painting a mother sits at one side of a room, sewing as she rocks her child's cradle. At the other side is a vision of the Virgin Mary, who stands upright, holding Christ and looking down approvingly at the Quebec mother and child. An open door between the two figures provides a view of a rural French Canadian village, in which a church occupies the most prominent position. The room's sole form of decoration is a small, framed painting. A Crucifix hangs from the lower edge of the frame, indicating that the subject matter of the painting is Christian. Possibly it was meant to represent the

FIG. 29 Guido Nincheri, mural paintings, 1918, Château Dufresne, Montreal

Mater Amabilis itself. Leduc's painting suggests that the ideal French Canadian Catholic home was decorated not with mural paintings devoted to garlands and cupids, but with simple presentations of religious images. On the back of the reproduced image a prayer urged Quebec women to remain faithful to their domestic duties and their responsibilities as wives. As Esther Trépanier writes of this painting: "Here, we see the bases of the clerical-nationalist ideology – religion, family, nation." She goes on to explain the need for this type of image and prayer at this time. "Not only had industrialization and urbanization already weakened the traditional [French Canadian] family, but the advent of the Second World War took women into the factories and men to the front. In such a context, the devotion of young girls to Catholic virtues and family duties could no longer be taken for granted."[22]

Nor did private social clubs in French Quebec commission elaborate secular mural paintings. The Catholic Church in Quebec (and elsewhere) banned films, books, and many types of secular social activities that promoted lifestyles of which it did not approve. At the same time, because it was anxious to keep French Canadians away from English social activities, it operated its own social clubs or confraternities. These clubs met in Catholic Church buildings, and so did not commission any mural paintings of the type described above.

In Ontario, in contrast, many homes and clubs were decorated with mural paintings. Several examples exist from the 1860s and later, but it is likely that the practice began as early as it did in the Maritimes – in the 1840s. One of the most elaborate displays is still intact in an Italianate villa-style house built for James Livingston in Baden, Ontario, in the 1870s. Livingston was one of the first Canadians to capitalize on the utility of flax (linseed) in the manufacture of paint. He grew flax on his 3000-acre Baden farm and used it as the basis of his lucrative Dominion Linseed Oil Company, which he established in 1872. He also established four state banks in the United States and entered politics. In the early 1870s he served as local country reeve, from 1878 to 1880 as provincial member of parliament, and from 1880 to 1900 as a federal member. Jacqueline Hucker says of Livingston: he was the "quintessential nineteenth century businessman [who] paid homage to the product that made him rich by embellishing his house with superbly painted mural decoration."[23]

In 1878 Livingston hired an artist named H. Schasstein to paint murals for the front hall and adjacent library at his Baden home, known as "Castle Kilbride." They are the most elaborate work in the house and clearly display the classical interests of mural painters and their patrons at this time. In the lower part of the entrance hall, painted in relatively subdued colours, there is a *trompe l'oeil* colonnade, a feigned classical female sculpture in a niche

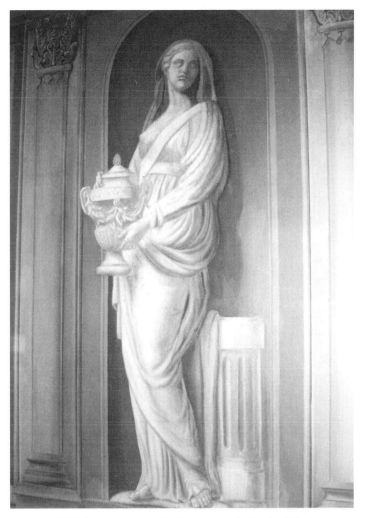

FIG. 30 H. Schasstein, mural painting, 1878, Castle Kilbride,
Baden, Ontario

(fig. 30), and a feigned *anthemion* floral border. On the glass dome of the
upper part of the entrance hall are classical allegories of the four elements:
air, fire, water, and earth.

The library is decorated in brighter colours. On the ceiling are various classi-
cal stencilled designs and stylized interlaced foliage. The foliage incorporates putti
that play lyres and a sunburst – attributes of Apollo, the Greco-Roman god of
music and culture. The library also has a remarkable *trompe l'oeil* frieze of fabric
tassels and, in the four corners, heads of the classical four seasons set in feigned gilt
medallions. In the centre of each long wall of the library is a narrative panel. One

FIG. 31 Mary Hiester Reid, *Castles in Spain*, 1896, Reid home, Toronto

represents the famous battle between Olympian gods and monsters; the other represents Zeus and Apollo in an Arcadian landscape, copied from Anton Raphael Mengs's *Parnasus* of 1761 for the Villa Albani in Rome.[24]

Other parts of Castle Kilbride were decorated over the next fifty years by unknown artists. They are less classical and less elaborate. For example, a small medallion with pipe and tobacco forms the main decoration of a small room on the second floor. Its size and location suggest that is was a "gentleman's dressing room." Grey-green arabesques and small landscapes, some of which were done as late as the 1920s, decorate the ceilings of the living and dining rooms (all *in situ*).

Many other houses in southern Ontario received similar decoration during the same time period. Those with their decoration still in place include John Livingston's in Listowel (James's brother), Robert McWilliam's in Drayton, Robert Scott's in Mount Forest, and two in Belleville.[25] Many, if not all, of the murals in the McWilliam house were likely painted by Josephine, Robert's wife.[26] They include portraits of late nineteenth-century Canadian politicians George Brown, John A. Macdonald, and Oliver Mowat and of English notables Queen Victoria, Prince Albert, and their son, Edward, prince of Wales. One portrait seems to represent Mary Queen of Scots.

Some mural paintings in private spaces in Ontario depicted Gothic themes. For example, in 1895 German immigrant artist Gustav Hahn painted Gothic images (destroyed) above the fireplace of the library at "Wymilwood," the Toronto home of Edward Wood. Wood was the vice president of the Central

Canada Loan and Savings Company and the developer of Dominion Securities Corporation. In these panels women in medieval clothing played medieval musical instruments.[27] In 1896 Mary Hiester Reid painted *Castles in Spain* for her home in Wychwood Park, Toronto (fig. 31).[28] Frederick Challener painted a medieval-style triptych over the mantel in the Toronto living room of Frank Stone at approximately the same time (present location unknown).[29] In the early twentieth century George Reid represented the voyage of the Vikings to North America in a mural painting for Toronto's Arts and Letters Club (*in situ*). Classical themes, however, were more popular than medieval ones for private mural paintings in Ontario and in other parts of Canada until well into the twentieth century. In 1911, for example, McGillivray Knowles painted seven panels with classical musical themes for the music room in "Ardwold," the Toronto home of Sir John Eaton (fig. 32, detail).[30]

Classical mural paintings also appeared in private sites in western Canada. In 1882 cherubs were chosen to decorate the reception room of the house of A.W. Austin at 122 Carlton Street in Winnipeg (destroyed).[31] In 1900 San Francisco artist William Schaefer decorated "Craigdarroch Castle" in Victoria,

FIG. 32 F. McGillivray Knowles, detail of *History of Music*, 1911, home of Sir John Eaton, Toronto

the home of Robert Dunsmuir, with mural paintings of cupids, roses, birds, and bees on the ceiling of the drawing room and fish and game in the dining room (murals destroyed). Dunsmuir had made his fortune from coal mining and from his position as overseer for the Hudson's Bay Company. Schaefer also painted murals for Dunsmuir's daughter's home, "Ashnola," in Victoria (both destroyed).[32] In 1913 the German artists Muller and Sturn painted Pompeian-style frescoes on the ceilings of the Victoria residence of William J. Pendray, who had made his money in soap manufacturing (*in situ*). According to a local newspaper of 1897, these artists had "worked in the largest castles and residences in Germany and Switzerland."[33]

After 1900 many muralists working in private sites in Canada turned from classical, medieval, and Renaissance themes to those of local importance, just as they did for their work in civic and commercial sites, and as muralists in other Western countries were doing. Some of the Canadian murals represented historical images; others represented contemporary activities. In both types, landscape often played a large role; this focus was not unexpected, given that the wealth that enabled Canadians to build homes and clubs for which the mural paintings had been commissioned came from the land. Furthermore, many Canadians had argued from the early nineteenth century that their culture was formed primarily by a history of the land, not by a history of the classical world. In 1926 Montreal architect and mural advocate Ramsay Traquair spoke against classical subject matter when he stated: "The man who does harm to the Fine Arts is not the wild cubist or futurist or vorticist, but the smooth classicist [who] sends us into a mental coma." Traquair referred to the writings of the popular English social critic John Ruskin and his promotion of nature study as a means of seeking God. Ruskin, Traquair reminded his readers, "brands [classical] Renaissance art as sensual, dishonest and immoral" (see chapter 9).[34]

This switch from classical, Renaissance, and medieval themes to local themes for mural paintings in private sites took place across Canada. In the Maritimes, for example, Charles Doyle, an itinerant painter, provided a seascape in 1907 in a naïve style for the first floor hallway of a house in Port Howe, Nova Scotia (*in situ*).[35] In the early twentieth century George Horne Russell painted two overmantle landscape murals for his home in St Andrews, New Brunswick (*in situ*). Between 1920 and 1931 Canon Harris, an amateur artist, provided the Masonic Lodge in Mahone Bay, Nova Scotia, with an idyllic pastoral landscape.[36] Just after 1926, American artist Lucille Douglass painted local landscapes for the meeting house of the Independent Order Daughters of the Empire in the same town (*in situ,* now the Niger

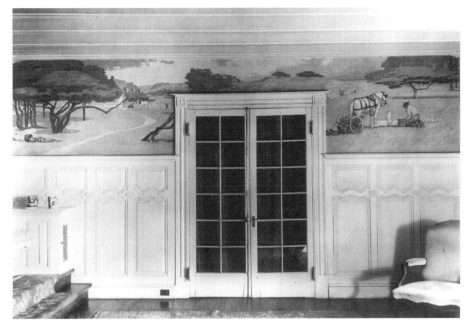

FIG. 33 William Brymner, mural paintings, 1899, home of Charles Porteous, Île d'Orléans, Quebec

Reef Tea House).[37] Given Ozias Leduc's interest in landscape painting, he too may have used landscape as subject matter for the murals he painted in the homes of the Kirk, MacIssak, and Thomson families in Antigonish between 1902 to 1903 (present locations unknown, probably destroyed).[38]

In English Quebec, Charles Porteous hired Montreal painter William Brymner in 1899 to paint murals for the dining room of his summer home at Sainte Pétronille on the Île d'Orléans (detail, fig. 33).[39] These murals represent four types of labour in four different seasons of the year, so function as modernized versions of the many classical and Renaissance mural paintings and other works of art devoted to the four seasons. Toronto muralist Harriet Ford painted an overmantle landscape for the same house (*in situ*). A few years later Brymner was hired to paint murals for the Île d'Orléans summer home of Sir Edward Clouson at St Anne's and for the nearby house of Clouson's daughter, Mrs John Todd. Two panels for Clouson's home depicted Canadian history (*The Order of Good Cheer and Frontenac Receiving the Envoy of Phips*). Another represented a woman and a little girl walking by a river in a large and imposing woodland setting (all three likely destroyed).[40]

In Montreal, in 1910, Maurice Cullen painted three impressionistic landscape murals (*in situ*) for the Arts and Crafts – style billiard room in the home

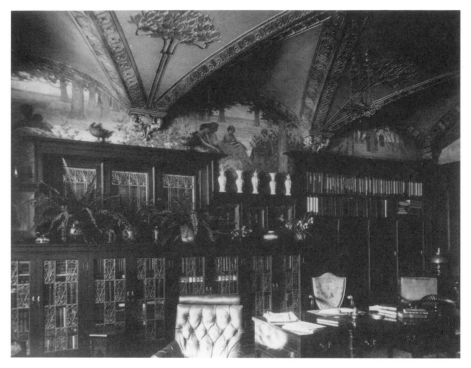

FIG. 34 George Reid, detail, mural paintings, 1899–1901, home of Byron Edmund Walker, Toronto

of James T. Davis, a prominent building contractor.[41] Cullen painted another landscape mural in the same style for the Montreal house of Richard R. Mitchell, the owner of a wrought-iron and brass company (*in situ*).[42] In 1927 Alexander Scott Carter painted a landscape map over the fireplace in the foyer of Montreal's University Club (*in situ*). It depicts the arrival of Jacques Cartier in Hochelaga (Montreal), his "discovery" of the Huron, and other events in miniature on a map of the region.[43]

Mural paintings of sylvan and pastoral landscape, such as Brymner's for the Charles Porteous house in Quebec, which evoked comparisons with ancient Greco-Roman Arcadia, were particularly popular in private homes and clubs in Ontario from the late nineteenth century. Gustav Hahn's medieval mural panel of 1895 for "Wymilwood" was accompanied by two Arcadian landscape panels. Similarly, Knowles's classical mural paintings for "Ardwold" have dominant landscape settings that look as much like Ontario as they do ancient Greece or Italy.

Between 1899 and 1901 George Reid painted an elaborate mural frieze, *The Scroll of Life,* for the library of "Long Garth," the Toronto home of

Byron Walker (fig. 34, now in the Art Gallery of Ontario). Here Reid translated the Renaissance theme of the passing of time into a contemporary Canadian idiom with the representation of a continuous pastoral scene at three times of day – morning, afternoon, and evening. In one panel a mother and child recline on the grass while another reclining figure plays a Pan pipe; in another, five youthful figures on the grass are engaged in conversation; and in a third, a group of philosophers on the grass converse with each other. Just after the First World War, Reid painted a deep landscape frieze devoted to spring, summer, and fall for the living room of H.H. Love, one of his neighbours in Wychwood Park (present location of the murals unknown). Reid had painted a mural with the same subject matter in 1899 for the summer home of New York lawyer Charles Russell in Onteora, New York (*in situ*), where he too spent his summers. He also designed many Arts and Crafts–style homes in Onteora, including Russell's and his own, and produced furniture and mural paintings for them.[44]

In 1909 John Beatty installed a large landscape mural over the fireplace and along the adjacent walls in the foyer of the Mississauga Golf Club. It represented Governor and Mrs Simcoe as they step out of a canoe on the Credit River in Mississauga (figs. 42 and 43). In 1916 Thomas Garland Greene painted murals for the Toronto home of his friend, Ernest C. Jury. They included images of a barn raising, a portage of voyageurs at sunset, fishing in a river, transportation of logs in a horse-drawn carriage, and log rolling on a river (present location unknown, possibly still *in situ*).[45]

In the spring of 1916 Tom Thomson, Arthur Lismer, and James MacDonald painted murals on the living-room walls of the summer cottage of Toronto ophthalmologist Dr James MacCallum at Go-Home-Bay, Ontario (all panels now in the National Gallery of Canada, Ottawa).[46] Although each panel was distinct in style and in subject matter, a low horizon line linked them all, so they appeared to be a frieze. Thomson painted decorative panels of local flora in an Art Nouveau style. Lismer painted *The Picnic* (fig. 35) and the *'Skinny' Dip,* both of which represent pleasurable activities on a sunny summer day against a pale-blue sky. Landscape dominates the human figures. The largest panel is MacDonald's *Inhabitants of Go-Home Bay* (fig. 36). It illustrates local flora – maple, birch, poplar, oak, sumac, and jack pine – and local history. At the left a Huron Indian is looking at a Récollet priest, who is teaching a Huron boy to read. Overlooking these two figures is French explorer Samuel de Champlain, who had spent some time in this area in 1615 with a Récollet priest. Further to the right are a fisherman (probably a portrait of Thomson who liked to fish), a trapper, and a lumberjack, who

appear to represent the sources of wealth that had existed in the area until the early twentieth century. Go-Home Bay had been the final stopping point for trappers before they returned home (see chapter 7).

In 1924 Sam McLaughlin, vice-president of General Motors, commissioned Frederick Challener to paint murals for the long hall on the first floor at "Parkwood," his family home in Oshawa, Ontario.[47] Challener painted the *Enchanted Woodland* on one large wall and on the surrounding areas of four doors and four windows on the other three walls (detail, plate 7, *in situ*). This mural provides a Greco-Roman, Arcadian woodland in which Pan plays the pipes while another faun watches him.[48] Just after Challener painted these murals, McLaughlin commissioned an Italianate garden for "Parkwood." This type of garden was based on Italian Renaissance garden designs that were closely linked to ancient Roman descriptions of Arcadia. Contemporary visitors to "Parkwood" clearly understood McLaughlin's associations. After journalist Mary MacPherson visited the garden she wrote: "A guest ... approaching the garden from across the wide law ... will suddenly find himself in a grove

FIG. 35 Arthur Lismer, *The Picnic*, 1916, summer home of Dr James MacCallum, Georgian Bay, Ontario

FIG. 36 James MacDonald, *Inhabitants of Go-Home Bay*, 1916, summer home of Dr James MacCallum, Georgian Bay, Ontario

of Arcady, with goddess, flowers, trees, pavilion and shadowy pools. His enchantment is complete."[49]

Challener may well have based his Arcadian murals at "Parkwood" on domestic mural paintings by English artist Frank Brangwyn. In 1895 Brangwyn painted two mural panels, *Music* and *Dance,* for the main foyer of a house in Paris, France (present location unknown). They represent a woodland in which a Pan figure plays the pipes and several women dance. Challener could easily have known of Brangwyn's work, since it was published in *Studio,* an art journal that many Canadian artists read.[50] Brangwyn's permits his figures and the classical associations to dominate the scene, as foreign muralists and pre–First World War muralists in Canada (including Challener) normally did. At "Parkwood," however, Challener did the opposite. He placed relatively small figures of McLaughlin's daughters and grandchildren in a springtime woodland setting. Through the use of local flora, he made it clear that Arcadia was also in Oshawa, and not only in some ancient time and culture. Birch trees composed of alternating patches of black and white predominate and provide a lively sense of rhythm to the overall scene, as do the trillium flowers. Toronto

FIG. 37 Unknown artist, mural paintings, 1912, Bidwell A. Holgate House, Edmonton, Alberta

artist Stanley Moyer wrote of these murals: "[They have a] delicate charm ... a freshness of colour and a note of joy that amounts almost to ecstasy."[51]

After these "Parkwood" hall mural paintings were completed, McLaughlin commissioned Challener to paint murals for the billiard room on the second floor (*in situ*). This deep frieze represents the outdoor activities – sailing, canoeing, horseback riding, and fishing – in which the McLaughlin family regularly took part. For these panels, Challener employed bright colours, an impressionistic style, and the linear surface effects of Art Nouveau – all of which provide a strong sense of energy. The colours of the foliage and the various weather conditions indicate the different seasons of the year. Thus Challener related his mural to the many representations of the four seasons from antiquity and the Renaissance, but he did so in a subtle manner permitting the McLaughlin family and Canadian identity to dominate.

Landscape mural paintings also appeared in private sites in western Canada after 1900. In Winnipeg an unidentified artist in 1907 decorated the walls of the living room of the home of Mr and Mrs R.R. Wilson with landscapes.[52] In Edmonton in 1912 another unidentified artist provided scenes of settlement in western Canada for a sitting room in the home of Bidwell A. Holgate (fig. 37). This artist (or another unidentified artist) also provided a forest of birch trees for the wall of one of the upstairs bedrooms (*in situ*). The

same artist likely provided the mural paintings in the nearby home of Holgate's architectural partner, William J. Magrath (*in situ*).[53]

Landscapes such as those at "Parkwood," "Long Garth," the Charles Porteous house, the MacCallum cottage, and the Holgate house may have been popular because they provided a response to Western culture's contemporary dilemma of domestic interior decoration. This dilemma arose in the mid to late nineteenth century as the function of the home changed significantly. Earlier in the century the home had been the private sphere in which an individual, in the language of the period, "developed character." By the late nineteenth century, according to Jürgen Habermas's theory of the merger of the public and the private spheres, the public sphere became dominant. It forced individuals to seek personal identity and self-expression within it. Concomitantly, the private sphere became less distinct from the public sphere and so, in a sense, merged with it. At this time the home took on a dual nature, a public cosmopolitan one and a private domestic one. This shift is symbolized in a concrete manner by the merger in the late nineteenth century of the formal front parlour (for visitors) and the sitting room (for the family) into the single space of the "living room."[54] As Janet Kardon states, in the late nineteenth century the home had to "[fuse] public and private concerns, domesticity and politics."[55]

This new dual nature of the home was reflected in the ardent contemporary debates that arose over domestic interior decoration throughout Western culture. On the one hand, time-honoured sources of advice such as the Bible discouraged lavish display in the home or anywhere else. English social critics John Ruskin and Matthew Arnold, whose work was widely read in all English-speaking countries, supported this point of view by denouncing lavish display as one of the many negative features of material progress. As an antidote, they suggested God's natural world with its opportunities to discover God's spirituality. In his widely read *Theory of the Leisure Class* of 1899, American social critic Thorstein Veblen even claimed that lavish display in the home contributed to the inequities of income distribution in the United States. It was immoral behaviour. Some social critics warned that these inequities would lead to the breakdown of basic structures of society. For example, American writer Edward Ross wrote: "Unless democracy mends the distribution of wealth, the mal-distribution of wealth will end democracy."[56]

On the other hand, lavish display as a form of interior decoration was widely encouraged as a microcosm of proclaiming material progress within a nation as a whole, at a time when material progress was regarded as an important type of social reform. In a sense, then, to display goods within the private sphere was a means of ensuring the continuity of material progress

and of working for the common good. New interpretations of the Bible even claimed that Christianity encouraged the display of material goods. An American, Daniel Seely Gregory, wrote: "The Moral Governor [God] has placed the power of acquisitiveness in man for a good and noble purpose."[57] Rags-to-riches novels and other forms of secular literature, including the many interior decorating manuals that appeared, made similar claims. Some cultural critics even suggested that the elaborate displays of department stores, world fairs, and museums, all of which glorified material progress, should be imitated by the householder.[58]

Rosalind Williams describes the same phenomenon in late-nineteenth-century France. There was an ambivalence, she wrote, that "formed a serious fault line in bourgeois culture. The desire [to display economic success] was justified by the scientific authority of evolutionary theory, which equated material and moral progress; the guilt [was] derived from religious and philosophical teachings of great antiquity, which upheld the virtues of austerity. Although modern science and traditional ethics were both respected authorities, in regard to consumption they offered conflicting and ultimately irreconcilable advice."[59]

The same debates over materialism, consumerism, and lavish display took place in Canada. In 1909 Montreal social critic William Monroe stated: "While the continued and increasing development of the vast and varied resources of our country is heaping up wealth at an enormous rate, and while the abounding prosperity of our country makes us rejoice, there are many signs in our midst that are undeniably disquieting. We have been trying to build up a civilization on individualism. It is this that has brought on our social crisis. We have an increasing, debilitating luxury that would outdo the Romans in the time of their decadence." [60] Monroe's argument was countered by Canadians such as the Reverend Thomas Kilpatrick, who, in an address to the Canadian Club of Toronto in 1905, stated: "Now wealth may be, often is, a very base and vulgar thing, and a very debasing thing in the make-up of a nation. But it need not be so ... it may be transfigured into a crown of glory – especially if acquired by diligence, and if it is distributed, not necessarily equally, but equitably – to be used in the service of humanity, to make life noble, more splendid and more magnificent."[61] Other Canadians joyously recognized the time in which they lived as "the age of the exhibition."[62] They were referring to the lavish agricultural, commercial, and industrial displays set up at public exhibitions and fairgrounds, which some social critics suggested as models for domestic arrangements.

Arguments in favour of lavish display dominated from the beginning and won in the end, as most individuals in modern societies succumbed to the

controlling pressures and values of consumerism. Still, ambivalence remained and remains. As American social historian Michael Barton explains: "Ambivalence about luxury is a national tradition. Americans have honored the rich and admired their possessions, at the same time imagining their corruption and comforting their enemies."[63] One way to deal with this ambivalence within the domestic space was, and still is, to decorate with an aesthetic sense – to apply an artistic or cultural veneer to decoration. Then, instead of merely displaying things or flaunting unmasked consumerism, the householder demonstrated a grasp of culture and verified a relationship with loftier and presumably more moral ideas. From the mid nineteenth century, this approach to consumerism was widely referred to as displaying "taste." The term was, and still is, frequently employed in decorating manuals and other guidebooks to home furnishings.[64] As American art critic Irene Sargent wrote in 1904: "The home as the greatest of social factors must then become a focus of art, but art in the new sense."[65]

One way for the middle classes to display taste in the nineteenth and the early twentieth century was to exhibit fine art and decorative art, including mural painting. From the second half of the nineteenth century another way to display taste – and one that also permitted the patron to reduce levels of ambivalence over materialism, consumerism, and lavish domestic display – was to use natural materials or images of nature, since nature was more difficult to associate with crassness. In 1882 the English writer Oscar Wilde gave a North American lecture tour on this topic (appearing in Canada in St John, New Brunswick). He urged his audiences to accept art in the home as a means of fostering morality and refinement. He also insisted on the use of natural materials, among many other things.[66]

To this end the British Pavilion at the Paris Exhibition of 1900 displayed an Arts and Crafts house made of natural materials as a demonstration of both national material progress and of national "taste."[67] For the same reason (and for other reasons relating to the domestic space as the female sphere), many homes from the late nineteenth century included natural objects, such as seashells, mineral specimens, and fossils, aquariums, terrariums, frames of pine cones, arrangements of dried flowers and leaves, indoor plants, floral wallpaper, and landscape paintings. Mural paintings devoted to the natural world, rather than antique, medieval, or Renaissance landscapes, would have provided "taste" for fine and decorative art as well as "taste" for the natural.

The foreign work of the Mural Movement, particularly that in England, France, and the United States – the countries whose mural paintings were

most familiar to Canadians – did not regularly employ dominant land-scapes for private sites. The classical tradition was too strong in France (and in other parts of Europe), while artists in England and the United States tended to look to Europe for models. In Canada, in contrast, artists frequently provided private spaces with mural paintings devoted to local landscape. These murals permitted their patrons not only to express taste by patronizing art but also to appear unconcerned with the crasser aspects of materialism. Concomitantly, and somewhat ironically, these mural paintings also glorified Canada's main source of material progress – the land. This self-presentation of Canadians as people with a deep connection to the land, and thus as less materialistic, especially in comparison with Americans, remains strong today, for it provides the basis of international advertisements to potential foreign tourists and investors and determines the choice of gifts to foreign dignitaries. In Challener's *Enchanted Woodland* mural for McLaughlin's house in Oshawa, the reference to material progress derived from the land was particularly ironic. The family fortune that paid for the installation of this representation of a local Arcadian scene came from an automobile factory. This fortune originated with the work of Samuel McLaughlin's father, an Irish immigrant farmer who burned the wood on the land he owned to turn it into potash.[68]

During the active period of the Mural Movement, many Canadians questioned (as they still do) the sincerity of this view of Canada as a New World Arcadia. In 1914, for example, Canadian humorist Stephen Leacock, who was also a political economist at McGill University and a former student of Thorstein Veblen at the University of Chicago, wrote the highly popular *Arcadian Adventures with the Idle Rich*. As Leacock satirized the lifestyle of wealthy citizens of a North American Arcadia, he might well have been describing McLaughlin's white neo-classical home, the expensive pastimes of his "valuable" children, his daily chauffeur-driven trips to and from the automobile factory, his membership in the private "Mausoleum Club," and the Arcadian refuges of garden and mural paintings, in both of which "the sunlight flickered through" (plate 7).[69]

The Mausoleum Club stands on the quietest corner of the best residential street in the City. It is a Grecian building of white stone. About it are great elm trees with birds – the most expensive kind of birds – singing in the branches. The street in the softer hours of the morning has an almost reverential quiet. Great motor cars move drowsily along it, with solitary chauffeurs returning at 10:30 after conveying the earlier of the millionaires to their down-town offices. The sunlight flickers through the

elm trees, illuminating expensive nursemaids wheeling valuable children in little perambulators. Some of the children are worth millions and millions ... There, in a lacquered perambulator, sails past a little hooded head that controls from its cradle an entire New Jersey corporation. The United States attorney-general is suing her as she sits, in a vain attempt to make her dissolve herself into constituent companies ... And through it all the sunlight falls through the elm-trees, and the birds sing and the motors hum, so that the whole world as seen from the boulevard of Plutoria Avenue is the very pleasantest place imaginable

.... When there are gala receptions at the club, its steps are all buried under expensive carpet, soft as moss and covered over with a long pavilion of red and while awning to catch the snowflakes ... Then indeed it is turned into a veritable Arcadia; for a beautiful pastoral scene, such as would have gladdened the heart of a poet who understood the cost of things, commend me to the Mausoleum Club on just such an evening.[70]

The "Disappearing" Native
in English Canadian Mural Paintings:
"But He Is Gone and I Am Here"

From the 1860s to the 1950s, English Canadian written accounts of Canadian history regularly claimed that Native Canadians had been materially unprogressive: they were either uninterested in material progress or incapable of taking part in it. Canadians of Anglo-Saxon ancestry, in contrast, had multiplied and prospered because they participated in material progress. Between the late 1890s to the late 1930s many English Canadian artists painted murals for civic, commercial, and private sites that supported these claims.

These mural paintings employed two basic types of images. In the first, both Native Canadians and Canadians of European ancestry (French and British) are present. The Canadians of European ancestry are represented as energetic figures engaged in materially progressive activities such as the exploration of land and waterways, agriculture, canal construction, and commercial transactions. The Native Canadians in the same scenes are represented as plodding assistants to, or awestruck observers of, the activities of the Canadians of European ancestry.[1] The activities in these mural paintings may be dated from about 1540, when Europeans began to come to Canada on a regular basis, to the mid to late nineteenth century.

In the second type of image, Canadians of European ancestry are represented just as they are in the first type of image, while Native Canadians are not represented at all. These scenes may be dated from about 1840 in eastern and central Canada, and from about 1890 in western Canada, to the time in which the mural was painted. This second type of image was often juxtaposed with the first type in a single mural program. Both types of images, alone or together, encouraged viewers to conclude that Native Canadians had begun to "disappear" in the middle of the nineteenth century and had completely disappeared

by late in the century. In fact, Native people had, in a sense, disappeared by the late nineteenth century, since the federal government had placed most of them on reserves. By not depicting this process, the mural paintings suggested that Native people had disappeared because they had not been interested in, or were unable to keep up with, material progress. In this way the murals glorified material progress, supported racial imperialism, and extolled the distinct identity of Western culture – all salient features of the modern nation-state.

Late-nineteenth- and early-twentieth-century Canadians of European ancestry who saw these murals knew that successive French, British, and Canadian governments had been involved from the seventeenth century in widescale efforts to place Native Canadians on reserves and to encourage or legislate them to adopt Western culture. These efforts intensified around 1840 in eastern Canada and around 1890 in western Canada as the richness of Canada's natural resources became more apparent. To enable these riches to be exploited and to discourage the Americans from taking over land in western Canada, the Canadian government lured British and European immigrants by promising this land to them. Correspondingly, by the late nineteenth century, the placement of Native Canadians on reserves was almost complete, while efforts to assimilate them were well under way. At this time the Canadian government also offered Native people the "opportunity to learn to become white" and to have their Native status removed.[2]

Most Canadians of European ancestry regarded all these procedures as a generous offer of material progress to Native Canadians and as a type of social reform. Since most Native Canadians rejected the offer, Canadians of European ancestry were able to supply the disappearance of Native Canadians – and the prosperity of Canadians of European ancestry – with a moral base. As Edward Said has explained, the power of the dominant culture blocks the narratives of the "other" from forming.[3]

The mural paintings that represented the "disappearance" of Native Canadians between the 1840s to the 1890s employed a variety of themes. One was the exploration and agricultural settlement of land. In George Reid's *Staking a Pioneer Farm* of 1899 for the foyer of the Toronto Municipal Building, for example, immigrant British workmen occupy the foreground as they survey land (fig. 38). In the background is a lone male Native who, appearing both awed and fearful, peeks out from behind the tree at the technical surveying equipment. Clearly this type of equipment is inaccessible and incomprehensible to him. More important, without it, he cannot lay claim to the land.

Contemporary viewers looked at this mural in just this way. Jean Grant, art critic for Toronto's *Saturday Night*, a magazine of general interest, stated

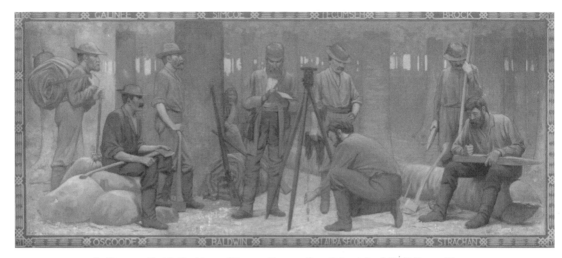

FIG. 38 George Reid, *Staking a Pioneer Farm,* 1899, Municipal Buildings, Toronto

within weeks of its installation: "[The pioneers] mean to take in hand this mighty forest, which the Indian has regarded as his, but whose possibilities for subsistence have never entered his simple mind ... Amazed and perplexed, the Indian, behind, views the operation."[4] For Grant, these circumstances were positive for all concerned. Several decades earlier historian John MacMullen seems almost to have envisioned Reid's mural when he wrote: "A poor and thinly-scattered community of improvident savages has been succeeded by an orderly, industrious, and enterprising people, whose genius and resources embody all the germs of a great nation."[5]

Arthur Lismer's mural paintings of 1927–32 for Toronto's Humberside Collegiate are based on a similar point of view (fig. 11). Proceeding from left to right through Lismer's panels, people of French ancestry conquer Native people; British people conquer the French and Native people; the British prepare the land for agricultural use; women care for and teach young children; and modern Western culture – including an airplane and a university graduate – develops. In the fourth panel, people of European ancestry hold axes and scythes in positions that indicate they are ready for action. They form a contrast to the Native man in the first panel who limply holds a hatchet down by his side. In the background of the fourth panel are two very small representations of Native people in historic dress. They have almost disappeared.

As one Canadian history book explained, "the Indian retreated before the axe of the settler."[6] "Patches of forest were occasionally cleared by [Indians] at an enormous sacrifice of time and labour, production results which are

now exceeded by a single backwoodsman in as many days."[7] This sentiment was reiterated until well into the twentieth century in Canadian history texts. In 1950 Donalda Dickie wrote: "Because of being uncivilized, our Indians could not make use of Canada's good farm land, nor of the other rich resources that nature had given her. To use these gifts Canada needed civilized people, and they were already at her door."[8]

Frederick Challener employed the same theme for one of eight painted mural panels he installed between 1906 and 1910 in the dining room of the Hotel Alexandra in Winnipeg.[9] As a program, the eight panels represented historical activities of local Native people, including religious rituals, the election of leaders, buffalo hunting, and fur trading with the Hudson's Bay Company. One panel, *Upper Fort Garry* (fig. 39), depicts a Native man seated at the edge of the forest and looking across a river towards Fort Garry. The river that runs between him and Fort Garry cuts him off from the material progress of people of European ancestry.

In 1923 J.E.H. MacDonald made use of the same theme for his oil sketch for a mural, *Friendly Meeting, Early Canada*. MacDonald's work was an entry in the Royal Canadian Academy's 1923 civic mural contest, the theme of

FIG. 39 Frederick Challener, *Upper Fort Garry*, c. 1905, Royal Alexandra Hotel, Winnipeg

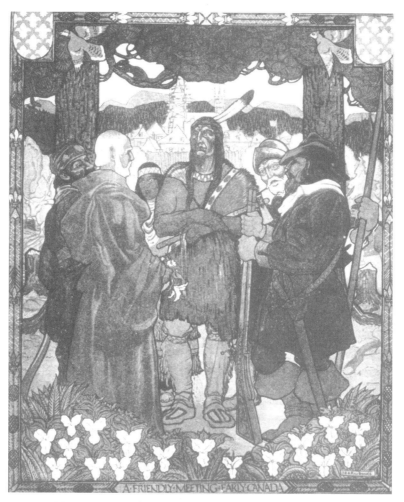

FIG. 40 J.E.H. MacDonald, *A Friendly Meeting, Early Canada*, 1923

which was the settlement of early Canada (fig. 40).[10] In this panel a Native Canadian stands in the centre of a wooded area, surrounded by four men of European ancestry. Behind the men are a European-style fort, a Native woman, and signs of Western agricultural practices (an oxen and felled trees). The men appear to be conversing. Given the theme of the competition, the title of MacDonald's panel, and the activities that MacDonald represents, it is reasonable to assume that the men are discussing the transfer of land from Native people to the Europeans and that the discussion is friendly.

However, the Native man looms over the four European men and exhibits a severe facial expression. With his frontal pose, he occupies more space than the other men. He appears potentially frightening and, in com-

parison, renders the Europeans as friendly. But the menacing Native is controlled compositionally by the four European men who surround him and by the fort that looms in the background. The Native woman wears a fearful expression on her face and appears uncomfortable in a space that suppresses her. With this composition, MacDonald clearly represented the power structure that existed between Native Canadians and Canadians of European ancestry both at the time of early settlement and at the time he painted this panel.

Other English Canadian mural paintings referred to the efforts that Canadians of European ancestry had made to persuade Native Canadians to practise agriculture and to become materially progressive. For example, one of Challener's Hotel Alexandra panels represented the Sun Dance of the Plains Native people. Many people who viewed this panel would have known that amendments of 1885 to the Indian Act of 1876 had effectively prevented Native Canadians from partaking in this dance and in other spiritual rituals. To participate in the Sun Dance, Native people had to come together in a single site for several days. But the amendments prevented Native Canadians from spending any length of time on reserves other than the one to which they had been assigned. These amendments were passed because the Sun Dance took Native Canadians away from agricultural production – from material progress – in the summer months and because its rituals were deemed certain to discourage assimilation into a Christian society.[11]

Many Canadians of European ancestry were convinced that the amendments to the Indian Act were beneficial to Native Canadians. Indeed, the amendments paved the way for Native Canadians to become materially progressive. As Nicholas North wrote: the sun dance "will soon be quite as much a thing of the past as the secret of fashioning arrowheads ... Only the older members continue ... The modern generation, for the most part, refuse to have anything to do with the pagan customs of their forefathers."[12] In the minds of many Canadians of European ancestry of this period, Native dances could and should simply be replaced by modern dancing, which took place as a form of leisure *after* materially progressive work was done. Undoubtedly, Toronto artist John Chester was influenced by this point of view when he painted a temporary mural in the 1920s, *Champlain Teaches Natives the Charleston,* for the Arts and Letters Club in Toronto (fig. 41, mural destroyed).[13]

Some Canadian mural paintings suggested that Native Canadians had no strong feelings about the confiscation of their land by Canadians of European ancestry for agricultural purposes. John Beatty's *Governor and Mrs. Simcoe*

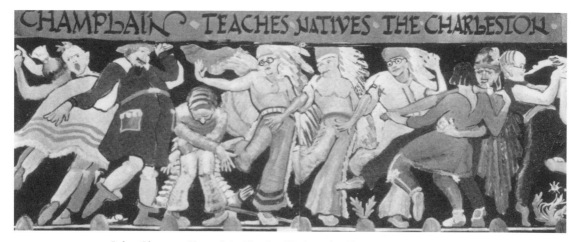

FIG. 41 John Chester, *Champlain Teaches Natives the Charleston*, 1920s, Arts and Letters Club, Toronto

FIG. 42 John Beatty, detail, *Governor and Mrs. Simcoe Paddled Up the Credit River,* 1908, Mississauga Golf Club, Mississauga, Ontario

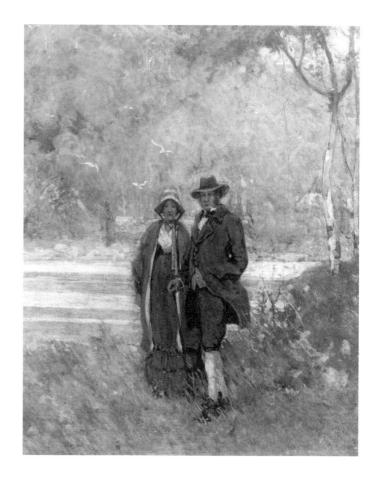

Paddled Up the Credit River of 1908, which he painted on the walls above and beside the fireplace in the foyer of the Mississauga Golf Club, is a good example (figs. 42 and 43). The land that this private club occupies, and through which the Credit River runs, once belonged to the Mississauga Native people. It was turned into farm lots for English immigrants approximately a century before Beatty installed his mural. In the centre of the mural, the Governor and his wife have just stepped out of a canoe onto a bank of the Credit River, an Arcadian setting bathed in the bright yellow sunshine of an impressionist palette. Native people are seated on the ground in front of birchbark wigwams, seemingly enjoying the balmy weather. They do not acknowledge the arrival of the governor, so they lead viewers to believe that the Mississauga people never challenged the takeover of their land. Yet, as Edward Said states, "Never was it the case that the imperial encounter pitted an active Western intruder against a supine or inert non-Western native; there was *always* some form of active resistance."[14]

Support for the belief that Native Canadians did not deserve land because they could not make "good use" of it, and did not need land because they would soon disappear, was widespread in Canada throughout the nineteenth century and until well into the twentieth. Ontario-born poet Charles Mair's

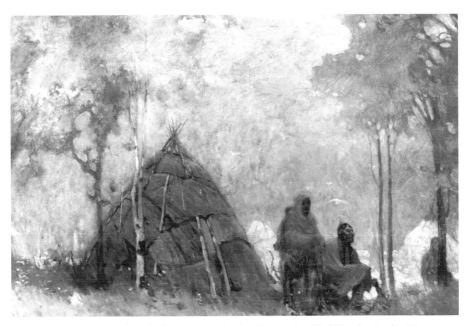

FIG. 43 John Beatty, detail, *Governor and Mrs. Simcoe Paddled Up the Credit River,* 1908, Mississauga Golf Club, Mississauga, Ontario

"Woodnotes" of 1868 is an early example of this view. It vividly evokes Beatty's mural as it expresses "glee" in the disappearance of Native people:

Here is a streamlet by whose side
The Naiads wandered long agone,
Ere old mythology had died,
And mankind's heart was turned to stone.
The Indian sought it year by year,
And listened to its rippling glee;
But he is gone, and I am here,
And all its rippling is for me.[15]

In 1933 Canadian anthropologist Marius Barbeau demonstrated the longevity of Mair's sentiment with an article entitled (erroneously, as it turned out) "Our Indians – Their Disappearance."[16] Stephen Leacock did the same in his history text of 1941:

There is little room for regret that the possession of her soil [has] been transferred to the Anglo-Saxon race, and that the rule of the fierce Indian has for ever passed away ... We think of prehistoric North America as inhabited by the Indians, and have based on this a sort of recognition of ownership on their part. But this attitude is hardly warranted. The Indians were far too few to count. Their use of the resources of the continent was scarcely more than that made by crows and wolves, their development of it nothing.[17]

Frederick Challener's representation of a buffalo hunt – one of the eight panels that he painted for the dining room of the Royal Alexandra Hotel in Winnipeg also depended on texts such as Leacock's. Hotel guests who viewed Challener's panel knew that the buffalo had disappeared from the prairies several decades before the murals were installed. To explain this situation to themselves, guests likely drew on information offered by most, if not all, Canadian history texts. These texts claimed that Plains Native people could no longer provide food for themselves because of a lack of intelligence, education, and ambition. As MacMullen stated: "Although vast herds of buffaloes traversed the prairies and forests of his nation land, [the Indian's] knowledge had not taught him to use them for the purposes of the dairy, nor to subdue them to the labours of the fields."[18]

This same sentiment informed the subject matter of George Southwell's mural panels planned in the 1930s (but not installed until the early 1950s) for the

pendentives of the dome of the main rotunda of British Columbia's Parliament Buildings in Victoria. They represent the contemporary industries of British Columbia – logging, fishing, mining, and agriculture (fig. 4, *Agriculture*). However, Native Canadians do not appear in these panels, even though many of them lived in British Columbia and worked in these industries at the time. Southwell's murals supported the idea that Native Canadians had disappeared by the 1930s.

Contrasts between Native and European modes of transportation offered muralists another means of demonstrating that Native culture was not materially progressive and, therefore, had to "disappear" or had "disappeared." For example, Arthur Crisp's sixteen-panel mural program of 1930 for the Foreign Exchange Department of the Bank of Commerce in Toronto begins with a depiction of a Native man (and a French Canadian or Métis man) in *Freight and Travel by Canoe* (plate 5). It ends with *The Empress of Britain: The Last Word in Ocean Travel* (fig. 20). Clearly, Native people had employed the same type of transportation for generations, while the British had developed larger and faster types.

According to Crisp's mural, French Canadians – of the post–British Conquest period – had been just as "unprogressive" as Native Canadians in terms of modes of transportation. Other Canadians of British ancestry extended this view, arguing often that French Canadians had not participated enough in material progress and that they, too, had to be assimilated. In 1931 Robert Watson, for example, explained that the use of canoes by Native Canadians and by "the light-hearted, loving and lovable, gaily bedecked" French Canadians had firmly ended.[19] As the American steel magnate Andrew Carnegie (who had just donated money to build over one hundred public libraries in Canada) said about modern technological development a few decades earlier, "The old nations of the earth creep on at a snail's pace; [modern ones] thunder past with the rush of the express."[20]

A similar reading may be taken from one of the panels of a large mural program executed in 1930 by Adam Sheriff Scott for the resort hotel at Lucerne-in-Quebec (now the Château Montebello, murals *in situ*).[21] Here Champlain makes an observation with an astrolabe on the Ottawa River while awestruck Native people watch. As one Canadian historian claimed: "[Indians] took no effective steps toward the building of craft that could be used on the two oceans that washed their shores. Had they done so, they would in all probability have come in touch with other civilizations and their whole isolated life would have been changed."[22]

Murals installed by Charles Jefferys in the writing room of the Château

Laurier in Ottawa in 1930 also called for recognition of the superiority of British waterway technology. One panel represents a Native man offering tobacco in ritualistic homage to the spirit of the local Chaudière Falls (fig. 44).[23] In another, English soldiers use mechanical equipment and massive cut-stone blocks to build Ottawa's Rideau Canal and control water for commercial purposes (fig. 45). The viewer might quickly suppose that the Native's unscientific attempt to control nature would result in failure, while that of the British would produce the desired effect.

George Southwell's panel *Enterprise* (fig. 2), painted for the lower level of the rotunda of the British Columbia Parliament Buildings in the 1930s, takes a similar approach. Here, men of British ancestry in a boat are about to push away from shore to take part in some materially progressive activity. On the dock, a number of Northwest Coast Native people stand or sit, with passive expressions on their faces. They are literally and figuratively being left behind. Two of the other three panels that Southwell did for the same space, *Courage* and *Labour (in situ)*, employed similar contrasts to suggest that Native Canadians did not have these qualities and could not be materially progressive.

The ability of Canadians of British ancestry to explore and conquer, and the inability of Native Canadians – and French Canadians in the face of the British – to do the same, formed the subject matter of murals that Jefferys and Challener installed in 1928 in Manoir Richelieu, a resort hotel at Murray Bay / Malbaie, Quebec, frequented by wealthy English Canadians and Americans.[24] Flanking an archway into the central lounge, the two panels depict *French Explorers at Malbaie, 1660* (fig. 46), and *Clan Fraser Lands at Murray Bay, 1760* (fig. 47). In the first panel, Native people sit on the ground at the edge of a forest, offering furs to the French. While one Frenchman makes the trade, others clear the forest with axes and prepare timber for construction. The region is called Malbaie. In the second panel, kilted Scottish immigrants have arrived. The Natives – and the French – have disappeared. Malbaie has become Murray Bay.

Challener's mural painting *Fort Rouillé* (fig. 48), installed on a wall in the main offices of Loblaws, a large Toronto grocery chain, made a similar statement.[25] First, viewers would have understood that the eighteenth-century French Fort Rouillé no longer existed and that the Loblaws office stood in its place. A modern English "trading post" had taken the place of an historical French trading post. This transfer of power was well represented on the site by a memorial sculpture to the fort that the City of Toronto erected in the late nineteenth century. At this time, anti-French sentiment was strong in Ontario. Presumably in response to this feeling, the city

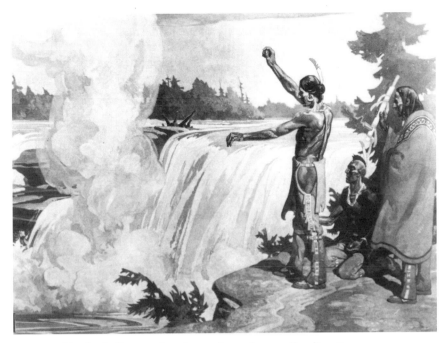

FIG. 44 Charles Jefferys, painted mural panel, 1931, Reading Room, Château Laurier Hotel, Ottawa

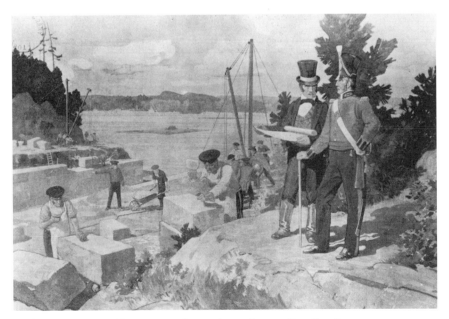

FIG. 45 Charles Jefferys, painted mural panel, 1931, Reading Room, Château Laurier Hotel, Ottawa

FIG. 46 Charles Jefferys and Frederick Challener, *French Explorers at Malbaie, 1660,* 1928, Manoir Richelieu Hotel, Malbaie, Quebec

renamed the site "Fort Toronto" and used this name on the sculpture, instead of Fort Rouillé. Moreover, a poem inscribed on the memorial (written by Sarah Curzon) argued that the "men of daring times," presumably the French, had "built our fortunes up / And poured into our coffers untold wealth / Wealth not all sordid, wealth of virtue's strain."[26] In other words, historical activities in French Canada had laid the basis for material progress in English Canada, but the French had now disappeared.

Challener's mural for Loblaws also suggests that European culture was superior to that of Native Canadians. The Native Canadians sit in a random arrangement on the ground at the edge of the forest. A French soldier stands in front of them. His body forms a bold, vertical, compositional element that is mirrored in the sturdy upright posts of the fort's wall and in the mast of a ship in the harbour. European culture is represented as strong, stable, and materially progressive, while Native culture is linked to the chaos of nature.

While Challener's mural provided a contrast between Canadians of European ancestry and Native Canadians in terms of material progress, the site on which the Loblaws office was constructed reinforced this contrast. By

FIG. 47 Charles Jefferys and Frederick Challener, *Clan Fraser Lands at Murray Bay, 1760,* 1928, Manoir Richelieu Hotel, Malbaie, Quebec

the time Challener painted *Fort Rouillé,* this site had been occupied for almost fifty years by the Canadian National Exhibition, the largest permanently held fair in the country (beginning in 1879 as the Industrial Exhibition).[27] From the middle of the nineteenth century, Canadians had participated at this fair and at many others across Canada in Western culture's enthusiasm for public exhibitions of agricultural, natural, and manufactured products as well as art. These fairs regularly featured various means of generating enthusiasm for imperialistic activities, including the display of indigenous colonial people and their artifacts along with the colony's natural products.[28] In all these exhibitions, artifacts associated with "primitive" cultures were presented as obsolete precursors of the work of "civilized" people. In contrast with exhibits of modern manufactured products, they supported recently devised theories of social and cultural evolution. They acted as signifiers of how far European and British cultures had travelled from "savagery."

In 1897 Canadian cultural critic Oliver Howland articulated and supported this type of display when he stated that Canadian exhibitions should "logically exhibit the traditions, arts and modes of life of the native tribes, the

FIG. 48 Frederick Challener, *Fort Rouillé*, 1928, Loblaws Office, Toronto

palimpsest upon which European colonization has written the later histo-ries."[29] His advice was taken for at least another half century. For example, in 1939 the exterior of the Canadian Pavilion at the New York World's Fair was decorated with two totem poles carved by Kwakiutl artist Mungo Martin, while the interior was treated with murals depicting Canada's indus-trial and commercial activities.[30] As visitors moved from the outside to the inside, the Native work disappeared.

Frederick Haines and Herbert Palmer employed a similar theme in 1929 for *The Settlement of Canada*, a mural of eight panels installed on the drum of the glass dome in the Dominion Government Building at the Canadian National Exhibition in Toronto (now in the National Trade Centre at Exhibition Place). Its subject matter was clearly related to the agricultural

FIG. 49 Frederick Haines, detail, *The Settlement of Canada*, 1929, Dominion Government Building, Canadian National Exhibition, Toronto

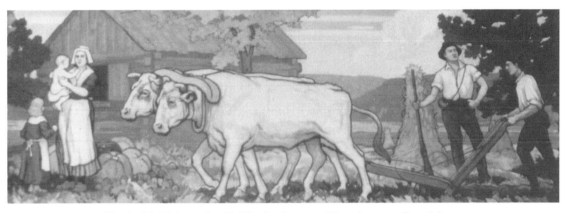

FIG. 50 Frederick Haines, detail, *The Settlement of Canada*, 1929, Dominion Government Building, Canadian National Exhibition, Toronto

component of the exhibition, since it celebrated the European takeover and subsequent agricultural use of Native land.[31] In one panel, two Native Canadians hunt buffalo against a background of wild prairie landscape (fig. 49). In another, a French man and woman arrive by boat on the banks of a river. In a third, a Canadian of British ancestry guides a plough pulled by two large white oxen (fig. 50). While the buffalo population had been reduced to the point of extinction by the 1880s, agriculture, the mural explained, was an ongoing and economically successful aspect of the Canadian economy in the 1920s. Moreover, people of British ancestry had replaced those of French ancestry, or so the mural seems to say. Visitors to an

exhibition that was largely concerned with the display of material progress were led to accept the futility of the Native way of life as well as that of French Canadians.

Other Canadian mural paintings suggested that Native Canadians were unable or did not want to govern themselves as they had once done – indeed, that they were pleased to be governed by Canadians of European ancestry. One of Challener's panels for the Hotel Alexandra, *The Government of the Indian Tribes*, represented Native people coming together to elect leaders. Since, by the time Challener painted this panel, Native Canadians did not govern themselves, viewers of the mural would have understood that Native self-government had failed. Canadian historical literature would have explained why. As MacMullen wrote in 1868: "Destitute of any form of local government, [Native people] knew nothing of the duties of the magistrate, and were left at liberty to follow the dictates of individual inclinations."[32] An Ontario school history text of 1910 concurred: "Under the system of responsible government, the condition of the Indians was greatly improved. As a result of the honesty and justice of our treatment of the Indians we have had none of the terrible wars which had disgraced the United States."[33] It was reasonable and admirable, a text written in 1912 declared, that "the Indian saw and felt the forms of British institutions, liked the principle of loyalty to a great King, and admired the strength of British love for law and order and for justice between races."[34]

George Southwell's painted mural panel of 1935, *Justice* (fig. 3), for the lower level of the rotunda of the British Columbia Parliament Buildings, illustrates this very belief. Here a man of Anglo-Saxon ancestry writes on a piece of paper. From the title it is reasonable to assume that he is a magistrate. Two colleagues flank him: one points to an image or reference on a page; the second sits with a book in front of him. Four Native men, with folded arms or arms not visible, quietly observe and accept the actions of the three men of Anglo-Saxon ancestry.

Many Canadian muralists formed a contrast between Native Canadians and Canadians of European ancestry by representing them in different positions: Native people seated on the ground and people of European ancestry in standing positions, from which they addressed the Native people. Thus the muralists created a contrast between nature and culture. Challener employed this arrangement for *Upper Fort Garry* (fig. 39), one of his eight panels for the Royal Alexandra Hotel in Winnipeg and for *Fort Rouillé* for the Loblaws office in Toronto (fig. 48), as did Beatty for his Mississauga Golf Club murals (figs. 42 and 43). George Reid made the same statement in his

Staking a Pioneer (fig. 38) for the Toronto Municipal Buildings and for the drawings he did for unexecuted murals for the same site (drawings now in the London, Ontario, Regional Art and Historical Museum). In Reid's drawings, Native people are seated on the ground listening to European explorers, who stand and read documents. Thus the Native, as nature, is addressed by the written word of culture.

Arthur Lismer also employed the nature / culture contrast for the murals he installed in Toronto's Humberside Collegiate (fig. 11). In the second panel, well below the upright soldiers and seated on the ground, are a Native man and woman. The man sits on a bearskin and demonstrates an association with the wild aspects of nature. The Native woman is modelled on one of Gauguin's Tahitian female figures, and so is associated with the supposedly "untamed" aspects of non-Western sexual practices. Contemporary history texts corroborated this view. The 1930 edition of *History of Canada for High Schools*, which was used at Humberside Collegiate, stated that "the Indian was, as it were, a part of the landscape."[35]

The most extensive Canadian historical mural program to contrast the lives of Canadians of European ancestry with those of Native ancestry is that installed by George Reid and Lorna Claire between 1929 and 1930 as a First World War memorial in the auditorium of Toronto's Jarvis Collegiate (fig. 12).[36] The program begins, at least chronologically, on the east wall with a representation of a Native women in an Indian village. There are no people of European ancestry in this panel. Presumably, it dates to a pre-European contact time period. This panel is the smallest one in the mural program and is situated in the most obscure part of the auditorium, under the balcony and on the lower level of a side wall where there are no other painted panels. Moreover, it was painted by Lorna Claire, a recent student of Reid's at the Ontario College of Art. She acted as Reid's assistant for the other panels, but was given this one panel to paint on her own. Thus, pre-contact Native culture in Canada – as well as female muralists – were rendered insignificant within the Jarvis mural painting program.

The Jarvis program originally continued chronologically, with *Ericson Discovering North America, 1000 A.D.*, likely on the upper level of the east wall high above the balcony (destroyed). On the south wall above the balcony is a long narrow frieze, *The Discoverers, 986–1610 A.D.* It represents European and British explorers with globes and compasses – Western technology – as they make their plans to come to North America. On the south wall below the balcony is a long, narrow frieze that represents *Champlain Ascending the Ottawa River, 1615*. From there the narrative moves to the west wall, on

which are depicted *John Cabot, Discoverer of North America, 1497; Jacques Cartier: Discovery of the St. Lawrence, 1534; Founding of the Hudson's Bay Company: Fur Trading in James Bay, 1668; United Empire Loyalists Ascending the St. Lawrence, 1783;* and *Alexander Mackenzie: Discovery of the Pacific, 1798.* Surrounding these panels are small painted scrolls with names of famous Canadian inventors, politicians, and industrialists of European ancestry.[37] These scrolls were painted by Claire. Finally, on the north wall, are *Patriotism* and *Sacrifice,* to the left and right of the stage.

In a now familiar arrangement, three panels depict the French in the seventeenth century. The next six represent the British from the late seventeenth century to the time at which the murals were painted, as they arrive in Canada, trade, command a large sailing vessel, conquer land "from sea to sea," and pay tribute to soldiers who died in the First World War. In the *Founding of the Hudson's Bay Company,* Native Canadians rush vigorously and enthusiastically towards the Hudson's Bay Company's ship – towards material progress, which arrives in the form of a commercial shipping company. Otherwise they sit on the ground, passively observe the arrival of the United Empire Loyalists, and look awestruck at Alexander Mackenzie's discovery of the Pacific Ocean.

In *Patriotism* and *Sacrifice,* people of British ancestry – soldiers, farmers, school children, men in academic gowns, boy scouts and girl guides – pay homage to the British and Canadian flags and refer to the acts of patriotism and sacrifice made by Canadians during the war. Native Canadians appear in all of Reid's historical scenes that are set in Canada up to 1798, but they do not appear in the contemporary representations of *Sacrifice* and *Patriotism.* Logically, some of the approximately four thousand Native Canadians who served in the war could also have appeared in these two panels.[38] The Jarvis murals state that Native Canadians, because they were materially unprogressive, had disappeared sometime between 1800 and the early twentieth century. It was during this time that the reserve system began to operate on a wide scale, that important aspects of Native Canadian culture were legally banned, and that the reserves were set up as training centres in which Natives could learn "to become white." In other words, it was quite possible for many Canadians of British ancestry to believe that, during this time, Native Canadians really had disappeared.

John Leman's mural painting of 1933, *Before the White Man Came,* for the Saskatchewan Legislative Building (plate 1) is much like that of Claire's panel at Jarvis Collegiate. Its represents a prosperous and peaceful Native village, but its title makes it clear that the village existed long ago. Otherwise,

its title would have been something like *A Prosperous Native Village*, a description that Canadians of European ancestry simply would not have understood in relation to a Native village in the 1930s. Given the recognizably progressive nature of the legislative site, Leman's mural stated, as did Claire's within its larger context, that Canadians of European ancestry had survived and flourished because they were materially progressive.

The murals that J.E.H. MacDonald and Arthur Lismer provided in 1916 for the summer home of Toronto ophthalmologist Dr James MacCallum at Go-Home Bay also document the disappearance of Native Canadians. MacDonald's panel (fig. 36) represents a seventeenth-century Catholic Récollet priest teaching a young Huron boy to read. An older Huron man and the seventeenth-century French explorer Champlain, who had visited the area in 1615, observe the priest and the boy. In two other panels for the same room, Lismer painted the contemporary arrival of the local cottagers' supply boat and their summer activities (swimming and picnicking, fig. 35). There are no Native Canadians in the contemporary activities, even though many lived in the area at the time the murals were painted.

At the same time, while accepting the widespread contemporary myth that Native people would soon disappear, many Canadians of European ancestry were eager to appropriate those aspects of Native culture they admired. In particular, in the face of an increasingly industrialized, urbanized, and secularized modern world, they valued aspects of Native spirituality. They also believed that this spirituality was theirs for the taking, just as the land had been. As a writer for *Canadian Forum* explained in 1927: "Perhaps all good Canadians are bound to have something of the Indian in them, having inherited his country and so put themselves in contact with that earth-memory of hers at which our mystics hint."[39]

In 1903 James Blomfield represented this type of appropriation with great flourish as he designed mural paintings for the ballroom of the lieutenant governor's house in Victoria, British Columbia (fig. 51). In each of the spaces between the five arches of the gallery, Blomfield placed a colossal figure of an Indian warrior with a tribal totem on his chest. Then he covered the Natives with garlands of local flora.[40] As these Native figures loomed over the ballroom, they must have appeared as protective totems for the guests of British ancestry.

In the late 1920s Frank Johnston employed Native images for the ten panels he provided for the boardroom of Pickering College, a private Quaker school in Newmarket, Ontario (*in situ*).[41] The design for British Columbia, for example, is a West Coast Native village with plank houses and totem

FIG. 51 James Blomfield, mural paintings, 1903, ballroom, Lieutenant-Governor's House, Victoria, British Columbia

poles. Presumably these images were chosen for a boys' school because, at this time, non-Native children, especially boys, were frequently urged to adopt particular characteristics, such as physical stamina, that non-Native people regarded as desirable and that they had attributed *en masse* to Native people. Therefore, non-Native children were encouraged to imitate the lifestyles of Native people by making campfires, sleeping in tents, paddling canoes, playing "Cowboys and Indians," and participating in the Boy Scout and Girl Guide organizations.[42]

In the early twentieth century, many Canadian hotels appropriated Native spirituality as they arranged for their guests to "become Indian" during their holiday – by camping "Indian style" and by observing Native rituals, especially dancing. They advertised this feature in newspapers, magazines, and posters.[43] At least one hotel also employed a mural as part of this campaign. In 1928 the Prince of Wales Hotel in Waterton Lake Federal Park, Alberta, commissioned nineteen Blood Indians to paint pictographs on the walls of the lobby/lounge (fig. 52, destroyed).[44] Traditionally, Blood and other Native Canadians obtained personal pictographs through spiritual visions, and painted them on their homes and other belongings. In this way

FIG. 52 Blood Indians, pictograph mural, 1929, Prince of Wales Hotel, Waterton Lake Provincial Park, Alberta

they and their families obtained the protective power of the spirit behind the pictograph.

When personal pictographs were painted on the walls of a public hotel, their protective powers, presumably, were thought to be transferred from the Blood to the hotel guests – or at least hotel guests would have been encouraged to see it that way. By the time the Blood enacted this "transfer," they had spent decades attempting to prevent a federal government takeover of their land – the land on which the hotel was situated. These attempts were in vain. The Blood were placed on a reserve located within the boundaries of Waterton Lake Federal Park.[45] The pictograph mural seems to represent a small-scale version of the larger loss of Native lands and lifestyles.

In conclusion, between the 1890s and the 1930s, many English Canadian muralists employed images of Native Canadians as foils to Canadians of European ancestry. The latter group was shown to have prospered as a result of their willingness to accept material progress. The former group was shown to have disappeared as a result of their lack of interest in, or inability to function within, material progress. At the same time, the Canadians of European ancestry were made to appear as if they were setting an example

for Native Canadians to follow. These new Canadians were depicted as taking on the "white man's burden" and "fulfilling God's purpose" by attempting to elevate "other" cultures to their own standards.[46] Because they appeared to themselves to be enacting a social reform for all Canadians, they were morally entitled to possession of Canada's land and the riches they could extract from it. As Toronto cultural critic William Sherwood wrote in 1893, "the art of the nation should reflect the genius of the race."[47]

Progress, Patriarchy, and Public Library Murals: "Whilst a Sweet-Faced Woman Finds the Books"

Modern Western nation-states began to take responsibility for public library services in the 1840s. Basically these services acted as a type of public education by providing reading material of both a practical and a literary nature. At the same time, public libraries worked until well into the twentieth century in a variety of ways – including the installation of mural paintings – to uphold the salient features of the modern nation-state. These characteristics, as we know, may be summarized as popular sovereignty, the material progress of capitalism, distinct identity, Christianity, and patriarchy.

Canadian public libraries, which opened around 1885, functioned just as foreign ones did. They dispensed books and, in various ways, until well into the twentieth century, supported Canada as a modern nation-state. As one Canadian social critic stated at the opening of a library in London, Ontario, in 1895: "We hope, round the altar here, that young Canadians will worship with a pure heart loftier ideals of national life."[1] Canadian social critics, like their counterparts abroad, offered explanations of how public libraries conducted this "worship of national life," presumably so the libraries would get full credit for this work. Not surprisingly, much of this Canadian rhetoric imitated that expressed by American social critics, for Canadian public libraries had close association with those in the United States.[2]

First, Canadian social critics, like those abroad, frequently reminded their audience that public libraries helped to safeguard democracy, or popular sovereignty. In 1908, for example, American artist Frederick Lamb explained that "men who would fit themselves for the most intelligent exercise of citizenship [politics] must acquaint themselves with the history of other countries and the development of republican institutions under other

conditions."[3] The public library, he claimed, was the best way to do so. In 1881 John G. Bourinot of Toronto, editor of *The Week*, stated that public libraries were necessary because "political freedom rests on a firm, broad basis of general education."[4] A few years later an editorial in the Hamilton *Spectator* declared that a library "will make people better able to govern themselves."[5] In 1907 George Locke, chief librarian of the Toronto Public Libraries, argued: The library "is the broadest of all democratic institutions; it is the most democratic of all our institutions; it levels rank by levelling *up* not *down*."[6]

Second, social critics explained that public libraries both represented and supported cultural and material progress, and that there was a symbiotic relationship between the two. Cultural progress, in the form of the library and the books, was dependent on taxes and individual philanthropy. The source of both was material progress. Concomitantly, material progress was dependent on the cultural progress of the public library, since public libraries organized and provided information of a technological and commercial nature.

John Cooper, a late-nineteenth-century Canadian social critic, neatly summarized this point of view when he claimed, in an article devoted to what he described as the astounding heights of Canada's material progress, "Now there are hundreds [of libraries]. [They] indicate progress."[7] An early twentieth-century American cultural critic explained in more detail: "It is the business of the free public library ... to maintain and develop [the intelligence of the workman]. Books dealing with practical matters will appeal to him, and in response to their influence he will become a larger man and a better workman."[8] George Locke publicly promoted the same idea in 1907 when he asked his audience at the Toronto Branch of the Canadian Club: "Where then is the boy to get the education that will ... enable him to progress in his work so that he may rise and be recognized? Modern industrialism exacts from the artisan and the worker in every branch increased skill and knowledge and the public library should furnish to the ambitious youth the *opportunity* to rise. Invention is the result of accumulated knowledge so that it may serve the ambitious one. The library is the depository of this accumulated knowledge."[9]

Public libraries in late-nineteenth- and early-twentieth-century Canada – and in other modern nation states – were also regarded as capable of curing social problems that had arisen as side effects of material progress.[10] In a sense, then, public libraries worked to eliminate hindrances to material progress. As Hamilton librarian Richard Lancefield stated in 1893, given a public educated by both schools and libraries, "there is little doubt but that many grave social problems which now threaten us with disaster would be peaceably and speedily resolved."[11]

FIG. 53 George Reid, *The Community*, 1926, Earlscourt Public Library, Toronto

A contemporary editorial in the Brampton, Ontario, *Conservator* of 1895 suggested that a public library would "keep some, at least, out of the bar rooms."[12]

Public libraries in Canada and elsewhere were also regularly assigned a direct role in the development of distinct identity, another feature of the modern nation-state. They promoted national literature, and they assimilated foreigners who used public library books to improve their ability in the language of the country to which they had immigrated.[13] Finally, public libraries supported patriarchy by regularly hiring men for supervisory positions and women for menial labour – and as maternal figures who supposedly would mould the characters of juvenile library patrons.

Many public libraries throughout Western culture were decorated with mural paintings designed to glorify some or all of these features of the modern nation-state. A few Canadian libraries were decorated in the same way. For example, between 1908 and 1914 in Ontario, Elizabeth Annie Birnie installed murals in the Collingwood Public Library (destroyed, subject matter unknown) and the Penetang Public Library (now in storage in Discovery Harbour in Penetang). The Penetang murals represent local historical events

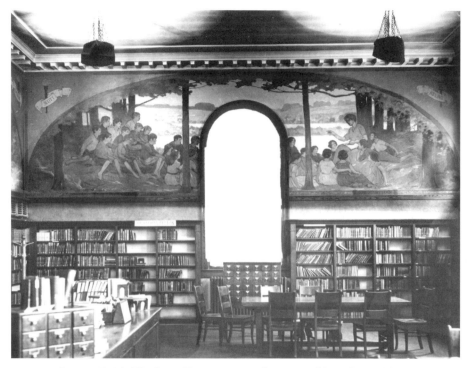

FIG. 54 George Reid, *The Story Hour*, 1926, Earlscourt Public Library, Toronto

set in landscape and lakeshore settings.[14] In 1920 Arthur Crisp decorated the reading room of the federal Parliament Buildings in Ottawa (fig. 10, *in situ*). This library was designed for the use of members of parliament and was private, but, given that the murals and the site itself were paid for with public funds, it is not unreasonable to include its murals in this discussion. Crisp's mural program, composed of seventeen panels, represents historical stages in the development of writing as well as landscapes that make reference to Canada's rich natural resources.

 In 1926 George Reid painted six panels on the walls of the general reading room of Earlscourt Public Library in Toronto. They represented men, women and children conversing, studying, and reading within landscape settings (fig. 53, *The Community,* and fig. 54, *The Story Hour*). In 1929 Lorna Claire painted illustrations of children's literature for the children's room of the same library (destroyed).[15] At approximately the same time, J.E.H. MacDonald's oil sketch for an uninstalled mural painting, *Friendly Meeting, Early Canada*, was hung over the fireplace in the same room. It represents the transfer of land from Native Canadians to Canadians of European ancestry in the seventeenth or eighteenth century (fig. 40).

These Canadian public library murals were designed for the same purpose as murals in foreign public library – to support the modern nation-state. Given the fact that many of the foreign murals were produced long before the Canadian ones, it is reasonable to assume that the Canadian artists considered the foreign work before they began their own. Indeed, Reid, and probably Birnie too, saw the mural paintings of the 1890s in the Boston Public Library and Washington's Library of Congress (see chapter 2 and below). Both may also have seen the mural paintings of around 1905 in the Ray Memorial Library in Franklin Massachusetts (*in situ*),[16] and Reid likely saw the mural paintings in the Bibliothèque Ste-Geneviève and the Bibliothèque Nationale in Paris and in the public library in Rouen (described below). MacDonald and Claire may also have seen foreign library murals. In any case, they and Reid would read about foreign public library murals in art periodicals that were available in early-twentieth-century Toronto. A survey of these periodicals reveals that they featured a number of French and American public library murals (although, curiously, no English ones) from approximately 1900 to 1930. Before considering how Canadian public library murals upheld the characteristics of the modern state, it is useful to look at French and American public library murals.

Some French and American library murals, such as those completed in 1896 for the Library of Congress in Washington (*in situ*), represent famous Western authors (and non-Western authors such as Confucius who had been absorbed into the Western canon) by means of portraits or names set within elaborate painted designs. These murals were designed to glorify distinct identity through examples of cultural production. Since private libraries belonging to aristocrats were often painted in the same way, this type of mural in a public setting identified public library patrons as the aristocracy of modern life – which in a sense they were.[17] Mary Antin, a Russian Jewish immigrant to the United States in the late nineteenth century, clearly understood this phenomenon when, as a child, she visited the Boston Public Library, which was extensively decorated with mural paintings. As she later wrote: "Did I not say it was my palace? Mine, because I was a citizen: mine, though I was born an alien: mine, though I lived on Dover Street. My palace – *mine*!"[18]

Other French and American public library murals employed classical Greco-Roman or medieval European themes to represent a sense of distinct identity. In the mid-nineteenth century Alexandre Desgoffe painted classical academic gardens for the foyer of the Bibliothèque Ste Geneviève and the Salle des Imprimés in the Bibliothèque Nationale in Paris (both *in situ*). In the 1890s the Boston Public Library commissioned French muralist Pierre

Puvis de Chavannes to paint classical personifications of various types of knowledge – such as chemistry – on the walls above the main stairway (*in situ*). It also commissioned American artist Edwin Austin Abbey to paint the popular medieval tale of the quest for the Holy Grail on the walls of its Call Room. A few years later Flower Memorial Library in Watertown, New York, commissioned George W. Breck, Ella Condie Lamb, and Frederick S. Lamb to install murals that represent classical personifications of different types of literature (*in situ*).[19]

Some foreign public library murals, especially those done after 1900, represented local historical events that had led to the formation of the boundaries of a modern nation-state. and thus to independence from other countries. In 1923, for example, Edwin Blashfield and Gari Melchers painted scenes of exploration and conquest in the Detroit area on the walls of the main stairway and the adults' reading room in the new Detroit Public Library (*in situ*).[20]

Occasionally foreign public library murals even extolled Christianity as an aspect of distinct identity. John Singer Sargent was commissioned in 1893 to paint the hall leading to the Special Collections Room in the Boston Public Library with a history of Judaism and Christianity (*in situ*, not completed). Entitled *The Triumph of Religion,* it depicts a chronology of religions, moving from Egyptian and Assyrian to Jewish and Christian. It suggests, even though there is some evidence that this was not Sargent's conscious intention, that Christianity was a glorious culmination of religious development.[21]

Some French and American public library murals directly glorified material progress. In the late nineteenth century Paul Baudoüin painted a history of the written word, moving from stone tablets to the modern printing press, above the main stairway of Rouen's public library (*in situ*). This mural and others like it, for example, Edward Laning's of the 1940s for the New York Public Library (*in situ*), were necessarily glorifying cultural progress at the same time. It is reasonable to state that public library murals of this type illustrated the symbiotic relationship between material progress and cultural progress that commentators so frequently and happily explained as the foundation of the public library (and other important aspects of modern life).

Finally, French, American, and other foreign public library murals supported patriarchy, another feature of modern nation-state until well into the twentieth century. Some of these murals supported patriarchy by representing male authors, to the exclusion of female authors, in scenes devoted to cultural progress. Others did so by representing men as medieval scribes, as operators of printing presses, to the exclusion of women who did the same

work. Many of these murals, especially before 1900, also included female figures as personifications or as muses for, or abstractions of, male genius.

Canadian public library murals performed the same functions. Elizabeth Annie Birnie's murals for the Penetang Public Library between 1908 and 1914, and MacDonald's mural sketch of 1923 in Earlscourt Public Library, represented local historical events associated with material progress, just like Blashfield's and Melchers' murals at the Detroit Public Library. Lorna Claire's illustrations of famous children's literature refers to cultural progress, just as Pearce's did in the Library of Congress.

At first glance, the activities in Reid's murals for the main reading room at Earlscourt may seem different from the other foreign and Canadian public library murals. On a superficial level they are. They represent contemporary, ordinary, unidentified men, women, and children engaged in relatively mundane activities, some of which do not immediately convey any information about a public library. Over the fireplace on the east wall, Reid painted *Family,* with six people of various ages conversing in a garden setting. In the centre of the south wall he painted *The Community* (fig. 53), with a young man reading to a group of people of various ages seated on the ground. On one side of *The Community* was *Nature Study,* in which a woman and a group of children sat on the ground and examined plants. On the other side was *Philosophy,* in which older people were engaged in serious conversation. In *The Story Hour* (fig. 54), which filled the upper level of the west wall, a woman read to a large group of children.

However, these activities are not very different from those represented in many foreign public library murals. Reid stated that the activities in his murals were educational features of "an ideal community."[22] In other words, he said that, in an ideal community, people of all ages take part in reading, studying, and intellectual discussions, all of which are educational. At the same time, Canadian (and foreign) social critics regularly described the activities of public libraries as sources of public education, while public education was widely regarded as the main source of culture. As Toronto's chief librarian George Locke claimed in 1909, the public library was "a living, civilizing social force in the community, recognized as having rank with the school and the church."[23] The activities in Reid's Earlscourt murals, then, were designed to represent cultural progress, just as many foreign public library murals were, even though the foreign libraries represented figures who were famous or from more exotic time periods.

Still, Reid's Earlscourt murals deviated from foreign public library murals by employing prominent and sometimes even dominant landscape settings

(*The Community* and *The Story Hour*).[24] On the north wall, which is not seen in the photographs, Reid painted a large and "continuous stretch of sylvan woodland, into which the sunlight breaks in flickering spots."[25] In *The Community* and *The Story Hour*, which represented public readings, he painted a river or lake behind the figures and pastoral farmland beyond the river. Normally public readings, which *The Community* and *The Story Hour* must represent, took place indoors. But, even if they did occasionally take place outdoors on a warm day, they did not happen in the woods or at a farm.[26] At the same time, all the activities in the other populated panels (except nature study) could just as easily have been placed in indoor settings. Therefore, it is only reasonable to assume that Reid chose the landscape settings with a deliberate intent. An examination of Charles Sprague Pearce's murals in the foyer of the Library of Congress in Washington, which Reid had seen and publicly praised, and likely used as models for his Earlscourt murals, supports this assumption. [27]

Pearce's program consists of seven panels with painted semicircular frames. Reid's consists of six panels with painted semicircular frames. All of Pearce's panels are surrounded with the painted names of famous European, British, and American authors and educators, while all of Ried's are surrounded with the names of famous English authors. Pearce depicted people of various ages engaged in educational pursuits, as did Reid. One of Pearce's panels is entitled *Study,* while one of Reid's panels is *Nature Study.* Both Pearce and Reid include a panel entitled *The Family.* In Pearce's *Religion* a young man and woman worship at a makeshift outdoor altar. They appear to be worshipping nature. There is a visual relationship between this panel and Reid's *Nature Study* panel. In Pearce's *Study* one woman holds a book and reads to another. Similarly, in Reid's *Story Hour,* a woman holds a book and reads to others.

Furthermore, the official guidebook of 1901 for the Library of Congress stated that Pearce's panels provided images of "an Arcadian country."[28] Arcadia, as a mythical location for people of ancient Greece and Rome, was composed of sylvan (wooded) and pastoral (agricultural) land. Correspondingly, Pearce dressed his figures in ancient Greek style clothing and set them in landscapes. Reid, too, placed his figures in Arcadia, albeit a modernized and local one, by providing them with both sylvan and pastoral settings and by describing his largest panel as "sylvan." There can be little doubt, then, that Reid consciously modelled his murals after Pearce's.

However, while Pearce permitted his classical figures to dominate Arcadia, leaving relatively little space for landscape, Reid permitted Arcadia to dominate his contemporary figures. Since Reid used Pearce's work as a

model, Reid can only have made these changes after some deliberation and with a particular intent. Given the strong association between material progress in Canada and the land of Canada, these settings must have been employed as signs of material progress. Given that the activities within Reid's murals clearly represent cultural progress, it is also reasonable to conclude that Reid intended his Earlscourt murals to represent the symbiotic relationship between cultural and material progress, just as many foreign murals did.

Reid could have employed an ancient setting, as Pearce had done, and still have made the same comment on material and cultural progress. However, he likely rejected the classical world because, working approximately thirty years after Pearce, he would have been aware of contemporary cultural critics, including many in Canada, who argued that the classics had little relevance to modern life. Indeed, many Canadian commentators had argued from the early nineteenth century that historical studies of the exploration and cultivation of Canada's land should replace the study of the classics.[29] Finally, Reid may have been persuaded to reject a classical setting by the intense criticism that the prominent classical features of the Library of Congress murals had engendered shortly after their completion in 1896.[30]

In the same way that Reid's mural paintings at Earlscourt worked to represent a symbiotic relationship between material and cultural progress by means of images of ordinary people engaged in ordinary activities within local landscapes, they also supported patriarchy. Reid's murals reinforced the position that contemporary Western power structures maintained in relationship to gender. In *The Community,* Reid painted a male figure in the upright pose of a lecturer who read to his seated listeners, and so was involved with the education or culture of adults. Given the library setting of the murals, this figure must have been a librarian or a library board member, both of whom gave public readings to the general public. For his efforts, this man received (perhaps accidentally) a small halo created by the shape of the branch above his head. In *The Story Hour* and *Nature Study,* a woman worked with a group of children. In the former panel the woman was likely a librarian, since female librarians regularly provided children with a story hour. In the latter panel she may have been a librarian or a teacher. In both panels the female figure sat on the ground, confirming the strong link that Western countries made between women and nature.

It might seem as if this traditional gender-based division of labour would not have affected public libraries – and their mural paintings – since public libraries were not established until the modern period. Furthermore, since their inception, public libraries had hired more female employees than

male.[31] However, for a number of reasons, this division of labour did affect public libraries when they opened, and for a long time afterwards.

Library workers were hired by members of boards established by town councils. Since members of town councils were always male until after women were enfranchised, and since the work that library board members did was governmental, and traditionally done by men, town councils normally appointed men rather than women as board members until well into the twentieth century. When these male board members first came to hire library workers, they could not have demanded that applicants have professional training, since library schools had not yet opened.[32] Therefore, they had to compose their own job descriptions. Very quickly they decided that the ideal library worker would have a good general education, be "refined," and be capable of "uplifting" the working classes. As Boston social critic Lloyd Smith declared, librarians "should belong to the Brahmin caste."[33]

At the same time, board members decided that library workers in supervisory positions should be male, while library workers in lower-level positions should be female and unmarried. This decision was based in part on tradition, which required women, when outside the domestic sphere, to be supervised by men. Furthermore, most men were more highly educated than most women. At first, men too did not have university degrees in library work, since these degrees were not established until later, but they had graduate university degrees in related fields such as literature and in professions such as the ministry, which were not available to women at this time.

Economics also played an important role in the decision to give supervisory positions to male library workers and lower-level positions to women. Libraries required a large amount of paper work and, therefore, a relatively large number of employees. As library collections grew and cataloguing systems became more complicated, more and more workers were needed. If males had been hired for these positions, they would, as financial providers for families, have demanded relatively high salaries, which members of library boards were not willing to pay. Unmarried superior women would not need salaries as high as those of married men, or so it was believed, while married women of this type were not supposed to work. Dr Samuel May, a library consultant for the Toronto Department of Education at the turn of the century, expressed his satisfaction with this arrangement when he stated that female librarians "can be employed at a far less cost."[34]

Essentialist arguments were also frequently used to hire women rather than men for lower-level library positions. Women were considered better at the small details of clerical work. Their personalities, too, were deemed

more suitable. The security that tradition offered – at a time when modernity enforced so much change – encouraged both female and male librarians to support these arguments. As American librarian Mary Fairchild claimed in 1904, the female librarian's "broad sympathies, her quick wits, her intuition and her delight in self-sacrifice give her an undoubted advantage."[35] Mary Black, a librarian in Fort William, Ontario, in the early twentieth century, held the same opinion. As she wrote: "If [a modern librarian] were asked to enumerate the qualifications necessary for successful librarianship, he would surely put the spirit of service and knowledge of people even before a knowledge of books and all three would precede an acquaintance with library technique and business training."[36]

Traditional views of women as caregivers and as more spiritual beings than men also supported the hiring of women rather than men for lower positions in libraries. Librarian Richard le Gallienne stated that "books ... should be tended by reverent hands ... should be given out as a priest dispenses the sacrament, and the next step to this ideal ministry is to have them issued by women."[37] Charles Cutter, an ex-preacher turned librarian, referred to library users as "patients" and to librarians as "literary physicians" who "must be able to administer from the bibliothecal dispensary just that strengthening draught that will suit each case."[38] Ironically, le Gallienne and Cutter were suggesting that women should take on some duties of the very professions that denied women easy access until well after the Second World War.

As public libraries opened children's departments at the turn of the century, largely as a result of newly developed studies in child psychology, women were assigned to work in them on the bases of their "essential maternal instincts."[39] One female American librarian claimed that women alone have "that kind of sympathetic second-sight which shall enable her to read what is often obscure in the mind of the child."[40] In Canada, Walter Nursey, an inspector of Toronto public libraries, suggested that young library patrons should have "a room in the sunniest corner of the library ... whilst a sweet-faced woman helps them find the books they want and introduces them to the world of the great and the wise."[41] Aletta Marty, the first female school inspector in Canada, concurred with Nursey when she stated that there is "a power that is biologically instinctive in the hearts of all women. The woman who finds maternity in marriage has perhaps the best opportunity to develop this moral power." Women who do not marry (as she did not), Marty advised, should find opportunities to display the same power in fields such as teaching.[42]

Children's librarians, who almost by definition were female, were charged not only with guiding children's reading but also with entertaining children

and moulding their characters. As American librarian Clara Hunt claimed in 1899, the librarian could control children's "habits of thought, their personal cleanliness [and] the whole trend of character development."[43] In other words, the female librarian was to take on the traditional role of mother. The story hour, as depicted in one of Reid's panels for Earlscourt, was an important part of the public library services that female librarian provided.

According to Canadian librarian H.M. Wodson, the object of the story hour was "to develop in children a taste for books which will give them an insight into a greater world than that in which they spend their little day ... A properly conducted Story Hour is a character moulder, an entertainer, an instructor. The evils of the street are counteracted, the precepts of the home and the teaching of the school are extended, and the child is given excellent mental discipline."[44] In other words, the story hour would begin to perform for children all the tasks that the library would eventually perform for adults. It would make them productive, law-abiding citizens who understood the value of and the relationship between cultural and material progress.

As female librarians worked to fulfill all these feminized roles, the austere custodial image of libraries began to be replaced by a "homey" atmosphere that established the female librarian as a wife/mother/housekeeper/host. Both men and women promoted this role. In 1905 American librarian Virginia Graeff argued that a librarian should "do the honors of a library as a hostess."[45] Lawrence J. Burpee, an American civil servant who reviewed the state of Canadian libraries and the status of Canadian librarians, similarly wrote: "The librarian should meet the reader in the position of a host or hostess welcoming a guest."[46] In 1889 American librarian Lilian Denio suggested that library reading rooms should have "a bright carpet on the floor, low tables, and a few rocking-chairs scattered about; a cheerful, open fire on dull days, attractive pictures on the wall." Denio then added, "and one can imagine a lady librarian filling the windows with plants."[47] The general reading room at Toronto's Earlscourt Public Library, with its fireplace and Reid's mural decorations, certainly fulfilled Denio's ideal library.

It is true that, by the time Reid installed his murals at Earlscourt, women in many Western countries, including Canada, had been enfranchised, partly as a result of their work in the war and partly as a result of lobbying. It is also true that at this time more and more middle-class women – the type of woman who was hired for library work – were working outside the home, partly because of their war work and partly because of rapidly expanding postwar economies in Western countries.[48] However, the belief that a woman's place was in the home received new strength in the postwar period

throughout Western culture. Many men and women argued that, with the end of the hostilities and the return of the men, middle-class women should cheerfully surrender their newly acquired positions outside the domestic sphere.[49] As a Canadian government poster campaign of the period boldly asked: "Do you feel justified in holding a job which could be filled by a man who has not only himself to support, but a wife and family as well? Think it over."[50] The war, with its thousands of lost lives, had enhanced the image of motherhood. If women had to work they were urged, as before the war, to seek "feminine" areas of employment such as teaching, nursing, and library work – traditional women's work that had been done in the domestic sphere and had simply moved to a public sphere.

Many women in the 1920s were happy to do just that, since they still valued the security that a patriarchal society could offer at times of intense social change. As one Canadian woman stated in 1918 in *Woman's Century*, women should work "to improve education, to beautify the home, and to develop local talent in literature, music and the finer things of life."[51] *Woman's Century* was the official publication of the National Council of Women of Canada, an organization that, among other things, worked to promote nationalistic sentiment as a means of strengthening the material and cultural progress of the modern nation-state. Its very title suggested that the twentieth century was one in which women would accomplish great things, but clearly its articles could suggest that one of these "great things" would be the maintenance of patriarchy.

Libraries in Canada and elsewhere in the 1920s were simply microcosms of the larger society of which they were a part. It is true that a larger number of women were occupying supervisory positions in libraries, while professional university library training had become available to both men and women. Moreover, some female librarians were questioning their lower pay for equal work and their lack of advancement to senior positions.[52] Still, many female library workers held the same point of view as the 1918 contributor to the *Woman's Century*. Often they compensated themselves by declaring in so many words that "devotion was its own reward," just as they had before the war. As journalist Ena Kirker admiringly wrote in 1927 about Canadian librarian Mary Black: "[She] belongs to no unions and does not work an eight hour day. Her day is a twenty-four hour one."[53]

Ramsay Traquair, a Montreal architect and a strong advocate of mural painting, neatly summarized this point of view in two articles he wrote in the 1920s. In 1923 he published "Women and Civilization" in the American magazine *The Atlantic Monthly*.[54] Here Traquair maintained that women could not excel in music, art, architecture, science, religion, or teaching male

students because they were not capable of the abstract thinking and high degree of imagination these fields required. Women could do well in business, social work, medicine, "literature that commented on life and society," and the teaching of female students, he argued, because these other fields required organizational and social skills with which women were naturally gifted. He concluded by stating that modern life had become unbalanced as a result of women's involvement in areas for which they had no innate skills. As a result, material prosperity was in decline. Three years later Traquair wrote another article, "Mural Decoration," as a promotion of civic mural painting. He illustrated it with Reid's Earlscourt murals.[55] It is easy to imagine that Reid's work, with its representation of the symbiotic relationship between material and cultural progress, and its clear relegation of the female librarian to the juvenile patrons, appealed to Traquair

This feminist reading of Reid's murals also provides a framework through which to look at Lorna Claire's mural paintings for the children's reading room at Earlscourt Public Library and at J.E.H. MacDonald's mural sketch that was hung over the fireplace in the same room. The conditions under which Claire produced her painted illustrations of children's literature for the walls of the children's room are not known. Given her acceptance of the Earlscourt commission, it is reasonable to assume that she believed in the importance of mural painting for a modern nation-state. However, she seems not to have worked as a professional mural painter before she came to Earlscourt in 1929 (unlike Reid and MacDonald), and seems to have had very little experience as a professional artist at all. Nor had she publicly supported mural painting, as Reid and MacDonald had done. There is also no evidence that she had seen any foreign public library murals; rather, there is some indication that she was not wealthy enough to travel. In other words, there is no clear explanation why Claire was hired to paint Earlscourt children's room.

Nevertheless, the conditions surrounding Reid's mural paintings at Earlscourt are well known and may help to explain those surrounding Claire's. In 1924 Reid had entered the Royal Canadian Academy's mural painting competition. This competition required entrants to submit a mural painting scheme for a particular site. Reid chose Earlscourt Public Library. It is possible that George Locke, the person responsible for the construction of Earlscourt in 1921, knew about the competition and asked Reid to choose this site. He and Reid were both members of Toronto's Arts and Letters Club and were at least acquaintances, if not friends. However, it is more likely that Reid chose Earlscourt himself and then asked Locke for permission to decorate it, since Reid was particularly eager to paint murals in civic sites. Moreover, the library

was close to his home. Having become familiar with foreign library murals, Reid would have despaired over the blank walls at Earlscourt and other Canadian public libraries. Reid was a well-known and well-respected artist and teacher in Toronto in the 1920s, so any offer he made to decorate a library – which the Royal Academy was funding rather than the library – would undoubtedly have been much appreciated and immediately approved.[56]

Clearly, then, by the time Reid finished his murals at Earlscourt, Locke and the local librarians would have held him in high regard. Five years earlier, Lorna Claire had graduated as a prize-winning student at the Ontario College of Art, where Reid and MacDonald taught, and she would assist Reid with his Jarvis Collegiate murals in 1930 (fig. 12). For the years in between her graduation in 1924 and the installation of her Earlscourt murals in 1929, Claire had been a part-time instructor at the Ontario College of Art. Given these facts, it seems likely that Clare was offered the Earlscourt commission by Reid or by Locke via Reid. Certainly she could not have obtained it through collegial associations within the Arts and Letters Club because, as a woman, she was not permitted to be a member. In any case, as juvenile library patrons listened to female librarians during the story hour in front of Claire's murals – after having first walked through the general reading room where Reid's much larger murals were installed – they must have absorbed the support that the juxtaposition of Claire's and Reid's murals would have given to patriarchy.

The conditions under which MacDonald's oil sketch for an unexecuted mural went to Earlscourt Library are also not known, but may be re-examined through the framework the analyses of Reid's and Claire's murals have provided. MacDonald submitted this sketch to the Royal Canadian Academy's mural contest of 1923, but, since this contest had not required artists to select a site for their work, MacDonald had not employed the sketch as the basis of a real mural installation.[57] At the same time, like Reid, MacDonald was a publicly vociferous mural advocate and had worked as a professional mural painter (in 1916 at the MacCallum cottage on Georgian Bay, Ontario, fig. 36; and at Toronto's St Anne's Anglican Church in 1923, fig. 24). He may also have seen some foreign library murals and could easily have read about them. In either case, he would have wanted to see similar work done in Canada. Furthermore, MacDonald was a colleague of Reid's at the Ontario College of Art and a member of the Arts and Letters Club, where he would have met Locke and socialized with both Reid and Locke.

It is reasonable to suggest that Reid or Locke persuaded MacDonald to donate his sketch to Earlscourt, simply because it had been designed for a civic site and had nowhere else to go. To stretch this framework somewhat,

it is also possible that Reid recognized a relationship between MacDonald's landscape mural, which depicted material progress, and Claire's murals, which denoted distinct cultural identity or cultural progress. Or Reid may simply have seen MacDonald's work as a masculine complement to Claire's work. At least one other public library, with which Reid, MacDonald, and Claire could well have been familiar, was decorated in a similar way. In 1923, while Edwin Blashfield and Gari Melchers were painting the main stairway and the adult reading room of the newly constructed Detroit Public Library with historical murals, Mary Chase Stratton was installing fireplace tiles with children's themes in the children's room (*in situ*).[58]

In conclusion, it would appear that Toronto's Earlscourt Public Library murals were not composed simply of Arcadian landscapes and innocent fairy tales. Rather, Reid decorated the general reading room, and possibly arranged for Claire to decorate the children's reading room, so that both rooms worked together to promote a symbiotic relationship between material and cultural progress and to support the assignment to women of traditionally maternal tasks associated with cultural progress.

As Neil Harris explains, public institutions such as libraries were posed between a commitment to and a fear of modern life.[59] In other words, while public libraries proclaimed liberal democracy, even for women, they were also fearful of some of its consequences. Therefore, they wanted to insert controls. As a result, public libraries of the period in which Reid's murals were installed in Earlscourt were as elitist as they were democratic. The readings that Earlscourt Library's patrons and employees took from the murals when they were first installed, and for several decades afterwards, could not have strayed far from those presented here. As Stanley Fish argues, a group of people will agree about the meaning of a given work of art because a reading is always undertaken within a discrete interpretive community. In turn, a community is shaped by the context in which the reading takes place and by the shared backgrounds of the community.[60] Therefore, as English social critic Raymond Williams concluded in a 1966 study on the relationship of a public library to its community, "real social relations" exist in "the character of a library building."[61] It is not surprising, then, that in the 1960s, when women's involvement in the workforce changed significantly in Canada, when the mandates of public libraries eliminated their parental activities, and when Earlscourt Public Library was being refurbished, the Earlscourt murals were destroyed.

Opalescent Glass Murals in Toronto Kindergartens:
"A High Import Latent Even in *Pat-a-Cake*"

Between 1913 and 1919 the Toronto Board of Education commissioned figural glass panels for at least thirty-four of its kindergarten classrooms – for classrooms in which the youngest pupils, the five year olds, were educated (fig. 55).[1] The medium of these panels may initially suggest that they were stained-glass windows and do not fit the parameters of mural painting. However, the glass panels did not function as windows, for they were installed on interior walls. They were not made of stained glass, but of opalescent glass, a medium that contemporary artists described as a type of mural painting because its layered structure allowed for a variety of pictorial effects.[2] It is reasonable, then, to consider these opalescent glass panels as mural paintings. Given their quantity, they form the largest single civic mural painting project in Canada in the first half of the twentieth century.

At first glance the subject matter of these glass mural paintings does not appear to fit comfortably into a study of Canadian mural paintings of the 1860s to 1930s, art that was designed to glorify and strengthen those salient features of the modern nation-state we have identified: popular sovereignty, the material progress of capitalism, distinct cultural identity, Christianity, and patriarchy. The kindergarten murals are composed of landscapes that are not recognizably Canadian; illustrations of fairy tales and nursery rhymes that originated in the British Isles or Europe (fig. 56); and representations of children at play, many of whom are Dutch (fig. 55, panels 2 and 5). Furthermore, contemporary discussions of school decoration suggest that kindergarten decoration in general was designed to delight the children. In 1921 American school architect John Donovan explained: "When [the architect] comes to the kindergarten there is every incentive for freedom since the kindergarten is more for supervised play

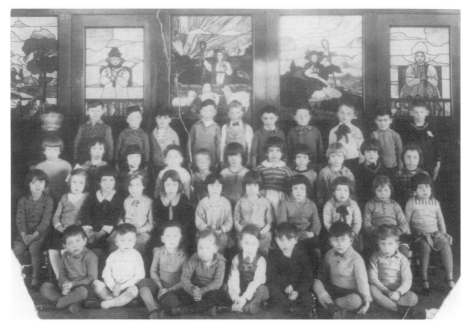

FIG. 55 Unknown artist, Clinton Street Public School kindergarten, Toronto, c. 1930, with opalescent glass murals of c. 1914

than for study, with its dances, games, singing, and its beautiful make-believes ... Therefore, the architect should feel free to exercise his taste and imagination in making this room a little wonderland of childhood."[3]

If the Toronto kindergarten murals were designed simply to create a wonderland, however, it is difficult to explain why this mural project was so large, why fragile glass was the medium of choice in a room occupied by five year olds, and why there are so many Dutch children in the murals. An examination of the complex conditions surrounding the production of these murals not only answers these questions but identifies the Toronto kindergarten panels as part of the Mural Movement. Unlike many of the other mural paintings in this book which directly glorified the modern nation-state, the glass murals were designed to work indirectly, by encouraging children to adopt behaviour appropriate to this purpose. In particular, these glass murals encouraged honesty, obedience, industriousness, thrift, perseverance, conformity, respect for elders, and Christian piety. In other words, the kindergarten murals were a result of the modern nation-state's acceptance of responsibility for the moral instruction of children.

Before modern nation-states had developed within Western culture, the family and the Christian church had shared the responsibility for the moral

instruction of children. By the mid-nineteenth century, however, many middle-class individuals, especially those in large cities, believed that the family and the church could not control behaviour on the scale that modern life required. Commerce and industry were developing at an unprecedented rate and attracting large numbers of rural and foreign immigrants to the cities. Urban squalor, diseases resulting from overcrowding, family breakdowns, and increased crime rates followed. Furthermore, scientific research had led to a decrease in church attendance, and foreign immigrants did not always share the values of the established population. Consequently, there was no longer an accepted single code of behaviour. Even if there had been, neither families nor churches in Western cities could have successfully encouraged the large urban populations of modern life to accept it. Modern Western nation-states therefore took responsibility for instruction in moral behaviour by making it part of the public school curriculum.

By the 1890s this description of modern urban life fit the city of Toronto perfectly. Until this time, Torontonians of Anglo-Saxon descent had made

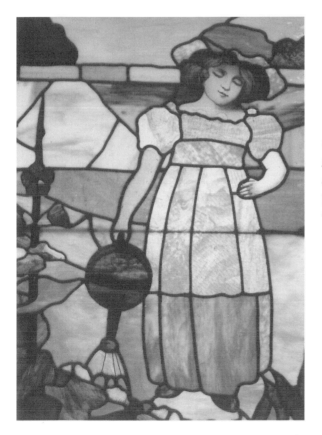

FIG. 56 Unknown artist, *Mary, Mary Quite Contrary*, c. 1916, Niagara Street Public School kindergarten, Toronto

up more than 90 per cent of the city population. Then industrialization and its concomitant negative features increased. Massive immigration, especially from Eastern Europe, began and continued on a wide scale over the next several decades. In response, many middle- and upper-class Torontonians of Anglo-Saxon descent expressed fears that their own values would not prevail. If they did not, material progress, one of the dominant characteristics of the modern nation-state, would take place at a much less rapid rate. Within this context, members of the Toronto Board of Education, all of whom were middle-class men of Anglo-Saxon ancestry, set out to mould behaviour with many things, including opalescent glass mural paintings in kindergarten rooms.[4]

As promotions of particular types of behaviour, the Toronto kindergarten murals were dependent on five important developments of the modern period: the Modern School Architecture Movement, the School Beautiful Movement, the Kindergarten Movement, a stereotype of Dutch children, and the widescale use of glass in domestic decoration. An explanation of these five developments and of the ways they intersected takes the kindergarten murals far beyond a category of art designed simply "to delight" young children.

In the mid-nineteenth century, when Western architects first began to build public schools, they simply modified church designs. Given the age-old association between the Christian church and education, this development was quite logical. Schools were composed of centrally planned blocks of several stories, with uniform-size classrooms and inadequate lighting, ventilation, and heating. In the last decade of the century, school architects began to provide the comforts and safety measures that recent scientific and educational research had been recommending.[5] One of these recommendations was a clear relationship between the size and shape of a classroom and its function. Consequently, school architects in all Western countries began to plan kindergarten classrooms that were approximately 65 feet by 45 feet – twice the size of a normal classroom – as a means of accommodating the playful activities of five-year-old pupils. To justify the extra costs, the kindergarten room was also used as an assembly space for the entire school on special occasions.

In some of these schools the wall that separated the kindergarten classroom from an inner hall was made of hinged dark-wooden panels that could be folded back to merge with the foyer to create an even larger assembly space. This type of room was known as an expanded-hall kindergarten.[6] As early as the late 1890s the architects of the Toronto kindergartens were installing opaque glass in the upper halves of these hinged wooden panels.[7] The use of opaque glass rather than clear glass may have been designed to

direct light from the large windows on the opposite wall of the kindergarten into the hall, while preventing activity in the hall from distracting the kindergarten children. However, it is also possible that the glass panels had an aesthetic purpose – that they were designed to relieve the heavy appearance of the solid wooden wall. Later developments provide some support for this suggestion.

As early as 1913, Toronto Board of Education architects began to arrange for the replacement of the opaque windows in the upper halves of the hinged wooden panels with figural opalescent glass panels. From this time until at least 1919, they ordered the installation of the same type of glass panel in all new kindergartens. Clearly these architects were not primarily concerned with light flow from the kindergarten room to the hall, for the layered quality of the opalescent glass panels permitted much less light to flow through them than the opaque glass had. Rather, they were concerned with the installation of figural images designed on a superficial level "to delight" and, on a more fundamental level, to encourage moral behaviour. They were responding not only to the Modern Architecture Movement but to the School Beautiful Movement as well.

The School Beautiful Movement, which developed in mid-nineteenth-century England, functioned to encourage the installation of art in classrooms as a means of encouraging moral behaviour. As its best-known spokesperson, John Ruskin, explained: "Education does not mean teaching people to know what they do not know," but "teaching them to behave as they do not behave."[8] Before the mid-nineteenth century, permanent forms of art had not been regularly installed in classrooms. As English architect Joseph Lancaster advised in his 1809 text on school architecture: "Let the bare brick be simply *lime-whited;* it will be healthy and look clean and may always be renewed at moderate effort."[9] When art was occasionally installed in classrooms before the mid-nineteenth century, it usually consisted of small framed prints devoted to Christian subject matter.[10] Adherents of the School Beautiful Movement would not have disapproved of this type of art, since, as Christians, they were eager to impose a Christian sense of morality on school children. However, they could not promote the use of overt Christian images in non-sectarian public schools. Adherents of the School Beautiful Movement believed that other types of art could produce the same result, and in ways that children would find more appealing, or "delightful."

Adherents of the School Beautiful Movement argued that since God had created the world, God was the source of both beauty and morality. They claimed that artists were more perceptive than other people and could better

recognize the beautiful aspects of God's world. Looking at the beautiful aspects of God's world, as represented by artists, would lead the viewer to God and to Christian morality.[11] In other words, the School Beautiful Movement participated in the nineteenth century's merger of German Idealism and neo-Platonic Christian teachings (see chapter 1).

Educators in all English-speaking countries, including Canada, regularly supported these tenets of the School Beautiful Movement, from just after the middle of the nineteenth century until well into the twentieth. In Toronto, for example, George Hodgins, the deputy minister of education for Ontario, wrote a book in 1876 for the use of school architects in which he stated that school buildings and grounds should be pleasant and attractive, and that "objects of beauty" should always be within sight of the children as a means of imparting a Christian morality. Therefore, a school should "not be on the highway, nor near noisy factories, distilleries or pork-houses." Hodgins warned that the appearance of the classroom had to be carefully controlled with such things as works of art; otherwise, bare walls might permit young minds to wander.[12] In 1900 he published a pamphlet on schoolroom decoration for circulation to Toronto schools. It stated that schools should be decorated so that they would "create an active desire for the beautiful, or artistic" and would "produce a refining and elevating influence upon the minds of the young. Only the best pictures – as Ruskin says – should be given a place."[13]

In 1892 Caroline Hart, inspector of Toronto kindergartens, explained that "beauty" was "appointed by God for the exaltation of the human soul."[14] In 1904 another Canadian teacher stated: "Our first and chief aim is to lead to an appreciation of Beauty in observing order and harmony in the material world. From nature and art [the pupil] receives new inspirations and has a deeper reverence for the God of nature. Vice becomes more and more repellent because of its ugliness. 'In true art,' Ruskin says, 'the hand, the head and the heart of man go together.'"[15] In the same year, "art" courses were substituted for mechanical drawing courses in Ontario, as they were in other parts of Canada and in other Western countries, in an effort to promote aesthetic understanding and its supposed concomitant moral associations.[16] In 1913 Canadian teacher Philip Ortiz wrote: "Art should supply the student with an antidote, as it were, against the poisonous influences of the materialistic tendencies of the present day."[17] The following year another teacher, Jean Walker, commented that school art would "promote happiness, lead to a new vistas of purity, beauty, and truth, repress evil, and cultivate purer habits of life."[18]

Support for school art as part of the School Beautiful Movement quickly led to the organization of associations or art leagues to assist in the selection

and payment of art and artists. In 1883 Mary Christie formed the Art for Schools Association in London, England. Ruskin served as its first president.[19] The Boston Public School Art League was founded in 1892 and, by 1914, there were at least forty such organizations in the United States. In 1896 James Hughes, inspector of schools for the Toronto Board of Education, recommended that "following a line of work introduced in certain districts of England by John Ruskin, and adopted also in Boston, [Toronto schools] should form Leagues to superintend the interior decoration of the school, in the belief that class-rooms made as attractive and beautiful as was consistent with their purpose must exert a refining and elevating influence on the characters of the pupils."[20] The first of the Toronto leagues was opened at Rosedale School in 1896. By 1916 there were nine of them. Their position was given official sanction within the province's educational system in 1898, when Hughes formed the Central School Art League. In 1908 the Ontario Department of Education supported school art leagues by establishing the Advisory Board of the Toronto School Art Leagues to advise on art purchases. Prominent mural advocate George Reid was its first president.

At the same time, the School Beautiful Movement did not equally endorse all types of artistic representations of God's world for all types of classrooms. First, they maintained that school art should be highly visible and not surrounded by competing images. Therefore, they recommended that schools invest, whenever financially possible, in large-scale permanent art such as mural painting rather than in a large number of relatively small reproductions of works of art. In 1914 the Ontario Department of Education took this advice into account and prepared a pamphlet on classroom decoration for teachers. It warned teachers of the youngest children in particular that "the habit of decoration with tissue-paper ornaments and garlands should generally be avoided." Rather, permanent forms of art should be installed.[21]

Second, the School Beautiful Movement proposed specific types of "beautiful" subject matter for particular age groups. Historical images, such as those installed in Toronto and Montreal high schools, were considered appropriate for older pupils (see chapter 2).[22] Images of the natural world, many of which appear in the Toronto kindergarten opalescent glass murals, were thought to be suitable for the youngest school children. Indeed, as the School Beautiful Movement was gathering strength, Western culture was redefining childhood and linking it to the natural world. Previously most people had believed that children were born in a state of corruption that had to be overcome through harsh methods of training. By the mid-nineteenth

century, theories that asserted the innocence and goodness of children – first put forward almost one hundred years earlier by Jean-Jacques Rousseau – were gaining wide support. By this time Western culture already had a 2000-year-old history of linking the natural world and rural life with "good," and city life with "evil," so it was only logical that it should link the goodness of children to nature.

As early as 1874, English school architect Edward Robson called for "pictures of animals [to be] exhibited around the schoolroom."[23] In 1901 Canadian teacher Sidney Silcox argued that, in the first year of school, children should look at "sun, moon, stars, clouds, rain, snow, ice, rainbows, creeks, valleys, hills [and] trees."[24] In its 1914 pamphlet on classroom decoration, the Ontario Department of Education advised teachers of the youngest pupils to use reproductions of well-known works of art with sunny pastoral landscapes, in which children and/or animals took part in familiar activities.[25] This focus on nature also led to the installation in classrooms for the youngest children of mural painting devoted to nature themes. In the United States, for example, school architect William Ittner arranged to have the walls of some of his turn-of-the-century kindergartens in St Louis decorated with painted friezes of children and animals at play.[26] In 1906 Toronto artist Frederick Haines painted a landscape mural for the public school in Meadowvale, Ontario (now in the offices of the Credit Valley Regional Conservation Authority).[27] Two years later, Toronto's Rosedale League of School Art commissioned Toronto artist John Beatty, an ardent supporter of the Mural Movement, as well as a member of the newly formed Advisory Board of the Toronto School Art Leagues, to paint a mural on a wall of its recently constructed kindergarten room (fig. 57 and plate 3).[28] A few years later the *Toronto Star Weekly* described the ensemble as "the most beautiful schoolroom in Canada."[29]

The Rosedale mural is composed of three panels, *Spring, Summer,* and *Autumn,* that depict school children taking part in clearly pleasant seasonal activities – a school picnic, a harvest, and a walk in fields of pumpkins and drying corn. Beatty's choice of subject matter was undoubtedly influenced by the emphasis that teachers' manuals, educational journals, and classroom textbooks placed on the change of the seasons as evidence of God in nature. For example, Clara Beeson Hubbard's *Merry Songs and Games for the Use of the Kindergarten* included a song entitled "The Seasons."[30] American art critic Irene Sargent, writing in 1904 and 1905 in *The Craftsman,* advised, as she praised Ruskin, that scenes of nature "typified by groups of figures, set in quasi-natural surroundings, and supposedly pursuing occupations appro-

FIG. 57 Rosedale Public School kindergarten, Toronto, c. 1910

priate to a special [season]" would be most appropriate for kindergartens.[31] And the Prang Company of Boston's art textbooks of 1904, used in Toronto kindergartens from 1908, included images of seasonal activities that are remarkably similar to Beatty's.[32]

The School Beautiful Movement's promotion of nature images for the youngest pupils easily accounts for the landscapes and for some of the nature-based nursery rhymes, such as "Baa Baa Black Sheep," in the Toronto kindergartens' opalescent glass murals. However, it does not account for the subject matter of the many other panels that are not primarily concerned with nature or for the use of large areas of glass in an area constructed to accommodate active youngsters. For the other subject matter, it is necessary to look at the contemporary kindergarten curriculum.

Between the 1820s and the 1840s German educator Friedrich Froebel designed a new curriculum known as a "kindergarten," or a "garden of children," for the teaching of young children. With it he boldly supplanted the classical and time-honoured educational system of his own childhood – one that had placed the highest value on the absorption of quantities of knowledge – with a system based on the development of moral character.[33] Froebel believed that the school's main duty was to bring children into harmony with God, nature, and other human beings within a loving, or "delightful," environment. He insisted that children should learn through the process of play – which he believed was natural to children – within a setting that was as

closely linked to the natural world as possible. To this end he recommended gardens with resident animals as ideal learning environments. Children would develop as plants in a garden, according to their own inclinations, with the assistance of a good gardener, or teacher (a "kindergartner"), who would "weed" out corruption. When a garden was not available, a large sunny room was the best substitute.

Froebel's views on childhood are clearly related to those of a number of late-eighteenth-century thinkers, such as Rousseau. They are also related to those of the School Beautiful Movement. This movement, which began in England, probably adopted some of Froebel's ideas via his students, who came from Germany to work in private schools in England in the middle of the nineteenth century. This relationship was well understood at the time. In 1889 John Hobson, one of Ruskin's biographers, compared Froebel's views with Ruskin's emphasis on an education that stressed "the union of head, heart and hand."[34] In 1892 Caroline Hart explained that, just as Froebel recognized the primary importance of developing "the divine spirit" in the kindergarten child through the observation of beauty, so Ruskin understood the necessity of taking measures to cultivate and to preserve "art intellect." Significantly, Hart also explained that preserving "art intellect" was to be done on behalf of the nation.[35]

In the late 1870s James Hughes began to investigate the Froebel curriculum and quickly became its leading Canadian exponent.[36] Between 1883 and 1914 he oversaw the establishment of seventy-eight Froebel kindergartens in public schools in Toronto. He also promoted provincial teacher training courses in Froebel methods. These courses became available in Toronto in 1886 and mandatory for all Ontario kindergartners after 1908.[37]

While Froebel's curriculum ostensibly focused on the "natural," it also included a rigid set of activities in which kindergarten children would participate on a regular basis. The most important for this study of kindergarten mural decoration are the "play songs." Froebel composed fifty of them, and every one was concerned with related types of work and play. Each occupied two pages in a teacher's manual: the first page outlined for the teacher what the children could learn from the play song; the second included the text of the song, an illustration of the activities in the song, and a diagram of finger movements that imitated the main activity of the song.[38] The Toronto opalescent glass murals make clear references to at least twenty-four of these play songs, most of which have a parallel in an English nursery rhyme.[39]

The glass panels that provide representations of landscapes with windmills and children flying kites (at Deer Park, John Fisher, Orde, and Western

schools) may be easily related to Froebel's play song "The Weather Cock." Froebel illustrated this play song with a variety of things that are blown by the wind, including a kite and a windmill. He used the effects of the wind to teach the ideas of cause and effect, invisible power, and God as the single power behind all things. The pendulum clock in a glass panel labelled *Hickory, Dickory Dock* at Givins/Shaw School looks much like that in Froebel's play song "Tick-Tack." Froebel intended this play song to teach the importance of making good use of time.

The glass panel entitled *Pat-a-Cake* at Givins/Shaw School is a direct quotation from Froebel's play song of the same name. It was designed to encourage a child to see his place in the order of life. The child was able to eat bread only after the farmer had grown the grain, the miller had ground it to flour, the baker had made the flour into bread, and the mother had purchased the bread for the child. The glass panel with an image of a dovecote at Manning School illustrates Froebel's play song "The Pigeon House," which supposedly extended the child's own experience of coming and going and taught the idea of the permanent in the transient.

The nursery rhymes "Little Jack Horner," who "stuck in his thumb and pulled out a plumb" (illustrated at Niagara, Palmerston, and Shirley schools), and "This Little Pig Went to Market" (illustrated at Niagara and Givins/Shaw schools) are related to several of Froebel's play songs that give names to the fingers: "The Thumb a Plumb," "Bend Your Head, Thumb!" "The Family [of fingers]," "Thumb! I say 'One' to You," "The Finger Piano," "Grandmother and Mother Kind Dear," "The Happy Brothers and Sisters," and "The Children on the Tower," all of which explained the usefulness of fingers.

Glass panels in which children look at the moon (at Eglinton and Park schools) and a glass panel entitled *The Man in the Moon* (at Givins/Shaw School) are obviously related to Froebel's play songs "The Child and the Moon," "The Little Boy and the Moon," and "The Little Girl and the Stars," which demonstrated the wondrous notion of a simultaneous separation by distance and a unity of nature within the universe. The English nursery rhyme "Mary, Mary, Quite Contrary," which was installed in glass panels in Eglinton, Frankland, Park, Niagara, and Shirley schools (fig. 56), illustrates Froebel's play song "The Little Gardener" (fig. 58). It directly adopts his depiction of a young girl with a watering can. The play song taught the importance of nurturing.

The English nursery rhyme "Little-Bo-Peep" was installed in glass panels in many of the Toronto kindergartens (Carlton, Clinton [panels 3 and 4

in fig. 56] John Fisher, Orde, Pape, and Williamson schools). It seems to have always occupied two panels: in one, Bo-Peep appears with her sheep; in the other she appears without them. Together these panels illustrate Froebel's play song "Hiding the Children," which was entitled "Little Bo-Peep" in all English translations. It was used to teach the fear of separation and the joy of reunion, and it featured a mother and her children rather than a shepherdess and her flock. To strengthen the sense of reunion at the finding of the sheep, Froebel's illustration (fig. 59) includes a rising sun, with rays that incorporate the entire scene, just as the opalescent glass mural designers did for the same scene (see panel 3 in fig. 55).[40]

As for those nursery rhymes that appear in the opalescent glass murals, but not in Froebel's finger games, it is reasonable to assume that they were selected to function within the spirit of Froebel's teachings. Indeed, contemporary educational philosophy regularly advised the use of any nursery rhyme that could teach morals in a Froebelian manner. "Jack and Jill," which appears in glass panels at Carlton, Eglinton, Givins, Pape, Park, Wilkinson, and Williamson schools, although not specifically mentioned by Froebel,

FIG. 59 Unknown artist, illustration for Friedrich Froebel's mother-play song, *The Hiding Children,* 1840s

was used to demonstrate the importance of water, helping mother, not rushing, and enduring pain, for example.[41] As Froebel follower David Salmon wrote in 1904: "Useful as Froebel's songs and rhymes are they cannot be followed blindly. The subjects are not all suitable for English children ... Indeed, the foreign character of some ... renders them quite unsuitable for our Kindergartens ... Consequently the beautifully illustrated *English* nursery rhymes are often better for English use ... but Froebel's book will always be invaluable to those who breath its spirit instead of copying its details."[42]

Another important part of Froebel's curriculum accounts for the fairy tales in the Toronto opalescent glass murals. Although Froebel did not recommend any specific fairy tales to be used in the kindergarten, he did state that they should be used to develop imagination and highlight the fact that certain mysteries of life could be explained only by the existence of God. Many of Froebel's followers elaborated on this recommendation. Susan Blow, the first public school kindergartner in North America, argued that fairy tales were "the world-literature of the infancy of our race, and correspond with the few supreme world-poems which touch the hearts and solve the problems of all mankind."[43] Caroline Hart described fairy tales as "the symbolic truths that voice the yearning of the human heart for Divine truth and beauty."[44] Another Canadian kindergartner spoke of the ability of fairy tales to encourage children to "indulge savage instincts" at a young age so that they would disappear by the time the child reached adulthood.[45] "Little

Red Riding Hood," which appears in the Toronto kindergarten murals, but is not specifically recommended by Froebel, was regularly used to demonstrate the importance of obedience.[46]

Nevertheless, the Froebel curriculum, the School Beautiful Movement, and the Modern School Architecture Movement cannot account for the many portraits of Dutch children in the Toronto murals (panels 2 and 5 in fig. 56). Nor can they explain the many images of Dutch children at play in the Toronto murals – riding see-saws, reading books, and playing with dolls. For these panels it is necessary to examine Dutch stereotypes that developed in the late seventeenth century in England and that were especially popular from the mid-nineteenth century to the First World War in North America. By the late seventeenth century the Dutch had adopted Protestantism, evicted their Spanish rulers, set up an independent nation, limited the power of the monarchy, and welcomed religious exiles from other parts of Europe. They were also increasing their prosperity on a wide scale through trade, establishing colonies, and vigorously reclaiming agricultural land from the sea through the use of dykes and windmills. At the same time, Dutch artists were producing thousands of relatively small-scale paintings that enshrined piety, orderliness, and cleanliness in the domestic space and in family life. Consequently, as early as the 1670s, other Western countries attributed these activities and values to the Dutch as a whole.[47]

As the United States approached its first centennial in 1876, many Americans began to seek a historical background that was not English. Dutch immigration had played a predominant role in early American history, and many Americans regarded Dutch culture, as they knew it from the stereotype, as more like their own than English culture. Consequently, some American historians "rewrote" American history and gave the Dutch a much larger role than had earlier historians.[48] As a result, a mania for anything Dutch developed in the United States and spilled over into other Western countries, including Canada. Many publications on Dutch life appeared with such titles as *Brave Little Holland and What she Taught Us*. Educational study groups such as those at Chautauqua, New York, devoted sessions to Dutch culture. Dutch painting, including both seventeenth-century work and that of the nineteenth-century Hague School, became popular in the United States. American artists regularly went to work in rural areas of Holland, where they found a lifestyle they could reasonably and happily compare with that of pre-industrial America.

American architects began to include Dutch motifs in their work, items such as stepped gables, steeply pitched roofs, and alternating stone and brick

voussoirs. Some built houses in the shape of windmills or turned old wind-mills into houses. Interior decorators advised Dutch accents such as blue and white tiles, lace curtains, and wallpaper and fabric with windmills and other Dutch motifs. Dutch lace caps came into fashion, and commercial companies built on Dutch stereotypes to sell their products. From 1905, for example, Dutch Cleanser employed an image of a Dutch woman chasing dirt with a stick.[49]

Of more direct relevance to this discussion is the widespread entry of the Dutch stereotype into children's literature. In 1865 American writer Mary Mapes Dodge published the now famous *Hans Brinker or the Silver Skates*. This novel tells the story of a young boy and his sister, who through honesty and hard work earn money to take care of their parents. It also includes the story of the Dutch boy who patiently held his finger in a dyke to save Holland from flooding. From this time there was an outpouring of children's story books with Dutch themes, such as *Our Little Dutch Cousin* by Blanche McManus, *The Dutch Twins* by Lucy Fitch Perkins, *Sunbonnet Babies in Holland* by Eulalie Osgood Grover, and the famous poem "Wynken, Blynken and Nod" by Eugene Field. As Hendrik de Leeus wrote in 1907, "Ever since the blessed day when tiny tots are able to see and read they are fed on a type of juvenile literature in which wooden-shoes, windmills, dikes and tulips are supposed to convey a true picture of all that is the Netherlands."[50]

From the late nineteenth century, educational journals frequently rec-ommended images of Holland as classroom decoration and the reading of stories that took place in Holland. In the early twentieth century the Ontario Department of Education officially sanctioned stories about the Dutch as part of the curriculum. In one textbook for very young pupils, teachers were advised, before reading the Dutch stories, to tell the pupils "about the quaint but sturdy Dutch people" and to read them parts of *Hans Brinker and the Silver Skates*.[51] It is reasonable to conclude that the images of Dutch chil-dren in the opalescent glass murals in Toronto kindergartens were selected to act as models of good behaviour. But how did the medium of opalescent glass come to be chosen for the Toronto kindergarten murals?

In 1913, as the architects of the Toronto kindergartens made plans to have these rooms decorated, they would, under the influence of the School Beautiful Movement, have favoured a permanent form of decoration such as mural painting. It is likely that they first considered the possibility of com-missioning artists to paint murals on the solid walls of the kindergarten rooms, for they would have been aware of the seasonal landscapes that Beatty had recently installed in Rosedale Public School's kindergarten room.

However, they would also have known that Beatty took three years to finish this work and that the costs, privately raised by the Rosedale League of School Art, had been considerable. They were looking for a type of mural decoration that was less expensive and that could be completed more quickly. Opalescent glass murals fit this requirement.

At the same time, the Toronto architects must have realized that the wall in kindergarten classrooms that could most easily receive decoration was the one with the hinged wooden panels. Indeed, unlike Rosedale School, one wall of most of the Toronto kindergarten rooms was taken up with a bay window, while the other two had doors leading into a cloakroom and a supply room. The only wall that was left was the one with the hinged wooden panels. But the architects could not seriously consider transforming this hinged wall into a solid wall because the hinged wall permitted the kindergarten room to merge with the foyer for assemblies. Since the upper halves of the earliest of these wooden panels had been provided with tinted semi-opaque glass, it was reasonable to replace this glass with figural, opalescent glass murals.

At first the Toronto Board of Education's architects may have considered using stained glass rather than opalescent glass for these murals. Indeed, they would have been familiar with the recommendations that many social critics had recently made for the use of architectural details of Christian churches in public school architecture. Social critics made these recommendations because they feared that, as the responsibility for moral instruction was transferred from home and church to the public school, associations with specifically Christian morality were being lost. To strengthen this association they frequently endorsed medieval architectural details, including stained glass, since they regarded the medieval period as particularly religious. As one American social critic stated in 1889: "The use of stained glass in public school buildings is particularly desirable, for there art has a lasting influence over the tastes and is a constant aid to education."[52] In 1910 American educator Fletcher Dresslar argued from the same point of view: "The assembly room is the place in the school where artistic and even lavish decoration [should be] the rule, for the assembly room has retained some of the religious atmosphere of those [churches] of bygone days."[53]

From the late nineteenth century until well into twentieth, many public schools took this advice. As one American social critic stated in the 1880s: "The school-house is becoming the American temple: it borrows from the church."[54] However, given the fragility of stained glass, these installations were always relatively small and located in areas of the school that did not

receive heavy traffic. Therefore, the Toronto kindergarten architects probably did not give serious consideration to stained glass. Rather, they quickly turned to a consideration of opalescent glass, which was not only less fragile but also less expensive and better at depicting detail. At the same time, opalescent glass was used from time to time in churches, albeit in areas that did not require the glass to transmit much light, while its invention, in 1877, stemmed from stained-glass production. Consequently, opalescent glass could also have been easily associated with Christian morality.

Between the 1880s and the 1920s, stained glass and opalescent glass were also frequently used to decorate the domestic space. Froebel's curriculum, in use during the same period, called for an intensely close relationship between home and school. Froebel had originally designed his curriculum to operate first in the home before the child went to school: in this phase the mother was the gardener, or kindergartner, and it was she who was supposed to introduce the play songs that appear in the Toronto glass panels. Indeed, the full name of these play songs was "mother-play songs." In the late nineteenth century, Froebel's Toronto followers (and those in other urban centres in North America) had an even more pressing reason to link home and school. The negative features of industrialization, urbanization, and secularization had been joined by those of massive immigration. Therefore, a significant proportion of the population did not share, or was not in a position to share, the values of Torontonians of Anglo-Saxon descent. To encourage the urban poor and immigrants to align themselves with this hegemonic population, members of the Toronto Board of Education arranged for kindergartners to make home visits and to establish mothers' meetings in the schools. During these visits and meetings, kindergartners urged mothers to practise Froebel's methods in the home. As American social critic Hamilton Mabie wrote in 1905: "The kindergarten in the tenement-house quarter is a fountain whence flow streams of influence that penetrate hundreds of homes and carry cleanliness, kindlier manners, and higher standards of living with them."[55]

If Froebel's followers in the late nineteenth and early twentieth centuries wanted to establish a clear relationship between the kindergarten and the home, employing stained or opalescent glass would have worked well to this end, since both were widely used to decorate homes at this time. Stained glass was used more often because it could function as both a source of light and a work of art while it blocked out unsightly views. Nevertheless, most of what contemporary critics had to say about stained glass in the home may be equally applied to opalescent glass. According to one American art critic writing in the early 1880s, "the use of [domestic] stained glass ... has become so universal that

FIG. 60 William van
Horne, mural painting,
1910, "Covenhoven,"
Minister's Island,
New Brunswick

scarcely a house of any architectural pretensions can be found that has no
stained glass in door or window."[56] Many other art and social critics explained
why. Stained glass lent "refinement" to the home. Furthermore, as the home
became an increasingly important refuge from the negative features of mod-
ern, especially urban, life, as well as a centre of social activity, stained glass
helped to satisfy the desire to infuse the domestic environment with "a sensu-
ally and emotionally soothing atmosphere."[57] Early-twentieth-century Toronto
certainly participated in this domestic use of stained and opalescent glass. As
Alvyn Austin explained, "between 1890 and 1930 almost every house that was
built in Toronto had at least one leaded or stained glass window. They were
not installed just as set-pieces in the mansions of the wealthy, but were as com-
mon – if not as elaborate – in the modest row-houses of the workers."[58]

Domestic stained and opalescent glass carried associations with the
church and with morality. At the same time, the subject matter of domestic
stained and opalescent glass was selected to relate to the particular use of the
domestic room that it decorated. Since linking children to nature as a means
of providing them with Christian morality was not limited to the School
Beautiful Movement or to the Froebel curriculum, but was part of the nine-
teenth century's redefinition of childhood, images of nature regularly
appeared in stained and opalescent glass (and in painted friezes and wallpa-
per) in children's rooms or nurseries from approximately 1870, at first in the
homes of the wealthy and then in the homes of the middle classes.
Illustrations of nursery rhymes and fairy tales, as well as of Dutch children,
found their way into the same media for the same reason.[59] In Canada in
1910, William Van Horne, president of the Canadian Pacific Railway, pro-

vided his grandson's room at "Covenhoven," the family summer home on Minister's Island, New Brunswick, with a mural painting of Dutch children at play (fig. 60, *in situ*).[60]

As contemporary interior decorators explained, while drawing consciously on the vocabulary of the School Beautiful Movement and the Froebel curriculum, nursery decoration was "not primarily to entertain and amuse."[61] Rather, nursery decoration should be designed to promote particular types of behaviour. American interior decorator Bertha Howland argued, just as Ruskin had on behalf of school art, that nursery decoration would ensure good health, happy temperament, a sense of good order, and "good taste that can never be lost."[62] Another wrote:: "[As works of art] are to the school-room, the wall coverings of the nursery may become to the home."[63] Still others compared nursery decoration to "the colored map and the illustrated chart" of the schoolroom,[64] suggested that parents look for decorations in kindergarten supply houses,[65] and recommended "a homelike appearance" for school decoration.[66] In Toronto, William A. Craik wrote about Rosedale Public School – where the kindergarten was decorated with Beatty's seasonal mural paintings – as having a "homelike appearance."[67] In 1905 Irene Sargent drew a particularly close association between domestic and school decoration in a series of four articles, all of which promoted a single type of decoration for the home nursery and the schoolroom. The title of one of the articles was "Art in the Home and in the School: Examples of Mural Decoration Based upon Dutch Types and Scenes."[68] Such images, Sargent stated, would illustrate the sturdy, submissive, enduring, industrious, and responsible character of the people of "thriving Holland."

In turn, many kindergarten teachers acknowledged the relationship between home and school decoration. American kindergartner Kate Douglas Wiggins suggested in 1893 that kindergartens should have "pretty, pleasant domestic interiors." Such decoration, she argued, would "lessen crime rates ... nourish and develop ... practical virtues, namely economy, thrift, temperance, self-reliance, frugality, industry, courtesy and patriotism ... [and] ... a sense of beauty leading to Christianity."[69] From the same point of view, Canadian teacher Ella Newman wrote: "Very few homes are void of pictures. If they are a necessity in the home, are they not more so in the schoolroom?"[70]

It is, therefore, reasonable to conclude that the decorators of the Toronto kindergartens chose opalescent glass as a medium for school art for the following reasons: it could provide permanent large-scale art as the School Beautiful Movement recommended; it was less expensive than murals painted on a solid wall, but appeared to be mural painting; it was less fragile than stained glass; it took on the Christian moral associations of stained glass which the School Beautiful Movement and Froebel viewed as essential to the developing child; and it connected the kindergarten to the home as the Froebel curriculum promoted.

It is also reasonable to conclude that the commissioning of these Toronto opalescent glass murals depended on five complex and interrelated developments of the nineteenth century that were concerned with the moulding of behaviour that would best suit the modern nation-state: the Modern School Architecture Movement, the School Beautiful Movement, the Froebel curriculum, the Dutch stereotype, and the use of decorative glass in the domestic space.

It seems unlikely that further research will identify the individual who came up with the idea to install these opalescent glass murals, who selected the subject matter (although kindergartners must have been involved), who selected the models, or who designed the images.[71] Still, it is now possible to understand the complexity of the context in which they were commissioned. As American kindergartner Susan Blow stated, there can be "a high import latent even in pat-a-cake."[72]

Canadian Mural Painting, 1940s and 1950s: The European-Based Mural Movement Lingers On

From approximately the 1830s to the 1930s, the hegemonic population of modern Western nation-states – enfranchised, middle-class, Christian men – supported the production of thousands of mural paintings that were generally designed to glorify the contemporary features of modern Western nation-states: popular sovereignty, the material progress of capitalism, distinct cultural identity (often expressed through racial and cultural imperialism), Christianity, and patriarchy. The individuals who promoted this type of artistic production believed that it could evoke nationalistic sentiment in viewers and persuade them to support the nation-state. Without such sentiment, mural patrons feared, they and their nations could not "flourish." This entire phenomenon may reasonably be described as the European-based Mural Movement.

Until approximately 1890, the artists who produced these mural paintings regularly worked in conservative painting styles. In civic, religious, and commercial sites, they employed sombre, didactic, and often classical themes. In commercial social settings, homes, and private clubs they provided more light-hearted themes, but, to ensure respectability, set them in classical, medieval, or Renaissance time periods – ones that were widely regarded as glorious bases of Western culture. From approximately the 1890s, mural painters continued to represent the characteristics of the modern nation-state, though they used images of ordinary people engaged in everyday activities to do so. They also turned to modernist painting styles, but, by adopting conservative versions of these styles and by introducing them well after they had appeared in easel painting, the work of the European-based Mural Movement remained conservative. This later work may reasonably be described as the second stage of the European-based Mural Movement.

By the 1920s some mural painters in some Western countries were beginning to work outside the tenets of the European-based Mural Movement. Some turned to abstraction, seeking a personal response from viewers to formal elements of painting. Le Corbusier, for example, painted an abstract mural (*in situ*) in the 1920s for the main-floor sitting room of the Pavilion Suisse, a building he designed for the Cité Université in Paris. Although abstraction has been shown to be as highly politicized as any other style of art, it is not part of this study. Other muralists of the early twentieth century turned to "modern mural painting," which employed readily recognizable subject matter designed to produce a group response. These mural painters also distinguished their work from the European-based Mural Movement (in stages one and two) and from abstract mural paintings.

First, modern mural painters employed severe modernist painting styles such as cubism, futurism, and expressionism. Second, they provided a personal or critical view of contemporary features of the modern nation-state. Some simply rejected the well-established bases of Western culture, such as ancient Greece and Rome, that had played an important role in the work of the European-based Mural Movement. Others depicted negative aspects of the modern nation-state, such as the chaos of contemporary life. The work of the European-based Mural Movement had glorified the progress and order that its adherents believed belonged to modern life. In a sense, then, modern mural painting occupies a place between the work of the European-based Mural Movement and abstract mural painting.

In the 1920s, English artist Stanley Spencer painted a memorial to First World War soldiers on three walls of Burghclere Chapel, a small building constructed for this purpose (murals *in situ,* renamed the Sandham Memorial Chapel). On the two long walls, Spencer depicted the day-to-day activities of the soldiers – boiling the kettle for tea, making beds, and taking care of frost-bitten limbs. He suggested that war had its distinctly mundane elements. On the third wall, at the front of the chapel, he represented a resurrection of the soldiers who had died in the war. Now, Christianity provides for the resurrection of those who have led a Christian life, and most people in early-twentieth-century Western culture believed that soldiers' military sacrifice automatically entitled them to a "Christ-like redemption." Still, this type of resurrection was generally understood as an event that would take place in the distant future, not immediately after the war. Spencer therefore supplied the mural with a personal view. At the same time, he imbued these scenes with a sense of modern life's dynamic and often frightening energy through the use of strident colours, an angular flattened figural style, and bright white

crosses that burst out of the ground and seem to explode around the church-yard.[1]

Clearly, Spencer's mural paintings are quite different from these that represent military activities within the parameters of the European-based Mural Movement in Canada and elsewhere. In 1883 Léon Glaize painted *The Triumph of the Republic* and *Great Men of the Revolution in Front of the Tribune of Posterity* for the Mairie of the Twentieth Arrondissement in Paris (*in situ*).[2] Here, famous men who rid France of despotic royal rule form a procession that culminates in front of classical personifications of appropriate virtues who sit or stand on a podium above the procession. Arthur Lismer's mural of 1927–32 for Toronto's Humberside Collegiate takes the same general approach (fig. 11). In the central panels, personifications of various virtues such as Justice, Wisdom, and Beauty sit or stand on a hill. On both sides they are approached by a stream of figures. From the left come various French and English explorers who settled Canada. Included are General Wolfe and General Montcalm, who fought each other in 1763 on the Plains of Abraham at Quebec. Montcalm, defeated by the British, sits on the ground holding the French flag, while Wolfe stands upright behind him holding the British flag and looking out eagerly to the land of Canada that Britain now controls. Wolfe, along with many other people, died in this battle. Nevertheless, Lismer chose to represent the glorious nature of an imperialistic war rather than its effect on the individual. The similarities between Lismer's and Glaize's work are clear, as are the differences between their work, as representative of the European-based Mural Movement, and Spencer's work as representative of modern mural painting.

Modern mural paintings such as Spencer's were produced throughout Western culture. In the 1930s Canadians became particularly interested in the large number of murals of this type that were being produced in Mexico and the United States. In Mexico these murals had been commissioned after the mid-1920s by a government that had been established in 1921 as the result of a revolution. This revolution had been propelled by the middle classes and, to some extent, by the rural poor against the upper classes, with their strong European associations. Fittingly, then, the Mexican mural paintings employed the bold expressionistic styles of modernist art to represent the injustices and the human suffering that the Mexicans had borne as a result of European domination, as well as the repositioning of Mexican pre-Columbian culture. Some of these mural paintings also embraced various brands of socialism and communism, while promoting popular sovereignty, material progress, and, at times, Catholicism.[3] Thus, the Mexican mural painters glorified some of the characteristics of the modern nation-state, but rejected others.

Contemporary American murals functioned in a similar way. During the 1930s and 1940s the Roosevelt administration commissioned mural paintings for civic sites both as a "make-work" project in response to the Great Depression of the 1930s and as a form of envious imitation of the government-sponsored Mexican mural paintings. Like the Mexican model, the American mural paintings employed highly expressionistic modernist styles to represent historical events and contemporary activities. They also restricted the historical events to those that took place either on American soil or during transatlantic crossings from the "old countries" to "the new." In other words, the American mural paintings, like the Mexican, did not glorify Europe as the base of American culture. Furthermore, although free enterprise was still upheld as sacred, some American mural painters began to represent the predatory elements of this economic system.[4] Others supported rural life as more moral than urban life and critiqued salient features of modern life.

In part, modern mural painting in America resulted from a new sense of confidence in American achievements and a growing sense of alienation from Europe. The United States had played an important role in the First World War and was in the process of imitating the European acquisition of an overseas empire. Yet Americans could not forget the horrors of the European war. Nor could they ignore certain aspects of European culture they now saw as decadent.[5] Therefore, they began to turn away from Europe and look inward. As the widely influential American philosopher John Dewey claimed at the time, "locality is the only universal."[6] From a similar point of view, American historian Frederick Jackson Turner argued that the unique and dynamic qualities of American life were determined by the availability of westward migration rather than European heritage.[7]

American art critics immediately recognized the difference between the modern mural painting they could easily relate to Dewey's and Turner's ideas and the work of the European-based Mural Movement. Many preferred the former and referred to the latter as "energetically discarded."[8] The new mural paintings, they claimed, had set the stage "for a vital national renaissance of American art."[9] By 1930 one American critic could write with satisfaction that "there is not a classical subject nor a composition executed in a classical style in the entire list of murals at the [1933 Chicago] Fair. Not a goddess, not a cornucopia, not a Greek hero, and not a chariot."[10]

By the mid-1930s many Canadian artists were becoming interested in modern mural painting, especially as it was being done in Mexico and the United States.[11] Consequently, they adopted modernist painting styles, but an analysis of this work shows that it remained more closely aligned with the

work of the European-based Mural Movement than the Mexican and American modern murals. Indeed, these Canadian mural paintings simply continued – unlike modern mural paintings – to glorify the key features of the modern nation-state. At the same time, the number of mural paintings of this type that were commissioned in Canada was relatively low, in part because the government was reluctant to fund public mural painting and also because many Canadians did not like modernist painting styles. Canadian murals painted in modernist styles from the mid-1930s to the mid-1950s may, therefore, be described as a third stage of the European-based Mural Movement, but clearly as a lingering stage, one that lacked the robust nature of the first two.

In 1931 French artist Natacha Carlu used a flattened curvilinear style to paint two panels for the Art Deco dining room of Eaton's department store in Montreal (*in situ*). The room was designed by French architect Jacques Carlu to be a replica of the luxurious dining room of the *Île de France* ocean liner. From the late nineteenth century until well into the twentieth, ocean liners of this type had regularly been decorated with murals that belonged to the European Mural Movement. In Carlu's murals, painted two years into the Great Depression, Diana, the Roman goddess of the hunt, and other antique mythological figures lounge in a pastoral setting. The artist represented the ancient Roman world as a glorious base of modern culture, just as the work of the European-based Mural Movement did. At the same time, the elongated figures – done in imitation of nineteenth-century pre-Raphaelite figures – and the pastel colours turn the work into a caricature of the first stage of the European-based Mural Movement.

In 1936 Charles Comfort employed the bright colours, angular forms, overlapping technique, and dramatic perspectives of cubism and futurism to paint men at work in the land-based activities, such as mining, that had traditionally provided Canadians with wealth for the Toronto Stock Exchange (murals now in the new Toronto Stock Exchange). Without any comment on the contemporary depressed economic state of the nation, these mural paintings glorified material progress just as the work of the European-based Mural Movement did. In 1938 Orville Fisher, Paul Goranson, and Edward Hughes also employed stylistic features of modernism – bold outlines, flattened figures, and bright colours – to represent early European explorations of the local area for the Malaspina Hotel in Nanaimo, British Columbia (five panels extant, one destroyed; in storage under the care of the Nanaimo Community Archives Society Board).[12]

In 1939 Charles Comfort depicted Captain Vancouver as the guest of honour at a Northwest Coast Native potlatch ceremony for the foyer of the newly

FIG. 61 Jock Macdonald, *Nootka Village*, 1939, Vancouver Hotel, Vancouver

constructed Hotel Vancouver (plate 8). This ceremony is an important feasting ritual that established status in highly structured Native societies, redistributed wealth through gift-giving, and celebrated rites of passage.[13] In 1885, fifty-five years before Comfort painted his mural, the Canadian government had banned the potlatch because it believed that the ceremony squandered resources and discouraged the development of individualism, thrift, and other desirable qualities that would support material progress. In Comfort's mural, Captain Vancouver and his fellow sailors are depicted full length as they stand on a platform above the subservient Native people, who are cut in half by the lower frame of the panel. The Native men are rendered powerless as they offer the gifts of the potlatch to the English.[14] Clearly, this mural stated, the potlatch had come under the control of the British. Just after Comfort's mural had been installed, Robert Ayre, art critic for *Saturday Night,* declared: "This mural is true to facts."[15] Unfortunately, it was. It glorifies cultural imperialism as a means of establishing distinct identity. Therefore, it belongs to the European-based Mural Movement, even though its bold simplified forms belong to modernist art styles.

As Comfort was painting his mural for the foyer of the Hotel Vancouver, Jock Macdonald was painting *Nootka Village* in a similarly modernist style for the hotel's dining room (fig. 61, destroyed). It represented the architecture of a traditional Native village of the West Coast Nootka people and provided an

aesthetically pleasing image of an "exotic" lifestyle for hotel visitors.[16] In 1939, Ayre stated in a review: "[The mural] is a fantasia on British Columbia characteristics – the sea, the fog, the beach, river, forest and mountain, fog and raincloud and the pouring sun, the life of the Indians."[17] Yet the Native architecture in *Nootka Village* had been reduced to fit within a single wall of a monumental and commercially successful hotel whose patrons were of European and British ancestry. The hotel itself had been part of the urban expansion that forced Northwest Coast Natives to relocate as early as the mid-nineteenth century. This mural, then, supported racial imperialism as an aspect of distinct identity, and so belongs to the European-based Mural Movement.

The movement continued to function in a weakened manner in Canada throughout the Second World War and even later. In 1941 Pegi Nichol Macleod depicted the trades and crafts taught at Fisher Vocational School in Woodstock, New Brunswick, on the walls of the school's hall (destroyed).[18] She, too, represented the material progress of Western culture's modern age. In 1947 Adam Sherriff Scott used a modernist style to paint five panels for the main Montreal branch of the Bank of Commerce (rue St Jacques, *in situ*). They provide a history of Canadian commerce, a "metahistory" that was typical of the European-based Mural Movement.[19]

In 1950 Charles Comfort also worked with a modernist style to provide another metahistory of material progress for the Dominion Bank in Vancouver 1950 (now the Toronto Dominion Bank, Granville and Pender streets, *in situ*). He clearly understood that his work was part of the European-based Mural Movement when he stated: "The ideology of my compositions deals largely with discovery and development, then and now: the West Coast Indians and their artifacts, the Spaniards, the French, the British."[20] André Biéler provided a similar glorification of material progress for the Shipshaw Power House on the Saguenay River in Quebec in the early 1950s.[21] At the same time, Alex Colville painted *The Circuit Rider* for Tweedie Hall at Mount Allison University, Sackville, New Brunswick. It too employs a modernist style to represent the history of the university and to glorify Christianity as its base. In the centre of the mural is the "circuit rider," a Christian minister who inspired Charles Allison to found the university.[22]

As some Canadian critics assessed the work of the third stage of the European-based Mural Movement, they found its use of modernist styles too avant-garde for public art. They even called for a return to the work of the more conservative stage two. In 1945 John Cowan compared Comfort's modernist *Captain Vancouver* in the Hotel Vancouver with John Innes's, mural paintings of 1927 for the David Spencer department store in the

FIG. 62 Charles Comfort, *Legacy,* 1967, National Library, Ottawa

same city. Innes's panels, Cowan wrote, "are more than a favourable contrast to the decorations for the foyer of the new Hotel Vancouver, particularly that of the wooden ... grotesquely garbed ... Captain George Vancouver."[23]

With this type of attitude in place as late as 1945, it is not surprising that the European-based Mural Movement lingered in Canada long after it had disappeared from other Western countries. It even made an appearance in Canada as late as 1967. At this time, as part of Canada's Centennial celebrations, the federal government commissioned Charles Comfort to paint two panels for the Reading Room of the National Library in Canada. On the east wall he painted *Heritage,* with famous figures from ancient Greece and Rome, England, France, and the United States, civilizations Comfort reasonably believed had contributed to Canada's (*in situ*). In the centre he placed an enthroned Moses, flanked by Christ's disciples Mark and Matthew, who appear to converse with Moses. On the west wall Comfort painted *Legacy,* (fig. 62) with the same basic composition but depicting important Canadian historical figures. For both panels Comfort employed a modernist style. He painted the figures in *grisaille,* so they appear to be photographic negatives, and placed them against stripes of ochre, green, and blue, which were supposed to "forecast an exploding technology."[24]

However, Comfort took his subject matter and composition for the National Library mural paintings from the work of the first stage of the

European-based Mural Movement. As he depicted important figures from various time periods of Western culture coming together in a single space, he was working in a common tradition – for example, Paul Delaroche's *Hemicycle* of 1837 for the Ecole des beaux-arts in Paris. Napoléon Bourassa had employed the same arrangement for his *Apotheosis of Christopher Columbus* of 1904–12 (fig. 6), which he modelled after Delaroche's work and planned, unsuccessfully, to install in the Palais législatif in Quebec City. Furthermore, the enthroned figures in Comfort's panels imitate the Italian Renaissance *sacra conversazione* composition, used frequently in Renaissance paintings and in the work of the first stage of the European-based Mural Movement (see fig. 5). At the same time, by giving key positions to important Christian figures, Comfort essentially proclaimed Christianity, another feature of the modern nation-state, as the national religion.

Clearly, then, Comfort's mural belongs to the waning but lingering stage of the European-based Mural Movement. Given the movement's goal of raising nationalistic sentiment, the intense levels of nationalistic sentiment in Canada at the time of the Centennial of Confederation in 1967, and Comfort's experience in mural painting that went back to the 1930s, this conservative approach to mural painting at such a late date is not surprising.

In the mid-1930s, however, Canadian critics generally welcomed work like Comfort's as modern mural paintings. Just like American critics, the Canadians even referred negatively to earlier mural paintings as "potboilers" and "insipid portrayals of romantic, ideal labour, industry and agriculture."[25] To some extent these critics must have based their opinions on mural painters who insisted that their new mural paintings were "modern." However, in the 1930s, some Canadian mural painters seem not to have understood the difference between the work they were producing and modern mural paintings. For example, in 1933 Arthur Lismer argued that his mural paintings for Humberside Collegiate (fig. 11) were much like those done by Thomas Hart Benton for the New School for Social Research in New York of the mid-1920s.[26] Yet Lismer employed an impressionistic style to depict classical personifications of Truth, Wisdom, and Beauty as overseers of British imperialism and Canadian material progress from the eighteenth century to the twentieth. Benton's mural paintings, in contrast, use modernist stylistic features such as bold colours, caricatures, and overlapping to represent the energy as well as the confusion and tedium of mundane activities of modern life such as subway travel, watching a movie, visiting a doctor, and working in a factory.

Lismer also illustrated a remarkable lack of understanding of the Mexican mural paintings when he stated that the communist beliefs of

Mexican muralist Diego Rivera were "irrelevant to [Rivera's] artistic achievements," even though Rivera clearly employed his art to demonstrate his commitment to the redistribution of wealth among the impoverished Mexican people.[27] Similarly, in 1937, while Canadian artist André Biéler was suggesting to the Canadian government that it should imitate the Mexican government's patronage of civic mural decoration, he also stated: "Even when the main themes of the [Mexican] frescoes are fiercely intense social questions, these remain fine works of art."[28]

In 1939 Comfort must have been working with the same misunderstanding when he claimed to have based his mural paintings for the Toronto Stock Exchange on Benton's mural paintings for the New School for Social Research in New York (*in situ*) and on Diego Rivera's mural paintings for the dining room of the San Francisco Stock Exchange (*in situ*).[29] Benton's and Rivera's mural paintings focus on the humanity of the workers, while Comfort's workers are remote mechanical figures "swamped by the dynamism of industry."[30] Just after Comfort's work was installed – in the midst of the Great Depression – Toronto art critic Pearl McCarthy simply and vaguely declared that it had "a philosophical flair."[31] Since McCarthy did not define this flair, it is likely that she was looking for some sort of social critique, found none, and was at a loss for words.

Some Canadian mural painters did understand the differences between the work of the European-based Mural Movement and the modern mural. In the early 1930s Julius Griffith Jr painted four panels for Shawnigan Lake School in Shawnigan, British Columbia (destroyed). One of the panels depicted scenes from the Trojan War. This mural might be assumed to belong to the European-based Mural Movement, but the three other panels designate Griffith's work as a modern mural painting. As a writer for the *Shawnigan Lake School Magazine* of 1934 said: "At the present time humanity is floundering in an economic morass chiefly [owing] to the fact that we do not understand how to use the [scientific] machinery at our disposal for the common good. [The panels suggest] that the [students] may feel the need of doing something definite as citizens and [to] make a real effort to do their share of setting things right rather than ... settling down to a smug life of money-making ... Poverty and plenty are represented in [images of] the slums and factories ... the manual worker is large, showing the importance that he plays in the running of the world. The warships and aeroplanes show that we still live under the menace eof war."[32] In other words, the modern world had many problems, none of which the murals of the European-based Mural Movement acknowledged.

In 1934 Harold Haydon painted a similarly modern mural for the gymnasium of Pickering College, a private Quaker school in Newmarket, Ontario (*in situ*). The general theme of Haydon's mural is "energy," in both a controlled and an uncontrolled state, which Haydon related to the types of activities that took place in a gymnasium. The first part of Haydon's mural represents scientific images of the evolution of plants and of sea and animal life. Other panels depict a society overshadowed by force and oppression, and a society inspired by concepts of brotherhood and cooperation. All these themes were frequently used in modern mural paintings outside Canada. The style of Haydon's mural paintings, as he explained at the time he painted them, was influenced by the modernist work of Diego Rivera in Mexico and the United States.[33]

In 1943 Marian Dale Scott painted a modern mural, *Endocrinology,* for the History Department of McGill University (*in situ*). It represents the dynamism of science and, given Scott's interest in the social problems of modern life, suggests that science may resolve some of these problems. Between 1946 and 1948 local artist Fred Ross painted a war memorial mural for the auditorium of Fredericton High School in Fredericton, New Brunswick (location unknown, probably destroyed). It consisted of two panels in a modernist style that mixed curvilinear flattened forms with the angularity and overlapping of cubism. One panel represented the horrors of war; the other, contemporary activities at the school.[34] In both style and subject matter, the mural was reminiscent of Stanley Spencer's mural paintings for Burghclere Chapel.

Within the framework provided by this book, the mural paintings by Ross, Scott, Haydon, and Griffith were clearly modern. However, this type of mural painting was not frequently done in Canada, and many of those that were done did not receive adequate support. They were devalued and not maintained. Some were not even retained. Griffith worked for the Shawnigan School simply because he had attended it. Details of his remuneration are not known, but he may well have donated the work. For his Pickering College mural paintings, Haydon received only room and board and the use of the studio and the studio's paints. Ross was forced to work with poor-quality materials. During later renovations, his mural was apparently discarded and is now lost. Other modern mural paintings planned for Canadian sites were never even installed. In 1941 Miller Brittain began to work on a program devoted to the theme of tuberculosis, its treatment and its causes (in one panel children would have walked by a smoky billiard room), for the St John Hospital in Saint John, New Brunswick. The

commission was cancelled because of a lack of funds (drawings in the New Brunswick Museum in St John).[35]

This lack of support for modern mural paintings may be easily explained. In terms of subject matter, some were highly personal, others critiqued modern life, and still others called for a rejection of long-held conservative values. Furthermore, the subject matter was combined with styles that many Canadians of the 1930s to 1950s found too avant-garde. At the same time, given Canada's small population of artists and enormous land mass, it was difficult for artists to organize in order to petition governments for support. Indeed, Canadian artists came together for the first time to consider government patronage of the arts only in 1941, at the Conference of Canadian Artists held in Kingston, Ontario. Therefore, Canadian artists who were interested in making personal and critical statements of the type made in so many modern mural paintings, especially in civic sites, were forced to do so through smaller formats such as easel painting and print-making, which could be published in sympathetic journals.[36] Commercial patrons, for obvious reasons, would also not have been interested in the modern mural painting.

In 1941 Maritime art critic Walter Abell lamented that Canadian civic buildings, such as schools and post offices, were " bleakly bare of significant art."[37] He also sadly contrasted Canada's lack of civic mural painting patronage with the enviable patronage provided by the American federal government of that time. In 1952 Toronto art critic Donald Buchanan wrote from a similar point of view: "No one can accuse the Canadian government of spending money foolishly on mural painting. In fact, it practically never appropriates money, either foolishly or wisely, for any such purpose."[38]

In the 1940s and 1950s Abell and Buchanan were clearly interested in seeing Canadian artists produce modern mural paintings in imitation of the Mexican and American mural paintings. Their observations on the infrequent installation of this type of mural in Canada were certainly correct. However, their support for the modern mural painting seems to have clouded their views on the general history of mural painting in Canada. Abell and Buchanan wrote as though little mural painting had been produced in Canada. When Buchanan argued that Canadian governments had "practically never appropriate[d] money" for civic mural painting, he was ignoring the many examples of civic murals discussed in this book.

Over the next three decades – the 1960s to 1980s – Canadian art historians J. Russell Harper and Dennis Reid continued to support statements like Buchanan's by excluding Canadian mural paintings of the 1860s to 1930s

from their surveys of Canadian painting. Since no other large-scale surveys of Canadian painting were published in English during these three decades, the history of the European-based Mural Movement in Canada "disappeared." In part, Harper and Reid (as well as Charles Hill in his *Canadian Painting of the Thirties* of 1975) excluded the mural paintings of the 1860s to 1930s because they found their styles to be old-fashioned and because they regarded other art (specifically the northern landscapes done by Tom Thomson and members of the Group of Seven) as more capable of evoking nationalistic sentiment in viewers. Harper, Reid, and Hill may also have been influenced by statements made by Buchanan and other Canadian art historians of the 1950s. In any case, since the 1950s, Canadian art historians have ignored the hundreds of mural paintings that were installed in civic, commercial, Christian, and private sites across Canada from the 1860s to the 1930s.

Despite this neglect, these earlier mural paintings are an important part of Canadian art history. Indeed, they were designed to raise nationalistic sentiment at a time when such sentiment was widely regarded as necessary if a country or region of a country were to "flourish." Furthermore, they appeared in all regions of Canada, and were a type of nationalistic art that reflected all parts of Canada. An awareness of this work calls for a rewriting of the history of Canadian painting.

APPENDIX

Canadian Murals Discussed in
A National Soul

The table is organized alphabetically by province and then by date. Figure numbers refer to illustrations in this book. Murals without figure numbers are discussed in this book, but not illustrated.

Artist	Subject Matter / Title	Original Location	Date	Present Location	Type
ALBERTA					
Unknown	Landscapes (fig. 37)	Den and bedroom, home of Bidwell Holgate, Edmonton	1912	*In situ*	Private
Unknown	Unknown	Home of William Magrath, Edmonton	1913	*In situ*	Private
John Girvan	World War I soldiers (?)	Memorial Hall, Edmonton	c. 1919	Probably destroyed	Civic
Unknown	Classicizing	Empire Theatre, Edmonton	1920	Destroyed	Commercial
Blood Indians, individuals unknown	Native pictographs (fig. 52)	Prince of Wales Hotel, Waterton Lake Provincial Park	1929	Destroyed	Commercial
BRITISH COLUMBIA					
William Schaefer	Cupids, garlands, bees in drawing room; fish and game in dining room	"Craigdarroch," home of Robert Dunsmuir, Victoria	1900	Destroyed	Private
William Schaefer	Classicizing	"Ashnola," home of daughter of Robert Dunsmuir, Victoria	1900	Destroyed	Private
Unknown	Frieze of local landscapes	Reading room, Empress Hotel, Victoria	1902–5	Destroyed	Commercial
James Blomfield	Upper walls, Native American totems (fig. 51)	Ballroom, Lieutenant-Governor's House, Victoria	1903	Destroyed	Civic
James Blomfield	Personifications of Acadia and Vancouver	Foyer, Royal Bank, Vancouver	1905	Probably destroyed	Commercial

Artist	Subject	Location	Date	Status	Type
Muller and Stern	Pompeian images	Reception areas/rooms, home of William Perdray, Victoria	1913	Destroyed	Private
Unknown	Classicizing	Royal Victoria Theatre, Victoria	1913	Destroyed	Commercial
Adelaide Langford	Local landscapes	Main hall of Canadian Pacific Railway Station, Vancouver	1916	In situ	Commercial
Unknown	Landscapes	Columbia Theatre, Vancouver	1920s	Destroyed	Commercial
John Girvan	Local waterfront commercial activities	Foyer, Vancouver Province Building, Vancouver	1925	Two panels lost, five panels in Vancouver Show Mart Building, Vancouver	Commercial
John Innes	Ten panels, local industries and natural resources	David Spencer department store, Vancouver	1927	In storage, Art Gallery of the University of British Columbia	Commercial
Julius Griffith Jr	One panel, Trojan War, three panels aspects of modern life	Shawnigan Lake School, Shawnigan Lake (private school)	1933	Destroyed	Private
Orville Fisher, Paul Goranson, Edward Hughes	Christian scenes	First United Church, Vancouver	1934	Destroyed	Religious
George Southwell	Eight panels, local history and industries (figs. 2–4)	Rotunda of Provincial Parliament Buildings, Victoria	1935–53	In situ	Civic
Orville Fisher, Edward Hughes Paul Goranson,	Local history	Malaspina Hotel, Nanaimo	1938	In storage, Community Archives Board	Commercial
Charles Comfort	Captain Vancouver (plate 8)	Hotel Vancouver, Vancouver	1939	Confederation Centre Art Gallery, Charlottetown	Commercial
Jock Macdonald	Nootka Village (fig. 61)	Hotel Vancouver, Vancouver	1939	Probably destroyed	Commercial
Charles Comfort	Local history	Dominion Bank, Vancouver	1950	In situ	Commercial

Artist	Subject Matter / Title	Original Location	Date	Present Location	Type
		MANITOBA			
Unknown	Classicizing	Home of A.W. Austin, Winnipeg	1882	Destroyed	Private
Frederick Challener	Eight panels, local history (fig. 39)	Dining room, Royal Alexandra Hotel, Winnipeg	1906–10	Four panels destroyed, four panels in the Manitoba Archives	Commercial
Henri Beau	Vineyards, possibly Dionysiac / Bacchic	Café, Royal Alexandra Hotel, Winnipeg	1906	Destroyed	Commercial
Unknown	Landscapes	Living room, home of Mr R. Wilson, Winnipeg	1907	Unknown	Private
Augustus Tack	Personifications of virtues (fig. 1)	Manitoba Legislative Building, Winnipeg	1920	*In situ*	Civic
Frank Brangwyn	World War I scenes	Manitoba Legislative Building, Winnipeg	1920	*In situ*	Civic
Ozias Leduc	Christian images	Chapel of St Joseph, Hospital of the Grey Sisters, St Boniface	1921	Unknown	Religious
Adam S. Scott	*The Building of Fort Charles and "The Pioneer" at Fort Garry* (fig. 21)	Above elevators, first floor, Hudson's Bay Company store, Winnipeg	1927	*"The Pioneer" In situ,* other panel in storage in HBC Archives	Commercial
		NEW BRUNSWICK			
Unknown	Fruits and vegetables on ceiling	Home of Mr. Moran, Saint John	1860s	*In situ*	Private
Unknown	Birds, flowers, grotesques; *trompe l'oeil* marbling	Parlour of 5 Prince William St, Saint John, possibly the house of James Dever	1860s–70s	*In situ*	Private

Artist	Subject	Location	Date	Status	Civic/Private
Unknown	Cupid and Psyche and other classicizing images	Vestibule, parlour, 1 Prince William St, Saint John	1880s	*In situ*	Private
Unknown	Roses, cupids, Acadia University, a suspension bridge, Niagara Falls	Drawing room, Count de Bury House, Saint John	c. 1900	Unknown	Private
Unknown	Nature images, birds, fruit, small landscapes (fig. 28)	Library/drawing room. "Old Manse," Newcastle	c. 1900	*In situ*	Private
William Van Horne	Dutch children at play (fig. 60)	Nursery, Van Horne summer home, Minister's Island	1910	*In situ*	Private
George Russell Horne	Overmantle landscapes	Dining room, Horne's home in Newcastle	1920s	*In situ*	Private
Lucille Douglass	Landscapes	IODE Meeting House, Newcastle	1920s	*In situ*	Private
Miller Brittain	Scenes of illness, causes of illness, and medical treatment	Planned for Saint John Hospital, Saint John, never installed	1941	Drawings in the New Brunswick Museum, Saint John	Civic
Pegi Nichol Macleod	Two panels, craft production	Fisher Vocational School, Woodstock	1941	Destroyed	Civic
Fred Ross	Two panels, local contemporary students and images of World War II	Fredericton High School, Fredericton	1946–48	Destroyed	Civic
Alex Colville	One panel, *The Circuit Rider*	Tweedie Hall, Mount Allison University, Sackville	1951	*In situ*	Civic/Private

NOVA SCOTIA

Artist	Subject Matter / Title	Original Location	Date	Present Location	Type
Unknown	British coat-of-arms	Lunenberg County Courthouse, Lunenberg	1810	*In situ*, now the parish hall of Saint John's Anglican Church	Civic
Unknown	Views of European cities copied from the *London Illustrated News*	Parlour in home of Hanna and William Croscup, Karsdale	1848	National Gallery of Canada, Ottawa	Private
Unknown	Non-figural stencilled patterns	Baptist Church, Falmouth	1870s	*In situ*	Religious
George Lyons	One panel, *Elaine's Death*	Home of John Wylie, Churchill, Hants Co.	1890	*In situ*	Private
Mr Page	Non-figural stencilled patterns	St John's Anglican Church, Lunenberg	c. 1870	Destroyed	Religious
Unknown	Non-figural stencilled patterns	St Mary's Basilica, Halifax	1889	Destroyed	Religious
Unknown	Non-figural stencilled patterns	St Paul's Anglican Church, Halifax	Late 19th century	Destroyed	Religious
Ozias Leduc	Unknown	Assembly Hall, St Francis-Xavier University, Antigonish	1902–3	Destroyed	Private/ Religious
Ozias Leduc	Unknown	Homes of Kirk, MacIsaak, and Thomson families, Antigonish	1902–3	Probably destroyed	Private
Ozias Leduc	Unknown	Halifax Banking Company, Antigonish	1902–3	Probably destroyed	Commercial
Ozias Leduc	Christian scenes	St Ninian's Cathedral, Antigonish	1902–3	*In situ*	Religious
Charles Doyle	One panel, landscape	House in Port Howe	1907	*In situ*	Private

Artist	Description	Location	Date	Status	Type
Charles Mackenzie	Floral motifs and a coat of arms	Pictou Opera House, Pictou	1915	In storage in bldg.	Commercial
Arthur Lismer and Harold Rosenberg	Thirteen panels, local landscape (fig. 14)	Restaurant(s?), Bedford or Halifax	1916	Unknown	Commercial
Canon Harris	One panel, landscape,	Pictou Opera House, Pictou	1915	In storage in bldg.	Commercial
Emmanuel Briffa	Eight panels, Canadian history (plate 4)	Capitol Theatre, Halifax	1930	Public Archives of Nova Scotia, and Halifax Historic Properties	Commercial

ONTARIO

Artist	Description	Location	Date	Status	Type
A. Todd	Classicizing	Ceiling, reading room, Mechanics' Institute, Toronto	1861	Destroyed	Civic
Firm of Gundry & Langley	Starry sky	Holy Trinity Anglican Church, Toronto	1867	Destroyed	Religious
Josef Moser	Coat-of-arms and *trompe l'oeil* architectural details	Victoria Hall, Cobourg	1860s	*In situ*	Civic
Unknown	Angels and non-figural patterns	Metropolitan Methodist Church, Toronto	1870s	Destroyed	Religious
John Walthew	*Trompe l'oeil* architectural motifs	Aylmer Town Hall, Aylmer	1873/4	*In situ*	Civic
H. Schasstein et al.	Classicizing motifs and narratives; *trompe l'oeil* sculpture, architectural motifs and textiles; portraits, landscapes (fig. 30)	All reception areas and bedrooms in home of James Livingston, Baden (Castle Kilbride)	1878 to 1920s	*In situ*	Private
Unknown	Classicizing motifs	Home of John Livingstone, Listowel	1880s	*In situ*	Private
Unknown	Classicizing motifs	Glanmore	1882–3	*In situ*	Private

Artist	Subject Matter / Title	Original Location	Date	Present Location	Type
Unknown	Classicizing motifs	Belleville	1880s	*In situ*, now the Hastings County Museum	Private
Unknown	Classicizing motifs	Home of Robert Scott, Mount Forest	Late 1800s	*In situ*	Private
Josephine McWilliam (?)	Classicizing motifs, landscapes, portraits of English royal and Canadian political figures(?)	Home of Josephine and Robert McWilliam, Drayton	1890s	*In situ*	Private
Gustav Hahn	Angels and non-figural decoration (fig. 22)	St Paul's Methodist Church, Toronto	1890	Destroyed	Religious
Gustav Hahn	Personifications of virtues, Celtic vine scroll, maple leaves (fig. 8)	Ceiling and upper parts of walls in Legislative Chamber, Ontario Legislative Buildings, Toronto	1892	*In situ,* mostly covered over, small sections uncovered	Civic
Gustav Hahn	Medieval women and landscapes	"Wymilwood," home of Edward Wood, Toronto	1895	Destroyed	Private
Members of the Toronto Society of Mural Decorators	Six panels of local commercial activities and two of classical personifications	Planned for the Council Chamber of the Toronto Municipal Buildings, Toronto	1895	Never installed	Civic
Mary Hiester Reid	*Castles in Spain* (fig. 31)	For Reid's Wychwood Park, Toronto, home	1896	Art Gallery of Ontario	Private
Frederick Challener	Classical figures associated with the arts (fig. 19)	Proscenium arch, Russell Theatre, Ottawa	1897	National Gallery of Canada	Commercial
George Reid	Canadian historical events set in landscape	Planned for the foyer of the Toronto Municipal Buildings, Toronto	Mid to late 1890s	Never installed, drawings in the London, Ontario, Regional and Historical Museum	Civic

Artist	Description	Location	Date	Status	Type
Members of Toronto Guild of Civic Art	Canadian history set in landscape	Planned for foyer and main stairwell of the Ontario Parliament Buildings, Toronto	1897–1907	Never installed	Civic
George Reid	Two panels, *The Arrival of the Pioneers* and *Pioneer Farm* (fig. 38)	Foyer, Toronto Municipal Buildings	1899	*In situ*	Civic
George Reid	Continuous landscape frieze (fig. 34)	"Long Garth," home of Byron Walker, Toronto	1899–1901	Art Gallery of Toronto	Private
Frederick Challener	One panel, classicizing (fig. 18)	S.S. *Kingston* passenger boat	1901	Destroyed	Commercial
Frederick Challener	One panel, *Fort Rouillé*	King Edward Hotel, Toronto	1901–6	Destroyed	Commercial
Members of the Toronto Guild of Civic Art	*Canada Receiving Her Children* – personifications of Canada and provinces, landscape	Planned for the rotunda of the federal Parliament Buildings, Ottawa	1904	Never installed	Civic
Frederick Haines	Local landscape	Meadowvale Public School, Meadowvale	1906	Offices of the Credit Valley Conservation Authority	Civic
Unknown	Classicizing	Grand Theatre, London	1907	*In situ*	Commercial
Frederick Challener	Proscenium arch, allegorical	Proscenium arch, Royal Alexandra Theatre, Toronto	1907	*In situ*	Commercial
Elizabeth Annie Birnie	Unknown	Library, Collingwood	1908–14	Destroyed	Civic
Elizabeth Annie Birnie	Historical scenes with lake views	Library, Penetang	1908–14	In storage, Discovery Harbour, Penetang	Civic
John Beatty	*Governor and Mrs Simcoe Paddled Up the Credit River* (figs. 42 and 43)	Mississauga Golf Club, Mississauga	1908–9	*In situ*	Private

Artist	Subject Matter / Title	Original Location	Date	Present Location	Type
John Beatty	Three panels, *Spring, Summer, Fall* (fig. 57 and plate 3)	Kindergarten room, Rosedale Public School, Toronto	1910	In new location in school	Civic
F. McGillivray Knowles	Seven panels, *History of Music* (fig. 32)	Music room in home of Sir John Eaton, Toronto	1911	Art Gallery of Ontario	Private
Mary Hiester Reid	Local landscape of Humber River Valley, *Autumn* (fig. 9)	Weston Town Hall, Weston	1913	Unknown, probably destroyed	Civic
Designers at Luxfer Prism, Dominion Glass, Hobbs Manufacturing, and Robert MacCausland	Opalescent glass panels of landscapes, Dutch children at play, illustrations of nursery rhymes, fairy tales, and Froebel's mother-play songs (figs. 55 and 56)	Kindergarten rooms in at least thirty-four Toronto public schools	1913–19	Some destroyed; some relocated in schools; *in situ* in 3 schools	Civic
George Reid	Landscape	Home of H.H. Love, Toronto	1915	Unknown	Private
Unknown	Non-figural patterns	Methodist Church, Hamilton	1915	Destroyed	Religious
Arthur Lismer, J.E.H. MacDonald, Tom Thomson	Landscapes, historical, and contemporary scenes (figs. 35 and 36)	Main room, summer home of Dr J. MacCallum, Georgian Bay	1916	National Gallery of Canada	Private
Thomas G. Greene	Landscape and natural resources	Home of Ernest C. Jury, Toronto	1916	Possibly *in situ*	Private
John Chester	One panel, *Champlain Teaches Natives the Charleston* (fig. 41)	Arts and Letters Club, Toronto	1920	Destroyed	Private
Arthur Crisp	Seventeen panels, personifications and natural resources (fig. 10)	Reading room, Canadian federal Parliament Buildings, Ottawa	1920	*In situ*	Civic

Artist	Description	Site	Date	Status	Category
J.E.H. MacDonald	One panel, *A Friendly Meeting in Early Canada* (fig. 40)	No planned site, never installed as a mural	1923	Metropolitan Toronto Reference Library	Planned as a civic mural
J.E.H. MacDonald, Herbert Stansfield et al.	Christian narratives, vine scroll, and non-figural decoration (fig. 24 and plate 6)	St Anne's Anglican Church, Toronto	1923	*In situ*	Religious
Frederick Challener	Woodland scenes and sporting activities (plate 7)	Main hall and library of home of Samuel McLaughlin, Oshawa	1924	*In situ*	Private
George Reid	Six panels, *An Ideal Community*, landscape and educational activities (figs. 53 and 54)	Earlscourt Library, Toronto	1924–26	Destroyed	Civic
Arthur Lismer	Five panels, Canadian history (fig. 11)	Auditorium of Humberside Collegiate, Toronto	1927–30	New auditorium, Humberside Collegiate, Toronto	Civic
Frederick Challener	One panel, *Fort Rouillé* (fig. 48)	Office of Loblaws, Toronto	1928	In storage, archives of the City of Toronto	Commercial
George Reid and Lorna Claire	Twelve panels, historical (fig. 12)	Jarvis Collegiate, Toronto	1928–30, early 1940s	Twelve panels *in situ*, one destroyed	Civic
Frederick Haines and students from Ontario College of Art	Eight panels, Canadian history (figs. 49 and 50)	Under the dome of the Dominion Government Building, Canadian National Exhibition, Toronto	1929	Foyer, National Trade Centre, Canadian National Exhibition, Toronto	Commercial
Lorna Claire	Illustrations of fairy tales	Earlscourt Public Library, Toronto	1929	Destroyed	Civic
Frank Johnston	Ten panels, Canadian landscape	Boardroom, Pickering College, Newmarket	Late 1920s	*In situ*	Private

Artist	Subject Matter / Title	Original Location	Date	Present Location	Type
Arthur Crisp	Eighteen panels, *History of Transportation* (fig. 20 and plate 5)	Main branch of Bank of Commerce, Toronto	1930	Sixteen panels *in situ*, two destroyed or never installed	Commercial
Unknown	At least 10 panels, landscapes	Hollywood Theatre, Toronto	1930	Destroyed	Commercial
Charles Jefferys	Four panels, history of the Rideau canal (figs. 44 and 45)	Reading room of the Château Laurier Hotel	1931	One panel destroyed, three in National Archives of Canada	Commercial
Charles Jefferys	Six panels completed, more planned – Historical, Mousterian and Bronze Age periods	Royal Ontario Museum, Toronto	1932–5	One panel in C.W. Jefferys School, Downsview, Ontario; some in storage, some destroyed	Civic
Harold Haydon	Scientific images and scenes of contemporary life	Pickering College, Newmarket	1934	*In situ*	Private
Peter Browne and sons	Christian narratives	St. Jude's Anglican Church, Brantford	1936	*In situ*	Religious
Charles Comfort	Industrial activities	Toronto Stock Exchange	1936	In the new Toronto Stock Exchange	Commercial
Will Ogilvie	Christian scenes (fig. 25)	Chapel, Hart House, University of Toronto	1936	*In situ*	Religious
George Reid	Thirty-four panels on pre-stone-age history (fig. 13)	Royal Ontario Museum, Toronto	1935–8	Some in storage, some destroyed	Civic
Charles Comfort	Two panels, *Heritage, Legacy* (fig. 62)	Reading Room, National Library, Ottawa	1967	*In situ*	Civic
Alfred Pellan	Two panels, *Knowledge, The Alphabets*	Reference Room, National Library, Ottawa	1936	*In situ*	Civic

PRINCE EDWARD ISLAND

Robert Harris	Christian narratives (fig. 23)	All Souls Chapel, St Peter's Anglican Church, Charlottetown	1898	*In situ*	Religious
François-Xavier Édouard Meloche	Christian narratives	St Simon and St Jude Catholic Church, Tignish	1885	*In situ*	Religious

QUEBEC

Unknown	Classicizing, cupids, flowers, *trompe l'oeil* architectural motifs	Home of Sir Hugh Allan, Montreal	After 1861	Destroyed	Private
Luigi Capello	Scenes from the life of the Virgin Mary	Notre Dame Cathedral, second gallery, Montreal	1874–92	Destroyed	Religious
Angelo Pienovi	Starry sky	Notre Dame Cathedral, Montreal	1875	*In situ,* repainted	Religious
Peter H. Almini	Ceiling and upper walls, classicizing figures and European landscapes (fig. 16)	Windsor Hotel, dining/ball room, Montreal	1877–78	Destroyed	Commercial
Daniel Müller	Christian scenes	Church of the Gesù, Montreal	1870s	*In situ*	Religious
Napoléon Bourassa	Immaculate Conception and other Christian narratives (fig. 26)	Notre-Dame-de-Lourdes, Montreal	Late 1870s–early 1880s	*In situ*	Religious
Napoléon Bourassa	One panel, *Apotheosis of Christopher Columbus* (fig. 6) and other French Canadian history scenes	Planned for the Palais législatif in Quebec City, never installed	1904–12	Musée de Québec	Civic

Artist	Subject Matter / Title	Original Location	Date	Present Location	Type
Ozias Leduc	Life of St Hilaire and other Christian scenes (fig. 27)	Church of St Hilaire, St. Hilaire	1896–9	*In situ*	Religious
Henri Beau, Joseph-Charles Franchère, Charles Gill, Ludger Larose	Christian and Canadian historical scenes	Chapel of the Sacred Heart, Notre-Dame Church, Montreal	1896	Probably destroyed	Religious
Charles Huot	Christian scenes	Church of Saint-Saveur, Quebec City	1887–90	*In situ*	Religious
William Brymner et al.	Landscapes (fig. 33)	Dining room, summer home of Charles Porteous on the Île d'Orléans	1899	*In situ*	Private
William Brymner	Three panels, landscape and Canadian history	Home of Sir Edward Clouson and daughter, Mrs John Todd, Île d'Orléans	c. 1900	Destroyed	Private
Frederick Hutchison	Classicizing nudes	Reception room, Charles Hosmer house, Montreal	1902	*In situ*	Private
Henri Beau	One panel, *The Arrival of Champlain* (plate 2)	Legislative Council Chamber of the Palais législatif, Quebec City	1903	Musée de Québec	Civic
Maurice Cullen	Three panels, landscape	Billiard room, home of James T. Davies, Montreal	1910	*In situ*	Private
Maurice Cullen	One panel, landscape	Home of Richard Mitchell, Montreal	1910	*In situ*	Private
Charles Huot	One panel, *The Debate on Language* (fig. 7)	National Assembly Chamber of the Palais législatif, Quebec City	1913	*In situ*	Civic

Artist	Title/Description	Location	Date	Status	Category
Charles Huot	*Je me souviens*, historical and classicizing	Ceiling of National Assembly Chamber of the Palais législatif, Quebec City	1914–20	*In situ*	Civic
Unknown	Vineyard with monkeys	Café of University Club, Montreal	c. 1915	Destroyed (photo in McCord Museum, Montreal)	Private
Ozias Leduc	Christian narratives	Church of Saint-Enfant-Jésus, Montreal	1917–19	*In situ*	Religious
Guido Nincheri	Christian images	Saint-Léon-de-Westmount, Montreal	1918, 1944–51	*In situ*	Religious
Guido Nincheri	Classicizing (fig. 29)	Château Dufresne, Montreal	1918	*In situ*	Private
Guido Nincheri	Ceiling, Allegorical (fig. 15)	Belmont Theatre, Montreal	1920	Destroyed	Commercial
Guido Nincheri	Christian images	Mother House of the Sisters of the Holy Name of Jesus, Montreal	1920	*In situ*	Religious
Donald Hill	One panel, *Time Pointing out the Opportunities to Acquire Education and Its Rewards* (fig. 5)	Strathearn School, Montreal	1924	Destroyed	Civic
Robert Pilot	One panel, *The First Traders of New France*	Montreal High School, Montreal	1924	Offices of the Protestant School Board of Montreal	Civic
Leslie Smith	One panel, *Education Extends an Open Hand to All Classes*	King Edward VII School, Montreal	1924	Destroyed	Civic
Charles Simpson	*St Columba Bringing the Elements of Celtic Art into Scotland*	Foyer, Montreal Museum of Fine Arts	1924	Trinity College School, Port Hope, Ontario	Civic

Artist	Subject Matter / Title	Original Location	Date	Present Location	Type
Hal R. Perrigard	One panel, *Mount Sir Donald Glacier, B.C.* (fig. 17)	Ladies' waiting room, Windsor Train Station, Montreal	1924	Destroyed	Commercial
Cory Kilvert	One panel, landscape map	ss *Northern*, passenger boat, Clarke Steamship Company	1926	Destroyed	Commercial
Charles Huot	*Sovereign Council*	Legislative Council Chamber of the Palais législatif, Quebec City (replaced Henri Beau's mural of 1903)	1926–30	*In situ*	Civic
Alexander Scott Carter	Landscape and Quebec historical map	University Club, Montreal	1927	*In situ*	Private
Charles Jefferys and Frederick Challener	Two panels, *French Explorers at Malbaie* and *Clan Fraser Lands at Murray Bay* (figs. 46 and 47)	Dining room, Manoir Richelieu Hotel, Malbaie	1928	*In situ*	Commercial
Adam S. Scott	Thirteen panels, local history	Grill room, Lucerne-in-Quebec Hotel (now the Château Montebello), Montebello	1930	*In situ*	Commercial
Thirteen artists (for names, see chapter 2)	Seventeen panels, Quebec history and maps	Chalet, Mont Royal Park, Montreal	1931	*In situ*	Civic
Natacha Carlu	Two panels, Diana and other mythological figures	Dining room, Eaton department store, Montreal	1930s	*In situ*	Commercial
Guido Nincheri	Christian narratives	Notre-Dame-de-la-Défense, Montreal	1930s	*In situ*	Religious

Ozias Leduc	Christian narratives	Notre-Dame-de-la-Présentation, Shawinigan-Sud	1942–55	*In situ*	Religious
Marian Dale Scott	*Endocrinology*	History Department, McGill University, Montreal	1943	*In situ*	Civic
Adam S. Scott	Five panels	Bank of Commerce, Montreal	1947	*In situ*	Commercial

SASKATCHEWAN

Count Berthold Von Imhoff	Christian narratives	St Peter's Catholic Church, Muenster	1919	*In situ*	Religious
Unknown	Classicizing	Capital Theatre, Saskatoon	1920	Destroyed	Commercial
John Leman	One panel, *Before the White Man Came* (plate 1)	Main foyer of Provincial Legislature, Regina	1933	*In situ*	Civic
Augustine Kenderdine	One panel, landscape	World's Grain Building, Regina	1933	Saskatchewan Archives Board, storage	Civic/Commerical

MURALS DONE OUTSIDE CANADA BY CANADIAN MURALISTS

George Reid	Trumpeting Angels	Onteora Church, Onteora, New York	1895	*In situ*	Religious
George Reid	Continuous landscape frieze	Living room, home of Charles Russell, Onteora, New York	1895	Unknown	Private

MURALS DONE OUTSIDE CANADA BY FOREIGN MURALISTS FOR CANADIAN PATRONS

Frank Brangwyn	*The Introduction of European Civilisation into the Country of the Red Indian*	Offices of the Grand Trunk Railway, London, England	1909	Canadian Government Confederation Centre, Ottawa	Commercial

NOTES

All references are given in their short form here. The complete bibliographical information is provided in the bibliography.

INTRODUCTION

1 A large body of literature describes the modern nation-state and nationalism – and the expression of pride in it. See, for example, Smith, *Theories of Nationalism;* Llobera, *The God of Modernity;* Baycroft, *Nationalism in Europe, 1789–1945;* and Gilbert, *The Philosophy of Nationalism.*
2 Vézina, *Napoléon Bourassa (1827–1916)*, 192–3.
3 Maurault, "Chronique d'art," 76. See also Maurault, "Tendances de l'art canadien," 369–73.
4 Carman, "Wall Paintings in Europe," 312.
5 Radford, "The Secret of Success in Art," 20.
6 MacTavish, *The Fine Arts in Canada,* 97, 99, 126–9.
7 Colgate, *Canadian Art,* 120, 233–40.
8 Donegan, "Mural Roots," 69.
9 Letter from J. Russell Harper to Mary Wrinch Reid, 8 November 1963, Gordon Conn Papers, Archives of the Edward P. Taylor Library, Art Gallery of Ontario.
10 Preston, "Regionalism and National Identity," 6.
11 Quoted in Underhill, *The Image of Confederation,* 15.
12 Merifield, *Speaking of Canada,* 3, 5.
13 Connor, "The Future of Canada," 146, 148. Muralists George Reid and E. Wyly Grier joined the Canadian Club's Toronto branch in 1902. See the *Constitution of the Canada Club of Toronto and Roll of Members, 1902–3,* copy available in the Archives of the Province of Ontario.
14 Clark, "Why Canadian Art Is Not Popular with Collectors," 10. For a later discussion of the relation between Ontario landscape painting and national sentiment in Canada, see Cook, "Landscape Painting and National Sentiment in Canada," 263–8.
15 Colgate, *The Toronto Art Students' League, 1886–1904.*
16 Daniel Hill, honorary president of the Canadian Club, quoted in Hill, *The Group of Seven,* 43.

17 Native people had, of course, lived in northern Ontario for thousands of years, while, since the mid-nineteenth century, northern Ontario had been providing people in southern Ontario with wealth in the form of fish, furs, timber, hydroelectric power, and minerals. See Walton, "The Group of Seven and Northern Development," 171–9.

18 Robert Linsley suggests that members of the Group of Seven, particularly Lawren Harris, were representing an unpopulated north to remove viewers not only from the negative aspects of urban life but also from racial problems that stemmed from massive immigration in the early twentieth century. See Linsley, "Landscapes in Motion," 80–95.

19 Walker was also the chairman of the committee that founded the Art Gallery of Ontario. Ontario support for the Group of Seven is thoroughly discussed in Hill, *Group of Seven*. See also Zemans, "Establishing the Canon," 6–36.

20 *Vancouver: Art and Artists, 1931–1983,* 32.

21 See the bibliography for publications on Canadian murals of the 1860s to the 1930s. They consist of a few articles of the 1970s on civic and Catholic Church murals; a few articles of the 1980s and 1990s on civic, commercial, Protestant Church, and private murals; some MA theses of the 1970s to 1990s on individual Quebec muralists and murals; and a number of conference papers of the 1980s and 1990s, produced by the Historic Sites and Monuments Board of Canada, but unavailable in public or university libraries, on individual murals in Ontario and Quebec.

CHAPTER 1

1 Quoted in Vanderbilt, *Charles Eliot Norton,* 205.

2 Baldry, "Professor Moira's Recent Mural Decorations," 22–34.

3 Said, *Culture and Imperialism,* xiii–xiv.

4 Femia, *Gramsci's Political Thought,* 44; Fish, *Is There a Text in This Class?*

5 For example, Mérimée, "De la peinture murale et de son emploi dans l'architecture moderne"; and Thomas, *Mural or Monumental Decoration,* 6–13.

6 Hamerton, "Paris VIII. – The Pantheon, the Invalides, and the Madeleine." *The Portfolio* 14 (1883): 149

7 La Farge, "Puvis de Chavannes." For a discussion of Puvis de Chavannes's influence in Canada, see Lacroix, "Puvis de Chavannes and Canada."

8 Quoted in McWilliam, *Dreams of Happiness,* 82–3; see also Chaudonnert, "1848."

9 Green, "'All the Flowers of the Field,'" 78.

10 Quoted in Port, *The Houses of Parliament,* 268–9

11 Quoted in Paul A.C. Sproll, "Matters of Taste and Matters of Commerce: British Government in Art Education in 1835," *Studies in Art Education* 35 (winter 1994): 109.

12 John Ruskin, *Time and Tide,* paras. 138, 139. See also [Ruskin], *The Lamp of Beauty,* 316–22.

13 "The Kyrle Society"; 210; Darley, *Octavia Hill,* 179–81

14 Sargent, "Comments upon Mr. Shean's 'Mural Painting from the American Point of View,'" 28–9.

15 Low, *A Painter's Progress,* 193.

16 Bénédite, "La peinture décorative aux Salons," 137.

17 Quoted in Powers, "Diplomacy at Hand," 36.

18 Crowninshield, "Mural Painting," 20; Low, *Painter's Progress,* 193.

19 Merrifield, *The Art of Fresco Painting,* viii.

20 Crowninshield, "Figure Painting Applied to Architecture," 22.

21 *The Brochure of the Mural Painters,* 12.

22 Troy, "Le Corbusier, Nationalism, and the Decorative Arts in France, 1910–1918." For a different interpretation, see Silverman, *Art Nouveau in Fin-de-Siècle France.*

23 Quoted in Boase, "The Decoration of the New Palace of Westminster, 1841–1863," 320.

24 Geddes, "Political Economy and Fine Arts," 4. For Geddes's discussion of murals, see Willsdon, "Aspects of Mural Painting in London, 1890–1930," 6. Ruskin's economic theories may be found in his *Fors Clavigera, Minerva Pulveris,* and *Two Paths.*

25 Blashfield, "Mural Painting in America," 356.

26 *Brochure of the Mural Painters,* 6, 10.

27 Blashfield, "Mural Painting," 101.

28 King, *American Mural Decoration,* 15.

29 Weintraub, "The Theory and Politics of the Public/Private Distinction."

30 Habermas, *The Structural Transformation of the Public Sphere.*

CHAPTER 2

1 For a discussion of the need for "signs" on new types of architecture in the modern period, see Choay, "Urbanism in Question," 241–58.

2 Barringer, "The Leighton Gallery at the V&A." In 1950 the area in which the frescoes were installed was boxed in, so that the murals, even though restored, are located in narrow, dark corridors.

3 For a discussion of the term "metahistory," see White, *Metahistory,* 1–2. See also Bann, *The Clothing of Clio,* especially chapter 1.

4 For example, Mechlin, "Mr. F.D. Millet's Decorations in the Baltimore Custom House"; Mechlin, "The Ships of All Ages in F.D. Millet's Mural Decorations in the Baltimore Custom House."

5 Folliot, "Les décors des mairies," 169.

6 *Canadians in Paris, 1867–1914;* Allaire, "Les artistes canadiens aux salons de Paris, de 1870 à 1914."

7 Hay, "The Westminster Frescoes." See also *Works of Art in the House of Lords;* and Heitzman, *The Revival of Fresco Painting in Britain in the 1840s.*

8 This mural was based on a play of 1909, *The Melting Pot,* by Israel Zangwill. See

Murray, "Painted Words," fig. 62; and Blake, *Catalog of Pictures, Sculptures and Other Works of Art in Edward Lee McClain High School.*

9 Promey, *Painting Religion in Public,* 165.

10 Folliot, *Le triomphe des mairies,* 94–7.

11 Illustrated in Greenaway, *Interior Decorative Painting in Nova Scotia,* 14, 33.

12 Dickinson and Young, *A Short History of Quebec,* 195.

13 Information from John Girvan's artist file in the Vancouver Public Library.

14 *Catalogue of Historical Paintings in the Legislative Building,* np.

15 *The Legislative Library of Saskatchewan,* 17.

16 "Editorial," *Canadian Forum* 2 (December 1921): 452; Lismer, "Mural Painting," 134.

17 Baker, *Manitoba's Third Legislative Building.*

18 Berry, *Vistas of Promise,* 63.

19 McDonald, *Making Vancouver.*

20 Cotton, *Vice Regal Mansions of British Columbia,* 103–5.

21 Radford, "The Secret of Success in Art," 20.

22 Segger, *The British Columbia Parliament Buildings.*

23 Scott, "Art in British Columbia," 383.

24 Quoted in Le Moine, *Napoléon Bourassa,* 213.

25 Vézina, *Napoléon Bourassa (1827–1916),* 153.

26 Quoted in L'Allier, *Henri Beau, 1863–1949,* 38.

27 Traquair, "The Royal Canadian Academy."

28 Panels in the Mont Royal chalet: *The Founding of Montreal Being Decoded in Paris* by William H. Taylor; *The Voyages of Jacques Cartier to Canada in 1534 and 1535, Plan of Hochelaga in 1535, Map of Montreal in 165, Montreal from 1645 to 1672, Montreal in 1760,* and *The Former Possessions of France in America,* all by Paul-Émile Borduas; *Death of Dollard des Ormeaux to Save the Colony* by Thurstan Topham; *Champlain Explores the Site of Montreal in 1603* by Marc-Aurèle Fortin; *Champlain Returns to the Site of Montreal in 1611* by Octave Bélanger; *La Salle about to Discover the Mississippi* by Edwin Holgate; *Jacques Cartier Arriving at Hochelaga, 1535* by Adrien Hébert; *Jacques Cartier Is Welcomed by a Native Chief* by Boudot and Cerceau; *Jacques Cartier on the Summit of Mont Royal* by Alfred Faniel; *Dollard des Ormeaux and His Companions Taking the Oath* by Raymond Pellus; *Maisonneuve Erecting a Cross on the Mountain* by Robert Pilot; *Founding of Montreal by Maisonneuve, May 18th, 1642* by Georges Delfosse.

29 Jones and Dyonnet, "History of the Royal Canadian Academy of Arts," 6.13–6.15; Royal Canadian Academy Council Meeting Minute Books, National Archives of Canada, 17, MG28, I, 26, 7 May and 21 November 1924; 1 May and 20 November 1925; "Royal Canadian Academy of Arts, Mural Competition."

30 Noppen and Deschênes, *Québec's Parliament Building,* 54.

31 Quoted ibid., 156.

32 Vézina, *Napoléon Bourassa,* 192.

33 L'Allier, *Henri Beau,* 45.

34 Noppen and Deschênes, *Québec's Parliament Building* 157; L'Allier, *Henri Beau,* 75.

35 Allaire, "The Charles Huot Paintings in Saint-Saveur Church, Quebec City."

36 Noppen and Deschênes, *Québec's Parliament Building,* 158.

37 Derome, "Charles Huot et la peinture d'histoire au Palais législatif de Québec (1883–1930)"; Ostiguy, *Charles Huot,* 25–6; "High Culture."

38 Noppen and Deschênes, *Québec's Parliament Building,* 160.

39 MacRae, *Cornerstones of Order,* 150; Harper, *Early Painters and Engravers of Canada,* 231.

40 MacRae, *Cornerstones of Order,* 194.

41 Dendy, *Lost Toronto,* 137.

42 Bayer, "A Critical Summary of Archival Material Relating to the History of the Parliament Buildings." For a contemporary description, see Yeigh, *Ontario's Parliament Buildings,* 112. In 1913, in an attempt to solve acoustical problems, the murals with covered with horsehair and a false ceiling. Small sections have recently been uncovered.

43 Copies of these drawings can be found in the Reid Papers in the Edward P. Taylor Research Library and Archives in the Art Gallery of Ontario.

44 Pepall, "The Murals by George A. Reid in the Toronto Municipal Buildings (1897–1899)," 32–3; Pepall, "The Murals in the Toronto Municipal Buildings," 145.

45 Wilson, *The City Beautiful Movement.*

46 Mavor, *Notes on the Objects of the Toronto Guild of Civic Art,* 1, 3.

47 Ibid., 6.

48 Sherwood, "A National Spirit in Art," 500. For a general discussion of the importance of the landscape to historical constructions of Canadian identity, see Harris, "The Myth of the Land."

49 Reid, "Mural Decoration" (*Canadian Magazine*). 504.

50 Challener, "Mural Decoration." *Canadian Architect and Builder* 17 (May 1904): 91.

51 Lismer, "Canadian Art," 173.

52 Kirby, *U.E.*

53 Duffy, *Gardens, Covenants, Exiles,* 55.

54 Lampman, *Poems,* 133.

55 Lampman, *Lyrics of Earth,* 47.

56 Miner, *G.A. Reid,* 105. Bayer states that the guild's promotion of decoration for the Ontario Legislative Buildings began in 1902: *The Ontario Collection,* 92. However, there is evidence that it began as early as 1897, since there is a drawing of the plan with this date in the Mavor Papers: box 29, no. 22, Thomas Fisher Rare Books Library, University of Toronto.

57 Miner, *G.A. Reid,* 103–5. An oil study for the central panel by George Reid is in the collection of the Art Gallery of Ontario, and some of the sketches are in the National Archives of Canada.

58 Frederick Haines's artist's file in the Edward P. Taylor Research Library and Archives, Art Gallery of Ontario; Falvey, "The Case Study of the Low-Pressure

Treatment of a Large-Scale Canvas Mural Painting. Haines's eight mural painting panels replaced eight others of 1928 painted by the English artist Maurice Grieffenhagen for the Empire Marketing Board's display at the Golden Jubilee of the Canadian National Exhibition. They depicted "epochal happenings in the various countries of the Empire." See Sinaiticus, "Canadian National Exhibition."

59 Anderson, "Work on the Walls."

60 *Memorial Exhibition of Paintings by Mary Hiester Reid;* Foss and Anderson, *Quiet Harmony,* 72–3. Miner states in *G.A. Reid* that George Reid painted a circular mural, *Dawn,* for the Weston Town Hall and then a copy of it. Both represented a classical personification of dawn trumpeting in the morning light. However, there is no other evidence that George Reid painted such a mural for the Weston Town Hall, while there is a circular easel painting entitled *Dawn* by him in the collection of the Province of Ontario. It could be the copy. Or, if Miner made a mistake, and the Weston Town Hall work was an easel painting rather than a mural, it could be the Weston Town Hall piece. A painting of this description, either the original or the copy, and possibly the work that was hung in the Weston Town Hall, is illustrated in MacTavish, *The Fine Arts in Canada,* 96.

61 Hale, "The Career of Arthur Crisp."

62 Jones and Dyonnet, "History of the Royal Canadian Academy," 6.13–6.14; Royal Canadian Academy Council Meeting Minute Books, 19 May 1922; 10 February and 19 May 1923.

63 Jones and Dyonnet, "History of the Royal Canadian Academy of Arts," 6.14–6.15; Royal Canadian Academy Council Meeting Minute Books, 7 May and 21 November 1924; and 1 May and 20 November 1925; "Royal Canadian Academy of Arts, Mural Competition," 182–3.

64 Rydell, *All the World's a Fair;* Walden, *Becoming Modern in Toronto;* Heaman, *The Inglorious Arts of Peace.*

65 Hodkinson, *Arthur Lismer's Drawings for the Humberside Mural.*

66 The program began in the southeast corner with *Ericson Discovering North America, 1000 A.D.* (destroyed). On the south wall above the balcony is a long narrow frieze, *The Discoverers, 986–1610 A.D.* It represents European and British explorers with globes and compasses as they make their plans to come to North America. Then the chronological narrative proceeds to a large frieze under the balcony. It represents *Champlain Ascending the Ottawa River, 1615.* From there the narrative moves to the west wall, on which are depicted *John Cabot, Discoverer of North America, 1497; Jacques Cartier, Discovery of the St. Lawrence, 1534; Founding of the Hudson's Bay Company, Fur Trading in James Bay, 1668; United Empire Loyalists Ascending the St. Lawrence, 1783;* and *Alexander Mackenzie: Discovery of the Pacific, 1798.* Surrounding these panels are small painted scrolls with the names of famous Canadian inventors, politicians, and industrialists of European ancestry. On the north wall are *Patriotism* and *Sacrifice,* to the left and right, respectively, of the stage. Reid returned to Jarvis Collegiate in the 1940s and painted murals of Second World War ships at sea over

the windows on the east wall. Apparently at this time his earlier panel, *Eric the Red, Discoverer of America, 1100,* which presumably was on the south end of the east wall, was painted over to accommodate the new mural panels.

67 For information on this commission, see Charles Jefferys's artist's file in the Library of the Royal Ontario Museum; Jefferys's artist's file and Jefferys's papers in box 25 in the Edward P. Taylor Research Library and Archives, Art Gallery of Ontario; and Duffy, "Cultural Nationalism and Spring Cleaning."

68 Miner, *G.A. Reid,* 170–2, 176–81.

69 Compare, for example, the American artist Charles Knight's mural paintings of pre-historic life in the Museum of Natural History in New York, the Field Museum of Natural History in Chicago, and the Natural History Museum of Los Angeles County. See Paul, "The Art of Charles R. Knight," and Bronner, "Object Lessons," 217–54.

70 Taylor, "Some Notes on the Relation and Application of the Sister Arts, Painting and Sculpture, to Architecture," 112.

71 Fairbairn, "A Decade of Canadian Art," 161.

72 Challener, "Mural Decoration," 91.

73 MacDonald, "Interior Decorations of St. Anne's Church, Toronto," 90.

74 Agostino Aglio painted murals around 1830 for Manchester's earlier Town Hall. Now destroyed, they were done in the fresco technique and represented aspects of British trade. See Heitzman, "Revival of Fresco," 13.

75 Challener, "Mural Decoration," 91.

76 Lismer, "Canadian Art" (1926), 174.

77 "The Mural Decorations at the New City Hall."

78 "Studio and Gallery."

79 Moyer, "An Office Boy Who Studied Art." *Canadian Magazine* 79 (August 1930): 46.

80 Mavor, *Notes on the Objects,* 7.

81 Grant, "Studio and Gallery," 13 May 1899.

82 Ibid., January 1899.

83 "Mural Painting," 19.

84 Lismer, "Canadian Art," 15 February 1925, 179.

85 Lismer, "Canadian Art" (1926), 177.

86 Challener, "Mural Decoration," 91.

87 Mavor, *Notes on the Objects,* 5.

88 Fairbairn, "A Decade of Canadian Art," 161.

89 Beatty, "A Canadian Painter and His Work," 551.

90 Arthur Crisp's file in the archives of the Canadian Imperial Bank of Commerce, Toronto.

91 Challener, "Mural Decoration," 91.

92 Levin, *Republican Art and Ideology in Late Nineteenth-Century France;* Green, "'All the Flowers of the Field'"; Aquilino, "Painted Promises"; Vaisse, *La Troisième République et les Peintres.*

93 For example, Reid, "Mural Decoration," April 1898.

232 NOTES TO PAGES 51–4

94 These changes are described in Aquilino, "Decoration by Design"; Aquilino, "Painted Promises"; and Marlais, *Conservative Echoes in "Fin-de-Siècle" Parisian Art Criticism.*

95 Quoted in Aquilino, "Painted Promises," 706.

96 Folliot, *Le triomphe des mairies,* 236–7.

97 These views are summarized in Aquilino, "Decoration by Design," 156–73. See also Marlais, *Conservative Echoes.*

98 Mauclair, *Albert Besnard, L'Homme et L'Oeuvre,* 25–50; Weisberg, "Albert Besnard at Berck-sur-Mer."

99 For Canadian discussions of the relevance of the classical world in the modern period, see Lambert, *Dethroning Classics and Inventing English.*

100 Thierry, "Plaisir et fête à l'Hôtel de Ville."

101 For a discussion of the changes in styles of civic murals, see Levin, *Republican Art and Ideology,* 178; and Vaisse, *La Troisième République,* chapter 10.

102 For a general discussion of the decorative scheme, see Imbert, "L'Hôtel de Ville de Paris." For negative criticisms of this work, see Aquilino, "Painted Promises," 706–8.

103 Quoted in Shaw, "Imagining the Motherland," 593.

104 Quoted in Willsdon, "Aspects of Mural Painting in London," 393.

105 van Rensselaer, "The Twelfth League Exhibition."

106 Shean, "Mural Painting from the American Point of View," 18; Cox, "Some Phases of Nineteenth Century Painting," 11, 14.

107 Reid, "Mural Decoration," April 1898, 507–8.

108 Scott, "Ford Madox Brown and the Manchester Town Hall Murals," 24; Archer, ed., *Art and Architecture in Victorian Manchester,* 162–207. For Manchester's Jubilee Exhibition of 1887, Brown also provided murals in the eight spandrels of the dome of the main building. They consisted of classical personifications of coal, corn, wool, spinning, weaving, shipping, iron, and commerce. See Newman and Wilkinson, *Ford Madox Brown and the Pre-Raphaelite Circle,* fig. 181.

109 Reid, "Mural Decoration," April 1898, 504.

110 Willsdon, "Aspects of Mural Painting in London," 28.

111 For a photograph of the original installation of Southall's murals, see Crawford, *By Hammer and Hand,* 63–4.

112 Goetze's murals were begun before the First World War and finished later. For a history of their installation, see Willsdon, "Aspects of Mural Painting in London," 243–8; Stamp, "The Nation's Drawing-Room"; Port, *Imperial London.*

113 Crawford, *By Hammer and Hand,* 65.

114 "Mural Decoration," 228.

115 Baldry, "Professor Moira's Recent Mural Decoration," 24.

116 For a history of the Royal Exchange murals, see Willsdon, "Aspects of Mural Painting in London," 11–77. MacDonald was probably referring to the Royal Exchange murals when he wrote: "[There was] many a fine decoration [in an English Exchange]" in "Interior Decorations of St. Anne's Church, Toronto," 90.

117 Boase, "The Decoration of the New Palace of Westminster," 322.

118 Ormond, *Leighton's Frescoes in the Victoria and Albert Museum;* Ormand, "Leighton and Mural Painting"; Newall, *The Art of Lord Leighton;* Barringer, "The Leighton gallery."

119 Minto, *Autobiographical Notes on the Life of William Bell Scott,* 2: 214–15.

120 Quoted in Robertson, *Sir Charles Eastlake and the Victorian Art World,* 65.

121 Scott, "Ford Madox Brown and the Manchester Town Hall Murals," 24.

122 Quoted in Willsdon, "Aspects of Mural Painting in London," 311.

123 Lovekin, "Three Epochs of History in Mural Tableau," 5.

124 Stamp, "The Nation's Drawing Room," 23.

125 Rutter, *The British Empire Panels Designed for the House of Lords by Frank Brangwyn, R.A.* See also Powers, "History in Paint," 321.

126 Lismer, "Mural Painting," 128.

127 Low, "National Art in a National Metropolis," 113.

128 Shean, "Mural Painting from the American Point of View," 21.

129 Fowler, "The Outlook for Decorative Art in America," 691.

130 Shean, "Mural Painting from the American Point of View," 21.

131 Harris, "The Foreign Aspects of Mural Painting," 539. See also Low, "The Mural Paintings in the Pantheon and Hotel de Ville of Paris," 661.

132 See, for example, King, *American Mural Painting.* Given the late eighteenth-century date for the establishment of popular sovereignty in the United States, it is possible to argue civic mural painting of the type that belongs to the Mural Movement began in 1814 in the United States with the paintings of Philadelphia artist George Bridgport on the ceiling of the Hall of the House of Representatives in Washington (destroyed). See Webster, "The Albany Murals of William Morris Hunt," 285. However, it is more reasonable to suggest that civic murals, which worked within the tenets of the Mural Movement, began in the 1850s in the United States – that is, after the establishment of widescale urbanization, commerce, and industry with, for example, the paintings of Constantino Brumidi in the Capitol Rotunda in Washington. See O'Connor, "The Murals by Constantino Brumidi for the United States Capitol Rotunda." In the late nineteenth century, when American art historians came to document the work of the Mural Movement, they ignored Brumidi's work. Presumably they did so on the basis of his foreign status. For more information on Hunt's murals, see Webster, *William Morris Hunt,* 151–5.

133 Van Brunt, "The New Dispensation of Monumental Art," 640. See also Brinton, "Modern Mural Decoration in America," 176.

134 "Public Art in American Cities," 3.

135 Shean, "Mural Painting from the American Point of View," 26–7. See also Crowninshield, *Mural Painting,* and Crowninshield's series of articles in 1889 in the *American Architect and Building News.*

136 For example, Reid, "Mural Decoration" (January 1898): 13.

137 For detailed discussions of the Boston Public Library, see Small, *Handbook of the New Public Library in Boston;* Fenollosa, *Mural Painting in the Boston Public Library;* and Cartwright, *Reading Rooms: Interpreting the American Public Library Mural,"* chapter 4.

For the Library of Congress, see *Handbook of the New Library of Congress in Washington* (Boston: Curtis & Cameron, 1901); and Murray, "Painted Words." For contemporary criticism of Sargent's work, see Promey, "Sargent's Truncated *Triumph.*" Promey's *Painting Religion in Public* provides a detailed study of Sargent's mural.

138 Small, *The Holy Grail.* For American criticisms, see Fowler, "The Outlook for Decorative Art"; Cox, "Some Phases of Nineteenth Century Painting," 11, 16; and Mather Jr., *The American Spirit in Art,* 98.

139 Traquair, "Mural Decoration," 183

140 Reid, "Mural Decoration," 508.

141 Grant, "Studio and Gallery," 16 April 1899, 9.

142 For a detailed discussion of the criticisms of the classical subject matter of the Library of Congress murals, see Moore, "In Search of an American Iconography." Canadian muralist Frederick Challener briefly mentioned an American critic's claim of a lack of harmony among the murals in the Library of Congress in Washington. See Challener, "Mural Decoration," 90.

143 "The Field of Art."

144 Views of classical subject matter in civic art as "un-American" had been voiced as early as the 1850s in reaction to the murals that Italian artist Constantino Brumidi had installed in the Naval Committee Room of the Capitol in Washington (*in situ*). For example, a critic for the *New York Tribune* sarcastically wrote: "We cannot see, for instance, the relation between Leda and the Swan ... and the American Navy, whether in a practical aesthetic or passional sense. The American eagle, we trust, is a bird of another feather, and not given to such erratic and erotic courses." Quoted in Webster, "The Albany Murals," 290.

145 Shean, "The Decoration of Public Buildings," 712, 720.

146 Brinton, "Modern Mural Decoration,"189.

CHAPTER 3

1 Baudrillard, *The Mirror of Production.*

2 Barthes, *The Fashion System.*

3 For an illustration of this room, see *Souvenir of a Visit to the Bon Marché* (p. 16), published by the store in the late nineteenth century for English tourists, a copy of which is available at the Metropolitan Toronto Public Library. For a description made just after the murals were installed, see Darcel, "Peintures de MM. H. Lévy et D. Maillart dans les galeries du *Bon-Marché,*" *La chronique des arts et de la curiosité* 27 March 1875: 105–6.

4 *Canadians in Paris, 1867–1914.*

5 For example, Winter, "Mural Decorations for the Cunard Building."

6 MacDonald, "Interior Decoration of St. Anne's Church, Toronto," 90; Lismer, "Mural Painting," 134.

7 For a history of the Royal Exchange murals, see Willsdon, "Aspects of Mural Painting in London, 1890–1930," 11–77.

8 Caffin, *Art for Life's Sake,* 96.

9 Walter, "Le Décor"; Prévost-Marcilhacy, "Le décor du buffet de la Gare de Lyon," 144–54. A similar but less elaborate mural program was done in 1900 for the buffet at the Gare d'Orsay, now the Musée d'Orsay (*in situ*). For contemporary murals in spas and casinos, see Walter, "Le décor de quelques établissements thermaux et casinos de 1850 à 1930," 67–8.

10 Troy, "Le Corbusier, Nationalism, and the Decorative Arts in France, 1910–1918." For a different interpretation, see Silverman, *Art Nouveau in Fin-de-Siècle France.*

11 Sturgis, "Painting," 408–9.

12 Deshazo, *Everett Shinn,* 94; Diamonstein, *The Landmarks of New York,* 285.

13 Dewing's mural is illustrated by Van Hook, "From the Lyrical to the Epic," 68. For a comparison to Tiepolo's work, see Cortissoz, "Mural Decoration in America," 117–18.

14 Bert, *Chicago's White City of 1893,* 152–4.

15 Walden, *Becoming Modern in Toronto,* chapter 4.

16 Several art historians have argued for a feminist stance in Cassatt's murals. See, for example, Pollock, *Mary Cassatt,* 27. For other interpretations, see Sund, "Columbus and Columbia in Chicago." For a more general history of this mural and others in the Woman's Building, see Kysela, "Mary Cassat's Mystery Mural and the World's Fair of 1893."

17 Greenaway, *Interior Decorative Painting in Nova Scotia,* 62–3.

18 *Ozias Leduc,* 291.

19 For illustrations of these murals, see Kelly, *Arthur Lismer,* 14–16. Lismer sent a letter from Bedford, Nova Scotia, to James E.H. MacDonald in Toronto dated 28 February 1918. It refers to thirteen panels done for a Bedford restaurant and included photographs of two of the thirteen panels. For the letter, see the National Archives of Canada, James E.H. MacDonald Collection, Acc. No. 1974–004 (A); the photographs are in the artist's file, 705–1969. Lois Darroch illustrates these panels and states that they were part of the panels from the Green Lantern Restaurant installation in Halifax. Kelly illustrates the same panels with the same identification. See Darroch, *Bright Land,* 45. It is, however, unlikely that Lismer confused Halifax and Bedford, which were two distinct places in the early twentieth century and separated by a distance of approximately 15 miles. He may, therefore, have decorated two restaurants, the Green Lantern in Halifax and another in Bedford.

20 Henry, *Remembering the Halifax Capitol Theatre 1930–1974* (Halifax, Black Book Publishing, 2000). See also Hilary Russell's *All That Glitters. A Memorial to Ottawa's Capitol Theatre and its Predecessors* (Ottawa: Department of Indian and Northern Affairs, 1989), Figs. 124–5. Briffa decorated many theatres in Montreal and others in the Maritimes. See Dana Lanken, *Montreal Movie Palaces. Great Theatres of the Golden Age 1884–1938* (Waterloo, Ontario: Penumbra Press, 1993).

21 "The Acoustics of a Motion Picture Theatre."

22 Lanken, *Montreal Movie Palaces;* Cashman, *A Pictorial History of Alberta,* 157; Segger and Franklin, *Victoria,* 143; *Oxford Companion to Canadian Theatre.*

23 d' Iberville-Moreau, *Lost Montreal,* 170.

24 This mural was one of six winning submissions to the Royal Canadian Academy's mural contest of 1924. See Jones and Dyonnet, "History of the Royal Canadian Academy of Arts"; and Royal Canadian Academy Council Meeting Minute Books, National Archives of Canada, 17, MG 28 I, 7 May, 21 November 1924, 481, 484; and 1 May, 20 November 1925, 492, 1.

25 Murals for passenger boats were an important part of the work of the Mural Movement. See, for example, William H. Miller Jr, *The Fabulous Interiors of the Great Ocean Liners in Historic Photographs;* and Vian, *Art décoratifs à bord des paque-bots français, 1880/1960.* For a discussion of Challener's murals for the SS *Kingston* and other boats, see "The Architectural Side of the Modern Passenger Boat"; McFaddin, "The Murals of F.S. Challener." Challener's mural paintings for the SS *Montreal* represented an allegory of the hours from dawn to dusk (destroyed). See Moyer, "An Office Boy Who Studied Art."

26 "Unique Decorative Feat." Adam Sherriff Scott painted a mural, *Quebec in 1810,* for the SS *Quebec* of the Canada Steamship Lines. See artist's file in the Library of the Montreal Museum of Fine Arts.

27 "Decorative Paintings for the Manoir Richelieu."

28 Lawson, "The Log Chateau-Lucerne-in-Quebec"; La Marche, *Au coeur de la Petite-Nation,* 129. The two murals in the mezzanine over the main dining room are *in situ: Papineau Speaking in 1837* and *English Troops Capture the Liberty Pole and Bring It to Montreal.* Nine of the murals that were designed for the Grill Room (now the downstairs bar) are *in situ: Seigniorial Custom: Setting up the May pole; Champlain with the Astrolabe 1613; Richelieu and the Company of 100 Associates; Jacques Cartier Landing; Laval, the First Bishop of Quebec; The Building of the Carillon Canal, 1829; The Heroic Stand of Dollard; The Defeat of the Rebels;* and *The First Raft on the Ottawa.* Two murals were removed from their original sites to the hall just outside the bar: *English Traders in Hudson Bay* and *Old Time Sugaring.*

29 O'Neill, "A Partial History of the Royal Alexandra Theatre, Toronto," 1: 65–72; Dendy and Kilbourn, *Toronto Observed,* 161–3.

30 MacDonald, "The Concourse Building, Toronto"; MacDonald, "City of Future Brilliant with Gold and Color"; Dendy and Kilbourn, *Toronto Observed,* 218–19.

31 Stacey, *C.W. Jefferys,* 20–1.

32 Sixteen panels are *in situ,* but two other panels, which are illustrated in the bank's internal magazine, *The Caduceus* 12 (October 1931): 30–4, are not. One of these two panels depicted airplane travel, the other skyscrapers. It is possible they were never installed.

33 Hale, "The Career of Arthur Crisp"; "The New Canadian Bank of Commerce Building, Toronto"; Dendy and Kilbourn, *Toronto Observed,* 221–3.

34 L'Allier, *Henri Beau,* 37.

35 Various publications give dates for the commission and/or the beginning of the installation that range from 1904 to 1906, and dates for the completion of the work

from 1906 to 1918. See *Four Challener Murals at the Winnipeg Art Gallery;* and McFaddin, "The Murals of F.S. Challener," 343.

36 Illustrated in an unpaginated supplement to *Canadian Architect and Builder* 18 (October 1905).

37 Barrett and Windsor, *Francis Rattenbury and British Columbia,* fig. 5.2.

38 See Adelaide Langford's artist's file in the Vancouver Public Library. Langford's brother-in-law was general superintendent of the Pacific Division of the Canadian Pacific Railway and likely was helpful in securing the commission for her. See also Kalman, *Exploring Vancouver,* 2, no. 8.

39 The titles of the extant murals are *Vancouver's First Post Office, 1865; Vancouver Harbour 1880; Vancouver the Day after the Great Fire of 1886; Vancouver in 1925;* and *Vancouver's First Newspaper.* Another panel was entitled *Old Steamship, "The Beaver."* The title of the seventh panel is not known. This information is from John Girvan's artist's file in the Vancouver Public Library. See also *Vancouver Province,* 13 February 1974, 13.

40 Cowan, *John Innes,* 26. Innes's murals were removed from the store and given to the University of British Columbia in 1949, according to the Vancouver *Sun,* 24 March 1949, 2. According to the George Southwell file in the Art Gallery of the University of British Columbia, the titles of eight of the panels are as follows: *Pioneer Agriculture; Pioneer Fishing; Pioneer Logging; Pioneer Mining; Ships of Spain off Point Grey, 1792; Trading with the Indians at Fort Victoria, 1845; Vancouver Exploring Burrard Inlet, 1892;* and *Simon Fraser's Canoe Descending the Fraser River, 1808.*

41 "Mr. Brangwyn's Tempera Frieze at the New London Offices of the Grand Trunk Railway," 34. See also Rolfe, "A British Artist and the Romance of Canada's Railways." In 1895 Toronto's newly formed Society of Mural Decorators planned murals for Toronto's Union Railway Station. The compositions are unknown, but at this early date they were likely dominated by human figures and machinery. See Pepall, "The Murals in the Toronto Municipal Buildings," 145; and Miner, *G.A. Reid,* 78. In 1920 murals were again contemplated for this site, but not installed. See "A Happy New Year for Art."

CHAPTER 4

1 For a recent thorough discussion of these murals, see Curran, "The Romanesque Revival, Mural Painting, and Protestant Patronage in America."

2 Dendy and Kilbourn, *Toronto Observed,* 50.

3 Greenaway, *Interior Decorative Painting in Nova Scotia,* 38–9.

4 Illustrated in *Construction* 8 (May 1915): 177.

5 Dendy, *Lost Toronto,* 145–7.

6 Reid spent twenty-five summers, beginning in 1891, in Onteora, New York, where he was part of the local artists' arts and crafts colony. Reid built All Souls' Church and many other buildings at Onteora. He also designed furnishings and mural paintings for many of these buildings. See Pepall, "Architect and Muralist."

7 Smith, *The Historic Churches of Prince Edward Island,* 76–7; and Tuck, *Gothic Dreams,* 91.

8 Illustrated in *Daily Post,* 20 November 1937, 3. See also *Vancouver,* 27–8.

9 Mattie, "The Painted Decorative Programme of St. Jude's Anglican Church, Brantford." The Browne family decorated hundreds of churches in Ontario, most of which were Catholic.

10 For Canadian interest in and purchases of the work of William Morris, including wallpaper and textiles with intertwined vine scroll, see Lochnan et al., eds., *The Earthly Paradise.*

11 MacDonald, "Interior Decorations of St. Anne's Church, Toronto," 89. For a more recent general discussion of St Anne's, see Hucker, "St Anne's Anglican Church,"

12 For MacDonald's designs and their relationship to the work of the Arts and Crafts movement, see Stacey, *J.E.H. MacDonald,* and Stacey, "Harmonizing 'Means and Purposes.'" St Anne's vine scroll may be compared with a particular Morris textile pattern that was used in Canada. See Lochnan ed., *The Earthly Paradise,* 131.

13 MacDonald's notes and sketches that indicate his models are in the National Archives of Canada, Acc. No. 1973–14. MacDonald did small-scale designs for all the work and for the full-scale panels of the Crucifixion, the Transfiguration, and the Storm at Sea. Frederick Varley painted the Nativity (with a self-portrait as a shepherd) and the prophets, Moses, Isaiah, Jeremiah, and Daniel at the base of the dome. Frank Carmichael painted the Adoration of the Magi and the Entry into Jerusalem; Herbert Palmer, the Resurrection; Herbert Stansfield, the Ascension; Arthur Martin, Christ Teaching in the Temple; Neil McKechnie, the Healing of the Lame Man; and Thoreau MacDonald, the Raising of Lazarus, St Anne (in the south arm), and St George (in the north arm). Francis Loring and Florence Wyle sculpted the four symbols of the Evangelists.

14 It is possible that the Reverend Lawrence Skey suggested the central position for the Transfiguration, since he wrote on the significance of this biblical event. This information comes from his papers, now in the possession of his grandson, Dr C.E. Rodgers, Brantford, Ontario.

15 MacDonald, "The Choir Invisible," 111.

16 *Toronto Daily Star,* 17 December 1923, 23.

17 Greenaway, "Lawrence Skey's Bysantine [sic] Defiance."

18 Mays, "Group of Seven Treasure Trove Saved."

19 St Anne's Vestry Meeting Minutes, Anglican Archives of Toronto, Acc. No. 89–6, box 1, 17 April 1906, 76.

20 A number of nineteenth-century buildings built in what is now described as a Romanesque revival style were described at the time of construction, and as late as the 1920s, as "Byzantine." The two styles were conflated because they both employed the round arch. Notre-Dame-de-Lourdes, Montreal, designed by Napoléon Bourassa between 1876 and 1880, is an example. However, it has a basilican plan and was modelled after Romanesque Catholic churches in France's

Périgord region, which were influenced by Byzantine architecture. See Vézina, *Napoléon Bourassa,* 110. Toronto's University College of 1856–59 (destroyed) is another example. When it was in the planning stages, its governor stated a preference for the Byzantine, while its architect, F.W. Cumberland, preferred Gothic. In the end the building became a mixture of Gothic, Romanesque, and "faint traces" of the Byzantine. See Arthur, *Toronto, No Mean City,* 137.

21 Sweatman, "St. Anne's Church." The relationship between Jewish synagogue architecture and Byzantine architecture has often been explored. In the nineteenth century, see, for example, Viollet-le-Duc, *Entretiens sur l'architecture,* 1: 215–26. For a recent discussion, see Wirgoden, *The Story of the Synagogue.*

22 Vestry Book (Service Register) 1897–1908, Anglican Archives of Toronto, Acc. 89–6, box 1. Mastin's reference is personal communication with Skey's grandson, C.E. Rodgers, who, when I spoke with him, referred to his grandfather's trip to Constantinople as "family gossip." See Mastin, "James Edward Hervey MacDonald."

23 Mastin, "James Edward Hervey MacDonald," 23, acknowledges widescale Anglican pleas for union. See also Coleman, ed., *Resolutions of the Twelve Lambeth Conferences, 1876–1988.* Toronto: Anglican Book Centre, 1992, 15, 22; and Douglas, *The Relations of the Anglican Churches with the Eastern-orthodox.* Many Canadians wrote on the subject of union in a variety of publications.

24 The 1889 Calendar of Wycliffe College in the University of Toronto, 28, states that Lawrence Skey won prizes for ecclesiastical history and homiletics.

25 Mark Crinson provides a brief history of the nineteenth-century European interest in Byzantine architecture as part of his study of Victorian colonial architecture. See *Empire Building,* 1–12, 72–92.

26 Ibid., 73–4.

27 For a history of modern interest in Byzantine art and architecture, see Mathews's bibliography in *The Early Churches of Constantinople";* and Rice, *Appreciation of Byzantine Art.* London: Oxford University Press, 1972.

28 For example, Léon Vaudoyer's Marseilles Cathedral, begun in 1853, and Paul Badie's Church of Sacré Coeur in Paris, begun in 1873.

29 For a discussion of Lindsay's work, see Steegman, "Lord Lindsay's History of Christian Art."

30 Quoted in Clark, ed., *Ruskin Today,* 197.

31 See Stein, *John Ruskin and Aesthetic Thought in America.* See Lochnan, ed., *The Earthly Paradise,* for a discussion of late-nineteenth-century interest in Morris in Canada.

32 For example, Cubitt, *Church Designs for Congregations,* 5–6; Gwilt, *An Encyclopaedia of Architecture,* 1007.

33 Service, *Edwardian Architecture,* 81. John Oldrid Scott's father, George Scott, submitted a plan for the Foreign Office in London in a style he called "Byzantinesque." See Toplis, *The Foreign Office,* 112. For other neo-Byzantine architecture in England, see Service, "Charles Harrison Townsend"; Taylor, "Byzantium in

Brighton," 280–8; Service, *London, 1900,* 168–9; and Ottewill, "Robert Weir Schultz." Consider also the late-nineteenth-century Byzantine interior decoration of St Augustine's Anglican Church in London, England.

34 Browne and Dean, *Westminster Cathedral;* Doyle, *Westminster Cathedral.*

35 Service, *London, 1900,* 169.

36 Philibert et al., *St. Matthew's of Washington.*

37 Goldstone and Dalrymple, *History Preserved,* 311. In 1919 St Bartholomew's Church was designed by Bertram Grosvenor Goodhue in a Byzantine style on Park Avenue in New York City (*in situ*).

38 For neo-Byzantine architecture built in Ontario after 1908, consider the First Methodist in Hamilton, Ontario, of 1914 (note 4 above), and the rotunda of the Royal Ontario Museum, Toronto, built in 1932, and decorated with Byzantine-style mosaics (*in situ*). See Sinaiticus, "ROM Toronto," and Young "The Dome of the Rotunda." In 1913 Stanley Presbyterian Church was built in a neo-Byzantine style in Montreal; see Gubbay and Hoof, *Montreal's Little Mountain,* fig. 124. Consider also the Thomas Foster Memorial Mausoleum in Uxbridge, Ontario (*in situ*), designed by H.H. Madill in 1936 as a central-plan, domed structure decorated with mosaics. See Gowans, *Building Canada,* fig. 200; and *The Thomas Foster Memorial.*

39 Dendy and Kilbourn, *Toronto Observed,* 142; de Wit, ed., *Louis Sullivan,* 88–9.

40 Greenaway, "Lawrence Skey's Bysantine [sic] Defiance," 22.

41 Waters, "The Home of the Gondolier," 388.

42 Clark, "London's New Ecclesiastical Edifice." See also a view of Westminster Cathedral in "Architectural Possibilities of Brick."

43 Walker, "Guild of Civic Art."

44 Carr, *Toronto Architect Edmund Burke,* 17.

45 Lears, *No Place of Grace,* especially 20–39.

46 Haultain, "A Search for an Ideal," 427.

47 Cited in Cook, *The Regenerators,* 27.

48 Browne and Dean, *Westminster Cathedral,* 26–7; and Doyle, *Westminster Cathedral,* 31–2.

49 *St. Anne's Church, Toronto,* 7.

50 Westfall, *Two Worlds,* 132.

51 Skey, "Anniversary Sunday."

52 Westfall, *Two Worlds,* 10–11.

53 White, *Protestant Worship and Church Architecture,* 95–8.

54 Westfall, *Two Worlds,* 10–11. See also Betjeman, "Nonconformist Architecture." For examples of this type of church, see Henry Langley's Wesleyan Methodist Church (now Metropolitan United), built between 1870 and 1872, and his Jarvis Street Baptist Church of 1874, in Carr, *Architect Edmund Burke,* 21–5.

55 Fiddes, *The Architectural Requirements of Protestant Worship,* 47.

56 Skey, "Anniversary Sunday."

57 Browne and Dean, *Westminster Cathedral,* 26–7; Doyle, *Westminster Cathedral,* 31–47.

58 Charlesworth, "Pictures That Can Be Heard."

59 Augustus Bridle, quoted in Hill, *The Group of Seven*, 93.

60 Landry, *The MacCallum-Jackman Cottage Mural Paintings*.

61 National Archives of Canada, Royal Canadian Academy Council Meeting Minute Books 17, MG 28, I, 10 February, 19 May, 23 November 1923.

62 Duval, *The Tangled Garden*, 20.

63 Thomas Kennedy, "Editorial," *St. Anne's Parish Magazine*, September 1923, 1

64 Skey, "The Re-opening and Diamond Jubilee of St. Anne's."

65 Greenaway, "Lawrence Skey's Bysantine [sic] Defiance." MacDonald belonged to the Arts and Letters Club, but there is no evidence that Skey did. MacDonald probably brought him as a guest.

66 Stacey, *J.E.H. MacDonald*, 117.

67 White, "The Work of Heywood Sumner."

68 Skey went to England in July 1892, according to *The Evangelical Churchman* 18 (18 May 1893): 236.

69 Duval, *Tangled Garden*, 148.

70 Garwood-Jones, "A Study of the Public Importance of the St. Anne's Anglican Church Mural Decoration Program." MacDonald, "Interior Decorations," 85.

71 MacDonald, "Interior Decorations," 85.

72 Hunter, *J.E.H. MacDonald;* Arthur, *Toronto*, xii, 20.

73 MacDonald, "Interior Decorations," 85. For Brown's work at Manchester, see *Art and Architecture in Victorian Manchester*, 162–207. For a discussion of the Royal Exchange paintings, see Saunders, *The Royal Exchange*,

74 MacDonald, "The Choir Invisible," 112.

75 Greenaway, "Lawrence Skey's Bysantine [sic] Defiance," 22.

76 Half of the funds, $5000, were provided by Samuel Stewart, a parishioner. That amount was matched by the congregation. See *St. Anne's Church, 1862–1987*, 9.

77 MacDonald, "Interior Decorations," 85. For a theoretical discussion of the obliteration of distinctions between the public and the private spheres in the late nineteenth century, see Habermas, *The Structural Transformation of the Public Sphere*.

CHAPTER 5

1 *Le Canadien* 24 (22 December 1854): 2.

2 Quoted in Cook, *Canada, Quebec, and the Uses of Nationalism*, 89.

3 Quoted in Dickinson and Young, *A Short History of Quebec*, 246.

4 From a speech ("French-Canadian Patriotism: What it is, and what it ought to be") by Henri Bourassa at the Monument national, 1902, reprinted in Cook, *Canada, Quebec*, 127.

5 Murphy and Perin, *A Concise History of Christianity in Canada*, 197.

6 From a speech ("Industry as a Means of Survival for the French-Canadian Nationality") given by Étienne Parent at the Institut canadien in 1846, reprinted in Cook, *Canada, Quebec*, 84.

7 Cook, *Canada, Quebec,* 90.

8 Mgr Louis-François Laflèche, "The Providential Mission of the French Canadians," reprinted in Cook, *Canada, Quebec,* 92–106.

9 From an address ("A Sermon on the French Race in Canada") given by Mgr L.-A. Pâquet in 1902 at the Diamond Jubilee of the Saint-Jean-Baptiste Society of Quebec, reprinted in Cook, *Canada, Quebec,* 156.

10 Quoted in Gehmacher, "'Authenticity' and the Rhetoric of Presentation," 47.

11 Quoted in Dickinson and Young, *Short History of Quebec,* 246–7.

12 Quoted in Lacroix, "A Dream of a Garden of Beauty," 25.

13 von Arx. S.J., ed., *Varieties of Ultramontanism.*

14 Trofimenkoff, *The Dream of a Nation,* 115–6.

15 Murphy and Perrin, *Concise History of Christianity,* illustration between 125–6.

16 Trofimenkoff, *Dream of a Nation,* 117.

17 Gehmacher, "The Mythologization of Ozias Leduc," 16; Bourassa, "Quelques réflexions critiques à propos de l'Art Association of Montreal," "Causerie artistique sur l'exposition de l'Art Association of Montreal," and "Du développement du goût dans les arts en Canada."

18 Maurault, "Chronique d'art," 76. See also Maurault, "Tendances de l'art canadien."

19 Quoted in Gehmacher, "Mythologization," 128, 133.

20 Quoted in Le Moine, *Napoléon Bourassa,* 222.

21 Vézina, *Napoléon Bourassa,* 81–2, 109.

22 Foucart, *Le renouveau de la peinture religieuse en France;* Marrinan, *Painting Politics for Louis-Philippe;* and Driskel, "An Introduction to the Art," 63–9.

23 Driskel, *Representing Belief,* 64.

24 Ibid., 86–7.

25 Toker, *Notre-Dame,* 92.

26 For discussions of Nincheri's work, see Micillo, *Guido Nincheri, maître verrier;* Fisher, "Joyous Hymns of Light and Colour," 70; and Salvatore, *Fascism and the Italians of Montreal.*

27 Goodspeed, "The Interior Decorative Programme of Saint-Léon-de-Westmount by Guido Nincheri." Nincheri had been trained to use the *buon* fresco technique and to paint in the style of the Italian Renaissance.

28 Quoted in Lacroix, "Drawing, Colour, Composition," 94. See also Stirling, *Ozias Leduc.*

29 Gehmacher, "Mythologization," 101.

30 *Ozias Leduc,* Monique Lanthier's text for catalogue entries 166–7, 212–13.

31 Ibid.

32 *Ozias Leduc,* quoted in Lacroix's text for catalogue entries 27 to 56, 110 n10.

33 Carman, "Wall Paintings in Europe," 312.

34 Quoted in Cook, *French-Canadian Nationalism,* 21. See also Rumilly, *Histoire de la Société Saint-Jean-Baptiste de Montréal.*

35 Bonenfant and Falardeau, "Cultural and Political Implications of French-Canadian Nationalism," 22.

36 *Ozias Leduc,* Gehmacher's text for catalogue entry 183, 230.

37 Quoted in Lacroix, "A Dream of a Garden of Beauty," 25; and *Ozias Leduc,* Lacroix's text for catalogue entries 27 to 56, 110 n10.

38 Gehmacher, "Mythologization," 165.

39 Barbara Winters, review of Lévis Martin's *Ozias Leduc et son dernier grand oeuvre,* in *Journal of Canadian Art History* 19 (1998): 84.

40 Preparatory drawings for these mural paintings are illustrated in *Ozias Leduc,* 276–86.

41 Winters, review of Martin's *Ozias Leduc,* 89.

42 Ibid., 90.

43 *Ozias Leduc,* quoted in Gehmacher's, text for catalogue entry 17, 79.

44 Goodspeed, "St.-Léon-de-Westmount," 124.

45 Smith, *The Historic Churches of Prince Edward Island,* 67–70.

46 The Saskatchewan Association of Architects, *Historic Architecture in Saskatchewan,* 122.

47 *Ozias Leduc,* 302.

CHAPTER SIX

1 Atkinson, "On Fresco Painting as Applied to the Decoration of Architecture," 318.

2 For discussions of mural painting as both fine art and craft, see Brown, "Of Mural Painting"; and Adams, "Frederick S. Lamb's Opalescent Vision of 'A Broader Art.'"

3 Spencer, "The Relation of the Arts and Crafts to Progress," 231.

4 Waters, "Painter and Patron." For other English domestic murals with classical themes, see Smith, *Decorative Painting in the Domestic Interior in England and Wales.*

5 Bouillon, *Maurice Denis,* 128–9.

6 Mahoney, *Gothic Style Architecture and Interiors from the Eighteenth Century to the Present,* 159–62.

7 Illustrated in "Studio-Talk," *Studio* 16 (May 1898): 270–1.

8 Likos, "Violet Oakley," 14–17. For other examples of classical murals installed in American homes, some as late as the 1920s, see *The Mural Decorations of E.H. Blashfield;* Shopsin et al., *The Villard Houses;* and Lewis, et al., *The Opulent Interiors of the Gilded Age.*

9 Edgerton, "Modern Murals Done in the French Spirit of Decoration," 28. In 1897 American cultural critics Edith Wharton and Ogden Codman Jr sanctified classical subject matter for American interior decoration in their *Decoration of Houses,* a manual that went into several subsequent printings.

10 Christian, *The Oxford Union Murals.*

11 Willsdon, "Aspects of Mural Painting in London, 1890–1930," 29; Girtin, *The Triple Crowns,* 355.

12 "Mr. Herbert Draper's Painted Ceiling," 36. For another elaborate example of mural painting in a private English Club, consider Frank Brangwyn's eleven large panels illustrating the British fur trade done for Skinners' Hall in London between 1902 and 1909 (*in situ*) and discussed and illustrated in Galloway, *The Oils and Murals of Sir Frank Brangwyn, R.A.,* 73.

13 Murray, "H. Siddons Mowbray."

14 Baker, *The Croscups' Painted Parlour.*

15 Cushing, "They Sent to Italy"; Pepall, "An Evaluation of the Interior Wall Paintings in the Houses at Numbers 1, 5 and 13 Prince William Street, Saint John, New Brunswick"; Pepall, "Painted Illusions."

16 MacAllister, *The Old Manse Library,* 3.

17 Greenaway, *Interior Decorative Painting in Nova Scotia,* 48. Greenaway's catalogue provides many other examples of small private murals in Nova Scotia.

18 Pepall, "Painted Illusions," 520–1.

19 Rémillard, *Mansions of the Golden Square Mile,* 164; Thomas, "Frederick William Hutchison."

20 Pinard, *Montréal,* 6: 36.

21 d'Iberville-Moreau, "Le Château Dufresne et la conservation du jeune patrimonie"; Giroux, "Le Château Dufresne."

22 *Ozias Leduc,* 268–70.

23 Hucker, "Decorative Mural Painting of Castle Kilbride," 1, 2; Knowles, *Castle Kilbride.*

24 Hucker, "Castle Kilbride," 7.

25 One of these houses is Glanmore, a Second Empire-style house of 1882–3. The other is now the Hastings Country Museum. See ibid., 10; and *Globe and Mail,* 15 July 1998, C8.

26 Patterson, "The McWilliam House Hallway"; Patterson, "The McWilliam House"; Wagner, "Mount Forest House Paintings Reveal Early Cultural Heritage."

27 Martyn, *Aristocratic Toronto,* 204–5. In a photo of Wymilwood, the room with the Gothic image also appears to have two landscape mural panels. For other domestic murals by Hahn, see Dendy and Kilbourn, *Toronto Observed,* 173–4; "An attractive Toronto Home in Elizabethan Design"; Dendy, *Lost Toronto,* 224–6.

28 Foss and Anderson, *Quiet Harmony,* 72.

29 Illustrated in Moyer, "An Office Boy Who Studied Art," 48.

30 Interoffice correspondence of Charles McFaddin, Art Gallery of Toronto (now Art Gallery of Ontario) to B.T. Baldwin (donor of panels), 14 May 1957.

31 Gibbons, *Stories Houses Tell,* 106.

32 Segger and Franklin, *Victoria,* 285–6.

33 Ibid., 165.

34 Traquair, *Art and Life,* 3, 5. See also Lambert, *Dethroning Classics and Inventing English.*

35 Greenaway, *Interior Decorative Painting,* 48.

36 Ibid., 17, 26, 27.

37 Lucille Douglass spent holiday time with her friends, the Ayscoughs, in St Andrews.

38 *Ozias Leduc,* 291.

39 Braide, *William Brymner,* 46, 69; Braide, *William Brymner, 1855–1925,* 15.

40 Braide, "William Brymner," 54–5.

41 *The Architecture of Edward & W.S. Maxwell,* 13.

42 Ibid., 128.

43 Illustrated in *The Journal of the Royal Architectural Institute of Canada* 5 (January 1928): 5.

44 Miner, *G.A. Reid,* 95–6, 136, 221–4; Martyn, *Toronto;* and Pepall, "Architect and Muralist," 44–7.

45 Studies for these murals are in the Marine Museum of Upper Canada, accession numbers: 1985.43.1.1; 1985.43.1.2; 1985.43.1.3; 1985.43.1.4; 1985.43.2; and 1985.43.3.

46 Landry, *The MacCallum-Jackman Cottage Mural Paintings.*

47 Robertson, *Driving Force,* 165, 193.

48 These panels perhaps make reference to the Parkwood lawn fêtes, in which the McLaughlin children danced as different kinds of flowers and as shepherdesses. Ibid., 210.

49 MacPherson, "Parkwood," 29.

50 Galloway, *Oils and Murals of Sir Frank Brangwyn,* 71. Challener could well have seen Brangwyn's murals illustrated in "Frank Brangwyn and His Art," *Studio* 12 (October 1897): 13, 14.

51 Moyer, "An Office Boy Who Studies Art," 12.

52 Gibbons, *Stories Houses Tell,* 94.

53 MacDonald, "Manor retains regal character"; MacDonald, *Historic Edmonton,* 180.

54 Karen Halttunen, "From Parlor to Living Room: Domestic Space, Interior Decoration, and the Culture of Personality," in Bronner, ed., *Consuming Visions,* 157–90.

55 Grier, *Culture and Comfort,* 1.

56 Quoted in Michael Barton, "The Victorian Jeremiad: Critics of Accumulation and Display," in Bronner, ed., *Consuming Visions,* 59.

57 Gregory, *Christian Ethics,* 224.

58 For a specific example of such a recommendation, see Lamb, "Lessons from the Expositions," 57. For a general discussion of these ideas, see Simon J. Bronner, "Reading Consumer Culture," in Bronner, ed., *Consuming Visions,* 13–54. For a discussion of display techniques at world's fairs, museums, and department stores, see Robert W. Rydell, "The Culture of Imperial Abundance: World's Fairs in the Making of American Culture," in Bronner, ed., *Consuming Visions,* 191–216. For a related Canadian discussion, see Walden, *Becoming Modern in Toronto.*

59 Williams, *Dream Worlds,* 14.

60 Monroe, "The Church and the Social Crisis," 343.

61 Kilpatrick, "Things That Make a Nation."

62 From a turn-of-the-century article in Toronto's *Mail and Empire,* quoted in Walden, *Becoming Modern in Toronto,* 15.

63 Barton, "The Victorian Jeremiad," 55.

64 For example, Garrett, *Suggestions for House Decoration;* Eastlake, *Hints on Household Taste in Furniture, Upholstery & Other Details;* Orrinsmith, *The Drawing-room;* and de Wolfe, *The House in Good Taste.* Canadians had access to these books and others of their type. See also recent discussions about domestic decoration in Seale, *The Tasteful Interlude;* Mayhew and Myers, *A Documentary History of American Interiors from the Colonial Era to 1915;* Thornton, *Authentic Décor;* Winkler and Moss, *Victorian Interior Decoration.*

65 Sargent, "Art in the Home and in the School," 268.

66 O'Brien, "'The House Beautiful,'" 396–418.

67 Long, *The Edwardian House,* 8.

68 Robertson, *Driving Force,* 193.

69 For a description of Parkwood and its material comforts, including forty servants, see ibid., 208.

70 Leacock, "A Little Dinner with Mr. Lucullus Fyshe," in his *Arcadian Adventures with the Idle Rich,* 7.

CHAPTER 7

1 Rarely, and only in French Canada, are Native Canadians shown inflicting physical harm on Canadians of European ancestry. For example, Ozias Leduc represented the death of Père Jacques Buteux at the hands of the Iroquois in 1652 in his murals of 1941 to 1955 for the church of Notre-Dame-de-la-Présentation at Shawinigan-Sud, Quebec. See Martin, *Ozias Leduc et son dernier grand oeuvre,* 108–18.

2 Assimilation of Native people had been attempted from the time of settlement, particularly by religious institutions. In 1836 it became official government policy in Upper Canada and, in 1876, was adopted federally. See Miller, *Skyscrapers Hide the Heavens,* 103–4.

3 Said, *Culture and Imperialism,* xiii.

4 Grant, "Studio and Gallery," 13 May 1899, 9.

5 MacMullen, *The History of Canada from Its First Discovery to the Present Time,* xxx.

6 Lawson, *History of Canada,* 131.

7 MacMullen, *History of Canada,* xxiii.

8 Dickie, *The Great Adventure,* 20.

9 The four extant panels are *Buffalo Hunt, Upper Fort Garry, The Government of the Indian Tribes,* and *Indian Camp.* Various publications give dates for the commission and/or the initiation of the installation that range from 1904 to 1906, and dates for the completion of the work that range from 1906 to 1918. See *Four Challener Murals at the Winnipeg Art Gallery* and McFaddin, "The Murals of F.S. Challener," 343.

10 Jones and Dyonnet, "History of the Royal Canadian Academy of Arts," 6.13–14. None of the murals in this contest were designed for specific sites and none of them appear to have been installed as murals.

11 For a discussion of the effect of the Indian Act amendments of the 1880s on Native rituals, see Miller, *Skyscrapers Hide the Heavens*, 175, 193–4; and Pettipas, *Severing the Ties that Bind*.

12 North, "Weasel Calf's Last Sun Dance."

13 Illustrated in *The Journal of the Royal Architectural Institute of Canada* 4 (January 1927): 37.

14 Said, *Culture and Imperialism*, xii.

15 Mair, *Dreamland and Other Poems*, 64.

16 Barbeau, "Our Indians – Their Disappearance."

17 Leacock, *Canada*, 19.

18 MacMullen, *History of Canada*, xxiv.

19 Watson, "Canada's Earliest Transport." For another publication in which writers of Anglo-Saxon origins discuss French Canadians in terms they also use for Native Canadians, see Hopkins, *Progress of Canada in the Century*, 35–6. Consider also the murals in the chalet of Mont Royal Park in Montreal, described in chapter 2 of this book. Events in French Canadian history end in these murals in the late eighteenth century.

20 Quoted in Lears, *No Place of Grace*, 8.

21 Lawson, "The Log Château-Lucerne in Quebec." For a list of the titles of the panels, see chapter 3 above.

22 Glazebrook, *A Short History of Canada*, 8.

23 Stacey, *C.W. Jefferys*, 20.

24 "Decorative Paintings for the Manoir Richelieu." See also the Charles W. Jefferys Papers, Library of the Art Gallery of Ontario, box 25.

25 Challener did an earlier version of the same subject for Toronto's King Edward Hotel around 1906. See Beatty, "A Canadian Painter and His Work," 548.

26 Quoted in Walden, *Becoming Modern in Toronto*, 230–1.

27 *Once upon a Century;* Walden, *Becoming Modern in Toronto*, 228–9.

28 Many fairs also exhibited colonized people. The 1904 Louisiana Purchase Exposition held in St Louis provided an American Indian reservation and a Philippines reservation. The latter included 1200 Filipinos who lived on the site. See Robert W. Rydell, "The Culture of Imperial Abundance: World's Fairs in the Making of American Culture," in Bronner, ed., *Consuming Visions*, 191–216.

29 Howland, "The Canadian Historical Exhibition, 1897," 167.

30 For illustrations of the interior murals, see Parmalee, "Canada's Participation in the World's Fair."

31 Falvey, "The Case Study of the Low-Pressure Treatment of a Large-Scale Canvas Mural Painting, *The Settlement of Canada*, by Frederick S. Haines."

32 MacMullen, *History of Canada*, xxviii.

33 *Ontario Public School History of Canada*, 247–8.

34 Hopkins, *The Story of Our Country,* 65.

35 McArthur, *History of Canada for High Schools,* 9.

36 For illustrations of all the panels, see Reid and Claire, *Descriptive Notes of Mural Decoration in Jarvis Collegiate Institute Auditorium, Toronto.* See also Miner, *G.A. Reid,* 130–2; and Medland, *Minerva's Diary,* 126–30.

37 Miner, *G.A. Reid,* 166, states that Reid studied five (unspecified) Canadian history texts as a basis for the Jarvis murals. These panels are probably also a condensed version of a mural program designed by Reid and other members of the Toronto Guild of Civic Art for the Ontario Legislative Building between 1897 and 1904. The program was never executed, much to Reid's disappointment, but a list of thirty planned subjects includes all the Jarvis subjects. See Miner, *G.A. Reid,* 90; Bayer, *The Ontario Collection,* 94; and chaapter 2 above.

38 Miller, *Skyscrapers Hide the Heavens,* 217.

39 The quotation is from "West Coast Indian Art," a review of an exhibition at the Art Gallery of Toronto in 1928. In the introduction to the exhibition catalogue, anthropologist Marius Barbeau wrote: "A commendable feature of this aboriginal art for us is that it is truly Canadian in its inspiration. It has sprung up wholly from the soil and the sea within *our* national boundaries" (italics mine). See *Exhibition of Canadian West Coast Art.* For other manifestations of this type of appropriation, see Cole, "Artists, Patrons and Public"; and Doxtater, *Fluffs and Feathers.*

40 Cotton, *Vice Regal Mansions of British Columbia,* 103–5.

41 "Panels for Pickering College."

42 Altmeyer describes this type of appropriation of Native lifestyle in "Three Ideas of Nature in Canada, 1893–1914."

43 See, for example, the poster, *Indian Days: Banff in the Canadian Rockies,* in Choko and Jones, *Canadian Pacific Posters, 1883–1963,* np.

44 "Prince of Wales Hotel, Waterton Lake, Alberta."

45 Dempsey, *Indian Tribes of Alberta,* 22–7.

46 A large body of literature expressed this view. See, for example, Mitchell, "Saviour of the Nordic Race."

47 Sherwood, "The Influence of the French School upon Recent Art," 641.

CHAPTER 8

1 George Ross, quoted in Bruce, *Free Books for All,* 66.

2 Library schools and library associations began in the United States before they did in Canada, so offered Canadians the closest sources of professional education. American library associations, which held annual conferences, were also larger than conferences held by Canadian library associations, and attracted many Canadian librarians.

3 Lamb, "The Flower Memorial Library," 399.

4 Quoted in Bruce, *Free Books for All,* 52.

5 Quoted ibid., 66.

6 Locke, "The Public Library," 142.

7 Cooper, "Canada's Progress in the Victorian Era," 161.

8 Lamb, "The Flower Memorial Library," 399.

9 Locke, "The Public Library," 140.

10 See discussions of this issue in, for example, Jackson et al., *A Century of Service;* Kelly, *History of Public Libraries in Great Britain, 1845–1975;* Garrison, *Apostles of Culture;* Barnett, *L'histoire des bibliothèques publiques en France de la Révolution à 1939.*

11 Quoted in Bruce, *Free Books for All,* 53.

12 Quoted ibid., 64.

13 Ibid., 66.

14 Anderson, "Work on the Walls." According to Anderson, Sir Edmund Walker of Toronto, who was a strong advocate of civic murals and a friend of George Reid, attended the opening exhibition of the Collingwood murals.

15 The Ontario College of Art Principal's Report of 1929 states that Claire did murals for the children's reading room at Earlscourt. A corner of one of Claire's panels, which appears incidentally in a photograph of a female librarian reading to children in the 1950s, looks as if it depicts the story of Cinderella. See Scrapbook 1 at Earlscourt Public Library, Toronto.

16 These murals were described and illustrated by Sargent in "The Ray Memorial Library, at Franklin, Massachusetts."

17 For mural paintings in private libraries in Western countries up to approximately 1800, see Masson, *The Pictorial Catalogue.* For a civic yet still exclusive library of the early nineteenth century, see Hopmans, "Delacroix's Decorations in the Palais Bourbon Library."

18 Written in 1912 and quoted in Promey, *Painting Religion in Public,* 163.

19 Lamb, "The Flower Memorial Library," 379–400.

20 Holden, "The Story of the Mind's Progress Told in Murals." For discussions of other American public library murals, see Cartwright, "Reading Rooms."

21 This mural is the focus of Promey's 1999 text. As Promey explains, Sargent claimed not to have intended to represent Christianity as superseding other religions.

22 Reid, *Descriptive Note of the Mural Decorations in the Earlscourt Library Painted by G.A. Reid, R.C.A.*

23 Locke, "The Public Library," 139–40.

24 Contemporary Scandinavian muralists employed landscape as subject matter in civic sites. See Avenard, "L'art à l'école en Suède."

25 Reid, *Descriptive Note.*

26 Bruce, *Free Books for All,* 118; Penman, *A Century of Service,* 23.

27 Reid, "Mural Decoration," April 1898.

28 Small, *The Library of Congress,* 30. For illustrations of Pearce's work, see ibid., 28–30; and Murray, "Painted Words."

29 Lambert, *Dethroning Classics and Inventing English,* 4.

30 For criticism of the classical subject matter of the Library of Congress murals, see Moore, "In Search of an American Iconography."

31 For example, in 1878 in the United States, 66 per cent of library workers were women. In 1920, 90 per cent were women. A similar situation existed in Canada. See Garrison, *Apostles of Culture,* 168; Bruce, *Free Books for All,* xvii.

32 The University of Toronto started a diploma program in library studies only in 1928 and a degree program only in 1936. Bruce, *Free Books for All,* xvii–xviii.

33 Quoted in Garrison, *Apostles of Culture,* 39. At this time, Bostonians frequently used the term "Brahmin" to describe a person who was wealthy, from a good family, and well educated. See Promey, *Painting Religion in Public,* 152, 154, 155, 156, 169.

34 Quoted in Bruce, *Free Books for All,* 47.

35 Quoted in Garrison, *Apostles of Culture,* 179.

36 Quoted in Bruce, *Free Books for All,* 219.

37 Quoted in Garrison, *Apostles of Culture,* 177.

38 Quoted ibid., 40.

39 "Boys' and Girls' Librarians in Special Conference."

40 Quoted in Garrison, *Apostles of Culture,* 180.

41 Nursey, "The Trustee and the Children's Department," 90.

42 Ridley, "Canada's First Woman Inspector," 49.

43 Quoted in Garrison, *Apostles of Culture,* 209.

44 Wodson, "The Story Hour," 87.

45 Quoted in Garrison, *Apostles of Culture,* 179.

46 Quoted in Bruce, *Free Books for All,* 118.

47 Quoted in Garrison, *Apostles of Culture,* 179.

48 Prentice et al., *Canadian Women,* chapter 9; Strong-Boag, *The New Day Recalled;* Wilson, *Women, Families & Work,* chapter 5.

49 Strong-Boag , *The New Day Recalled,* 218.

50 Prentice, *Canadian Women,* 218.

51 "The Progressive Women of the West," 21.

52 Garrison, *Apostles of Culture,* 180; Strong-Boag, *The New Day Recalled,* chapter 2.

53 Quoted in Bruce, *Free Books for All,* 232.

54 Traquair, "Women and Civilization."

55 Traquair, "Mural Decoration."

56 Jones and Dyonnet, "History of the Royal Canadian Academy of Arts" 6.13–15; Royal Canadian Academy Council Meeting Minute Books, National Archives of Canada, 17, MG 28 1 26, 7 May and 21 November 1924, 1 May and 20 November 1925. For a description of the work of the five other winners of the 1924 competition, see chapter 2 above.

57 Jones and Dyonnet, "History of the Royal Canadian Academy of Arts," 6.13–15; Royal Canadian Academy Council Meeting Minute Books, 9 May 1922, 10 February and 19 May 1923.

58 Holden, "The Story of the Mind's Progress," 18–19.

59 Harris, "Cultural Institutions and American Modernization," 110.

60 Fish, *Is There a Text in This Class?*

61 Williams, "The Library's Relation to the Community," 70.

CHAPTER 9

1 The opalescent glass murals are *in situ* at Park, Palmerston, and Wilkinson schools. Some or all of the murals installed in the following schools have been relocated in other parts of the school or in new school buildings: Brown, Carleton Village (formerly Carlton), Clinton, Eglinton, Frankland, Givins/Shaw (formerly Givins), Howard Park, John Fisher, Charles G. Fraser (formerly Manning), Niagara, Orde, Pape, Shirley, and Indian Road (formerly Western). Glass murals from the following schools have been lost or destroyed or have become part of private collections: Annette, Balmy Beach, Davisville, Deer Park, Duke of Connaught, Earl Grey, Essex, Humewood, Jesse Ketchum (planned, but possibly never installed), Kent, Lansdowne, Pauline, Regal Road, Ryerson, St Clair, Strathcona, Winchester, and Williamson Road. A limited amount of information on the original installations (date, cost, and manufacturing company) is available in the *Minutes of the Toronto Board of Education* and in the *Annual Reports of the Toronto Board of Education* located in the Records, Archives and Museum of the Toronto District School Board. A few of the panels are illustrated in Sisler, *Art for Enlightenment,* 92, 153. The Board of Education used the following Toronto manufacturers for the panels: Luxfer Prism Company, Robert MacCausland, Hobbs Manufacturing, and Dominion Stained Glass.

2 Opalescent glass was invented by American artist John La Farge in 1877 in response to clients and patrons who wanted art glass with more detailed images than stained glass could provide. It contains opaque particles (unlike stained glass) that render the medium cloudy. Furthermore, these particles provide a layered structure that allows for the blending or two or more different colours within one sheet of glass and depicts details well. Consequently, artists regarded opalescent glass, when installed in walls, as a type of mural painting. See Adams, "Frederick S. Lamb's Opalescent Vision of a 'Broader Art,'" 331.

3 Donovan, *School Architecture,* 279.

4 For a discussion of Torontonians' fears concerning immigration, see Linsley, "Landscapes in Motion."

5 For examples of schools designed according to ecclesiastical models, see Kendall, *Designs for Schools and Schoolhouses Parochial and National.* For Canadian discussions and illustrations of "modern" schools, see, for example, *Canadian Architect and Builder* 3 (October 1890): 111; La Chance, *Modern Schoolhouses;* Johnson, *Historic Schools in Canada,* volumes 154, and 5; and Parke-Taylor, *Plans for Education.*

6 For examples of early twentieth-century "expanded-hall" kindergartens in the United States, see Bruce, *Grade School Buildings,* 27, 164; Lockhart, *Public Schools,* 177; and Donovan, *School Architecture,* 35.

7 For an example of glass panels in the hinged, wooden panels of an expanded-hall kindergarten in a Toronto school, see a photograph of the Winchester School kindergarten, taken in the late 1890s, in the Records, Archives and Museum of the Toronto District School Board. It is possible that the wooden panels of expanded-hall kindergartens in other parts of Canada and in other Western countries had glass in their upper halves, but I have not found any.

8 Ruskin, *The Crown of Wild Olive,* 142; Herbert, ed., *Art Criticism of John Ruskin,* 421–3.

9 Lancaster, *Hints and Directions for Building, Fitting Up and Arranging School Rooms on the British System of Education,* 19.

10 Murals of biblical scenes were installed in a school in the village of Waterford, Northumberland, England, in the early 1860s. They were commissioned by Lady Waterford. See Christian, *Oxford Union Murals,* 8.

11 [Ruskin], *The Lamp of Beauty,* 317.

12 Hodgins, *The School House,* 10, 11, 66–73.

13 Hodgins, *School Room Decoration,* 5.

14 Hart, "The Relationship of the Kindergarten to the Art," 278.

15 Rankin, "Art in Canadian Schools," 272.

16 Wood, "The Hidden Curriculum of Ontario School Art." See also Efland, "School Art and Its Social Origins."

17 Ortiz, "School Room Decoration," 211.

18 Walker, "The Ethical Side of Art."

19 Cook, *The Life of John Ruskin,* 368–9.

20 Quoted in Carter, "James L. Hughes and the Gospel of Education," 321. See also *School Art Leagues,* 2; Reid, "School Decoration and Picture Study," 479; Burgoyne, *A History of the Home and School Movement in Ontario,* 3; and *The Rosedale League for School Art.* This phamphlet provides a history of the Rosedale League.

21 *List of Reproductions of Works of Art,* 6, 12.

22 For example, historical murals were installed by Barry Faulkner, Robert K. Ryland, J. Mortimer Lichtenauer, and Salvatore Lascari between 1909 and 1934 in Washington Irving High School in New York City (*in situ* and recently restored under the "Adopt-a-mural" program of the New York Municipal Art Society and the Art Commission of the City of New York). See also the discussion of Vesper Lincoln George's *Melting Pot* of 1915 for the Edward Lee McClain High School in Greenfield, Ohio, in chapter 2 above. For early twentieth-century French and Swedish high school murals, see Vitry, "Art et l'école"; and Avenard, "L'art à l'école en Suède," 125–27.

23 Robson, *School Architecture,* 14.

24 Silcox, "The Psychology of Nature Study," 342.

25 *List of Reproductions.* This focus on nature also led to the development of nature study courses that emphasized the relationship between nature and morality. See, for example, Dearness, *The Nature Study Course.*

26 See the Bryan Mullanphy and Laclede schools' kindergarten friezes illustrated in Donovan, *School Architecture* 286–7. William Ittner was commissioner of school

buildings in St Louis from 1897 to 1910 and architect of the Board of Education of St Louis from 1910 to 1916. For other Ittner kindergartens, see Bruce, *Grade School Buildings,* 171, 59, 109; Ittner, "St. Louis Public School Buildings," 36–44. See also "Biographical Sketch of William Butts Ittner"; Guy Study, "The Work of William B. Ittner"; and Freedman, "William B. Ittner." The first Froebel kindergarten in North America opened in St Louis in 1873 and, from that time, the St Louis school system was considered to be avant-garde. See Woodward, "A New Era in the Public Schools of St. Louis," 493; and Reese, "St. Louis School Buildings," 487. There were strong links between Toronto kindergartens and those in St Louis. In April 1882 Toronto schools inspector James L. Hughes went to St Louis to study kindergartens. In September of that same year the Toronto Board of Education sent Ada Marean to St Louis to observe kindergartens. Marean was an American trained kindergartner who had opened a private kindergarten in Toronto in 1878 at Hughes's urging. In November 1882 Susan Blow, St Louis' first kindergartner, lectured to the Toronto Board of Education. After 1885, Hughes and Marean (who were married that year) regularly attended American educational conferences, where William Ittner often spoke. In 1897 Hughes wrote a kindergarten text, *Froebel's Educational Laws,* at the request of William Harris, superintendent of St Louis Schools from 1868 to 1880 and the United States commissioner of education from 1889 to 1906. Caroline M.C. Hart, inspector of kindergartens for the province of Ontario from 1886 to 1892, studied with Blow in St Louis. From 1886 to 1894 Leontine T. Newcomb of St Louis was the kindergarten supervisor in Hamilton, Ontario.

27 See Frederick Haines's artist file in the Edward P. Taylor Library and Research Archives, Art Gallery of Ontario.

28 The earlier building was built between 1896 and 1898. See *Rosedale League of School Art;* "How We Decorated Our School, 1: Rosedale Public School"; and Farr, *J.W. Beatty,* 22–3.

29 Craik, "Boys Outnumber Girls at Rosedale Public School." For a photo of the Rosedale kindergarten room, see *Toronto Star Weekly* 31 March 1917, 8.

30 Hubbard, *Merry Songs and Games for the Use of the Kindergarten,* 87.

31 Sargent, "Art in the Home and in the School: Examples of Mural Decoration based upon Dutch Types and Scenes," 58, 59.

32 See Froehlick and Snow, *Textbooks of Art Education, Book I,* 5, 7, 13; and *Syllabus of Studies and Regulations for the Normal Schools at Hamilton, London, Ottawa, Peterborough, Stratford and Toronto, 1908–1909.* Beatty could also have modelled his work after Maurice Chabas's impressionistic family picnic mural panel and harvest mural panel – which Beatty likely saw – installed in the *mairie* of the Fourteenth *arondissement* in Paris in 1888 (*in situ*).

33 Froebel's ideas on the kindergarten may be found in various English editions of anthologies of his writings published between 1826 to 1844, such as *The Education of Man, Education by Development,* and *Mothers' Songs, Games and Stories.* For recent

discussions of Froebel's curriculum, see Shapiro, *Child's Garden;* Liebschner, *A Child's Work;* and Brosterman, *Inventing Kindergarten.*

34 Hobson, *John Ruskin,* 233.

35 Hart, "Relationship of the Kindergarten," 278.

36 James Hughes published a great deal on kindergartens, held important positions in Canadian and American kindergarten associations, and gave lectures on Froebel's curriculum and other issues related to the kindergarten throughout England, the United States, and Canada. For a list of Hughes's publications, see Carter, "James L. Hughes." Hughes's wife, Ada Marean Hughes, opened Canada's first public kindergarten at Louisa Street School in Toronto in 1883. She founded the Toronto Kindergarten Association, served three times as president of the International Kindergarten Union, and was president of the World's Kindergarten Association in 1893. For her views, see Hughes, "The Kindergarten as Related to the Nursery and School," and "A Kindergarten Message to Mothers." From the 1880s, too, many Canadian educators published and attended conferences on Froebel kindergartens, both nationally and internationally. For a history of the kindergarten movement in Ontario, see Corbett, *"The Public School Kindergarten in Ontario,"* and Corbett, *A Century of Kindergarten Education in Ontario.*

37 *The Annual Report of the Toronto Board of Education,* 61; appendix to *The Minutes of the Toronto Board of Education,* 1287; *Syllabus of Studies,* 19.

38 Many kindergartners elaborated on the lessons that might be learned from Froebel's play songs. For example, Blow, *The Songs and Music of Friedrich Froebel's Mother-Play;* Snider, *Froebel's Mother-Play Songs;* and Arnold, *Notes on Froebel's Mother-Play Songs.*

39 William Ittner's mural paintings for the Laclede School and the Bryan Mullanphy School in St Louis included illustrations of at least one of Froebel's play songs. One panel in each of these murals represented a pendulum clock and was labeled "Tick Tack," the exact title of the Froebel play song, rather than the normal English words for the sound of a clock, "Tick Tock." Other panels may also have illustrated other Froebel play songs. See Donovan, *School Architecture,* 286 and 287. Given the strong relations between the Toronto Board of Education and the St Louis Board, it is reasonable to surmise that the architects of one board took the idea for murals from the architects of the other board. However, the earliest date that can be given for the installation of the Toronto murals is 1913, while Ittner was given the commission for the two St Louis Schools in 1913 and may well have planned the murals at this time. Bryan Mullanphy opened in 1914 and Laclede in 1915. Therefore, these dates do not identify the Toronto architects or the St Louis architects as the originators of the idea to illustrate Froebel's play songs. It is quite possible that other earlier kindergarten architects designed mural paintings, though I have not found any.

40 For translations of all these play songs and of Froebel's lessons to be learned from them, as well as for reproductions of Froebel's original illustrations, see Lord, *Mother's Songs, Games and Stories.*

41 Blow, *Educational Issues in the Kindergarten,* 89.

42 Salmon, *Infant Schools,* 286, 287. Many kindergartners expressed the same point of view. See, for example, Bryan, "The Letter Killeth," especially 574–5: "[Do not mistake his gift-work] as a prescribed formal line of teaching, instead of tools to be skillfully and discriminatingly used"; Stewart, "Changes in Kindergarten Play and Games": "[It] would be a mistake [to teach a] game as it is simply because she finds it in Froebel's collection ... It is the spirit, not the form, that is important ... Many new and excellent plays and games have been invented since the time of Froebel ... New ones have been invented to suit our new conditions."

43 Froebel, *The Mottoes and Commentaries of Friedrich Froebel's Mother-Play,* 93, 95. Over twenty years earlier, Scudder, "Nursery Classics in School," 800, claimed the same abilities for fairy tales within kindergartens when he wrote: "The child that has spent the hours devoted to ... fables, fairy-tales [and] folk tales ... has had a foundation laid for steady progress into the higher air of poetry and all imaginative, creative, and inspiring literature ... In this plea for the introduction of nursery classics into the school-room, I have assumed that the finest use to which the power of reading can be put is in the enlightenment of the mind, not in its information." For more recent discussions of past educational uses of fairy tales, see Tatar, *Off with Their Heads.*

44 Hart, "Relationship of the Kindergarten," 280–1.

45 Harriman, "Some Social Aspects of the Kindergarten," 290; "Place of the Fairy Tale in the Child's Life," 990.

46 Blow, *Educational Issues,* 89. For other late-nineteenth and early-twentieth-century explanations of the ability of specific nursery rhymes and fairy tales to teach specific morals within a Froebel curriculum, see Bowen, *Froebel and Education through Self-Activity,* 73; Blow, *Symbolic Education,* 220; and Baker, "The Dramatic Arts in Kindergarten," 427.

47 Sir William Temple, an English ambassador to The Hague, remarked on many of these features of Dutch life in his *Observations upon the United Provinces of the Netherlands,* first published in 1673 (reprint of 1932 edition, edited by Sir George Clark, Oxford: Clarendon Press, 1973).

48 See any of the many editions of John Lothrop Motley's *The Rise of the Dutch Republic,* first published in 1855, and Motley's *History of the United Netherlands,* first published in 1867.

49 This phenomenon has recently been thoroughly studied by Stott, *Holland Mania.* For the appearance in Canada of "Holland Mania" from the 1870s, and in Toronto from the 1890s, especially with regard to Dutch painting, see Hurdalek, *The Hague School.*

50 de Leeus, *Crossroads of the Zuider Zee,* 7

51 *The Art-Literature Readers,* 67. In the same text, see other discussions of Holland and Dutch children, 58, 60, 64, 66. Many volumes of *The Canadian Teacher,* c. 1914–15, provide illustrations of Dutch life, related poems, stories, and other items. The Ontario Department of Education's *List of Reproductions of Works of Art* of 1914

recommended reproductions of seventeenth-century Dutch landscapes and domestic interiors for kindergartens, as did the department's *Catalogue of Books Recommended for Public and Separate School Libraries* of 1915.

52 Parkhurst, "A Plea for Stained Glass," 698.

53 Dresslar, *American Schoolhouses,* 35.

54 Scudder, "Nursery Classics," 800. For the use of stained glass in an early private kindergarten in the United States, see "Kindergarten at Winchester, Mass." Ittner installed a small stained-glass window with a portrait of Friedrich Froebel in the Shepard School in St Louis in 1904. It is now in the Carondelet Historical Society in St Louis. See Brosterman, *Inventing Kindergarten,* 92, for an illustration. Ittner also installed stained glass in the kindergarten room of the contemporary Lyon School in St Louis. See Ittner, "School Buildings of St. Louis, Missouri: Part I," 168. Stained glass was installed in many Canadian schools – for instance, in 1912 in Vancouver's King Edward High School. See Watt, *Rainbows in Our Walls,* 17. The Toronto Board of Education ordered stained-glass windows in 1917 from the Luxfer Prism Company in Toronto for its administration building. See the appendix to the *Minutes,* 1917, 354.

55 Mabie, "The Free Kindergarten." A large body of literature connecting the kindergarten to the home, and especially to the homes of the working classes, appeared from the middle of the nineteenth century. The topic was also frequently discussed at educational conferences. See, for example, Gilder, "The Kindergarten." References to the formation of "Little Mothers' Leagues" in Toronto can be found throughout appendices to the *Minutes* – for example, 1914: 332, 497.

56 *The Inland Architect and Builder* 1 (May 1882): 52, quoted in Darling, *Chicago Ceramics and Stained Glass,* 101.

57 Howe, "The Use of Ornament in the House," 90.

58 Austin, "Toronto Stained Glass Windows," 18.

59 For an example of a painted frieze with Dutch images designed for a nursery and an example of stained glass with Dutch images designed for a nursery, see, respectively, Hodgman, "The Walls of the Nursery"; and *The Studio Yearbook of Decorative Art,* 142. The Arts and Crafts movement, whose goal was the promotion of hand-made objects of beauty for the home, frequently promoted Dutch images within the home in stained glass. See Johnson, "Frans Hals to Windmills." For an example of a nursery rhyme (Humpty-Dumpty) in stained glass in a nursery, see "Stained Glass for Home Decoration." Kate Greenaway's and Beatrix Potter's books contain the best known late-nineteenth-century illustrations whose nature designs for children's books were made into wallpaper. Ruskin particularly admired Greenaway's illustrations (see Robert L. Hebert, ed., *Art Criticism of John Ruskin,* 422). For examples of children's wallpaper designed by other nineteenth-century children's book illustrators such as Walter Crane, see Lynn, *Wallpaper in America;* Oman and Hamilton, *Wallpapers;* and Hapgood, *Wallpaper and the Artist,* especially, "Artists' Wallpapers for Children," 237–246, which includes Dutch friezes of "Bo Beep" and "Simple Simon"

of 1910 designed by Will Owen . See also "Your Own Home, Number Seven"; Miall, *The Victorian Nursery Book;* and White, *The World of the Nursery.*

60 Vaughan, *Sir William Van Horne,* 371.

61 "The Age of the Child." For other examples of similar attitudes towards children's rooms, see "A Child's Room Is His Castle"; Howland, "The Importance of the Child's Room"; and Tachau, "A Child's Room," 258–9.

62 Howland, "Importance of the Child's Room," 343. Magazines devoted to domestic issues often included school issues. See, for example, Nida, "Lighting of Schoolrooms."

63 Dyer, "The Modern Nursery."

64 "Nursery Wall Coverings in Indian Designs," 97.

65 "The Age of the Child."

66 "Making the Schoolroom Attractive."

67 Craik, "Boys Outnumber Girls," 11.

68 Sargent, "Art in the Home and in the School: Mural Decoration Based on Dutch Types," 58, 59; see also Sargent, "Art in the Home and in the School"; Sargent, "Art in the Home and in the School: A Lesson from Boutet de Monvel"; and Sargent, "Art in the Home and in the School: A Selection from the Child-Types of Kate Greenaway."

69 Wiggins, "The Relationship of the Kindergarten to Social Reform," 21, 27, 28.

70 Newman, "Schoolroom Decoration," 373.

71 It is reasonable to consider that Toronto Board of Education architect Franklin E. Belfry (1881–1951) may have been instrumental in the decision to place opalescent glass murals in the Toronto kindergartens. Belfry was hired by the board in 1913 – just at the time that the first opalescent glass murals appeared. He corresponded with the Toronto stained glass manufacturer, Robert McCausland Ltd, about the manufacturing of opalescent glass panels for the kindergarten in Lansdowne School in 1914 (letter from McCausland to Franklin Belfry, 5 June 1914 in Letter Book of Robert McCausland Ltd). The Greater Toronto Board of Education has no records on Belfry. The *Canadian Architect and Builder* 18 (January 1905): 7, states that he was elected vice-president of the Beaux-Arts Club in Toronto that year.

72 Blow and Eliot, *Mottoes and Commentaries,* 296.

CHAPTER 10

1 MacCarthy, *Stanley Spencer,* 24; Malvern, "Memorizing the Great War."

2 Folliot, "Le décor des mairies," 169–71.

3 There is a large body of literature on the Mexican mural paintings of the 1920s to 1940s. See, for example, Folgarait, *Mural Painting and Social Revolution in Mexico, 1920–1940.*

4 A vast body of literature exists on the American mural paintings of the late 1920s to the early 1940s. See, for example, Marling, *Wall-to-Wall America.* For the work of Mexican mural painters in the United States and the influence of this work on American artists, see Hurlburt, *The Mexican Muralists in the United States.*

5 Lears discusses this phenomenon at length in *No Place of Grace.*

6 Dewey, *Art as Experience,* 10. See also Dewey, "Americanism and Localism," 687–8.

7 Turner, *The Frontier in American History,* 1–38. These ideas were first presented in a speech, "The Significance of the Frontier in American History," at the Chicago World's Fair, 12 July 1893.

8 "Co-ordination between Mural Painting and Architectural Setting."

9 Biddle, "Mural Painting in America," *American Magazine of Art* 27 (July 1935): 361.

10 "Modern Mural Decorations."

11 In 1940 the National Gallery of Canada provided a belated exhibition of drawings for American civic mural paintings of the 1930s. See *Mural Designs for Federal Buildings from the Section of Fine Arts Washington, D.C.*

12 These mural paintings were uncovered in 1996. Their titles are *Captain Malaspina Mapping the Coast of British Columbia* for the banquet room; *Captain Malaspina Sketching the Sandstone "Galleries" on Gabriola Island* for the banquet room; *Captain Malaspina Trading with Chief Maquinna at Friendly Cove, West Coast of Vancouver Island* for the banquet room; *Lieutenant Dionisio Galiano Landing at Departure Bay, Nanaimo* for the dining room (destroyed); *Captain George Vancouver Meeting Governor Bodega y Quadra at San Miguel, Nootka Sound, Vancouver Island* for the dining room; and *Captain James Cook Repairing His Ship "Discovery" at Nootka Sound, 1778* for the dining room. See Dunae, "Historical Significance of the Malaspina Hotel Murals"; and Welburn, "Romancing the Murals," 1.

13 Miller, *Skyscrapers Hide the Heavens,* 140–1.

14 Gray et al., *Charles Comfort,* 19, 74.

15 Ayre, "Murals in Our Public Buildings." In the 1960s, when the Hotel Vancouver was renovated and Comfort's mural was removed and given to the University of British Columbia, the university was deluged with requests from Native people, and from non-Native people who were beginning to question non-Native constructions of Native history, not to hang the work. For more details on the controversy, see Cronin, "Captain Vancouver by Charles Comfort," 21–2. See also the Michener Papers, National Archives of Canada.

16 Zemans, *Jock Macdonald,* 92–3.

17 Ayre, "Murals in Our Public Buildings," 2.

18 MacLeod, "Adventure in Murals." See also Caughlin, "Woodstock Reaction to Murals."

19 Illustrated in "Montreal Branch Celebrates," *Imperial Reporter,* 15 September 1947, 10–11.

20 Comfort, "Mural in a Bank," 19.

21 Biéler, "Mural of the Saguenay."

22 Illustrated in Buchanan, "New Murals in Canada," 66.

23 Cowan, *John Innes,* 26.

24 McDougall, "The Murals at the National Library."

25 Buchanan, "Embryology on a Wall."

26 Lismer, "Mural Painting," 128; Baigell, *Thomas Hart Benton,* 111–21.

27 Lismer, "Mural Painting,"128.

28 *Proceedings of the Conference of Canadian-American Affairs, Queen's University, Kingston, Ontario, June 14–18,* 136. For a discussion of Mexican influence on Canadian art in the 1940s, see Boyanoski, *The Artists' Mecca.*

29 Dendy and Kilbourn, *Toronto Observed,* 226–7; Donegan, "Mural Roots"; Donegan, "Legitimate Modernism." Comfort also designed the stone frieze on the facade of the Toronto Stock Exchange. It provides subject matter similar to that of the mural paintings.

30 Hill, *Canadian Painting in the Thirties,* 92.

31 Quoted in Donegan, "Mural Roots," 69.

32 *Shawnigan Lake School Magazine,* 1934, 15.

33 Buchanan, "Embryology on a Wall," 154. See also Buchanan, "The Haydon Mural at Pickering College, Newmarket, Ontario."

34 Jones, "The Case of the Missing Mural."

35 Lord, *Painting in Canada,* 186–9.

36 For a discussion of Canadian artists such as André Biéler, Fritz Brandtner, Paraskeva Clark, Charles Comfort, Prudence Heward, Lawrence Hyde, Yvonne McKague, and Miller Brittain, who employed art for the purpose of social reform (but not in mural painting), see Hill, *Canadian Painting in the Thirties,* 15–17. For prints by Brandtner and Hyde, see *New Frontier* 1 (January and March 1937).

37 Abell, "Art and Democracy," 8 –9.

38 Buchanan, "New Murals," 64.

BIBLIOGRAPHY

ARCHIVES

Anglican Church of Canada, Toronto
Arts and Letters Club, Toronto
Bibliothèque d'Art et d'Archéologie (Fondation Jacques Doucet), Paris
Bibliothèque Ste Geneviève, Paris
Boston Public Library
Canadian Imperial Bank of Commerce, Toronto
Canadian National Exhibition, Toronto
Canadian Pacific Railway, Montreal
City of Toronto
Courtauld Institute, London
Edmonton Journal
Edward P. Taylor Research Library and Archives, Art Gallery of Ontario
Hudson Bay Company, Winnipeg
Marine Museum of Upper Canada, Toronto
McCord Museum, Montreal
Metropolitan Toronto Reference Library
Montreal Museum of Fine Art
Municipal Art Society of New York
National Archives, Ottawa
National Gallery of Canada, Ottawa
New York Public Library
Ontario Institute for Studies in Education, Toronto
Protestant School Board of Montreal
Provincial Archives of Alberta, British Columbia, Manitoba, New Brunswick, Nova
 Scotia, Ontario, Prince Edward Island, Quebec, and Saskatchewan
Robert McCausland Limited, Toronto
Royal Ontario Museum, Toronto
St Louis, Missouri Board of Education
Toronto District School Board
United Church of Canada, Toronto
University of British Columbia Art Gallery

University of Toronto

Vancouver Public Library

York University, Toronto

BOOKS AND ARTICLES

L'Abbé, J. Pierre N. "Catholic Critics on Religious Art in France, 1870–1920." PhD thesis, University of Toronto, 1990

Abell, Walter. "Art and Democracy." *Maritime Art* 2 (October 1941): 8–12

"The Acoustics of a Motion Picture Theatre." *Construction* 24 (March 1931): 106

Adams, David. "Frederick S. Lamb's Opalescent Vision of 'A Broader Art': The Reunion of Arts and Crafts in Public Murals." In Bert Denker, ed., *The Substance of Style: Perspectives on the American Arts and Crafts Movement*, 317–40. Winterthur, Delaware: Henry Francis du Pont Winterthur Museum, 1996

"The Addition to the Robert Simpson Store, Toronto." *Construction* 22 (March 1929): 75–82

"The Age of the Child." *Good Housekeeping* 66 (February 1918): 111

Allaire, Sylvain. "Les artistes canadiens aux Salons de Paris de 1870 à 1914." MA thesis, University of Montreal, 1985

– "The Charles Huot Paintings in Saint-Saveur Church, Quebec City." *Bulletin of the National Gallery* 2 (1978–9): 16–30

Allen, Edward B. *Early American Wall Paintings, 1710–1850.* Sturbridge, Massachusetts: Old Sturbridge Village, 1952. Reprinted, New York: Dutton & Co., 1972

Altmeyer, George. "Three Ideas of Nature in Canada, 1893–1914." *Journal of Canadian Studies* 11 (August 1976): 21–36

The American Renaissance, 1876–1917. Brooklyn, New York: The Brooklyn Museum, 1979

Anderson, Janice. "Work on the Walls: Elizabeth Annie Birnie and Canadian Mural Painting," np. *Abstracts of the Universities Art Association of Canada.* Vancouver, 1997

Andrews, Keith. *The Nazarenes: A Brotherhood of German Painters in Rome.* Oxford: Clarendon Press, 1964

Aquilino, Marie. "Decoration by Design: The Development of the Mural Aesthetic in Nineteenth Century French Painting." PhD thesis, Brown University, 1989

– "Painted Promises: The Politics of Public Art in Late Nineteenth-Century France." *Art Bulletin* 75 (December 1993): 697–712

Archer, John H.G., ed. *Art and Architecture in Victorian Manchester.* Manchester: Manchester University Press, 1985

"Architectural Possibilities of Brick." *Construction* 2 (April 1909): 40

"The Architectural Side of the Modern Passenger Boat." *Construction* 4 (August 1911): 65–76

The Architecture of Edward & W.S. Maxwell. Montreal: Montreal Museum of Fine Arts, 1991

Arnold, Jean Carpenter. *Notes on Froebel's Mother-Play Songs*. Chicago: National
 Kindergarten College, 1914
Art for Architecture: Washington, D.C., 1895–1925. (Washington, DC: National Collection
 of Fine Arts, Smithsonian Institute, 1975
The Art-Literature Readers: A Primer. Canadian Series. Toronto: W.J. Gage, 1914
Arthur, Eric. *Toronto, No Mean City*. 3rd ed.Toronto: University of Toronto Press 1986
Atkinson, J. Beavington. "On Fresco Painting as Applied to the Decoration of
 Architecture." *The Art-Journal* 3 (1 November 1864): 317–20
"An Attractive Toronto Home in Elizabethan Design." *Construction* 3 (November
 1910): 59–63
Austin, Alvyn J. "Toronto Stained Glass Windows." *Canadian Collector* 10 (July / August
 1975): 18–22
Avenard, Étienne. "L'art à l'école en Suède." *Art et décoration* 16 (October 1904): 125–9
Ayre, Robert. "Murals in Our Public Buildings." *Saturday Night* 55 (25 May 1940): 2
Baigell, Matthew. *Thomas Hart Benton*. New York: Harry N. Abrams, 1975
Baker, Edna Dean. "The Dramatic Arts in Kindergarten: Game, Song and Story as the
 Basis of a Democratic Education." *Journal of the Proceedings and Addresses of the
 National Education Association* 55 (1917): 421–7
Baker, Marilyn. *Manitoba's Third Legislative Building: Symbol in Stone: The Art and Politics
 of a Public Building*. Winnipeg: Hyperion Press Limited, 1986
Baker, Victoria. *The Croscups' Painted Parlour*. Ottawa: National Gallery of Canada, 1990
Baldry, A. Lys. "Professor Moira's Recent Mural Decorations." *The Studio* 40 (February
 1907): 22–34
Baltz, Trudy. "Pageantry and Mural Painting: Community Rituals in Allegorical Form."
 Winterthur Portfolio 15 (autumn 1980): 211–28
Bann, Stephan. *The Clothing of Clio: A Study of the Representation of History in Nineteenth
 Century Britain and France,* Cambridge: Cambridge University Press, 1984
Barbeau, Marius. "Our Indians – Their Disappearance." *Queen's Quarterly* 38 (autumn
 1931): 691–707
Barnett, Graham Keith. *L'histoire des bibliothèques publiques en France de la Révolution
 à 1939*. Translated by T. Lefèvre and Yves Sardat. Paris: Promodis, 1987
Barrett, Anthony A., and Rhodri W. Liscombe. *Francis Rattenbury and British Columbia:
 Architecture and Challenge in the Imperial Age*. Vancouver: University of British
 Columbia Press, 1983
Barringer, Tim. "The Leighton Gallery at the V&A: The Context, Conservation and
 Redisplay of the South Kensington Frescoes." *Apollo* 143 (February 1996): 56–64
Barthes, Roland. *The Fashion System*. New York: Hill and Wang, 1983
– *Mythologies*. New York: Noonday Press, 1972
Baudrillard, Jean. *The Mirror of Production*. (Trans. M. Leven. St Louis: Telos Press, 1975
Baycroft, Timothy. *Nationalism in Europe, 1789–1945*. Cambridge: Cambridge University
 Press, 1998
Bayer, Fern. "A Critical Summary of Archival Material Relating to the History of the

Parliament Buildings." Unpublished manuscript prepared for the Ministry of Government Services, 1978. Available in the offices of the provincial art curator, Queen's Park, Toronto

– *The Ontario Collection.* Toronto: Fitzhenry & Whiteside, 1984

Beatty, John W. "A Canadian Painter and His Work." *Canadian Magazine* 26 (April 1906): 546–51

Beauregard, Christiane. "Napoléon Bourassa: la chapelle Notre-Dame-de-Lourdes à Montréal." PhD thesis, University of Montreal, 1984

Bellely, Cécile. "François-Édouard Meloche (1855–1914), muraliste et professeur: Le décor de l'église Notre-Dame-de-la-Visitation de Champlain." MA thesis, Concordia University, 1989

Bénédite, Léonce. "La peinture décorative aux Salons." *Art et décoration* 3/1 (1898): 129–46

Berger, Carl. *The Sense of Power: Studies in the Ideas of Canadian Imperialism, 1867–1914.* Toronto: University of Toronto Press, 1970

Berry, Virginia. *Vistas of Promise: Manitoba, 1874–1919.* Winnipeg: Winnipeg Art Gallery, 1987

Bert, David F. *Chicago's White City of 1893.* Lexington: University of Kentucky Press, 1976

Betjeman, John. "Nonconformist Architecture." *Architectural Review* 88 (December 1940): 161–74

Biddle, George. "Mural Painting in America." *American Magazine of Art* 27 (July 1935): 361–71

Biéler, André. "Mural of the Saguenay." *Canadian Art* 9 (Christmas/New Year's, 1951–2): 70–1

"Biographical Sketch of William Butts Ittner." *Architectural Forum* 48 (March 1928): 420

Blake, Grace Atkinson. *Catalog of Pictures, Sculptures and Other Works of Art in Edward Lee McClain High School.* Greenfield, Ohio: Greenfield Printing and Publishing Company, 1980

Blashfield, Edwin. "Mural Painting." *Municipal Affairs* 2 (1898): 98–110

– *Mural Painting in America.* New York: Charles Scribner's Sons, 1914

– "Mural Painting in America." *Scribner's Magazine* 54 (September 1919): 353–65

Blow, Susan E. *Educational Issues in the Kindergarten.* New York: D. Appleton and Company, 1909

– *The Songs and Music of Friedrich Froebel's Mother-Play.* New York: D. Appleton and Company, 1907

– *Symbolic Education: A Commentary on Froebel's "Mother-Play."* New York: D. Appleton and Company, 1897

Blow, Susan, and Henrietta R. Eliot. *The Mottoes and Commentaries of Friedrich Froebel's Mother-Play.* New York: D. Appleton and Company, 1910

Boase, Thomas S.R. "The Decoration of the New Palace of Westminster, 1841–1863." *Journal of the Warburg and Courtauld Institutes* 17 (1954): 319–58

Bonenfant, Jean-C., and Jean-C. Falardeau. "Cultural and Poltical Implications of French-Canadian Nationalism." In Ramsey Cook, ed., *Canada, Quebec, and the Uses of Nationalism.* Toronto: McClelland & Stewart, 1986

Bouillon, Jean-Paul. *Maurice Denis.* Geneva: Skira Editions, 1993

Bourassa, Napoléon. "Causerie artistique sur l'exposition de l'Art Association of Montreal." *Revue canadienne* 2 (March 1865): 170–9

– "Du développement du goût dans les arts en Canada." *Revue canadienne* 5 (5 January 1868): 67–80; 5 (5 March 1868): 207–15

– "Quelques réflexions critiques à propos de l'Art Association of Montreal." *Revue canadienne* 1 (March 1864): 171–82

Bowen, H. Courthope. *Froebel and Education through Self-Activity.* New York: Charles Scribner's Sons, 1897

Boyanoski, Christine. *The Artists' Mecca: Canadian Art and Mexico.* Toronto: Art Gallery of Ontario, 1992

"Boys' and Girls' Librarians in Special Conference." *Ontario Library Review* 7 (1922/23): 50–2

Braide, Janet. "William Brymner: The Artist in Retrospect, 1855–1925." (MA thesis: Concordia University, 1979

– *William Brymner, 1855–1925: A Retrospective.* Kingston, Ontario: Agnes Etherington Art Centre, 1979

Brinton, Selwyn. "Modern Mural Decoration in America." *The Studio* 51 (December 1910): 175–90

The Brochure of the Mural Painters: A National Society. New York, 1916

Bronner, Simon J., ed. *Consuming Visions: Accumulation and Display of Goods in America, 1880–1920.* New York: W.W. Norton, 1989

– "Object Lessons: The Work of the Ethnological Museums and Collections." In Simon J. Bronner, ed., *Consuming Visions,* 217–54. New York: W.W. Norton, 1989

Brosterman, Norman. *Inventing Kindergarten.* New York: Harry N. Abrams, 1997

Brown, Ford Madox. "Of Mural Painting." *Arts and Crafts Essays by Members of the Arts and Crafts Exhibition Society.* London: Rivington, Percival & Co., 1893, 149–60

Browne, John, and Timothy Dean. *Westminster Cathedral: Building of Faith.* London: Booth-Clibborn Editions, 1995

Bruce, Lorne. *Free Books for All: The Public Library Movement in Ontario, 1850–1930.* Toronto: Dundurn Press, 1994

Bruce, William C. *Grade School Buildings.* Milwaukee: The Bruce Publishing Company, 1914

Bryan, Anna E. "The Letter Killeth." *Journal of the Proceedings and Addresses of the National Education Association* 29 (1890): 573–81

Buchanan, Donald W. "Embryology on a Wall." *Canadian Forum* 15 (January 1935): 154–5

– "The Haydon Mural at Pickering College, Newmarket, Ontario." *Saturday Night* 50 (15 December 1934): 2, 11

– "New Murals in Canada." *Canadian Art* 10 (October 1952): 64–6

Buck, Winifred. "Pictures in the Public Schools." *Municipal Affairs* 6 (June 1902): 189–97

Burgoyne, Lola. *A History of the Home and School Movement in Ontario*. Toronto: Charters Publishing, 1934

Burrage, Severance, and Henry Turner Bailey. *School Sanitation and Decoration*. Boston: D.C. Heath & Co., 1899

Caffin, Charles. *Art for Life's Sake*. New York: The Prang Company, 1913

Canadians in Paris, 1867–1914. Toronto: Art Gallery of Ontario, 1979

Careless, James M.S. *Toronto to 1918: An Illustrated History*. Toronto: J. Lorimer, 1983

Carman, Albert. "Wall Paintings in Europe." *Canadian Magazine* 26 (February 1906): 307–12

Carr, Angela. *Toronto Architect Edmund Burke: Redefining Canadian Architecture*. Montreal and Kingston: McGill-Queen's University Press, 1995

Carter, Bruce, N. "James L. Hughes and the Gospel of Education." (PhD thesis, University of Toronto, 1966

Cartwright, Derrick. "Reading Rooms: Interpreting the American Public Library Mural, 1890–1930." PhD thesis, University of Michigan, 1994

Cashman, Tony. *A Pictorial History of Alberta*. Edmonton: Hurtig Publishers, 1979

Catalogue of Books Recommended for Public and Separate School Libraries. Toronto: Ontario Department of Education, 1915

Catalogue of Historical Paintings in the Legislative Building. Regina: Government of Saskatchewan, 1933

Caughlin, Grace A. "Woodstock Reaction to Murals." *Maritime Art* 2 (December 1941): 39

Ces Belles Mairies de France. Paris: Éditions Patrimoine Plus, 1995

Challener, Frederick S. "Mural Decoration." *The Canadian Architect and Builder* 17 (May 1904): 90–4

Charensol, Georges. "Peintures murales commandés par l'État." *Arts et décoration* 67 (1938): 121–8

Charlesworth, Hector. "Pictures That Can Be Heard." *Saturday Night* 19 (18 March 1916): 5

Chaudonnert, Marie-Claude. "1848: 'La République des Arts.'" *The Oxford Art Journal* 10 (1987): 59–70

Chemins de la Mémoire: Monuments et sites historiques du Québec. Volumes 1 and 2. Commission des biens culturels. Québec: Les Publications du Québec, 1990

Chennevières, Phillipe de. "Rapport de l'instruction publique des cultes et des beaux-arts." *La chronique des arts et de la curiosité* (2 February 1878): 423–4

"A Child's Room Is His Castle." *Good Housekeeping* 66 (February 1918): 36–7

Choay, Francoise. "Urbanism in Question," 241–58. In Mark Gottdiener and Alexandros Ph. Lagopoulos, eds., *The City and the Sign*. New York: Columbia University Press, 1986

Choko, Marc H., and D.L. Jones. *Canadian Pacific Posters, 1883–1963*. Montreal: Meridian Press, 1988

Christian, John. *The Oxford Union Murals.* Chicago and London: University of Chicago Press, 1981

Clark, Gregory. "Why Canadian Art Is Not Popular with Collectors." *Toronto Star Weekly,* 21 November 1914, 10

Clark, Herbert M. "London's New Ecclesiastical Edifice – Catholic Cathedral Erected at Westminster a Striking Example of the Early Byzantine Style." *Construction* 2 (June 1909): 41

Clark, Kenneth, ed. *Ruskin Today.* London: John Murray, 1964

Cole, Douglas. "Artists, Patrons and Public: An Enquiry into the Success of the Group of Seven." *Journal of Canadian Studies* 13 (summer 1978): 69–78

Cole, John, and Henry H. Reed. eds. *The Library of Congress: The Art and Architecture of the Jefferson Building.* New York: Norton, 1997

Coleman, Ronald, ed. *Resolutions of the Twelve Lambeth Conferences, 1876–1988.* Toronto: Anglican Book Centre, 1992

Colgate, William. *Canadian Art: Its Origin and Development.* 2nd ed. Toronto: McGraw-Hill Ryerson, 1967

– *The Toronto Art Students' League, 1886–1914.* Toronto: Ryerson Press, 1954

Comfort, Charles. "Mural in a Bank." *Canadian Art* 9 (October 1951): 18–20

Connor, Ralph. "The Future of Canada," 144-9. In Addresses *Delivered before the Canadian Club of Toronto.* Toronto: Warwick Brothers & Rutter, 1905.

Cook, Clarence. "Recent Church Decoration." *Scribner's Monthly* 15 (February 1878): 570–4

Cook, Ramsay, ed. *Canada, Quebec, and the Uses of Nationalism.* Toronto: McClelland & Stewart, 1986

– *French Canadian Nationalism: An Anthology.* Toronto: Macmillan of Canada, 1969

– "Landscape Painting and National Sentiment in Canada." *Historical Reflections* 1 (1974): 263–8

– *The Regenerators: Social Criticism in late Victorian English Canada.* Toronto: University of Toronto Press, 1985

Cook, E. Thomas. *The Life of John Ruskin.* London: G. Allen, 1912

Cooper, John A. "Canada's Progress in the Victorian Era." *Canadian Magazine* 9 (June 1897): 161–5

"Co-ordination between Mural Painting and Architectural Setting." *Architectural Record* 56 (August 1924): 191

Corbett, Barbara E. *A Century of Kindergarten Education in Ontario.* Mississauga, Ontario: Froebel Foundation, 1989

– "The Public School Kindergarten in Ontario, 1883–1967." PhD thesis, University of Toronto, 1968

Cortissoz, Royal. "Mural Decoration in America." *The Century Magazine* 51 (November 1895): 110–21

Cotton, Peter N. *Vice Regal Mansions of British Columbia.* Vancouver: Elgin Publications, 1981

Cowan, John. *John Innes: Painter of the Canadian West.* Vancouver: Rose, Cowan & Latta, 1945

Cox, Kenyon. "Some Phases of Nineteenth Century Painting. Part III: Mural Painting in France and America." *Art World* 2 (April 1917): 11–16

Craik, William A. "Boys Outnumber Girls at Rosedale Public School." *Toronto Star Weekly,* 17 March 1917, 11

Crawford, Alan. *By Hammer and Hand: The Arts and Crafts Movement in Birmingham.* Birmingham: Birmingham Museums and Art Gallery, 1984

Crinson, Mark. *Empire Building: Orientalism and Victorian Architecture.* London and New York: Routledge, 1996

Cronin, Ray. "Captain Vancouver by Charles Comfort: Four Native Perspectives (David Neel, Edward Poitras, Teresa Marshall, Joane Cardinal-Schubert." *Arts Atlantic* 15 (fall / winter 1997): 20–1

Crowninshield, Frederic. "Figure Painting Applied to Architecture." An address delivered to the Architectural League of New York, 5 November 1888. Copy in New York Public Library

– "Mural Painting." *American Architect and Builder* 19 (9 January 1886): 19–21

– *Mural Painting.* Boston: Ticknor and Company, 1887

Cruikshank, Tom. "Painted Parlours." *Canadian Country Home.* December 1986–January 1987: 26–45

Cubitt, James. *Church Designs for Congregations: Its Development and Possibilities.* London: Smith, Elder and Co., 1870

Curran, Kathleen. "The Romanesque Revival, Mural Painting and Protestant Patronage in America." *Art Bulletin* 81 (December 1999): 693–722

Cushing, Eileen. "They Sent to Italy." *Dalhousie Review* 36 (spring 1956): 65–8

Cutrer, Emily Fourmy. "Negotiating Nationalism, Representing Region: Art, History and Ideology at the Minnesota and Texas Capitols." In Patricia M. Burnham and Lucretia Hoover Giese, eds., *Redefining American History Painting.* Cambridge: Cambridge University Press, 1995

Darcel, Alfred. "Peintures de MM. H. Lévy et D. Maillart dans les galeries du *Bon Marché.*" *La chronique des arts de de la curiosité,* 27 March 1875, 105–6

Darley, Gillian. *Octavia Hill.* London: Constable Press, 1990

Darling, Sharon S. *Chicago Ceramics and Stained Glass.* Chicago: The Chicago Historical Society, 1979

Darroch, Lois. *Bright Land: A Warm Look at Arthur Lismer.* Toronto / Vancouver: Merritt Publishing, 1981

Dearness, John. *The Nature Study Course.* Toronto: Copp, Clark, 1905

"Decorative Paintings for the Manoir Richelieu." *Journal of the Royal Architectural Institute of Canada* 5 (June 1929): 208–9

Dempsey, Hugh A. *Indian Tribes of Alberta.* Calgary: Glenbow-Alberta Institute, 1978

Dendy, William. *Lost Toronto: Images of the City's Past.* 2nd ed. Toronto: McClelland & Stewart, 1993

Dendy, William, and William Kilbourn. *Toronto Observed: Its Architecture, Patrons, and History.* Toronto: Oxford University Press, 1986

Derome, Robert. "Charles Huot et la peinture d'histoire au Palais législatif de Québec (1833–1930)." *Bulletin of the National Gallery of Canada* 27 (1976): 2–44

Deshazo, Edith. *Everett Shinn, 1876–1953: A Figure in His Time.* New York: Clarkson N. Potter, 1974

Dewey, John. "Americanism and Localism." *The Dial* 68 (June 1920) 684–8

– *Art as Experience.* New York: Milton, Balch & Company, 1934

Diamonstein, Barbara. *The Landmarks of New York.* New York: Harry N. Abrams, 1988

Dickie, Donalda. *The Great Adventure: An Illustrated History of Canada for Young Canadians.* Toronto: J.M. Dent & Sons, 1950

Dickinson, John A., and Brian Young. *A Short History of Quebec.* 2nd ed. Toronto: Copp Clark Pitman, 1993

Dickman, Chris. *Toward a Union of the Arts.* Oshawa, Ontario: Durham Art Gallery, 1985

Donegan, Rosemary. *Industrial Images.* Hamilton: Art Gallery of Hamilton, 1987

– "Legitimate Modernism: Charles Comfort and the Toronto Stock Exchange," 51–67. In *Designing the Exchange: Essays Commemorating the Opening of the Design Exchange.* Toronto: Design Exchange, 1994

– "Mural Roots: Charles Comfort and the Toronto Stock Exchange." *Canadian Art* 4 (summer / June 1987): 64–9

Donovan, John. *School Architecture: Principles and Practices.* New York: Macmillan, 1921

Doucet, Danielle. "Art public moderne au Québec sous Maurice Duplessis." *Journal of Canadian Art History* 19 (1998): 32–73

Douglas, John Albert. *The Relations of the Anglican Churches with the Eastern-Orthodox, Especially in Regard to Anglican Orders.* London: Faith Press, 1921

Doxtater, Deborah. *Fluffs and Feathers: An Exhibit on the Symbols of Indianness. A Resource Guide.* Rev. ed. Brantford, Ontario: Woodland Cultural Centre, 1992

Doyle, Peter. *Westminster Cathedral, 1895–1995.* London and New York: Geoffrey Chapman, 1995

Dresslar, Fletcher B. *American Schoolhouses.* Washington, DC: US Bureau of Education, 1910

Driskel, Michael Paul. "An Introduction to the Art." In *The Art of the July Monarchy: France, 1830 to 1848,* 17–69. (Columbia: University of Missouri Press, 1990)

– *Representing Belief: Religion, Art and Society in Nineteenth-Century France.* University Park: Pennsylvania State University Press, 1992

Duffy, Dennis. "Cultural Nationalism and Spring Cleaning." *Canadian Forum* 58 (April 1976): 10–11

– *Gardens, Covenants, Exiles: Loyalism in the Literature of Upper Canada / Ontario.* Toronto: University of Toronto Press, 1982

Dunae, Patrick A. "Historical Significance of the Malaspina Hotel Murals," a report of c. 1997, copy in the files of the Vancouver Art Gallery

Duval, Paul. *The Tangled Garden.* Scarborough: Cerebrus / Prentice Hall, 1978

Dyer, Walter A. "The Modern Nursery." *Art World* 3 (November 1917): 156

Eastlake, Charles. *Hints on Household Taste in Furniture, Upholstery & Other Details.* New York: Dover, 1969. Reprint of the 1878 edition

Edgerton, Giles. "Modern Murals Done in the French Spirit of Decoration: Everett Shinn's Designs for the Wall Decorations of a Room in Mrs. William Coe's Home on Long Island." *Arts & Decoration* 22 (November 1924): 28–30

– "The Relation of Mural Decoration to the Vitality of a National Art." *The Craftsman* 14 (April 1908): 65–73

Efland, Arthur. "School Art and Its Social Origins." *Studies in Art Education* 24 (1983): 149–57

Evenard, Étienne. "L' art à l'école en Suède." *Art et décoration* 16 (October 1904): 125–27

Exhibition of Canadian West Coast Art. Toronto: Art Gallery of Toronto, January 1928

Fairbairn, Margaret, L. "The Art of George A. Reid." *Canadian Magazine* 22 (November 1903); 3–9

– "A Decade of Canadian Art." *Canadian Magazine* 17 (June 1901): 159–63

Falardeau, Jean-C. "Rôle et importance de l'Église au Canada français." Marcel Rioux and Yves Martine, dirs., *La Société canadienne française,* 349–61. Montreal: Hurtubise, 1971

Falvey, Diane. "The Case Study of the Low-Pressure Treatment of a Large-Scale Canvas Mural Painting, *The Settlement of Canada*, by Frederick S. Haines," 153–9. *Papers of the 8th Triennial Meeting of ICCROM.* Sydney, Australia, 1987

Farr, Dorothy M. *J.W. Beatty, 1869–1941.* Kingston: Agnes Etherington Art Centre, 1981

Femia, Joseph V. *Gramsci's Political Thought: Hegemony, Consciousness and the Revolutionary Process.* Oxford: Clarendon Press, 1981

Fenollosa, Ernest F. *Mural Painting in the Boston Public Library.* Boston: Curtis and Company, 1896

Fiddes, Victor. *The Architectural Requirements of Protestant Worship.* Toronto: Ryerson Press, 1961

"The Field of Art." *Scribner's Magazine* 20 (August 1896): 257–8

Fish, Stanley. *Is There a Text in This Class? The Authority of Interpretive Communities.* Cambridge, Massachusetts: Harvard University Press, 1980

Fisher, Luke. "Joyous Hymns of Light and Colour: Montrealer Guido Nincheri's Stained Glass and Frescoes Adorn Dozens of Churches." *Maclean's* 8 January 1996, 68–70

Folgarait, Leonard. *Mural Painting and Social Revolution in Mexico, 1920–1940: Art of the New Order.* Cambridge and New York: Cambridge University Press, 1998

Folliot, Frank. "Le décor des mairies." In *Le triomphe des mairies: Grands décors républicains à Paris.* Paris: Musée de Petit Palais, 1986

Foss, Brian, and Janice Anderson. *Quiet Harmony: The Art of Mary Hiester Reid.* Toronto: Art Gallery of Ontario, 2000

Foucart, Bruno. *Le renouveau de la peinture religieuse en France (1800–1860).* Paris, Arthéna, 1987

Four Challener Murals at the Winnipeg Art Gallery. Winnipeg: Winnipeg Art Gallery, 1973

Fowler, Frank. "The Outlook for Decorative Art in America." *Forum* 18 (1894): 686–93

Freedman, Margaret Mosinger. "William B. Ittner: The Man and His Work." Undergraduate research paper, May 1972. Copy in the archives of the St Louis Board of Education

Froebel, Friedrich. *The Mottoes and Commentaries of Friedrich Froebel's Mother-Play.* (Translated and edited by Susan E. Blow. New York: D. Appleton and Company, 1910

Froehlick, Hugo B., and Bonnie E. Snow. *Textbooks of Art Education, Book I.* New York: The Prang Educational Co., 1904

Galloway, Vincent. *The Oils and Murals of Sir Frank Brangwyn, R.A., 1867–1958.* Leigh-on-Sea, England: F. Lewis Publishers, 1962

Garrett, Rhoda and Agnes. *Suggestions for House Decoration.* New York: Garland, 1978. Reprint of 1877 edition

Garrison, Dee. *Apostles of Culture: The Public Librarian and American Society, 1876–1920.* New York: The Free Press, 1979

Garwood-Jones, Allison. "A Study of the Public Importance of the St. Anne's Anglican Church Mural Decoration Program." *Abstracts of the Universities' Art Association of Canada.* Victoria, British Columbia, 1992), np

Geddes, Patrick. "Political Economy and Fine Arts." *The Scottish Art Review* 2 (June–December 1889): 3–4

Gehmacher, Arlene. "'Authenticity' and the Rhetoric of Presentation." In *Ozias Leduc: An Art of Love and Reverie.* Montreal: Montreal Museum of Fine Arts, 1996

– "The Mythologization of Ozias Leduc, 1890–1954." PhD thesis, University of Toronto, 1995

Gibbons, Lillian. *Stories Houses Tell.* Winnipeg: Hyperion Press, 1979

Gilbert, Paul. *The Philosophy of Nationalism.* Boulder, Colorado: Westview Press, 1998

Gilder, Richard Watson. "The Kindergarten: An Uplifting Social Influence in the Home and the District." *Journal of the Proceedings and Addresses of the National Education Association* 41 (1903): 388–400

Giroux, Louise. "Le Château Dufresne." *Continuité* 38 (winter 1988): 12–15

Girtin, Thomas. *The Triple Crowns: A Narrative History of the Drapers' Company.* London: Hutchinson, 1964

Glazebrook, George Parkin de T. *A Short History of Canada.* Oxford: Clarendon Press, 1950

Goldstone, Harmon H., and M. Dalrymple. *History Preserved: A Guide to New York City Landmarks and Historic Districts.* New York: Simon & Schuster, 1974

Goodspeed, Rhona. "The Interior Decorative Programme of Saint-Léon-de-Westmount by Guido Nincheri, 4311 boulevard de Maisonneuve ouest, Montréal." *Agenda Papers of the Historic Sites and Monuments Board of Canada* 4 (1997): 117–40

Gowans, Alan. *Building Canada: An Architectural History of Canadian Life.* Toronto: Oxford University Press, 1966

Grant, Jean. "Studio and Gallery." *Toronto Saturday Night* 11 (16 April 1899);12 (16 January 1899; 13 May 1899): 9

Gray, Margaret, et al. *Charles Comfort.* Toronto: Gage Publishing, 1976

Green, Nicholas. "'All the Flowers of the Field': The State, Liberalism and Art in France under the Early Third Republic." *Oxford Art Journal* 10 (1987): 71–84

Greenaway, C. Roy. "Lawrence Skey's Bysantine [sic] Defiance: A Triumph of Toronto Artists." *Toronto Star Weekly,* 19 January 1924, 22

Greenaway, Cora. *Interior Decorative Painting in Nova Scotia.* Halifax: Art Gallery of Nova Scotia, 1986

Gregory, Daniel Seely. *Christian Ethics: The True Moral Manhood and Life of Duty.* Philadelphia: Eldredge and Brother, 1875

Grier, Katherine C. *Culture and Comfort: People, Parlors, and Upholstery, 1850–1930.* Rochester, New York: The Strong Museum, 1988

Gubbay, Aline, and Sally Hoof. *Montreal's Little Mountain: A Portrait of Westmount.* Montreal: Livres Trillium Books, 1979

Gwilt, Joseph. *An Encyclopaedia of Architecture: Historical, Theoretical and Practical.* 4th ed. London: Longmans, Green, 1872

Habermas, Jürgen. *The Structural Transformation of the Public Sphere: An Inquiry into a Category of Bourgeois Society.* Translated by T. Burger. Cambridge, Mass.: MIT Press, 1989. First published 1962

Hale, Katherine. "The Career of Arthur Crisp." *Saturday Night* 48 (13 May 1933): 3

Hamerton, Philip G. "Paris VIII: The Pantheon, the Invalides, and the Madeleine." *The Portfolio* 14 (1883): 147–52

Handbook of the New Library of Congress in Washington. Boston: Curtis & Cameron, 1901

Hapgood, Marilyn Oliver. *Wallpaper and the Artist: From Dürer to Warhol.* New York: Abbeville Press Publishers, 1992

"A Happy New Year for Art." *The Rebel* 4 (January 1920): 158

Harper, J. Russell. *Early Painters and Engravers of Canada.* Toronto: University of Toronto Press, 1970

– *Painting in Canada: A history.* Toronto: University of Toronto Press, 1st ed., 1966, 2nd ed., 1977. French edition: Les Presses de l'Université de Laval, 1966

Harriman, Susan S. "Some Social Aspects of the Kindergarten." *Minutes of the Proceedings of the Dominion Educational Association* (1892): 282–93

Harris, Cole. "The Myth of the Land," 27–43. In Peter Russell, ed. *Nationalism in Canada.* Toronto: McGraw-Hill Ryerson, 1966

Harris, Neil. "Cultural Institutions and American Modernization." *Journal of Library History* 16 (winter 1981): 28–47; reprinted in his *Cultural Excursions: Marketing Appetites and Cultural Tastes in Modern America,* 96–111. Chicago: University of Chicago Press, 1990

Harris, William L. "The Foreign Aspect of Mural Painting." *The Craftsman* 6 (September 1904): 527–40

Hart, Caroline C. "The Relationship of the Kindergarten to the Art." *Minutes of the Proceedings of the Dominion Educational Association,* 1892, 274–81

Haultain, Arnold. "A Search for an Ideal." *Canadian Magazine* 22 (March 1904): 427

Hay, Malcolm. "The Westminster Frescoes: The Restoration of the Victorian Murals." *Apollo* 135 (May 1992): 307–11

Heaman, E.A. *The Inglorious Arts of Peace: Exhibitions in Canadian Society during the Nineteenth Century.* Toronto: University of Toronto Press, 1999

Heitzman, Leslie S. "The Revival of Fresco Painting in Britain in the late 1840s: The Fine Arts Commission and the Houses of Parliament." MA report, Courtauld Institute of Art, London, 1993

Henry, Cynthia. *Remembering the Halifax Capitol Theatre, 1930–1974.* Halifax: Atlantic Black Book Publishing, 2000

Herbert, Eugenia. *The Artist and Social Reform: France and Belgium, 1885–1898.* Freeport, New York: Books for Libraries Press, 1961

Herbert, Robert L., ed. *Art Criticism of John Ruskin.* Gloucester, Massachusetts: P. Smith, 1969

"High Culture: Saving the Ceiling in the Salon Bleu." *Canadian Heritage,* May 1982, 22–4

Hill, Charles. *Canadian Painting in the Thirties.* Ottawa: National Gallery of Canada, 1975

– *The Group of Seven: Art for a Nation.* Ottawa: National Gallery of Canada, 1995

Hillman, Ida. "The Art of School Decoration." *The School* 1 (September 1912): 261–6

Hills, Patricia. *Turn-of-the-Century America.* New York: Whitney Museum of American Art, 1977

Hobson, John Atkinson. *John Ruskin: Social Reformer.* London, J. Nisbet, 1899

Hodgins, John George. *The School House: Its Architecture, External and Internal Arrangements.* Toronto: Copp, Clark, & Co., 1876

– *School Room Decoration.* Toronto: Warwick Brothers and Rutter, 1900

Hodgman, Alden. "The Walls of the Nursery." *Country Life in America* 12 (July 1907): 340–1

Hodkinson, Ian. *Arthur Lismer's Drawings for the Humberside Mural: Development of a Grandiose Patriotic Theme.* Kleinburg, Ontario: McMichael Canadian Collection of Art, 1992

Holden, Marion. "The Story of the Mind's Progress Told in Murals." *Arts and Decoration* 19 (October 1923): 18–19

Hopkins, J. Castell. *Progress of Canada in the Century.* London: W. & R. Chambers, and Philadelphia: The Bradley-Garretson Co., 1903

– *The Story of Our Country: A History for Four Hundred Years.* Toronto: J.C. Winston Co., 1912

Hopmans, Anita. "Delacroix's Decorations in the Palais Bourbon Library: A Classic Example of an Unacademic Approach." *Simiolus* 17 (1987): 240–69

"How We Decorated Our School, 1: Rosedale Public School." *The School* 1 (September 1912): 323–7

Howe, Samuel. "The Use of Ornament in the House." *The Craftsman* 3 (November 1902): 361–5

Howland, Bertha M. "The Importance of the Child's Room." *The House Beautiful* 44 (November 1918): 312–13, 341, 343

Howland, Oliver Aiken. "The Canadian Historical Exhibition, 1897." *Canadian Magazine* 7 (June 1896): 165–70

Hubbard, Clara Beeson. *Merry Songs and Games for the Use of the Kindergarten.* Cincinnati, Ohio: Robert Clarke & Co., and New York: J.W. Schirmerhorn, 1881

Hucker, Jacqueline. "Decorative Mural Painting of Castle Kilbride, 60 Snyder's Road, Baden, Ontario." *Agenda Papers of the Historic Sites and Monuments Board of Canada* 23 (1993): 1–17

– "St. Anne's Anglican Church, 270 Gladstone Avenue, Toronto, Ontario." *Agenda Papers of the Historic Sites and Monuments Board of Canada* 32 (1996): 98–116

Hughes, Ada Marean. "A Kindergarten Message to Mothers." *Journal of Proceedings and Addresses of the National Education Association* 37 (1898): 614–19

– "The Kindergarten as Related to the Nursery and School." *Canada School Journal* 2 (March 1878): 51–3

Hughes, James L. "Art as a Factor in Culture." *Journal of the Proceedings and Addresses of the National Education Association* 46 (1908): 803–8

– "The Triumph of the Kindergarten Philosophy." *Methodist Magazine and Review* 55 (February 1902): 117–24

Hunter, E. Robert. *J.E.H. MacDonald: A Biography and Catalogue of His Work.* Toronto: Ryerson Press, 1940

Hurdalek, Marta H. *The Hague School: Collecting in Canada at the Turn of the Century.* Toronto: Art Gallery of Ontario, 1983

Hurlburt, Laurance P. *The Mexican Muralists in the United States.* Albuquerque: University of New Mexico Press, 1989

Hutchinson, John, and Anthony D. Smith, eds. *Nationalism.* New York: Oxford University Press, 1994

d'Iberville-Moreau, Luc. "Le Château Dufresne et la conservation du jeune patrimoine." *Vie des Arts* 22 (1977), 12–15

– *Lost Montreal.* Toronto: Oxford University Press, 1975

Imbert, Daniel. "L'Hôtel de Ville de Paris." In *Le triomphe des mairies: Grands décors republicains à Paris, 1870–1914.* Paris: Musée de Petit Palais, 1986

In Pursuit of Beauty: Americans and the Aesthetic Movement. New York: Metropolitan Museum of Art, 1987

Ittner, William B. "School Buildings of St. Louis, Missouri: Part I." *American Architect and Builder* 106 (16 September 1914): 161–8, 171

– "St. Louis Public School Buildings." In Alfred D.F. Hamlin, ed., *Modern School Houses,* 36–45. New York: The Swetland Publishing Co., 1910

Jackson, Sidney L., et al. *A Century of Service: Librarianship in the United States and Canada.* Chicago: American Library Association, 1976

Jamieson, Jack. "The Canadian Interior." *Canadian Collector* (September / October 1975): 34–5

Jaycocks, T.G. "Murals in Sir Adam Beck Collegiate Cafeteria." *Saturday Night,* 16 November 1940, 2, 22

Johnson, Dana J. *Historic Schools in Canada,* volume 1: *The History of School Design in Canada before 1930: An Introduction;* volume 4: *"The Noblest Monument is the School": The Urban Public School in Canada before 1930;* volume 5: *Urban Schools in Canada to 1930.* Ottawa: Parks Canada, Historic Sites and Monuments Board of Canada, 1984

Johnson, Kathleen Eagen. "Frans Hals to Windmills: The Arts and Crafts Fascination with the Culture of the Low Countries." In Bert Denker, ed., *The Substance of Style: Perspectives on the American Arts and Crafts Movement,* 47–97. Winterthur, Delaware: Henry Francis du Pont Winterthur Museum, 1996

Jones, Hugh G., and Edmund Dyonnet. "History of the Royal Canadian Academy of Arts." Unpublished typescript, 1934. Copy available in the Metropolitan Toronto Reference Library

Jones, Ted. "The Case of the Missing Mural." *The Atlantic Advocate* 78 (June 1988): 10–13

Kalman, Harold. *Exploring Vancouver,* 2nd ed., volume 2. Vancouver: University of British Columbia Press, 1978

Kelly, Gemey. *Arthur Lismer: Nova Scotia, 1916–1919.* Halifax: Dalhousie Art Gallery, 1983

Kelly, Thomas. *History of Public Libraries in Great Britain, 1845–1975.* London: The Library Association, 1977

Kendall, Henry Edward. *Designs for Schools and Schoolhouses Parochial and National.* London: John Williams & Company, 1847

Kilpatrick, Thomas. "Things That Make a Nation." *Addresses Delivered before the Canadian Club of Toronto,* 51–2. Toronto: Warwick Brothers & Rutter, 1905

"Kindergarten at Winchester, Mass." *American Architect and Building News* 4 (October 1878): 132

"A Kindergarten Message to Mothers." *Journal of Proceedings and Addresses of the National Education Association* 37 (1898): 614–19

King, Pauline. *American Mural Painting.* Boston: Noyes, Platt & Company, 1902

Kirby, William. *U.E.: A Tale of Upper Canada.* Niagara, Ontario: Privately printed, 1859

Knobe, Bertha Damaris. "Beautifying the Public Schools." *The World's Work* 4 (June 1902): 2157–62

Knowles, Paul. *Castle Kilbride: The Jewel of Wilmot Township.* New Hamburg, Ontario: Commemorative Collectibles, 1994

"The Kyrle Society." The *Magazine of Art* 3 (1880): 210

Kysela, John D. "Mary Cassat's Mystery Mural and the World's Fair of 1893." *The Art Quarterly* 29 (1966): 129–40

La Chance, Walter. *Modern Schoolhouses.* Toronto: Briggs, 1919

Lacroix, Laurier. "Drawing, Colour, Composition: The Painter's Trinity." In *Ozias Leduc: An Art of Love and Reverie.* Montreal: Montreal Museum of Fine Arts, 1996

– "A Dream of a Garden of Beauty. " In *Ozias Leduc: An Art of Love and Reverie.* Montreal: Montreal Museum of Fine Arts, 1996

– "La décoration religieuse d'Ozias Leduc à l'évêché de Sherbrooke." MA thesis, Université de Montréal, 1973

– "La peinture murale dans les églises du Québec." *Sessions d'étude de la Société canadienne d'histoire de l'Église catholique* 47 (1980): 95–8

– "Puvis de Chavannes and Canada." *Journal of Canadian Art History* 4 / 1 (1977): 6–12

La Farge, John. "Puvis de Chavannes." *Scribner's Magazine* 28 (December 1900): 672–84

L'Allier, Pierre. *Henri Beau, 1863–1949.* Quebec: Musée de Québec, 1987

La Marche, Jacques. *Au coeur de la Petite-Nation: Le Château Montebello.* Ottawa: Les Éditions de la Petite-Nation, 1984

Lamb, Frederick S. "The Flower Memorial Library: A New Library and a New Departure." *The Craftsman* 7 (January 1905): 379–400

– "Lessons from the Expositions." *The Craftsman* 3 (October 1902): 49–58

Lambert, Garth R. *Dethroning Classics and Inventing English: Liberal Education and Culture in Nineteenth-Century Ontario.* Toronto: James Lorimer, 1995

Lampman, Archibald. *Poems.* 3rd ed. Toronto: Morang & Co., William Briggs, 1905

– *Lyrics of Earth.* Toronto: Musson Book Company, 1925

Lancaster, Joseph. *Hints and Directions for Building, Fitting Up, and Arranging School Rooms on the British System of Education.* London, 1809

Landry, Pierre B. *The MacCallum-Jackman Cottage Mural Paintings.* Ottawa: National Gallery of Canada, 1990

Lanken, Dane. *Montreal Movie Palaces: Great Theatres of the Golden Age, 1884–1938.* Waterloo, Ontario: Penumbra Press, 1993

Lawson, Harold. "The Log Chateau-Lucerne-in-Quebec." *Journal of the Royal Architectural Institute of Canada* 8 (January 1931): 13–22

Lawson, Maria. *History of Canada.* Toronto: W.J. Gage, 1906

Leacock, Stephen. *Arcadian Adventures with the Idle Rich.* Toronto: McClelland & Stewart, 1989. First published 1913

– *Canada: The Foundation of Its Future.* Montreal: Private publication, 1941

Lears, T. J. Jackson. *No Place of Grace: Antimodernism and the Transformation of American Culture, 1880–1920.* New York: Pantheon Books, 1981

de Leeus, Hendrik. *Crossroads of the Zuider Zee.* Philadelphia: J.B. Lippincott Co., 1938

The Legislative Library of Saskatchewan: A History. Regina: Saskatchewan Legislative Library, 1986

Le Moine, Roger. *Napoléon Bourassa: L'homme et l'artiste.* Ottawa: Éditions de l'Université d'Ottawa, 1974

Levin, Miriam. *Republican Art and Ideology in Late Nineteenth-Century France.* Ann Arbor, Michigan: UMI Research Press, 1986

Lewis, Arnold, et al. *The Opulent Interiors of the Gilded Age.* New York: Dover Publications, 1987

Liebschner, Joachim. *A Child's Work.* Cambridge, England: The Lutterworth Press, 1992

Likos, Patricia. "Violet Oakley." *Bulletin of the Philadelphia Museum of Art* 75 (June 1979): 1–32

Linsley, Robert. "Landscapes in Motion: Lawren Harris, Emily Carr and the Heterogenous Modern Nation." *Oxford Art Journal* 19 (1996): 80–95

Lismer, Arthur. "Canadian Art," *Addresses delivered before the Canadian Club of Toronto* (Toronto: Warwick Brothers & Rutter, 1926), 168–77

 "Canadian Art." *Canadian Theosophist* 5 (15 February 1925): 177–9

– "Mural Painting." *Journal of the Royal Architectural Institute of Canada* 10 (July 1933): 127–35

List of Reproductions of Works of Art. Educational Pamphlets, No. 5. Toronto: Department of Education, 1914

Litvak, Marilyn M. *Edward James Lennox: "Builder of Toronto."* Toronto: Dundurn Press, 1995

Llobera, Joseph R. *The God of Modernity: The Development of Nationalism in Western Europe.* Oxford: Berg, 1994

Lochman, Katherine A., et al., eds. *The Earthly Paradise: Arts and Crafts by William Morris and His Circle from Canadian Collections.* Toronto: Art Gallery of Ontario, 1993

Locke, George. "The Public Library." *Addresses Delivered to the Canadian Club.* Toronto: Warwick Brothers & Rutter, 1907

Lockhart, George L. *Public Schools.* St Paul, Minnesota: H.W. Kingston Company, 1918

Long, Helen C. *The Edwardian House: The Middle-Class Home in Britain, 1880–1914.* Manchester and New York: Manchester University Press, 1993

Lord, Barry. *Painting in Canada: Toward a People's Art.* Toronto: NC Press, 1974

Lord, Frances and Emily. *Mother's Songs, Games and Stories.* 2nd ed. London: W. Rice, 1888

Lovekin, Louis Anthony. "Three Epochs of History in Mural Tableau: Impressive Decorations on Ceiling of Quebec Legislative Chamber." *Saturday Night* 40 (7 February 1925): 5

Low, William H. "The Mural Paintings in the Pantheon and Hôtel de Ville of Paris." *Scribner's Magazine* 12 (December 1892): 661–77

– "National Art in a National Metropolis." *International Quarterly* 6 (September 1902): 113–15

– *A Painter's Progress.* New York: Charles Scribner's Sons, 1910

Lynn, Catherine. *Wallpaper in America: From the Seventeenth Century to World War I.* New York: W.W. Norton & Company, 1980

Mabie, Hamilton W. "The Free Kindergarten." *Harper's Monthly Magazine* 111 (October 1905): 649–57

MacAllister, Edith. *The Old Manse Library, Newcastle, New Brunswick: The Boyhood Home of Lord Beaverbrook.* Newcastle, New Brunswick: Newcastle Printing Co. 1980

MacCarthy, Fiona. *Stanley Spencer: An English Vision.* New Haven, Connecticut: Yale University Press, 1997

MacDonald, Jac. *Historic Edmonton.* Edmonton: The Edmonton Journal, 1987

– "Manor retains regal character. Our historic buildings: Holgate Mansion." *Edmonton Journal,* 18 January 1985, D1

MacDonald, James E.H. "The Choir Invisible," *Canadian Forum* 3 (January 1923): 111

– "City of Future Brilliant with Gold and Color." *Toronto Telegram,* 26 February 1929, 28

– "The Concourse Building, Toronto." *Construction* 22 (May 1929): 138–43

– "Interior Decorations of St. Anne's Church, Toronto," *Journal of the Royal Architectural Institute of Canada* 2 (May / June 1925): 89–94

MacLeod, Pegi Nichol. "Adventure in Murals." *Maritime Art* 2 (December 1941): 37–8

MacMullen, John Mercier. *The History of Canada from Its First Discovery to the Present Time.* Brockville: MacMullen & Co., 1868

MacPherson, Mary E. "Parkwood: The Estate of R.S. McLaughlin, Esq." *Canadian Homes and Gardens* 6 (May 1929): 29–30

MacRae, Marion. *Cornerstones of Order: Courthouses and Town Halls of Ontario.* Toronto: Clarke, Irwin, 1983

MacTavish, Newton. *The Fine Arts in Canada.* Toronto: Macmillan, 1925

Mahoney, Kathleen. *Gothic Style Architecture and Interiors from the Eighteenth Century to the Present.* New York: Harry N. Abrams, 1995

Mair, Charles. *Dreamland and Other Poems.* Montreal: Dawson Brothers, 1868

"Making the Schoolroom Attractive." *The Ladies' Home Journal* 27 (1 September 1910): 29

Malvern, Sue. "Memorizing the Great War: Stanley Spencer at Burghclere." *Art History* 23 (June 2000): 182–204

Mandel, Eli and David Taras. *A Passion for Identity: Introduction to Canadian Studies.* Toronto: Methuen, 1987

"Making the Schoolroom Attractive." *The Ladies Home Journal* 27 (1 September 1910): 29

Marlais, Michael. *Conservative Echoes in "Fin-de-Siècle" Parisian Art Criticism.* University Park: Pennsylvania State University Press, 1992

Marling, Karal Ann. *Wall-to-Wall America: A Cultural History of Post-Office Murals in the Great Depression.* Minneapolis: University of Minnesota Press, 1982

Marrinau, Michael. *Painting Politics for Louis-Philippe: Art and Ideology in Orléanist France, 1830–1848.* New Haven and London: Yale University Press, 1988

Martin, Lévis. *Ozias Leduc et son dernier grand oeuvre: La décoration de l'église Notre-Dame-de-la-Présentation de Shawinigan-Sud.* Montréal: Fides, 1996

Martyn, Lucy Booth. *Aristocratic Toronto: 19th Century Grandeur.* Toronto: Gage Publishing, 1980

– *Toronto: 100 Years of Grandeur.* Toronto: Pagurian Press, 1978

Masson, André. *The Pictorial Catalogue: Mural Decoration in Libraries.* Oxford: The Clarendon Press, 1981

Mastin, Catherine. "James Edward Hervey MacDonald and the St. Anne's Anglican Church Mural Decoration Program." MA thesis, York University, 1988

Mather, Frank Jr. *The American Spirit in Art.* New Haven, Connecticut: Yale University Press, 1927

Mathews, Robin. *Canadian Identity: Major Forces Shaping the Life of a People.* Ottawa: Steel Rail Press, 1988

Mathews, Thomas F. *The Early Churches of Constantinople: Architecture and Liturgy.* University Park: Pennsylvania State University Press, 1971

Mattie, Joan. "The Painted Decorative Programme of St. Jude's Anglican Church, Brantford – An Example of the Ecclesiastical Wall Paintings of the Browne Family in Ontario." *Agenda Paper of the Historic Sites and Monuments Board of Canada* 21 (1993): 643–59

Mauclair, Camille. *Albert Besnard, l'homme et l'oeuvre*. Paris: Librairie Delagrave, 1914

Maurault, Olivier. "Chronique d'art." *L'Action française* 4 (February 1920): 75–9

– "Tendances de l'art canadien." *L'Action française* 2 (August 1918): 369–73

Mavor, James. *Notes on the Objects of the Toronto Guild of Civic Art and on the Exhibition of Prints of Mural Paintings with Condensed Catalogue*. Toronto: Rowsell & Hutchison, 1898

Mayhew, Edgar, and Minor Myers. *A Documentary History of American Interiors from the Colonial Era to 1915*. New York: Charles Scribner's Sones, 1980

Mays, John Bentley. "Group of Seven Treasure Trove Saved." *Globe and Mail*, 5 April 1980, E: 11

McAleer, Philip. *A Pictorial History of the Basilica of St. Mary, Halifax, Nova Scotia*. Halifax: Tech Press, 1984

McArthur, Duncan. *History of Canada for High Schools*. Toronto: W.J. Gage, 1930

McDonald, Robert A.J. *Making Vancouver: Class, Status, and Social Boundaries, 1863–1913*. Vancouver: UBC Press, 1996

McDougall, Anne. "The Murals at the National Library: How They Got There, Why They Last." *National Library News* 25 (December 1993): 2–4

McFaddin, Charles. "The Murals of F.S. Challener." *Canadian Art* 20 (November / December, 1963): 340–4

McInnes, Graham C. "Mural – Romance of Nickel." *Saturday Night* 52 (10 July 1937): 6

McKay, Marylin. "Byzantium versus Modernity: St. Anne's Anglican Church, Toronto." *Journal of Canadian Art History* 18 (1997): 6–27

– "J.W. Beatty at Rosedale Public School." *Journal of Canadian Art History* 13 (1990): 53–60

– "Murals, Material Progress, Morality, and the 'Disappearance' of Native People." *Journal of Canadian Art History* 15 (1992): 63–83

McWilliam, Neil. *Dreams of Happiness: Social Art and the French Left, 1830–1850*. Princeton: Princeton University Press, 1993

Mechlin, Leila. "Mr. F.D. Millet's Decorations in the Baltimore Custom House." *Architectural Record* 24 (August 1908): 98–108

– "The Ships of All Ages in F.D. Millet's Mural Decorations in the Baltimore Custom House." *The Craftsman* 15 (January 1909): 426–35

Medland, Harvey. *Minerva's Diary: A History of Jarvis Collegiate*. Belleville, Ontario: Mika Press, 1979

Memorial Exhibition of Paintings by Mary Hiester Reid. Toronto: Art Gallery of Toronto, 1922

Méras, Mathieu. "Contribution à l'histoire de le Préfecture de Rhône." *Le rôle de Lyon dans les échanges artistiques entre l' Europe du nord et le monde méditerranéen: Architecture et décors à Lyon au XIXe siècle*. Vol. 6. Lyon: Travaux de l'Institut de l'Art de Lyon, 1980

Mérimée, Prosper. "De la peinture murale et de son emploi dans l'architecture moderne." *Revue générale de l'architecture et des travaux publics* 9 (1851): 258–78, 327–37

Merifield, Russell R. *Speaking of Canada: The Centennial History of the Canadian Clubs.* Toronto: McClelland & Stewart, 1993

Merrifield, Mrs M.P. *The Art of Fresco Painting as Practised by the Old Italian and Spanish Masters.* London: Charles Gilpin, 1846

Méthot, Gabrielle. "La commande du curé Sentenne pour la chapelle du Sacré-Coeur de l'église Notre-Dame de Montréal (1890–1895)." PhD thesis, Université de Montréal, 1986

Miall, Antony and Peter. *The Victorian Nursery Book.* London: Dent, 1980

Micillo, Sylvana Villata. *Guido Nincheri, maître verrier: Les vitreaux des églises montréalaises.* Montreal: Société de diffusions du patrimoine artistique et culturel des Italo-Canadiens, 1995

Miller, R. *Skyscrapers Hide the Heavens: A History of Indian-White Relations in Canada.* Toronto: University of Toronto Press, 1989

Miller, William H., Jr. *The Fabulous Interiors of the Great Ocean Liners in Historic Photographs.* New York: Dover Publications, 1985

Miner, Muriel Miller. *G.A. Reid: Canadian Artist.* Toronto: Ryerson Press, 1946

Minto, William. *Autobiographical Notes on the Life of William Bell Scott.* 2 vols. London: James R. Osgood, McIlvaine, 1892

Mitchell, Claudine. "Time and the Idea of Patriarchy in the Pastorals of Puvis de Chavannes." *Art History* 10 (June 1987): 188–202

Mitchell, George W. "Saviour of the Nordic Race." *Canadian Magazine* 61 (June 1923): 138–40

"Modern Mural Decorations." *Design* 35 (October 1933): 4

Monroe, William. "The Church and the Social Crisis." *The University Magazine* 8 (April 1909): 341–8

Moore, Sarah J. "In Search of an American Iconography." *Winterthur Portfolio* 25 (winter 1990): 231–9

Morisset, Gérard. *La peinture traditionnelle au Canada français.* Montreal: Cercle du livre du France, 1960

Moyer, Stanley. "Interpreting the Pioneers: A Study of the Dean of Canadian Artists, George Agnew Reid." *Canadian Magazine* 76 (August 1931): 17–18, 36

– "An Office Boy Who Studies Art." *Canadian Magazine* 74 (August 1930): 12–13, 46–8

"Mr. Brangwyn's Tempera Frieze at the New London Offices of the Grand Trunk Railway." *The Studio* 48 (October 1909): 31–6

"Mr. Herbert Draper's Painted Ceiling: For the Livery Hall of the Drapers' Company." *The Studio* 29 (June 1903): 33–40

"Mural Decoration." *The Magazine of Art* 3 (1880): 228–9

"The Mural Decorations at the New City Hall." *Toronto Saturday Night* 12 (20 May 1899): 6

The Mural Decorations of E.H. Blashfield. Williamstown, Massachusetts: Sterling and Francine Clark Art Institute, 1978

Mural Designs for Federal Buildings from the Section of Fine Arts Washington, D.C. Ottawa: The National Gallery of Canada, 1940

"Mural Painting." *Construction* 14 (January 1921): 18–19

Mural Painting in Great Britain, 1919–1939: An Exhibition of Photographs May 25th–June 30th 1939. London: The Tate Gallery, 1939

The Mural Paintings by Edward Laning in the New York Public Library. New York: The New York Public Library, 1961

Murphy, Terrance, and Roberto Perin. *A Concise History of Christianity in Canada.* Toronto: Oxford University Press, 1996

Murray, Richard. "H. Siddons Mowbray: Murals of the American Renaissance." In I.B. Jaffe, ed., *The Italian Presence in American Art, 1860–1920,* 106–20. New York: Fordham University Press, and Rome: Istituto Della Enciclopedia Italiana, 1992

– "Painted Words: Murals in the Library of Congress." In John Cole and Henry H. Reed, eds., *The Library of Congress: The Art and Architecture of the Jefferson Building,* 193–224. New York: Norton, 1997

"New Canadian Bank of Commerce Building, Toronto." *Journal of the Royal Architectural Institute of Canada* 8 (April 1931): 134–53

"The New Princess Theatre, Montreal." *Construction* 11 (February 1918): 69

Newall, Christopher. *The Art of Lord Leighton.* Oxford: Phaidon, 1990

Newman, Ella. "Schoolroom Decoration." *The School* 2 (February 1914): 372–4

Newman, Teresa, and Ray Wilkinson. *Ford Madox Brown and the Pre-Raphaelite Circle.* London: Chatto & Windus, 1991

Nida, William L. "Lighting of Schoolrooms." *Good Housekeeping* 51 (September 1910): 263–7

Noppen, Luc, and Gaston Deschênes. *Québec's Parliament Building: Witness to History.* Quebec: Direction générale de l'information, 1986

Noppen, Luc, and Lucie K. Morisset. *Art et architecture des églises à Québec.* Quebec: Les Publications du Québec, 1996

North, Nicholas. "Weasel Calf's Last Sun Dance." *Maclean's Magazine* 35 (1 July 1922): 23

"Nursery Wall Coverings in Indian Designs." *The Craftsman* 5 (October 1903): 95–9

Nursey, Walter. "The Trustee and the Children's Department." *Proceedings of the Ontario Library Association Meeting, Toronto, March 1913,* 89–93

O'Brien, Kevin H.F. "'The House Beautiful': A Reconstruction of Oscar Wilde's American Lecture." *Victorian Studies* 17 (June 1974): 395–418

O'Connor, Francis V. "The Murals by Constantino Brumidi for the United States Capitol Rotunda: An Iconographic Interpretation." In Irma B. Jaffe, ed., *The Italian Presence in American Art, 1860–1920,* 81–96. New York: Fordham University Press, and Rome: Istituto della Enciclopedia Italiana, 1992

Oman, Charles C., and Jean Hamilton. *Wallpapers: A History and Illustrated Catalogue of the Collection of the Victoria and Albert Museum.* London: Sotheby Publications, 1982

Once upon a Century: 100 Year History of the 'Ex.' Toronto: J.H. Robinson, 1978

O'Neill, Mora D. Guthrie. "A Partial History of the Royal Alexandra Theatre, Toronto, Canada, 1907–1939," 2 vols. PhD thesis, Louisiana State University and Agricultural and Mechanical College, 1976

Ontario Public School History of Canada. Toronto: Morang Educational Co., 1910

Orell, John. *Fallen Empires: The Late Theatres of Edmonton.* Edmonton: NeWest Publishing, 1981

Ormond, Richard. "Leighton and Mural Painting." *Apollo* 143 (February 1996): 50–5

– *Leighton's Frescoes in the Victoria and Albert Museum.* London: Victoria and Albert Museum, 1975

Orrinsmith, Lucy. *The Drawing-room: Its Decorations and Its Furniture.* London: Macmillan, 1878

Ortiz, Philippe. "School Room Decoration." *The School* 2 (December 1913): 211–16

Ostiguy, Jean-René. *Charles Huot.* Ottawa: National Gallery of Canada, 1979

– "The Paris Influence on Quebec Painters." *Canadian Collector* 13 (January/ February,1978): 50–4

Ottewill, David. "Robert Weir Schultz (1860–1951): An Arts and Crafts Architect." *ArchitecturalHistory* 22 (1979): 88–115

The Oxford Companian to Canadian Theatre. Toronto: Oxford University Press, 1989

Ozias Leduc: An Art of Love and Reverie. Montreal: Montreal Museum of Fine Arts, 1996

"Panels for Pickering College." *Canadian Forum* 7 (September 1927): 369

Park, Kip. *Historic Winnipeg.* City of Winnipeg, 1983

Parkhurst, Henry L. "A Plea for Stained Glass." *Municipal Affairs* 3 (1899): 694–701

Parke-Taylor, Michael. *Plans for Education: Selected Architectural Drawings, Toronto Board of Education.* Toronto: Toronto Board of Education, 1986

Parmalee, James G. "Canada's Participation in the World's Fair." *Canadian Geographical Journal* 19 (July 1939): 85–9

Patterson, Nancy-Lou. "The McWilliam House: A Wellington County Painted Hallway in Historic Context." *Wellington County History* 13 (2000): 5–13

– "The McWilliam House Hallway: A Painted Room in Drayton, Ontario." *Material History Bulletin* (fall 1987): 29–34

Paul, Gregory S. "The Art of Charles R. Knight." *Scientific American* 274 (June 1996): 86–93

Penman, Margaret. *A Century of Service: Toronto Public Libraries, 1883–1983.* Toronto: Toronto Public Library, 1983

Pepall, Rosalind. "Architect and Muralist: The Painter George Agnew Reid in Onteora, New York." *Canadian Collector* 19 (July/August 1984): 44–7

– "An Evaluation of the Interior Wall Paintings in the Houses at Numbers 1, 5, and 13 Prince William Street, Saint John, New Brunswick." *Agenda Papers of the Historic Sites and Monuments Board of Canada* 29 (1984): 499–529

– "The Murals by George A. Reid in the Toronto Municipal Buildings, 1897–1899." (MA thesis, Concordia University, 1982

– "The Murals in the Toronto Municipal Buildings: George Agnew Reid's Debt to Puvis de Chavannes." *Journal of Canadian Art History* 9 (1986): 142–61

– "Painted Illusions: Decorative Wall Painting in St. John, New Brunswick." *The Canadian Collector* (March / April 1985): 21–5

Pettipas, Katherine. *Severing the Ties That Bind: Government Repression of Indigenous Religious Ceremonies on the Prairies.* Winnipeg: University of Manitoba Press, 1994

Philibert, Helene, et al. *St. Matthew's of Washington, 1840–1940.* Baltimore: A. Hoen, 1940

Pierce, Lorne. *Fifty Years of Public Service: A Life of James L. Hughes.* Toronto: Oxford University Press, 1924

Pinard, Guy. *Montréal: Son Histoire, son Architecture.* Vol. 1: Montreal: Les Éditions la Presse, 1987; Vols. 5 and 6: Éditions du Méridien, 1992 and 1995

"Place of the Fairy Tale in the Child's Life." *Canadian Teacher* 25 (25 May 1921): 990

Pollock, Griselda. *Mary Cassatt.* London: Jupiter Books, 1980

Port, Michael H. *The Houses of Parliament.* New Haven, Connecticut: Yale University Press, 1976

– *Imperial London: Civil Government Building in London, 1851–1915.* New Haven, Connecticut: Yale University Press, 1995

Powers, Alan. "Diplomacy at Hand: Restoration of the Foreign Office." *Country Life* 186 (12 March 1992): 36–39

– "History in Paint: The Twentieth-Century Murals." *Apollo* 135 (May 1992): 317–21

Prentice, Alison, et al. *Canadian Women: A History.* Toronto: Harcourt Brace Jovanovich, 1988

Preston, Richard. "Regionalism and National Identity: Canada." In Mahendra Prasad Singh and Chandra Mohaw, eds., *Regionalism and National Identity,* 6-11. Christchurch, New Zealand: Association for Canadian Studies in Australia and New Zealand, 1985

Prévost-Marcilhacy, Pauline. "Le décor du buffet de la Gare de Lyon." In Karen Bower, ed., *Les grandes gares parisiennes au XIXe siècle,* 144–58. Paris: Délegation à l'Action Artistique de la Ville de Paris, nd

Price, Aimée Brown. *Pierre Puvis de Chavannes.* New York: Rizzoli, 1994

Price, William L. "Mural Painting in Relation to Architecture: The Importance of Establishing an Intimacy between the Two Arts." *The Craftsman* 16 (April 1909): 312

"Prince of Wales Hotel, Waterton Lake Alberta." *Construction* 21 (August 1928): 267–9

Proceedings of the Conference of Canadian-American Affairs, Queen's University, Kingston, Ontario, June 14–18. Montreal: Ginn and Company, 1937

"The Progressive Women of the West." *Woman's Century* 5 (April 1918): 22–4

Promey, Sarah M. *Painting Religion in Public: John Singer Sargent's Truncated "Triumph of Religion" at the Boston Public Library.* Princeton: Princeton University Press, 1999

– "Sargent's Truncated *Triumph*: Art and Religion at the Boston Public Library, 1890–1925." *Art Bulletin* 79 (June 1997): 212–50

"Public Art in American Cities." *Municipal Affairs* 2 (March 1898): 3–13

"Public School Art Societies." *The Chautauquan* 38 (October 1903): 169–72

Quand Paris dansait avec Marianne, 1879–1889. Paris: Musée du Petit Palais, 1989

"Quiller." "Mural Painting in Toronto." *Toronto Saturday Night* 14 (17 August 1907): 6

Radford, John. "The Secret of Success in Art." *Vancouver Sun,* 28 May 1938, 20

Rankin, Emily. "Art in Canadian Schools: What It Is and What It Might Be." *Proceedings of the Dominion Educational Association* (1904): 271–4

Reese, Cara. "St. Louis School Buildings: A Searching Study of Their Defects." *Good Housekeeping* 50 (April 1910): 485–93

Reid, Dennis. *A Concise History of Canadian Painting.* Toronto: Oxford University Press, 1st ed., 1973, 2nd ed., 1988

Reid, George A. *Descriptive Note of the Mural Decorations in the Earlscourt Library Painted by G.A. Reid, R.C.A., under the Auspices of the Royal Canadian Academy of Arts.* A single-page circular distributed by the Public Library Board of the City of Toronto, c. 1926. Copy available in the Baldwin Room of the Metropolitan Toronto Reference Library

– "Mural Decoration." *The Canadian Architect and Builder* 11 (January 1898): 12–15

– "Mural Decoration." *Canadian Magazine* 10 (April 1898): 501–8

– "School Decoration and Picture Study." *The School* 2 (April 1914): 479–82

Reid, George A., and Lorna Claire. *Descriptive Notes of Mural Decoration in Jarvis Collegiate Institute Auditorium, Toronto.* Toronto: Private publication, 1930. Copy available in the library of the Art Gallery of Toronto

Rémillard, François. *Mansions of the Golden Square Mile: Montreal, 1850–1930.* Montreal: Méridian Press, 1987

Rey, Raymond. "L'Art mural et l'état." *L'art et les artistes* 36 (March 1938): 193–8

Rice, David Talbot. *Appreciation of Byzantine Art.* London: Oxford University Press, 1972

Ridley, Hilda M. "Canada's First Woman Inspector." *Canadian Magazine* 62 (November 1923): 47–52

Robertson, David. *Sir Charles Eastlake and the Victorian Art World.* Princeton: Princeton University Press, 1978

Robertson, Heather. *Driving Force: The McLaughlin Family and the Age of the Car.* Toronto: McClelland & Stewart, 1995

Robson, Edward. *School Architecture.* London: John Murray, 1874. Reprinted Leicester: Leicester University Press, Victoria Library Edition, 1972

Rolfe, Christopher. "A British Artist and the Romance of Canada's Railways." *British Journal of Canadian Studies* 8 (1993): 42–52

The Rosedale League of School Art. Toronto: Private publication, 1911. Copy available in Robarts Library, University of Toronto

"Royal Canadian Academy of Arts, Mural Competition." *Journal of the Royal Architectural Institute of Architecture* 3 (September–October 1926): 182–3

Rumilly, Robert. *Histoire de la Société Saint-Jean-Baptiste de Montréal.* Montreal: Les Éditions de l'Aurore, 1975

Ruskin, John. *The Crown of Wild Olive.* New York: A.L. Burt, 1890

[–] *The Lamp of Beauty: Writings on Art by John Ruskin.* Edited by Joan Evans. London: Phaidon Press, 1959

– *Time and Tide.* London: George Allen, 1901

Russell, Hilary. *All That Glitters: A Memorial to Ottawa's Capitol Theatre and Its Predecessors*. Ottawa: Department of Indian and Northern Affairs, 1989

Russell, Peter, ed. *Nationalism in Canada*. Toronto: McGraw-Hill, 1966

Rutherford, Paul. *A Victorian Authority: The Daily Press in Late Nineteenth-Century Canada*. Toronto: University of Toronto Press, 1982

Rutter, Frank. *The British Empire Panels Designed for the House of Lords by Frank Brangwyn, R.A.* Essex: F. Lewis Publishers, 1932

Rydell, Robert W. *All the World's a Fair: Visions of Empire at American International Expositions, 1876–1916*. Chicago: University of Chicago Press, 1984

Said, Edward. *Culture and Imperialism*. New York: Random House, 1993

Salmon, David. *Infant School: Their History and Theory*. London: Longmans, Green and Co., 1904

Salvatore, Filippo. *Fascism and the Italians of Montreal: An Oral History, 1922–1945*. Toronto: Guernica Editions, 1998

Sargent, Irene. "Art in the Home and in the School." *The Craftsman* 7 (December 1904): 263–79

– "Art in the Home and in the School: A Lesson from Boutet de Monvel." *The Craftsman* 7 (January 1905): 400–11

– "Art in the Home and in the School: A Selection from the Child-Types of Kate Greenaway." *The Craftsman* 7 (February 1905): 519–29

– "Art in the Home and in the School: Examples of Mural Decoration Based upon Dutch Types and Scenes." *The Craftsman* 8 (April 1905): 55–64

– "Comments upon Mr. Shean's 'Mural Painting from the American Point of View.'" *The Craftsman* 7 (October 1904): 28–34

– "The Mural Paintings by Robert Reid in the Massachusetts State House." *The Craftsman* 7 (March 1905): 699–712

– "The Ray Memorial Library, at Franklin, Massachusetts." *The Craftsman* 8 (April 1905): 14–42

The Saskatchewan Association of Architects. *Historic Architecture of Saskatchewan*. Saskatoon: Focus Publishing, 1987

Saunders, Ann. *The Royal Exchange*. London: Guardian Royal Exchange, 1991

"School Architecture." *Canadian Architect and Builder* 3 (October 1890): 111

School Art Leagues. Toronto: Education Department of Ontario, Warwick Bros. & Rutter, 1899

Scott, Charles H. "Art in British Columbia." *Canadian Forum* 12 (July 1932): 382–8

Scott, Duncan. "Ford Madox Brown and the Manchester Town Hall Murals: An Account of a Civic Commission." (MA report, University College, London, 1975

Scott, Louise. "Elevating Environments: Reflections of an Ideal Order in French Mural Decoration, 1830–1860." PhD thesis, University of Wisconsin-Madison, 1989

Scudder, H.E. "Nursery Classics in School. *The Atlantic Monthly* 59 (June 1887): 800–3

Seale, William. *The Tasteful Interlude: American Interiors through the Camera's Eye, 1860–1917*. New York: Praeger, 1975

Segger, Martin. *The British Columbia Parliament Buildings.* Arcon: Vancouver, 1979

Segger, Martin, and Douglas Franklin. *Victoria: A Primer for Regional History in Architecture.* Watkin Glen, New York: The American Life Foundation and Study Institute, 1979

Service, Alistair, "Charles Harrison Townsend." In Service et al., eds., *Edwardian Architecture and Its Origins, 162–82.* London: The Architectural Press, 1975

– *Edwardian Architecture: A Handbook to Building Design in Britain, 1890–1914.* New York and Toronto: Oxford University Press, 1977

– *London, 1900.* London: Granada Publishing, 1979

Service, Alistair, et al. *Edwardian Architecture and Its Origins.* London: The Architectural Press, 1975

Shaw, Jennifer L. "Imagining the Motherland: Puvis de Chavannes, Modernism and the Fantasy of France." *Art Bulletin* 77 (December 1997): 586–610

Shapiro, Michael S. *Child's Garden: The Kindergarten Movement from Froebel to Dewey.* University Park: Pennsylvania State University Press, 1983

Shean, Charles M. "The Decoration of Public Buildings." *Municipal Affairs* 5 (September 1901): 711–20

– "Mural Painting from the American Point of View." *The Craftsman* 7 (October 1904): 18–27

Sherwood, William Albert. "The Influence of the French School upon Recent Art." *Canadian Magazine* 1 (October 1893): 64–8

– "A National Spirit in Art." *Canadian Magazine* 2 (October 1894): 495–500

Shopsin, William C., et al. *The Villard Houses: Life Story of a Landmark.* New York: Viking Press, 1980

Shtychno, Alexandra. "Luigi Giovanni Vitale Capello, aka, Cappello (1843–1902): Intinerant Piedmontese Artist of Late Nineteenth-Century Quebec." MA thesis, Concordia University, 1991

Silcox, Sidney. "The Psychology of Nature Study." *Minutes of the Proceedings of the Dominion Educational Association,* 1901, 335–50

Silverman, Debora. *Art Nouveau in Fin-de-Siècle France: Politics, Psychology, Style.* Berkeley: University of California Press, 1989

Sinaiticus. "Canadian National Exhibition." *Construction* 21 (October 1928): 327–34

– "ROM Toronto," *Construction* 25 (November 1932): 249–52

Sisler, Rebecca. *Art for Enlightenment: A History of Art in Toronto Schools.* Toronto: Fitzhenry & Whiteside, 1993

Skey, Lawrence. "Anniversary Sunday." *St. Anne's Parish Magazine,* October 1921, 1

– "The Re-opening and Diamond Jubilee of St. Anne's." *St. Anne's Parish Magazine,* December 1923, 1

Small, Herbert. *Handbook of the New Public Library in Boston.* Boston: Curtis and Company, 1895

– *The Holy Grail: An Explanation of the Meaning of the Series of Panels Composing Edwin A. Abbey's Frieze Decoration in the Boston Public Library.* Boston: Curtis & Company, 1910

– *The Library of Congress: Its Architecture and Decoration.* Boston: Curtis & Cameron, 1897

Smith, Anthony D. *Theories of Nationalism.* New York: Holmes & Meier Publishers, 1983

Smith, Helen. *Decorative Painting in the Domestic Interior in England and Wales* c. *1850–1890.* New York and London: Garland Publishing, 1984

Smith, H.M. Scott. *The Historic Churches of Prince Edward Island.* Erin, Ontario: Boston Mills Press, 1986

Snider, Denton J. *Froebel's Mother-Play Songs: A Commentary,* Chicago: Sigma Publishing Company, 1895

Souvenir of a Visit to the Bon Marché. Paris: Bon Marché, nd

Spencer, Arthur. "The Relation of the Arts and Crafts to Progress." *The Craftsman* 6 (June 1904): 228–33

Sproll, Paul A.C. "Matters of Taste and Matters of Commerce: British Government in Art Education in 1835," *Studies in Art Education* 35 (winter 1994): 105–13

St. Anne's Church, 1862–1987. Toronto: Private publication, 1987

St. Anne's Church, Toronto: Fiftieth Anniversary and Jubilee, 1862–1912. (Toronto: Carleton Press, 1912

St. Anne's Parish Magazine. St. Anne's Anglican Church, Toronto

Stacey, Robert. *C.W. Jefferys.* Ottawa: National Gallery of Canada, 1985

– "Harmonizing 'Means and Purposes': The Influence of Morris, Ruskin and Crane on J.E.H. MacDonald." In David Latham, ed., *Scarlet Hunters: Pre-Raphaelitism in Canada,* 92–128. Toronto: Archives of Canadian Art and Design, 1998

– *J.E.H. MacDonald: Designer.* Ottawa: Archives of Canadian Art, 1996

"Stained Glass for Home Decoration." *House Beautiful* 54 (November 1923): 478–9, 524, 526

Stamp, Gavin. "The Nation's Drawing-Room: Restoring the Foreign Office." *Apollo* 136 (July 1992): 23–9

Steegman, John. "Lord Lindsay's History of Christian Art." *Journal of the Warburg and Courtauld Institute* 10 (1947): 123–31

Stein, Roger B. *John Ruskin and Aesthetic Thought in America, 1840–1900.* Cambridge: Harvard University Press, 1967

Stewart, Sarah A. "Changes in Kindergarten Play and Games." *Journal of Proceedings and Addresses of the National Education Association* 32 (1893): 330–1

Stirling, J. Craig: *Ozias Leduc et la décoration interieure de l'église de Sainte-Hilaire.* Quebec: Ministry of Cultural Affairs 1970

Stott, Annette. *Holland Mania: The Unknown Dutch Period in American Art & Culture.* Woodstock, New York: The Overlook Press, 1998

Strong-Boag, Veronica. *The New Day Recalled: Lives of Girls and Women in English Canada, 1919–1939.* Toronto: Copp Clark Pitman, 1988

The Studio Year-Book of Decorative Art. London, Paris, New York: Offices of *The Studio,* 1906

"Studio and Gallery." *Toronto Saturday Night* 10 (3 April 1897): 15

Study, Guy. "Junior and Senior High Schools." *Architectural Record* 60 (September 1926): 202–24

– "The Work of William B. Ittner, FAIA." *The Architectural Record* 57 (February 1925): 97–124

Sturgis, Russell. "Mural Painting." *The Forum* 37 (January 1906): 367–84

– "Painting." *The Forum* 34 (January–March 1903): 403–23

Stychno, Alexandra. "Luigi Giovanni Capello, a.k.a. Capello (1843–1902): Itinerant Piedmontese Artists of the Late Nineteenth-Century." MA thesis, Concordia University, 1991

Sund, Judy. "Columbus and Columbia in Chicago, 1893: Man of Genius Meets Generic Woman." *Art Bulletin* 74 (September 1993): 444–66

Sweatman, Arthur. "St. Anne's Church." *Canadian Churchman* 8 (8 October 1908): 649

Syllabus of Studies and Regulations for the Normal Schools at Hamilton, London, Ottawa, Peterborough, Stratford and Toronto, 1908–1909. Toronto: King's Printer, 1908

Tachau, Nina. "A Child's Room." *Art World* 3 (December 1917): 258–60

Tatar, Maria. *Off with Their Heads: Fairytales and the Culture of Childhood.* Princeton: Princeton University Press, 1992

Taylor, Andrew Thomas. "Some Notes on the Relation and Application of the Sister Arts, Painting, Sculpture, to Architecture." *Canadian Architect and Builder* 5 (November 1892): 112–13

Taylor, Nicholas. "Byzantium in Brighton." In Alistair Service et al., eds., *Edwardian Architecture.* London: The Architectural Press, 1975

Thierry, Solange. "Plaisir et fête à l'Hôtel de Ville: Le salon Chéret." *L'Oeil* 420–1 (July / August 1990): 40–5

The Thomas Foster Memorial. Uxbridge, Ontario: Scott Historical Society, 1986

Thomas, Stephanie. "Frederick William Hutchison, 1871–1953." MFA thesis, Concordia University, 1982

Thomas, William Cave. *Mural or Monumental Decoration: Its Aims and Methods.* London: Winsor and Newton, 1869

Thornton, Peter. *Authentic Décor: The Domestic Interior, 1620–1920.* New York: Viking Press, 1984

Toker, Franklin. *The Church of Notre-Dame in Montreal.* Toronto and London: McGill-Queen's University Press, 1970

Toplis, Ian. *The Foreign Office: An Architectural History.* London and New York: Mansell Publishing, 1987

Traquair, Ramsay. *Art and Life: The Influence of the Classics,* Montreal: McGill University Publications, series 12, no. 6, 1921

– "Mural Decoration." *Journal of the Royal Architectural Society of Canada* 3 (September / October 1926): 183–4

– "The Royal Canadian Academy." *Canadian Forum* 1 (December 1920): 84

– "Women and Civilization." *The Atlantic Monthly* 132 (September 1923): 289–96

Trask, John. "The Influence of World's Fairs on the Development of Art." *Art and Progress* 6 (February 1915): 113–17

Le triomphe des mairies: Grands décors républicains à Paris, 1870–1914. Paris: Musée de Petit Palais, 1986

Trofimenkoff, Susan Mann. *The Dream of a Nation: A Social and Intellectual History of Quebec.* Toronto: Gage Educational, 1983

Troy, Nancy. "Le Corbusier, Nationalism and the Decorative Arts in France, 1910–1918." In Richard Etlin, ed., *Nationalism in the Visual Arts,* 65–88. Washington: National Gallery of Art, 1991

Tuck, Robert C. *Gothic Dreams: The Life and Times of a Canadian Architect, William Critchlow Harris, 1854–1913.* Toronto: Dundurn Press, 1978

Turner, Frederick Jackson. *The Frontier in American History.* New York: Henry Holt and Company, 1920

Underhill, Frank. *The Image of Confederation.* Toronto: Canadian Broadcasting Corporation, 1964

"Unique Decorative Feat: A Geographical Picture by the Noted Canadian Artist Cory Kilvert." *Saturday Night* 4 (17 July 1926): 5

Vaisse, Pierre. "La machine officielle: Regard sur les murailles des édifices publics." *Romantisme* 41 (1983): 19–40

– *La Troisième République et les peintres.* Paris: Flammarion, 1995

Van Brunt, Henry. "The New Dispensation of Monumental Art." *Atlantic Monthly* 43 (May 1879): 633–41

Vancouver: Art and Artists, 1931–1983. Vancouver: Vancouver Art Gallery, 1983

Vanderbilt, Kermit. *Charles Eliot Norton: Apostle of Culture in a Democracy.* Cambridge, Massachusetts: Belknap Press, 1959

Van Hook, Bailey. "From the Lyrical to the Epic. Images of Women in American Murals." *Winterthur Portfolio* 26 (spring 1991): 63–80

Van Rensselaer, Marianne G. "The Twelfth League Exhibition." *American Architect and Building News* 55 (20 March 1897): 94

Van Zanten, David. *Designing Paris: The Architecture of Duban, Labrouste, Duc, and Vaudoyer.* Cambridge, Massachusetts: MIT Press, 1987

Vaughan, Walter. *Sir William Van Horne.* London and Toronto: Oxford University Press, 1926

Vaughan, William. "A 'Better Prospect'? The First Mural Scheme for the New Palace." *Apollo* 135 (May 1992): 312–16

Vézina, Raymond. *Napoléon Bourassa (1827–1916): Introduction à l'étude de son art.* Montreal: éditions élysées, 1976

Vian, Louis-René. *Arts décoratifs à bord des paquebots français, 1880/1960.* Paris: Éditions Fonmare conseil, 1992

Villata Micillo, Sylvana. *Guido Nincheri, maître verrier: Les vitreaux des églises montréalaises.* Montreal: Société de diffusion du patrimoine artistique et culturel des Italo-Canadiens, 1995

Viollet-le-Duc, Eugène E. *Entretiens sur l'architecture.* Vols. 1 and 2. Paris: Morel, 1863–72

Vitry, Paul. "L'art et l'école." *Arts et décoration* 16 (July 1904): 51–6

von Arx, Jeffrey. *Varieties of Ultramontanism.* Washington, DC: The Catholic University of America Press, 1998

Wagner, Rosemary. "Mount Forest House Paintings Reveal Early Cultural Heritage." *Wellington County History* 13 (2000): 15–20

Walden, Keith. *Becoming Modern in Toronto: The Industrial Exhibition and the Shaping of a Late Victorian Culture.* Toronto: University of Toronto Press, 1997

Walker, Byron Edmund. "Guild of Civic Art." *Globe,* 13 April 1898, 12

Walker, Jean. "The Ethical Side of Art." *The School* 7 (January 1919): 306–8

Walter, Elisabeth. "Le Décor." *Monuments Historique* 6 (1978): 35–44

– "Le décor de quelques établissements thermaux et casinos de 1850 à 1930." *Monuments historiques* 1 (1978): 65–83

Walton, Paul. "The Group of Seven and Northern Development." *RACAR* 14 (1990): 171–9

Waters, Bill. "Painter and Patron: The Palace Green Murals." *Apollo* 102 (November 1975): 338–41

Waters, Erie. "The Home of the Gondolier." *The Canadian Magazine* 27 (September 1906): 387–91

Watson, Robert. "Canada's Earliest Transport." *The Canadian Magazine* 76 (July 1931): 16, 37

Watt, Robert D. *Rainbows in Our Walls: Art and Stained Glass in Vancouver, 1890–1940.* Vancouver: Vancouver Centennial Museum, 1980

Webster, Sally B. "The Albany Murals of William Morris Hunt." PhD thesis, City University of New York, 1980

– *William Morris Hunt, 1824–1879.* New York: Cambridge University Press, 1991

Weintraub, Jeff. "The Theory and Politics of the Public/Private Distinction." In Jeff Weintraub and Krishan Kumar, eds., *Public and Private in Thought and Practice. Perspectives on a Grand Dichotomy,* 1–42. Chicago: University of Chicago Press, 1997

Weisberg, Gabriel. "Albert Besnard at Berck-sur-mer: Decorative Art Nouveau Painting in Public Buildings." *Apollo* 151 (May 2000): 52–7

Welburn, Lynn. "Romancing the Murals." *Harbour City Star,* 23 January 1997, 1, 9, 74

"West Coast Indian Art." *The Canadian Forum* 8 (February 1928): 525

Westfall, William. *Two Worlds: The Protestant Culture of Nineteenth-Century Ontario.* Montreal and Kingston: McGill-Queen's University Press, 1989

Wheelwright, Edmund March. *School Architecture.* Boston: Roger & Manson, 1901

White, Colin. *The World of the Nursery.* New York: E.P. Dutton, 1984

White, Gleeson. "The Work of Heywood Summer, I. Sgraffito Decorations." *The Studio* 13 (April 1898): 153–63

White, Hayden V. *Metahistory: The Historical Imagination in Nineteenth-Century Europe.* Baltimore: Johns Hopkins University Press, 1973

White, James. *Protestant Worship and Church Architecture: Theological and Historical Considerations.* New York: Oxford University Press, 1964

Wiggins, Kate Douglas. "The Relationship of the Kindergarten to Social Reform." In Wiggins, ed., *The Kindergarten,* 3–27. New York: Harper & Brothers Publishers, 1893

Williams, Raymond. *Culture and Society, 1780–1950.* New York: Columbia Press, 1983

– "The Library's Relation to the Community." In David Gerard, ed., *Libraries in Society: A Reader,* 70–7. London: Clive Bingley, Publishers, 1978

Williams, Rosalind H. *Dream Worlds: Mass Consumption in Late Nineteenth-Century France.* Berkeley: University of California Press, 1982

Willsdon, Clare. "Aspects of Mural Painting in London, 1890–1930." MA thesis, Cambridge University, 1988

Wilson, Susannah J. *Women, Families & Work.* Toronto: McGraw-Hill Ryerson, 1996

Wilson, William H. *The City Beautiful Movement.* Baltimore: Johns Hopkins University Press, 1989

Winkler, Gail Caskey, and Roger W. Moss. *Victorian Interior Decoration.* New York: H. Holt, 1992

Winter, Ezra. "Mural Decorations for the Cunard Building." *Architectural Forum* 35 (July 1921): 9–16

Winters, Barbara, review of Lévis Martin's *Ozias Leduc et son dernier grand oeuvre* in *Journal of Canadian Art History* 19 (1998): 84–91

Wirgoden, Geoffrey. *The Story of the Synagogue.* Jerusalem: The Domino Press, 1986

de Wit, Wim, ed. *Louis Sullivan: The Function of Ornament.* New York and London: W.W. Norton, 1986

Wodson, W.H. "The Story Hour." *Proceedings of the Ontario Library Association. Annual Meeting, March 1913,* 87–100

de Wolfe, Elsie. *The House in Good Taste.* New York: Century Co., 1913

Wood, B. Anne. "The Hidden Curriculum of Ontario School Art, 1904–1940." *Ontario History* 78 (December 1986): 351–2

Woodward, Calvin M. "A New Era in the Public Schools of St. Louis." *The School Review* 11 (June 1903): 486–94

Works of Art in the House of Lords. London: Her Majesty's Stationery Office, 1980

Yeigh, Frank. *Ontario's Parliament Buildings: A Historical Sketch.* Toronto: Williamson Book Company, 1893

"Your Own Home, Number Seven: The Modern Nursery." *The Craftsman* 28 (June 1915): 263–72

Young, David A. "The Dome of the Rotunda." *Rotunda,* spring 1983, 2–3

Zemans, Joyce. "Establishing the Canon: Nationhood, Identity, and the National Gallery's First Reproduction Programme of Canadian Art." *Journal of Canadian Art History* 16 (1995): 6–36

– *Jock Macdonald: The Inner Landscape.* Toronto: Art Gallery of Ontario, 1981

INDEX

Abbey, Edwin Austin: murals for Boston
 Public Library, 57, 162
Abell, Walter, 204
Alexander, John White: murals for
 Carnegie Institute, Pittsburgh, 59
All Saints' Church, London, England:
 murals by William Dyce, 79
Allan, Sir Hugh: murals for Montreal
 home of, 116
Almini, Peter H.: murals for Windsor
 Hotel, Montreal, 69, fig. 16
American mural painting: civic, 25, 26,
 55–9, 161; 26, 55–9, 161; commercial, 62,
 65–6; domestic, 113; general discussion,
 20, 21, 22; of the 1930s; religious, 79
Antigonish, NS: St Ninian's Cathedral, 67
antimodernism, 111
Appleyard, Frederick: murals for Royal
 Academy, London, England, 65
Arcadia: general discussion, 41–5, 132,
 164–5; representation in American
 murals, 66, 164; in Canadian murals,
 120, 122, 124–5, 126–7, 132–3, 164
Arnold, Matthew, 88, 129
Arts and Crafts Movement, 81, 86, 111, 131
Ashnola house, Victoria, BC: murals in, 121
Atkinson, J. Beaver, 110
Austin, J.W.: murals in Winnipeg home
 of, 121
Aylmer, Ontario: murals in Town Hall, 39

Baden, Ont.: murals in Castle Kilbride, 118
Baldry, A. Lys, 16, 22, 54

Barbeau, Marius, 142
Barthes, Roland, 61
Baudelaire, Charles, 18
Baudrillard, Jean, 61
Beatty, John W.: in England, 25; on
 mural style, 50; murals at Mississauga
 Golf Club, 125, 139, 141, figs. 42, 43;
 murals at Rosedale School, 45, 180–1,
 fig. 57, plate 3
Beau, Henri: mural for Palais législatif,
 Quebec, 36–7, 74, 102, plate 2
Beaverbrook, Lord: murals in Newcastle,
 NB, home, 115
Bedford, NS: murals for a restaurant in,
 67, fig. 14
Belleville, Ont.: domestic mural, 120
Belmont Theatre, Montreal: murals in,
 68, fig. 15
Bénédite, Léonce, 21
Benton, Thomas Hart: murals for New
 School for Social Research, New York,
 201, 202
Besnard, Albert: mural for Sorbonne, 51;
 as muralist, 37; murals by, 37
Bibliiothèque municipale, Rouen: murals
 in, 161, 162
Bibliothèque nationale, Paris: murals in,
 161
Bibliothèque Ste Geneviève, Paris:
 murals in, 161
Biéler, André, 202: murals for the
 Shipshaw Power House, Quebec, 199
Birmingham, England, School of Art, 54

Birnie, Elizabeth Annie: murals for Penetang and Collingwood, Ont., libraries, 25, 43, 159, 163

Blashfield, Edwin: 22; murals for Detroit Public Library, 162, 163, 172; as promoter of mural painting

Blomfield, James: murals for Lieutenant-Governor's house, Victoria, BC, 31, 153, fig. 51; murals for Royal Bank, 74

Blood Indians: mural by, 154–5, fig. 52

boats: murals in, 70, fig. 18

Boston Public Library: murals in, 56, 57, 58, 161, 162

Boston Public School Art League, 179

Boulanger, Gustave: murals for a Paris *mairie*, 26

Bourassa, Henri, 97

Bourassa, Napoléon: on French Canadian nationalism, 99; on importance of mural painting for French Canada, 5, 31; murals for Quebec's Palais législative, 35–6, fig. 6; on Notre-Dame-de-Lourdes, 101, fig. 26

Bourget, Mgr Ignace, 97, 99

Bowdoin College Chapel, Maine: murals in, 79

Brangwyn, Frank: murals for England's House of Lords, 55; house in Paris, 127; London office of Grand Trunk Railway, 76; Manitoba Legislature, 30; ss *Empress of Britain*, 65

Bridle, Augustus, 83, 89

Briffa, Emmanuel: murals for Halifax's Capitol Theatre, 67–8, plate 4

Brinton, Selwyn, 59

British Columbia Parliament Buildings, 5, 31, 41, 142–3, 144, 150, figs. 2, 3, 4

Brittain, Miller: murals for St John's Hospital, 203–4

Brown, Eric, 10

Brown, Ford Madox: murals for Manchester Town Hall, 48, 53, 54, 55, 91

Browne family: church decorators, 80

Brownell, Franklin: mural plans for Federal Parliament Buildings, Ottawa, 43

Brymner, William: mural for Île d'Orléans home of Charles Porteous, 123, fig. 33

Buchanan, Donald, 204

Burges, William: murals for Cardiff Castle, 112

Burne-Jones, Edward: murals for George Howard's house, London, England, 112; the Oxford Union, 113

Byzantine revival, 81–90, 91

Caffin, Charles, 64

Calonne, Alphonse de, 52

Canadian Art Club, 9

Canadian Bank of Commerce: murals in Montreal, 199; Toronto, 50, 62, 74, 143, fig. 20, plate 5

Canadian Club, 9, 50, 130, 158

Canadian National Exhibition: murals for, 45, 73, 147, 148–9, figs. 49, 50

Canadian Pacific Railway: murals for, 73, 76, 191

Capello, Luigi: murals for Notre-Dame Cathedral, Montreal, 104

Capital Theatre, Saskatoon: murals for, 68

Capitol Theatre, Halifax: murals for, 67–8, plate 4

Carlu, Natacha: mural for Eaton's, Montreal, 197

Carlyle, Thomas, 20, 88

Carman, Albert, 5

Carmichael, Frank: mural for St Anne's Anglican Church, Toronto, 83

Carter, Alexander Scott: mural for University Club, Montreal, 124

Cassatt, Mary: mural for World's Columbian Exposition, Chicago, 66

Castle Kilbride, Baden, Ont., murals, 118–20, fig. 30

Catholic Church murals, 94–108

Challener, Frederick: on the importance of mural painting, 41, 48, 49, 50; murals for Federal Parliament Buildings, Ottawa, 43; home of F. Stone, Toronto, 121; Loblaws' mural, 19, 144, 146–7, fig. 48; Manoir Richelieu, Malbaie, Quebec, 71, 144, figs. 46, 47; Parkwood, Oshawa, Ontario, 126–8, 132–3, plate 7; Royal Alexandra Hotel, Winnipeg, 74, 137, 139, 142, 144, 150, fig. 39; Royal Alexandra Theatre, Toronto, 49; Russell Theatre, Ottawa, 3, 72, fig. 19; Toronto City Hall, 40; ss *Kingston,* 70, fig. 18

Charlesworth, Hector, 89

Château Dufresne, Montreal: murals in, 116, fig. 29

Château Laurier Hotel, Ottawa: murals for, 73–4, figs. 44, 45

Château Montebello (Lucerne-in-Quebec): murals in, 71, 143

Chéret, Jules: mural for Hôtel de Ville, Paris, 52

Chester, John: mural for Arts and Letters Club, Toronto, 139, fig. 41

Chevalier, Michel, 19

Chicago: World's Columbian Exposition, 39, 66

City Beautiful Movement, 41

civic murals
– American, 25, 26, 55–9, 161–2
– Canadian: British Columbia, 31, 142–3, 144, 150, 153, 197; general discussion, 24–59, 135–6; Maritimes, 27–8, 199; Ontario, 38–59, 135–6, 148–9, 151–2, 159–61, 163–5, 170–2; Prairie Provinces, 28–31, 152; Quebec, 31–38, 95
– English, 25, 26, 48, 53–5; 63

– French, 25–7, 51–3, 161–2

Claire, Lorna: mural for Earlscourt Library, 160, 163, 170, 171, 172; Jarvis Collegiate, 151, 152;

Clairin, Georges, 37

Clarke Steamship Company: mural for, 70

classical images: Apollo, 3, 119, 120; Bacchus, 74, 116; cherubs, 121; cupids, 122; Cupid and Psyche, 114; Flora, 64, 65; general use of, 4, 16, 25, 27, 43, 55, 60, 61, 64, 66, 68, 69, 110, 161; Mercury, 64; in movie theatres, 68; Olympian deities, 120; popularity of, 132; Prospero, 113; rejection of by muralists, 17–18, 28, 39, 51–2, 57, 58–9, 69–70, 75, 122, 165, 193; sea nymphs, 70, 113; Venus, 111; Venus and Adonis, 49 72; Zeus, 120

Clinton Street Public School, Toronto: opalescent glass mural in, 173–4, fig. 55

clubs, private: murals in American, 114; Canadian, 116, 118, 122, 124, 125, 139–41, figs. 42, 43; English, 113

Cockerell, Charles, 20

Colgate, William, 6

Collingwood Public Library: murals in, 43

Columbia Theatre, Victoria, BC: murals for, 68

Colville, Alex: mural in Tweedie Hall, Mount Allison University, 199

Comfort, Charles: murals for Dominion Bank, 199; Hotel Vancouver, 197–8; National Library, 200, fig. 62; Toronto Stock Exchange, 197; plate 8

commercial murals
– American, 62, 65–6
– Canadian, 60–77; British Columbia, 68, 74–6, 197–9 ; Maritimes, 66–7, 199; Ontario, 68, 71–4, 143–4, 146–7, 150–2, 197; Prairie Provinces, 68, 74–5, 76, 137, 139, 142, 150, 152, 154–5; Quebec, 68–71, 144
– English, 65

– French, 62, 64–5

Concourse Building, Toronto: murals in, 72

Conference of Canadian Artists, Kingston, 1941, 204

consumerism, 130–1, 132

Craigdarroch house, Victoria, BC: murals for, 121

Crisp, Arthur: murals in Canadian Bank of Commerce, Toronto, 50, 62, 74, 143, fig. 20, plate 5; Federal Parliament Buildings, Ottawa, 45, 160, fig. 10

Croscup House, Karsdale, NS: murals for, 114

Crowninshield, Frederic: murals for Hotel Manhattan, 65; as promoter of mural painting 21

Cullen, Maurice, 123–4

Cunard shipping offices, New York, 62

Cupid and Psyche, 114

dancing, 139

Darwin, Charles, 88

Davies, James T.: murals in Montreal home of, 123–4

Delaroche, Paul: mural for École-des-beaux-arts, Paris, 35, 201

Denis, Maurice: as church decorator, 106; murals for the home of Gabriel Thomas, 112; murals in Palais de Chaillot, Paris, 52

Denison George, 9

Desgoffe, Alexandre: murals for the Bibliothèques Ste Geneviève and Nationale, Paris, 161

Detroit Public Library: murals in, 162, 163, 172

Dever, John: murals in Saint John, NB, home of, 115

Dewey, John, 196

Dewing, Thomas: murals for New York's Imperial Hotel, 65

domestic murals

– American, 113

– Canadian, 109–33; British Columbia, 121–2; Maritime Provinces, 114–16; 122–3; Ontario, 116–21, 124, 124–8, 132–3, 153; Prairie Provinces, 121, 128–9; Quebec, 116–18, 123–4

– English, 110–12

– Welsh, 112

Dominion Bank, Vancouver: murals in, 199

Douglass, Lucille: murals in the Newcastle, NB, meeting house of the IODE, 122

Doyle, Charles: murals in the Pictou Opera House, NS, 122

Dufresne, Oscar and Marius: murals in the Montreal home of, 116, fig. 29

Dutch children, images of in kindergarten murals, 173, 186–7, 191

Dyce, William: murals at All Saints' Church, Margaret Street, London, England, 79

Dyonnet, Edmund: plan for murals for Federal Parliament Buildings, Ottawa, 43

Earlscourt Public Library, Toronto: murals for, 45, 159–65, 168, 170–2, 179, figs. 53, 54

Eaton, Sir John: murals for home of, 121, fig. 32

Eaton's department store, Montreal: mural in, 197

Empire Theatre, Edmonton: murals for, 68

Empress Hotel, Victoria, BC: murals for, 75

encaustic, 18

English mural painting: civic, 25, 26, 48, 53–5, 63; commercial, 65; domestic, 112–13; general discussion, 16, 17, 20, 21–2; religious, 79

European-based Mural Movement (the Mural Movement), 12, 15–23, 174, 193, 197, 199

Fairbairn, Margaret, 46, 50
fairy tales, 185–6
Falmouth, NS, Baptist Church: murals in, 79
Faulkner, Barry: murals in the Cunard shipping offices, New York, 62
Federal Parliament Buildings, Ottawa: murals for, 43, 45, 160, fig. 10
Ferry, Jules, 20
First Methodist Church, Hamilton, Ont.: murals for, 80
First United Church, Vancouver: murals for, 80
Fish, Stanley, 17, 172
Fisher, Orville: mural for First United Church, Vancouver, 80; for Malaspina Hotel, Nanaimo, 197
Fisher Vocational School, Woodstock, NB: murals for, 199
Flandrin, Hippolyte: as muralist in France,101
Flower Memorial Library, Watertown, New York: murals in, 162
Forbes, Stanhope: mural for London's Royal Exchange, 63
Ford, Harriet: mural for the Charles Porteous house, Île d'Orléans, 123
Fowler, Frank, 56
Franchère, Joseph-Charles: mural for Notre-Dame Cathedral, Montreal, 102
Francis-Xavier University, Antigonish, NS: mural for Assembly Hall, 109
Fredericton High School, NB: murals for, 203
French Canadian nationalism, 95–100
French mural painting: civic, 25–27, 51–3, 161–2; commercial, 62, 64–5; domestic, 112; general discussion, 19–20, 51–3; religious, 101–2

fresco, 17, 54
Froebel, Friedrich, 181–6, 190, figs. 58, 59; mother-play songs in writings, 182–5

Geddes, Patrick, 22
George, Vesper Lincoln: mural for Edward Lee McClain High School, Ohio, 26
Gill, Charles: mural for Notre-Dame Cathedral, Montreal, 102
Girvan, John: mural for Memorial Hall, Edmonton, 28; Vancouver Province building, 76
Glaize, Léon: mural for Paris mairie, 25, 195
Goetze, Sigismund: murals in Foreign and Commonwealth Office, London, 53–4, 55
Goranson, Paul: mural for First United Church, Vancouver, 80; for Malaspina Hotel, Nanaimo, 197
Gramsci, Antonio, 17
Grand Theatre, London, Ont.: mural in, 68
Grand Trunk Railway offices, London, England: mural for, 76–7
Greenberg, Clement, 7, 12
Greene, Thomas Garland: mural for Toronto home of Ernest C. Jury, 125
Grey Sister's Hospital, St Boniface, Man.: murals for, 108
Grier, E. Wyly: mural plan for Federal Parliament Building, 43
Griffith, Julius Jr: mural for Shawnigan Lake School, Shawnigan Lake, BC, 202
Groulx, Lionel, 97, 98
Group of Seven: dominance of in Canadian art history, 8, 9, 10, 11, 12, 205
Guildhall, London, England: murals for, 53
Gundry & Langley, Toronto, 79

Habermas, Jürgen, 22, 49, 129

Hahn, Gustav: mural for home of Edward Wood, Toronto, 120–1; Ontario Legislative Buildings, 39, fig. 8; St Paul's Methodist Church, Toronto, 80, 92, fig. 22; Wymilwood, Toronto, 124

Haines, Frederick: murals for Canadian National Exhibition, 43, 45, 73, 148–50, 180, figs. 49, 50

Halifax Banking Company, Antigonish, NS: murals for, 67

Hamerton, Philip, 19

Hamilton, Ont., Methodist Church: murals for, 79–80

Harper, J. Russell, 6, 7, 8, 11, 204

Harris, Canon: murals for Masonic Lodge, Mahone Bay, NS, 122

Harris, Robert: murals for St Peter's Anglican Cathedral, Charlottetown, 80, fig. 23

Harris, William, 56

Hart, Caroline, 178, 182, 185

Hart House Chapel, University of Toronto: murals in, 92, fig. 25

Haultain, Arnold, 88

Haydon, Harold: murals in Pickering College, Newmarket, Ont., 203

Hill, Charles: as promoter of Group of Seven, 6, 7, 8, 205

Hill, Donald: mural for Strathearn School, Montreal, 26, 34, 42, fig. 5

Hodgins, George, 178

Holgate, Bidwell A.: murals in Edmonton house of, Alberta, 128, fig. 37

Hollywood Theatre, Toronto: murals for, 68

Holy Trinity Anglican Church, Toronto: murals for, 79

Holy Trinity Church, Boston: murals in, 79

Horne, George Russell: murals in family home, Newcastle, NB, 122

Hosmer, Charles: murals for Montreal house of, 115

Hospital of the Grey Sisters, St Boniface, Man.: murals for, 108

Hôtel de ville, Paris: murals in, 51, 52

Hotel Vancouver: murals for, 198, fig. 61, plate 8

Houses of Parliament, London, England: murals in, 26, 53, 54, 55

Housser, Fred: as supporter for Group of Seven, 10

Howland, William Ford: as architect of St Anne's Anglican Church, Toronto, 84, 87

Hudson's Bay Company, Winnipeg: murals in, 74, fig. 21

Hughes, Edward: mural for First United Church, Vancouver, 80; for Malaspina Hotel, Nanaimo, 197

Hughes, James L., 179, 182

Humberside Collegiate, Toronto: murals in, 45, 50, 151, 201, fig. 11

Hunt, William: murals in State Capitol, Albany, NY, 56, 57

Hunter, W.E.N.: murals for Hamilton, Ont., Methodist Church, 79

Huot, Charles: murals for Palais législatif, Quebec, 8, 37, 38, fig. 7

Hutchinson, Frederick: murals for Montreal home of Charles Hosmer, 115

Imhoff, Count Berthold von: murals in St Peter's Catholic Church, Muenster, Sask., 108

impressionist painting style, 19

Independent Order Daughters of the Empire: murals in meeting house, Newcastle, NB, 122

Indian Act of 1876, 139

Innes, John: murals for Spencer's
 Department Store, Vancouver, 76
Italian Renaissance, 49, 113
Ittner, William, 180

Jarvis Collegiate, Toronto: murals in, 45,
 151–2, fig. 12
Jefferys, Charles: art copied by Briffa, 67;
 murals for Château Laurier, Ottawa,
 143–4, figs. 44, 45; Manoir Richelieu,
 Malbaie (Murray Bay), Quebec, 71,
 144, figs. 46, 47; Royal Ontario
 Museum, 46
Jenkins, Lynn: murals for English home
 of W.F. Unsworth, 112–13
Johnston, Frank: murals for Pickering
 College, Newmarket, Ont., 153
Jones, Owen: *Grammar of Ornament,* 69

Kant, Immanuel, 18
Kemp-Welch, Lucy: mural in Royal
 Exchange, London, England, 63
Kenderdine, Augustus: mural for
 World's Grain Exhibition and
 Conference, Regina, 29
Kilpatrick, Reverend Thomas, 130
Kilvert, Cory: mural "map" for the ss
 Northern, 70
Kindergarten Movement, 176, 181–6
King, Pauline, 22
King Edward VII School, Montreal:
 mural for, 26, 34
Kirby, William, 42
Knowles, F. McGillivray: mural for
 Toronto home of John D. Eaton, 121,
 fig. 32

La Farge, John: murals for Boston's Holy
 Trinity Church, 79
Laflèche, Mgr Louis-François, 98, 99
Lamb, Ellie Condie: murals for Flower
 Memorial Library, Watertown, NY, 162

Lamb, Frederick: murals for Flower
 Memorial Library, Watertown, NY,
 162; on the importance of public
 libraries, 157–8
Lampman, Archibald, 42
landscape in Canadian mural painting:
 in British Columbia murals, 75–6; in
 Maritime murals, 67; in Ontario
 murals, 74, 92, 124–28, 132, 160–164,
 173, 180–1; in Prairie Provinces
 murals, 128–9; in Quebec, 70, 123–4; in
 theatre murals, 68; of European sites,
 69; promotion of by Toronto artists,
 9–10, 41–7
Langford, Adelaide: murals for
 Canadian Pacific Railway, 75–6
Laning, Edward: murals in New York
 Public Library, 162
Larose, Ludger: murals for Notre-Dame
 Cathedral, Montreal, 102; on the
 importance of mural painting for
 French Canadians, 32
Laurendau, Arthur, 100
Le Corbusier: murals for Pavilion Suisse,
 Paris, 194
Leacock, Stephen, 42, 132–3, 142
Leduc, Ozias: on domestic art, 67, 117;
 murals for Antigonish, NS, 67; Hospital
 of the Grey Sisters, St Boniface, Man.,
 108; Notre-Dame-de-la-Présentation,
 Shawinigan-Sud, Que., 106–7; in
 Saint-Enfant-Jésus, Montreal, 104–5;
 in Saint-Hilaire, 103–4, fig. 27
Leighton, Lord: murals in South
 Kensington (Victoria and Albert)
 Museum, London, England, 25, 54, 63
Leman, John: mural in Saskatchewan
 Legislative Building, 28, 152, 153, plate 1
Lévy, Henry: mural for Bon-Marché,
 Paris, 62
librarians: working conditions in North
 America, 165–8, 169

library murals, 157–72; American, 161–2; Canadian, 159–61, 163–5; French, 161–2

Lieutenant-Governor's house, Victoria, BC, 31, 153, fig. 51

Lismer, Arthur: in England, 25, 63; on importance of mural painting, 55; on Mexican mural painting, 201; murals at Humberside Collegiate, 45, 136, 151,195, fig. 11; MacCallum cottage, 125, 153, fig. 35; as nationalistic, 8, 41, 49, 50; Nova Scotia restaurant mural, 67, fig. 14

Listowel, Ont.: murals in, 120

literary themes in mural painting, 26, 162

Livingstone, James: murals in Baden, Ont., home of, 118–20, fig. 30

Livingstone, John: murals in Listowel, Ont., home of, 120

Loblaws, Toronto: mural for, 72, 144, 146, 150, fig. 48

Locke, George, 158, 163, 170, 171

London, Ont.: Grand Theatre, mural in, 68

Long Garth, Toronto: murals for, 124–5, fig. 34

Love, H.H.: murals in Toronto home of, 125

Low, William, 20, 56

Lucerne-in-Quebec (Château Montebello), murals in, 71, 143

Lunenberg, NS: murals in County Courthouse, 27; St John's Anglican Church, 79

Lyons, George: murals in the John Wylie Churchill house, Hants Co., NS, 154

MacCallum, James, E.: murals in summer home of, 125, 171, figs. 35, 36

MacDonald, James E.H.: in England, 63; mural competition, 1923, 45, 137–9, 160, 163, 170, 171, 172, fig. 40; murals for Concourse Building, Toronto, 72–3; MacCallum cottage, 125–6, 153, fig. 36; St. Anne's Anglican Church, Toronto, 48, 81–3, 86, 90–3, fig. 24

Macdonald, Jock: 198–9, mural for Hotel Vancouver, fig. 61

McGill University: murals for, 116, 203

Mackenzie, Charles, 67

McLaughlin, Samuel: murals for Oshawa, Ont., home of, 126, 127, 128, 132

Macleod, Pegi Nichol: murals for Fisher Vocational School, Woodstock, NB, 199

MacMonnies, Mary: mural for World's Columbian Exposition, Chicago, 66

MacMullen, John, 136, 142, 150

MacTavish, Newton, 6

McWilliam, Josephine and Robert: home of, Drayton, Ont., 120; Josephine as muralist, 120

Mahlstick Club, Toronto, 9

Maillart, Diogène: mural for Bon-Marché, Paris, 62

Mair, Charles, 42, 142

Malaspina Hotel, Nanaimo, BC: murals for, 197

Malbaie (Murray Bay), Qué.: murals for Manoir Richelieu, 71, 144, figs. 46, 47

Manchester Town Hall, England: murals in, 48, 53, 54, 55, 91, 93

Manitoba Legislative Building, Winnipeg: murals in, 29–30, fig. 1

marouflage, 17, 57

Masonic Lodge, Mahone Bay, NS: mural in, 122

Martin, Henri: murals for the Capitole, Toulouse, France, 52

material progress: as driving force of nationalism, 8–9, 18, 24, 60, 129–31, 132, 135, 162; supposed lack of in Canadian Native culture, 134

Maurault, Olivier, 5, 99

Mavor, James, 41, 49, 50

Mays, John Bentley, 83

Meadowville, Ont., Public School: mural for, 180

Mechanics' Institute, Toronto: mural for, 39

medieval themes in Canadian mural painting: Byzantine, 81–90, 91; general, 3, 4, 64, 109, 110, 111, 162; Gothic, 62, 121; Vikings, 121

Melchers, Gari: murals for Detroit Public Library, 162, 163, 172

Meloche, François-Xavier-Édouard: murals in St Simon and St Jude Catholic Church, Tignish, PEI, 108

Memorial Hall, Edmonton: mural for, 28

Merrifield, Mrs: on the importance of mural painting, 21

messianism: in French Canada, 98–9

Metropolitan Methodist Church, Toronto: murals for, 80

Mexican murals of the 1920s and 1930s, 195, 201–2, 203

Millet, Frank: mural in the Custom House, Baltimore, 25

Minister's Island, NB, mural, 190, fig. 60

Mississauga, Ont., Golf Club: murals in, 125, 139, 141, figs. 42, 43

Mitchell, Richard: mural in Montreal home of, 123–4

Moira, Gerald: murals for English home of W.F. Unsworth, 112

Mont Royal Park, Montreal: chalet murals, 33

Montreal High School: mural for, 34

Montreal Museum of Fine Arts: mural for, 34

Montreal: murals for Notre-Dame Cathedral, 102; Windsor Hotel, 69, fig. 16

Moran, Mr: murals in home of, St John, NB, 114–15

Moser, Josef: mural for Cobourg, Ont., Town Hall, 39

Mount Allison University: mural in, 199

Mowbray, Siddons: mural for University Club, New York, 114

Muller and Sturn: murals in Victoria, BC, 122

Mural Movement (European-based), 12, 13, 15, 23; patronage, 15–16

nation-state: Canada as, 5, 6, 95; as patrons of mural painting, 4–5, 12, 15, 24, 60, 173, 174, 193

National Gallery of Canada, 7, 11

National Library, Ottawa: murals in, 200–1, fig. 62

National Society of Mural Painters, 21, 56

nationalistic sentiment, 9, 10, 11, 12

New York Public Library, murals in, 162

Newcastle, NB: mural in "Old Manse Library," 115, 122, fig. 28

Nincheri, Guido: murals for Belmont Theatre, Montreal, 68, fig. 15; Château Dufresne, Montreal, 116, fig. 29; Notre-Dame-de-la-Défense, Montreal, 103

Norton, Charles Eliot, 16

Notre-Dame Cathedral, Montreal: murals for, 102

Notre-Dame-de-la-Défense, Montreal: murals in, 103

Notre-Dame-de-la-Présentation, Shawinigan: murals for, 106

Notre-Dame-de-Lourdes, Montreal: murals in, 3, 101, fig. 26

nursery decoration, 189

nursery rhymes, 185

Oakley, Violet: murals for Charlton Yarnall house, Philadelphia, 113

Ogilvie, Will: 92, murals for Hart House Chapel, University of Toronto, fig. 25

oil paint, 17, 54

Ontario Legislative Buildings: murals for, 39, 43, fig. 8

Onteora, NY: murals by G.A. Reid, 80, 125

opalescent glass murals, 173, 188; relationship to stained glass, 190

Ottawa, Federal Parliament Buildings: murals planned for, 43, 45, 160, fig. 10

Page, Mr: murals for St John's Anglican Church, Lunenberg, NS, 79

Palais législatif, Quebec: murals for and in, 34, 35, 36, 37, figs. 6, 7, plate 2

Palmer, Herbert: mural for St Anne's Anglican Church, Toronto, 148

Papineau, Louis-Joseph, 96

Pâquet, Mgr L.-A., 98

Parent, Étienne, 97

Paris: murals for Bon-Marché, 62 Gare de Lyon, 64, 65

Parkwood, Oshawa, Ont., murals in, 126–8, 132–3, plate 7

Parliament Buildings. See Federal Parliament Buildings

patriarchy, 16, 24, 26, 66, 73, 165–70

Pearce, Charles Sprague: murals for the Library of Congress, Washington, 164

Pendray, William, murals for home in Victoria, BC, 122

Penetang, Ont., Public Library: murals for, 43, 159, 163

Perrigard, Hal: mural for Montreal's Windsor Station, 70, fig. 17

personifications: in American murals, 26, 65, 163; in Canadian murals, civic, 30, 31, 34, 35, 37, 39, 40, 43, 45, 46, 49, in Canadian murals, commercial, 74, 75; of drama, 65, 72; in English murals, 25, 65; in French murals, 25–6, 27, 62, 64; of Mother Earth, 65; of seasons, 65, 123; times of day, 65

Pickering College, Ont., murals in, 153–4, 203

pictographs: Canadian Native, as mural subject matter, 154–5

Pictou, NS, Opera House: mural in, 67

Pienovi, Angelo: mural for Notre-Dame Cathedral, Montreal, 102

Pilot, Robert: murals for Montreal High School, 34

Platonic ideas of beauty, 18, 29, 49, 101, 106, 178

Port Howe, NS: mural in, 122

Porteous, Charles: murals in Île d'Orléans home of, 123, fig. 33

Preston, Richard, 8

Prince of Wales Hotel, Waterton Lake Federal Park, Alta: murals in, 154–5, fig. 52

Prince William Street houses, Saint John, NB: murals in, 115–16

private school murals: British Columbia, 202; Ontario, 153, 203

Protestant church murals, 78–9, in Canada, 79–93; England, 79; United States, 79

Puvis de Chavannes, Pierre-Cécile: as worthy of imitation, 19, 37, 43, 50, 52, 56, 57, 58, 162

Quebec Act, 95

Quiet Revolution, 106

Reid, Dennis: as promoter of Group of Seven, 6, 7, 8, 11, 12, 204

Reid, George Agnew, 6; as adviser for murals at Rosedale School, 45, 179, 187–8, 191; on American murals, 31, 58, 164–5; Earlscourt Library, 45, 159–65, 170–2, 179, figs. 53, 54; Jarvis Collegiate, 46, 63, 151–2, fig. 12; Long Garth, Toronto, 124–5, fig. 34; Onteora, New York, 80; Royal Ontario Museum, 47,

fig. 13; murals for Toronto Arts and Letters Club, 121; Toronto home of Ernest C. Jury, 12; Toronto home of H.H. Love, 125; Toronto Municipal Buildings, 40, 135, fig. 38; plans for murals in Federal Parliament Buildings, 43; as promoter of mural painting, 41; views on English murals, 53; visit to United States, 25; visit to the World's Columbian Exposition, 66

Reid, Mary Hiester: murals for Weston Town Hall, 25, fig. 9; Wychwood Park, Toronto, home, 121, fig. 31

Reid, Mary Wrinch, 6

Renaissance, Italian: Florence; 113; gardens, 126; general references, 62, 4, 7, 21, 49, 64, 78, 109, 110, 111; Heracles, 113; Michelangelo, 49; Perugino, 22; Pintoricchio, 114

Rensselaer, Marianna van, 53

Richelieu & Ontario Navigation Company: mural for, 70

Rivera, Diego, 202

Roquebrune, Robert de, 107

Rosedale School, Toronto: murals in, 45, 180–1, fig. 57, plate 3

Rosenberg, Harold: Nova Scotia restaurant mural, 67, fig. 14

Ross, Fred: mural for Fredericton High School, 203

Rossetti, Dante Gabriel: mural for Oxford Union, 113

Royal Alexandra Hotel, Winnipeg: murals for, 74, 137, 150, fig. 39

Royal Alexandra Theatre: mural in, Toronto, 72

Royal Bank, Vancouver: mural for, 74–5

Royal Canadian Academy: mural contest, 1923, 34, 90, 137, fig. 40; mural contest, 1924, 34, 170, 171, figs. 53, 54

Royal Exchange, London, England: murals in, 54, 63, 91, 93

Royal Ontario Museum, Toronto: mural for, 45, 47, fig. 13

Royal Victoria Theatre, Victoria, BC: mural for, 68

Ruskin, John, 20, 85, 86, 88, 122, 129, 178, 179, 180, 182, 191

Russell Theatre, Ottawa: mural for, 72, fig. 19

Said, Edward, 17, 135

St Anne's Anglican Church, Toronto: murals for, 48, 81–93, 171, fig. 24, plate 6

Saint-Charles, Joseph: mural for Notre-Dame Cathedral, Montreal, 102

Saint-Enfant-Jésus, Church of Mile End, Montreal: murals in, 104–6

Saint-Hilaire, Church of, St Hilaire, Quebec: murals in, 103, fig. 27

Saint-Saveur, Church of, Quebec City: murals in, 100

St Francis-Xavier University, Antigonish, NS: mural for, 108

Saint-Jean-Baptiste Society, 105

St John's Anglican Church, Lunenberg, NS: murals in, 79

St Jude's Anglican Church, Brantford, Ont.: murals in, 80, 92

Saint-Léon-de-Westmount, Church of: murals in, 103

St Louis Missouri: public kindergartens, 180

St Ninian's Cathedral, Antigonish, NS: murals in, 67

St Paul's Methodist Church, Toronto: murals for, 80, 92, fig. 22

St Peter's Anglican Church, Charlottetown: murals in, 80, fig. 23

St Peter's Catholic Church, Muenster, Sask.: murals in, 108

Saint-Saveur Church, Church of, Quebec City: murals in, 100

St Simon and St Jude Catholic Church, Tignish, PEI: murals in, 108

Sargent, Irene, 20, 180, 191

Sargent, John Singer: murals in Boston Public Library, 57, 58, 162

Saskatchewan Legislative Building: mural in, 29, plate 1

Schaefer, William: murals for Victoria, BC, homes, 121–2

Schasstein, H.: mural for Castle Kilbride, Baden, Ont., 118, fig. 30

Schmit, Jean-Philippe, 102

School Beautiful Movement, 176, 177–81, 182, 190

Scott, Adam Sheriff: murals for Dominion Bank, Vancouver, 199; Hudson's Bay Company, 71, 74, 143, fig. 21

Scott, Charles, 31

Scott, Duncan Campbell, 43

Scott, Marian Dale: murals in McGill University, 203

Scott, Robert: murals in home of, 120

Sentenne, Léon-Alfred, 102

Shawnigan Lake School, BC: murals for, 202

Shean, Charles, 56, 58

Sherwood, William, 9, 41, 156

Shinn, Everett, 65

Simon, Frank: as architect of Manitoba Legislative Building, 29

Simpson, Charles: mural for Montreal Museum of Fine Arts, 34

Sisters of the Holy Name of Jesus, Montreal Convent: mural for, 108

Skey, Reverend Lawrence, 81, 83, 84, 85, 89, 90, 91

Smith, Goldwin, 88

Smith, Leslie: mural for King Edward VII School, Montreal, 26, 34

Society of Mural Decorators, Toronto, 39

South Kensington (Victoria and Albert) Museum, London, England, 25, 53, 54

Southall, Joseph: murals for Town Hall, Birmingham, England 53

Southwell, George: murals for the British Columbia Legislative Building, 5, 31, 41, 142–3, 144, 150, figs. 2, 3, 4

Spencer, Stanley: murals for Burghclere Chapel, England, 194, 195

spirit fresco, 17, 54

Stansfield, Herbert: mural in St Anne's Anglican Church, Toronto, 83, plate 6

ss *Kingston*: mural for, 70, fig. 18

ss *Northern*: mural for, 77

Strathearn School, Montreal: mural for, 26, 34, 42, fig. 5

Stratton, Mary Chase: ceramic tiles for Detroit Public Library, 172

symbolism, 105–6

Taché, Eugène: as architect of Palais législatif, Quebec, 35, 38

Tack, Augustus: murals for the Manitoba Legislative Building, 29–30, fig. 1

Tardivel, Jean-Paul, 97

Third Republic, France, 20, 37, 51

Thomson, Tom, 8, 9, 10, 11, 125, 205

Todd, A.: murals for Toronto's Mechanics' Institute, 39

Toronto Art Students' League, 9

Toronto Arts and Letters Club, 91, 121, 170, 171, fig. 41

Toronto: kindergarten murals, 45, 173–92, figs. 55, 56, 57; as most active mural centre, 9, 14; as wealthy city, 8, 71

Toronto Board of Education, 173, 176, 177, 189

Toronto Guild of Civic Art, 40–1

Toronto Municipal Buildings: murals for and in, 39–40, 135, fig. 38

Toronto School Art Leagues, 179, 180

Toronto Society of Mural Decorators, 39

Toronto Stock Exchange: murals in, 197

Toronto-centric, Canadian history as, 8

Traquair, Ramsay, 122, 169–70

Treaty of Paris, 95

Turner, Frederick Jackson, 196

ultramontanism, 99, 102, 104–5

United Empire Loyalists, 42, 96

University Club, Montreal: murals in, 116, 124

University of Toronto, Hart House Chapel: murals in, 92, fig. 25

Van Horne, William: murals for "Covenhoven," 190, fig. 60

Vancouver, 68, 74–6, 80, 197–201, 202

Vancouver Province murals, 76

Varley, Frederick, 83

Vauthier, Pierre, 51

Veblen, Thorstein, 129, 132

Victoria Hall, Cobourg, Ont.: murals in, 39

Victory Hall, Balcombe, Sussex, England: murals in, 53

Viger, Jacques, 105

Walker, Sir (Byron) Edmund: on importance of mural painting, 87; murals in home of, 124–5, fig. 34; as promoter of Group of Seven, 10

Walthew, John: murals in Town Hall, Aylmer, Ontario 39

Washington, Library of Congress: murals in, 56, 57, 58, 161, 164, 165

waterglass technique, 17, 54

Waterton Lake, Alta, Prince of Wales Hotel: murals in, 154–5, fig. 52

Weintraub, Jeff, 22

Welsh mural painting, 112

Weston Town Hall: mural for, 45, fig. 9

Wilde, Oscar, 130

Williams, Raymond, 172

Wilson, R.: Winnipeg home of, 128

Windsor, Hotel, Montreal: mural for, 69, fig. 16

Windsor Train Station, Montreal: mural for, 70, fig. 17

Winter, Ezra: mural for Cunard shipping offices, New York, 62

Wood, Edward, 92, 120

world fairs, 66, 131, 148, 196

World's Columbian Exposition, Chicago, 39, 56, 66

World's Grain Exhibition and Conference, Regina: mural for, 29

Wylie, John: murals in home of, Hants Co., NS, 154